ISBN 978-1-330-87798-2
PIBN 10116065

This book is a reproduction of an important historical work. Forgotten Books uses
state-of-the-art technology to digitally reconstruct the work, preserving the original format
whilst repairing imperfections present in the aged copy. In rare cases, an imperfection in
the original, such as a blemish or missing page, may be replicated in our edition. We do,
however, repair the vast majority of imperfections successfully; any imperfections that
remain are intentionally left to preserve the state of such historical works.

1 MONTH OF
FREE
READING

at
www.ForgottenBooks.com

By purchasing this book you are eligible for one month membership to ForgottenBooks.com, giving you unlimited access to our entire collection of over 1,000,000 titles via our web site and mobile apps.

To claim your free month visit: www.forgottenbooks.com/free116065

MIND AND HAND

MANUAL TRAINING
THE CHIEF FACTOR IN EDUCATION

By CHARLES H. HAM

BEING THE THIRD EDITION OF
‘‘MANUAL TRAINING, THE SOLUTION
OF SOCIAL AND INDUSTRIAL PROBLEMS’

ILLUSTRATED

NEW YORK ·:· CINCINNATI ·:· CHICAGO
AMERICAN BOOK COMPANY

PREFACE TO THE THIRD EDITION.

THE work of which this is the third edition has been before the public of this country, England, and all English-speaking countries since 1886—thirteen years. As it proposes a revolution in educational methods, it was not to be presumed that it would escape criticism. But, while the reviews of it have been numerous, they have, on the whole, been very generous. My most radical postulates have, however, been received by educators of the old régime with expressions of emphatic dissent. In presenting the third edition of the work I have, therefore, thought it wise to support the text with many high authorities in the form of foot-notes. As was to be expected, my analysis of Greek history and character provoked the severest criticism. It is regarded, indeed, as conclusive evidence of gross ignorance of the entire subject. To meet the charge of ignorance, I have made a large number of citations from Herodotus, Thucydides, Xenophon, Plutarch, and others—authors consulted, originally, in the preparation of this part of the work. I may venture to observe, with due deference to those schoolmen who regard the ancient Greeks as an ideal people, that I have searched contemporaneous history in vain for evidence of the verity of this claim; and I am hence constrained to adhere firmly to the extreme views expressed in the text. And if these views are correct, it follows that the passion for

Greek models in education is not only a mental dissipation, but a moral crime.

The other new notes are commended to the careful consideration of the reader, as the fruit of my added years of research and reflection.

The Appendix contains a compilation, in tabular form, of all the facts obtainable from original sources, through the aid of a skilled statistician, showing the physical progress of Manual Training in this country, and the chief countries of Europe, during the last fifteen years.

In this edition the disguise of the first edition is dropped. In that edition a certain school was referred to as "the Chicago school," whereas it was, in fact, purely an ideal school, which had no existence except in the mind of the author. But it embodied educational theories and ideas of Comenius and other great men which the author desired to see adopted. That desire not having been realized, I content myself here by quoting the observation of Oscar Browning as to the proneness of the schoolmaster to neglect opportunities: "The more we reflect on the method of Comenius, the more shall we see that it is replete with suggestiveness, and we shall feel surprised that so much wisdom can have lain in the path of school-masters for two hundred and fifty years, and that they never stooped to avail themselves of its treasures."

It is proper to state that the terms "Kindergarten," "Manual Training," and "The New Education," are used throughout the work as equivalents.

The change of title to "Mind and Hand: Manual Training the Chief Factor in Education"—is made in response to the common and just criticism of the original title as too narrow for the broad treatment of the subject which characterized the text.

The notes prepared especially for this edition will be found at the ends of the chapters to which they respectively belong.

Wherever in this work apparent discrimination in favor of the male sex is indulged through the employment of the pronoun "he," "his," or "him," rather than the corresponding feminine parts of speech, it is merely apparent, not real; for I urge the co-education of the sexes as I urge the co-education of Mind and Hand, because the woman is the complement of the man as the hand is the complement of the mind. For I believe, with John Stuart Mill, that "The true virtue of human beings is fitness to live together as equals; and to enable them to live together as equals, they must be associated in education"; and with Mary Wollstonecraft, that "Virtue will never prevail in society till the morals of both sexes are founded on reason, and till the affections common to both are allowed their due strength by the discharge of mutual duties."

THE AUTHOR.

NEW YORK CITY, *March*, 1900.

PREFACE TO FIRST EDITION.

In 1879 I read a paper before the Chicago Philosophical Society on the subject of "The Inventive Genius; or, an Epitome of Human Progress." The suggestion of the subject came from Mr. Charles J. Barnes, to whom I desire in this public way to express my obligation for an introduction to a profoundly interesting study, and one which has given a new direction to all my thoughts.

At the conclusion of my labors in the preparation of the paper, I realized the force of Bacon's remark, that "the real and legitimate goal of the sciences is the endowment of human life with new inventions and riches."

In tracing the course of invention and discovery, I found that I was moving in the line of the progress of civilization. I found that the great gulf between the savage and the civilized man is spanned by the seven hand-tools—the axe, the saw, the plane, the hammer, the square, the chisel, and the file — and that the modern machine-shop is an aggregation of these tools driven by steam. I hence came to regard tools as the great civilizing agency of the world. With Carlyle I said, "Man without tools is nothing; with tools he is all." From this point it was only a step to the proposition that, It is through the arts alone that all branches of learning find expression, and touch human life. Then I said, The true definition of education is the development of all the powers

of man to the culminating point of action; and this power in the concrete, the power to do some useful thing for man—this must be the last analysis of educational truth.

These ideas are not new. They pervade Lord Bacon's writings, are admirably formulated in Rousseau's "Emile," and were restated by Mr. Herbert Spencer twenty-five years ago. More than this, Comenius, Pestalozzi, and Froebel attempted to carry them into practical operation in the school-room, but with only a small measure of success. It remains for the age of steel to show how powerless mere words are in the presence of things, and so to emphasize the demand for a radical reform in educational methods.

In 1880 my attention was drawn to the Manual Training Department of the Washington University of St. Louis, Mo. In that school I found the realization of Bacon's aphorism, "Education is the cultivation of a just and legitimate familiarity betwixt the mind and things." I made an exhaustive study of the methods of the St. Louis school, and reached the conclusion that the philosopher's stone in education had been discovered. The columns of the *Chicago Tribune* were opened to me, and I wrote constantly on the subject for the ensuing three years. Meantime the Chicago Manual-Training School (the first independent institution of the kind in the world) was founded and opened, and the agitation spread over the whole country, and indeed over the whole civilized world.

This work was commenced two years ago. I found the labor much more arduous than I anticipated, and its completion has hence been delayed far beyond the time originally contemplated for placing it in the hands of a publisher. It may be summarized briefly as consisting

of four divisions: 1. A detailed description of the various laboratory class processes, from the first lesson to the last, in the course of three years. 2. An exhaustive argument *a posteriori* and *a fortiori* in support of the proposition that tool practice is highly promotive of intellectual growth, and in a still greater degree of the upbuilding of character. 3. A sketch of the historical period, showing that the decay of civilization and the destruction of social organisms have resulted directly from defects in methods of education. 4. A brief sketch of the history of manual training as an educational force.

To Dr. John D. Runkle, of the Massachusetts Institute of Technology, the founder of manual training as an educational institution in this country, I cannot express too strongly my deep obligation for valuable suggestions and constant encouragement. To him also am I indebted for nearly all my illustrations, as also particularly for the excellent portrait of M. Victor Della Vos, the founder of the new system of education in Russia. I am also under obligations to Col. Augustus Jacobson, a leading advocate of the new education, for constant counsel and support, as also to Dr. Henry H. Belfield, Director of the Chicago Manual Training School, and Mr. John S. Clark, of Boston.

Of the authors consulted, I cannot forbear mention of Lord Bacon, Rousseau, and Herbert Spencer, whose great works constitute the foundation of the new system of education according to nature. Nor can I omit to acknowledge, with all the emphasis of which words are susceptible, my obligations to Mr. Samuel Smiles. His works, from the lives of the engineers to the shortest of his biographies, constitute an inexhaustible treasure-house of facts from which I have drawn without stint. Mr. Smiles

has traced the springs of English greatness to their true source, the workshop. I have attempted to continue his office by showing that the workshop is a great educational force, and hence that its educational element ought to be incorporated in the system of public instruction.

The propositions of the following pages involve an educational revolution destined to enlighten, and so ultimately to redeem manual labor from the scorn of the ages of slavery, and, in the end, to render the skilled laborer worthy of high social distinction, thus presenting at once a solution not only of the industrial question but of the social question.

CHARLES H. HAM.

INTRODUCTION TO THE THIRD EDITION

By Col. Francis W. Parker,
Principal of the Chicago Normal School.

The last twenty-five years have brought much of intrinsic value into American education. Rapid increase in population and ever-changing conditions have made imperative demands for schools adequate to self-government.

The Kindergarten led the way to other substantial reforms in education, and called attention to the actual needs of childhood. It proved conclusively that hand-work is one of the dominant interests of the child, and demonstrated the absolute dependence of brain-growth upon Manual Training.

Manual Training is thus a direct outcome and sequence of the Kindergarten. It supplies a need for which there is no substitute. The belief that that which is begun in the Kindergarten should be continued and expanded in all upper grades, forces itself more and more upon thoughtful minds. Modern psychology brings its potent evidence as to the tremendous value of the work of the hand in the building of the brain. The trend of educational thought will always be in the direction of hand training as a fundamental element in education.

Twenty-five years ago Manual Training was little known in this country as a factor in education. Charles H. Ham,

imbued with a fervid patriotism, saw clearly that one of
the intrinsic needs of education—an absolute necessity in
the evolution of a democracy—is the training of the whole
being, hand, brain, and soul, through educative work. He
was, indeed, a pioneer, beginning his work when there was
very little attention given to this important subject, and
at a time, too, when it was opposed by nearly all leading
educators.

Mr. Ham, together with Colonel Jacobson, brought a
strong influence to bear upon the Commercial Club of
Chicago, to found a Manual-Training school. This school
is now a department of the Chicago University and has
been in successful operation for thirteen years. There
are in Chicago to-day the Armour Institute, the Lewis
Institute, and the Jewish Manual-Training School, all
prominent and well established. There is also a high
school for Manual Training in connection with the public
schools, and, best of all, there are indications which show
that hand-work is making its way throughout the grades.

Mr. Ham, without doubt, had a strong influence upon
the late George M. Pullman, which led him to provide,
through his will, for a Manual-Training school for the
children of the city which he built.

Manual-Training schools are now maintained in almost
every city in the Union. Much remains to be done be-
fore Manual Training takes its true place in education.
The majority of these schools now in existence are for
boys who have graduated from the grammar school, which
leaves the years between six and fourteen with little or
no hand-work. Thus the most important period for brain-
growth through hand activity is neglected.

The future of Manual Training is to introduce hand-
work as the principal factor in the first four years' work,

to be continued in the four years of the grammar grades, and correlated with all other subjects. Indeed, the ideal is to introduce Manual Training in all courses of study, from the Kindergarten to the University, inclusive.

The patrons of Cook County Normal School owe to Mr. Ham ·the establishment of Manual Training in connection with the primary grades of the school, nearly fifteen years ago; for without the practical aid he gave it, it could not have been accomplished at that time. The children — indeed, all the people of this country — owe him an immense debt of gratitude for his heroic championship of hand-work.

Manual Training gives a true dignity to labor; it calls attention to the place of hand-work in human progress, and as civilization goes on it will have a higher and still higher place in the hearts of the people.

CONTENTS.

CHAPTER V.

THE CARPENTER'S LABORATORY.

CHAPTER VI.

THE WOOD-TURNING LABORATORY.

CHAPTER VII.

THE FOUNDING LABORATORY.

CHAPTER VIII.

THE FORGING LABORATORY.

CHAPTER IX.

THE MACHINE-TOOL LABORATORY.

CHAPTER X.

MANUAL AND MENTAL TRAINING COMBINED.

CHAPTER XI.

THE INTELLECTUAL EFFECT OF MANUAL TRAINING.

CHAPTER XII.

THE EDUCATION OF WOMEN A NECESSITY.

CHAPTER XIII.

THE MORAL EFFECT OF MANUAL TRAINING.

CHAPTER XIV.

THE MIND AND THE HAND.

CHAPTER XV.

THE POWER OF THE TRAINED HAND.

CHAPTER XVI.

THE INVENTORS, CIVIL ENGINEERS, AND MECHANICS OF ENGLAND, AND ENGLISH PROGRESS.

CHAPTER XVII.

POWER OF STEAM AND CONTEMPT OF ARTISANS.

CHAPTER XVIII.

AUTOMATIC CONTRASTED WITH SCIENTIFIC EDUCATION.

CHAPTER XIX.

AUTOMATIC CONTRASTED WITH SCIENTIFIC EDUCATION—*Continued.*

CHAPTER XX.

AUTOMATIC CONTRASTED WITH SCIENTIFIC EDUCATION—*Continued.*

CHAPTER XXVII.

PROGRESS OF THE NEW EDUCATION—1883–1899.

Educational Revolution in 1883–4. — Urgent Demand for Reform.— Existing Schools denounced as Superficial, their Methods as Automatic, their System as a Mixture of Cram and Smatter.— The Controversy between the School-master of the Old Régime and the Reformer.—The Leaders of the Movement, Col. Parker, Dr. MacAlister, and others—followers of Rousseau, Bacon, and Spencer. — "The End of Man is an Action, not a Thought."— The Conservative Teachers fall into Line.—The New Education becomes an Aggressive Force pushing on to Victory.—The Physical Progress of Manual Training—its Quality not equal to its Extent.—The New System of Training confided to Teachers of the Old Régime.— Ideal Teachers hard to find.—Teachers willing to Learn should be Encouraged.—The effects of Manual Training long antedate its Introduction to the Schools. — Bacon's Definition of Education.— Stephenson and the Value of Hand-work.—Manual Training is the union of Thought and Action.—It is the antithesis of the Greek methods, which exalted Abstractions and debased Things. — The Rule of Comenius and the Injunction of Rousseau—few Teachers comprehend them.—The Employment of the Hands in the Arts is more highly Educative than the acquisition of the rules of Reading and Arithmetic.—What the Locomotive has accomplished for Man. —Education must be equal, and Social and Political Equality will follow.—The foundation of the New Education is the Baconian Philosophy as stated by Macaulay.—Use and Service are the Twin-ministers of Human Progress.—Definitions of Genius.—Attention. —Sir Henry Maine.—Manual Training relates to all the Arts of Life. —Mind and Hand.—Newton and the Apple.—The Sense of Touch resides in the Hand.—Robert Seidel on Familiarity with Objects.— Material Progress the basis of Spiritual Growth.—Plato and the

ILLUSTRATIONS.

POWER.

"*His tongue was framed to music,*
And his hand was armed with skill;
His face was the mould of beauty,
And his heart the throne of will."

—Emerson.

MIND AND HAND:

MANUAL TRAINING THE CHIEF FACTOR IN EDUCATION.

CHAPTER I.

THE IDEAL SCHOOL.

Its Situation.—Its Tall Chimney.—The Whir of Machinery and
Sound of the Sledge-hammer.—The School that is to dignify
Labor.—The Realization of the Dream of Bacon, Rousseau, Co-
menius, Pestalozzi, and Froebel.—The School that fitly represents
the Age of Steel.

THE Ideal School is an institution which develops and
trains to usefulness the moral, physical, and intellectual
powers of man. It is what Comenius called Humanity's
workshop, and in America it is becoming the natural
center of the Public School system. The building, well-
designed for its occupancy, is large, airy, open to the light
on every side, amply provided with all appliances requis-
ite for instruction in the arts and sciences, and finished
interiorly and exteriorly in the highest style of useful
and beautiful architectural effects. The distinguishing
characteristic of the Ideal School building is its chim-
ney, which rises far above the roof, from whose tall stack
a column of smoke issues, and the hum and whir of
machinery is heard, and the heavy thud of the sledge-
hammer resounding on the anvil, smites the ear.

It is, then, a factory rather than a school?

No. It is a school; the school of the future; the
school that is to dignify labor; the school that is to

generate power; the school where every sound contrib-
utes to the harmony of development, where the brain
informs the muscle, where thought directs every blow,
where the mind, the eye, and the hand constitute an
invincible triple alliance. This is .the school that Locke
dreamed of, that Bacon wished for, that Rousseau de-
scribed, and that Comenius, Pestalozzi, and Froebel
struggled in vain to establish.

It is, then, science and the arts in apotheosis. For if
it be, as claimed, the Ideal school, it is destined to lift
the veil from the face of Nature, to reveal her most
precious secrets, and to divert to man's use all her
treasures.

Yes; it is to other schools what the diamond is to
other precious stones—the last analysis of educational
thought. It is the philosopher's stone in education; the
incarnated dream of the alchemist, which dissolved earth,
air, and water into their original elements, and recom-
bined them to compass man's immortality. Through it
that which has hitherto been impossible is to become a
potential reality.

In this building which resembles a factory or machine-
shop an educational revolution is to be wrought. Edu-
cation is to be rescued from the domination of mediæval
ideas, relieved of the enervating influence of Grecian
æstheticism, and confided to the scientific direction of
the followers of Bacon, whose philosophy is common
sense and its law, progress. The philosophy of Plato
left in its wake a long line of abstract propositions,
decayed civilizations, and ruined cities, while the philos-
ophy of Bacon, in the language of Macaulay," has length-
ened life; mitigated pain; extinguished diseases;
increased the fertility of the soil; given new securities

to the mariner; spanned great rivers and estuaries with bridges of form unknown to our fathers; guided the thunderbolt innocuously from heaven to earth; lighted up the night with the splendor of the day; extended the range of the human vision; multiplied the power of the human muscles; accelerated motion; annihilated distance; facilitated intercourse, correspondence, all friendly offices, all dispatch of business; enabled man to descend to the depths of the sea, to soar into the air, to penetrate securely into the noxious recesses of the earth, to traverse the land in cars which whirl along without horses, and the ocean in ships which run ten knots an hour against the wind."

It is this beneficent work of Bacon that the Ideal school is to continue—the work of demonstrating to the world that the most useful thing is the most beautiful thing—discarding Plato, the apostle of idle speculation, and exalting Bacon, the minister of use.

In laying the foundations of education in labor it is dignified and education is ennobled. In such a union there is honor and strength, and long life to our institutions. For the permanence of the civil compact in this country, as in other countries, depends less upon a wide diffusion of unassimilated and undigested intelligence than upon such a thorough, practical education of the masses in the arts and sciences as shall enable them to secure, and qualify them to store up, a fair share of the aggregate produce of labor.

If this school shall appear like a hive of industry, let the reader not be deceived. Its main purpose, intellectual development, is never lost sight of for a moment. It is founded on labor, which, being the most sacred of human functions, is the most useful of educational methods. It

is a system of object-teaching—teaching through things instead of through signs of things. It is the embodiment of Bacon's aphorism—"Education is the cultivation of a just and legitimate familiarity betwixt the mind and things." The students draw pictures of things, and then fashion them into things at the forge, the bench, and the turning-lathe; not mainly that they may enter machine-shops, and with greater facility make similar things, but that they may become stronger intellectually and morally; that they may attain a wider range of mental vision, a more varied power of expression, and so be better able to solve the problems of life when they shall enter upon the stage of practical activity.

It is a theory of this school that in the processes of education the idea should never be isolated from the object it represents; [1] (1) because the idea, being the reflex perception or shadow of the object, is less clearly defined than the object itself, and (2) because joining the object and the idea intensifies the impression. Separated from its object the idea is unreal, a phantasm. The object is the flesh, blood, bones, and nerves of the idea. Without its body the idea is as impotent as the jet of steam that rises from the surface of boiling water and loses itself in the air. But unite it to its object and it becomes the vital spark, the animating force, the Promethean fire. Thus steam converts the Corliss engine—a huge mass of lifeless iron —into a thing of grace, of beauty, and of resistless power. Suppose the teacher, for example, desires to convey to the mind of a child having no knowledge of form an impression of the shape of the earth; he says, "It is globular." The child's face expresses nothing because there is in its mind no conception of the object represented by the word globular. The teacher says, "It is a

sphere," with no better success. He adds, "A sphere is a body bounded by a surface, every point of which is equally distant from a point within called the centre." The child's face is still expressionless. The teacher takes a handful of moist clay and moulds it into the form of a sphere, and exhibiting it, says, "The earth is like this." The child claps its hands, utters a cry of delight, and exclaims, "It is round like a ball!"

This is an illustration of the triumph of object-teaching, the method alike of the kindergarten and the manual training school. As the child is father of the man, so the kindergarten is father of the manual training school. The kindergarten comes first in the order of development, and leads logically to the manual training school. The same principle underlies both. In both it is sought to generate power by dealing with things in connection with ideas. Both have common methods of instruction, and they should be adapted to the whole period of school life, and applied to all schools.

The Ideal school, most precisely representative of the present age—the age of science—is dedicated to a homogeneous system of mental and manual training, to the generation of power, to the development of true manhood. And above all, this school is destined to unite in indissoluble bonds science and art, and so to confer upon labor the highest and justest dignity—that of doing and responsibility. The reason of the degradation of labor was admirably stated by America's most distinguished educational reformer, the late Mr. Horace Mann, who said, "The labor of the world has been performed by ignorant men, by classes doomed to ignorance from sire to son ; by the bondmen and bondwomen of the Jews, by the helots of Sparta, by the captives who passed under the Roman

yoke, and by the villeins and serfs and slaves of more modern times."

When it shall have been demonstrated that the highest degree of education results from combining manual with intellectual training, the laborer will feel the pride of a genuine triumph; for the consciousness that every thought-impelled blow educates him, and so raises him in the scale of manhood, will nerve his arm, and fire his brain with hope and courage.

[1] "And the attempt to convey scientific conceptions without the appeal to observation, which can alone give such conceptions firmness and reality, appears to me to be in direct antagonism to the fundamental principles of scientific education.—"Physiography," [Preface], p. vii. By T. H. Huxley, F.R.S. New York: D. Appleton & Co., 1878.

This theory is the antithesis of that of Plato, namely; "that the simplest and purest way of examining things, is to pursue every particular by thought alone, without offering to support our meditation by seeing or backing our reasonings by any other corporal sense."— Plato's "Divine Dialogues," p. 180. London: S. Cornish & Co., 1839.

CHAPTER II.

THE MAJESTY OF TOOLS.

Tools the Highest Text-books — How to Use them the Test of Scholarship—They are the Gauge of Civilization—Carlyle's Apostrophe to them.—The Typical Hand-tools.—The Automata of the Machine-shop.—Through Tools Science and Art are United.—The Power of Tools—Their Educational Value.—Without Tools Man is Nothing ; with Tools he is All.—It is through the Arts alone that Education touches Human Life.

SACRED to the majesty of tools might be appropriately inscribed over the entrance to this Ideal school ; for its highest text-books are tools, and how to use them most intelligently is the test of scholarship. To realize the potency of tools it is only necessary to contrast the two states of man—the one without tools, the other with tools. See him in the first state, naked, shivering with cold, now hiding away from the beasts in caves, and now, famished and despairing, gaunt and hollow-eyed, creeping stealthily like a panther upon his prey. Then see him in the poetic, graphic apostrophe of Carlyle:— " Man is a tool-using animal. He can use tools, can devise tools ; with these the granite mountains melt into light dust before him ; he kneads iron as if it were soft paste ; seas are his smooth highway, winds and fire his unwearying steeds. Nowhere do you find him without tools ; without tools he is nothing, with tools he is all ! "

What a picture of the influence of tools upon civilization ! It is through the use of tools that man has

reached the place of absolute supremacy among animals. As he increases his stock of tools he recedes from the state of savagery. The great gulf between the aboriginal savage and the civilized man is spanned by the seven hand-tools—the axe, the saw, the plane, the hammer, the square, the chisel, and the file. These are the universal tools of the arts, and the modern machine-shop is an aggregation of them rendered automatic and driven by steam.

The ancients constructed automata which were exceedingly ingenious. In the statues that could walk and talk, the Chinese puppets and the marionettes of the Greeks there was a hint of the modern automatic tools, which, driven by steam, fashion with equal accuracy the delicate parts of the watch and the huge segments of the marine engine. The ancients knew more of science than of art. They were familiar with the power of steam, but knew not how to apply it to the wants of man. They knew that steam would turn a spit, but they had not a sufficient knowledge of art to convert the power they had discovered into a monster of force, and train it to bear the burdens of commerce. They never thought to apply the jet of steam used to turn a spit to great automatic machines, and to fit into them saws and files, and needles and drills, and gimlets and planes, and compel them to do the work of thousands of men. But this is precisely what the modern mechanic has accomplished. In making a slave of steam, science and art have combined to free mankind.

We marvel at the dulness of the ancients as shown in their failure to utilize in the useful arts the discoveries of science. That they should have studied the stars over their heads to the neglect of the earth under their feet is

incomprehensible to the modern mind. But will not fut--
ure generations marvel at us? Is it not an astounding
fact that, with a knowledge of the tremendous influence
of tools upon the destiny of the human race so graphic-
ally depicted by Carlyle, the nations have been so slow
in incorporating tool-practice into educational methods?
The distinguishing features of modern civilization sprang
as definitively from cunningly devised and skilfully han-
dled tools as any effect from its cause. And yet the
world's statesmen have failed to discover the value of
tool-practice as an educational agency. The face of the
globe has been transformed by the union of art and
science, but the world's statesmen have not discerned the
importance of uniting them in the curriculum of the
schools. If the ancients could see us as we see them,
they would doubtless laugh at us as we laugh at them.

We might take a lesson from the savage. He is taught
to fight, to hunt, and to fish, and in these arts the brain,
the hand, and the eye are trained simultaneously. He is
first given object-lessons, as the pupil of the kindergarten
is taught. Then the tomahawk, the spear, and the bow
and arrow are placed in his hands, and he fights for his
life, or fishes or hunts for his dinner. The young Indian
is taught all that it is necessary for him to know, and he
is educated, practically, in the savage's three workshops
—the battle-field, the forest and plain, the sea and lake.
Thus the young savage enters upon the duties of his life
with an exact practical knowledge of them. He has not
been taught a theory of fighting, he has used the weap-
ons of warfare; he has not studied the arts of fishing and
hunting, he has handled the spear and the bow and ar-
row, and their use is as familiar to him as the multiplica-
tion table is to the boy in the public school.

We have more and better tools than the savage possesses. With the aid of science and art we harness steam to our chariot and compel it to draw us whither we will. We steal fire from the clouds and make it serve us as a messenger. We imprison the air, and with it stop the flying railway train; with the aid of science and art we reduce the most subtile forces of nature to servitude. But we neither teach our youth how to master their elements nor how to use them.

Tools represent the steps of human progress—in architecture, from the mud hut to the modern mansion; in agriculture, from the pointed stick used to tear the turf to a thousand and one ingenious instruments of husbandry; in ship-building, from the rudderless, sailless boat to the ocean steamer; in fabrics, from the matted fleece of the shepherd to the varied products of countless looms; in pottery, from the first rude Egyptian cup to the exquisite vase of the Sevres factory. And so of every art that contributes to the comfort and pleasure of man; the development of each has been accomplished by tools in the hands of the laborer.

Since, then, man owes so much to labor, he has doubtless educated the laborer and showered honors upon him (?). On the contrary, the labor of the world has been performed by the most ignorant classes, by bondmen, by helots and captives, by serfs and slaves. The laborer has been held in such contempt, and been so debased by ignorance, that he has often violently protested against improvements in the tools of the trades, and with vandal hands destroyed the mill, the factory, and the forge erected to ameliorate his condition. At the top of the social scale the sage has studied the stars and invented systems of abstract philosophy; at the bottom ignorance has dei-

fied itself and starved. This divorce of science from art has resulted in such incongruities as the Pyramids of Egypt and periodical famines; as the hanging gardens of Babylon and the horrors of Jewish captivity; as the Greek Parthenon and dwellings without chimneys; as the statues of Phidias and Praxiteles, and royal banquets without knives, forks, or spoons; as the Roman Forum and the Roman populace crying for bread and circuses; as Socrates, Plato, Seneca and Aurelius, and Caligula, Claudius, Nero and Domitian.

On the other hand the union of science with art tunnels the mountain, bridges the river, dams the torrent, and converts the wilderness into a fruitful field.

Science discovers and art appropriates and utilizes; and as science is helpless without the aid of art, so art is dead without the help of tools. Tools then constitute the great civilizing agency of the world; for civilization is the art of rendering life agreeable. The savage may own a continent, but if he possesses only the savage's tools — the spear and the bow and arrow — he will be ill-fed, ill-housed, ill-clothed, and poorly protected both against cold and heat. He might be familiar with all the known sciences, but if he were ignorant of the arts his state, instead of being improved, would be rendered more deplorable; for with the thoughts, emotions, sensibilities, and aspirations of a sage he would still be powerless to steal from heaven a single spark of fire with which to warm his miserable hut.

In the light of this analysis Carlyle's rhapsody on tools becomes a prosaic fact, and his conclusion—that man without tools is nothing, with tools all—points the way to the discovery of the philosopher's stone in education. For if man without tools is nothing, to be unable to use tools

2*

is to be destitute of power; and if with tools he is all,
to be able to use tools is to be all-powerful. And this
power in the concrete, the power to do some useful thing
for man—this is the last analysis of educational truth.

There is no better definition of education than that of
Pestalozzi—"the generation of power." But what kind
of power? Not merely power to think abstractly, to
speculate, to moralize, to philosophize, but power to act
intelligently. And the power to act intelligently in-
volves the exertion, in greater or less degree, of all the
powers, both mental and physical. Education, then, is
the development of all the powers of man to the culmi-
nating point of action. What kind of action? Action
in art. What is art? "The power of doing something
not taught by nature or instinct; power or skill in the
use of knowledge; the practical application of the rules
or principles of science." Again we have the last analy-
sis of education—"skill in the use of knowledge; the
application of the rules or principles of science." And
this is tool practice.

It is unnecessary, in an educational view, to divide
the arts by the employment of the terms "useful" and
"fine;" for the fine arts can only exist legitimately
where the useful arts have paved the way. In a har-
monious development the artist will enter on the heels
of the artisan. Art is cosmopolitan. It is not less
worthily represented by the carpenter with his square,
saw, and plane, and the smith with his sledge, than by the
sculptor with his mallet and chisel, and the painter with
his easel and brush; both classes contribute to the com-
fort and pleasure of man; for comfort is enhanced by
pleasure, and pleasure is intensified by comfort. It fol-
lows that the ultimate object of education is the attain-

ment of skill in the arts. To this end the speculations and investigations of philosophy and the experiments of chemistry lead. At the door of the study of the philosopher and of the laboratory of the chemist stands the artisan, listening for the newest hint that philosophy can impart, waiting for the result of the latest chemical analysis. In his hands these suggestions take form; through his skilful manipulation the faint indications of science become real things, suited to the exigencies of human life.

It is the most astounding fact of history that education has been confined to abstractions. The schools have taught history, mathematics, language and literature, and the sciences, to the utter exclusion of the arts, notwithstanding the obvious fact that it is through the arts alone that other branches of learning touch human life. As Bacon has so aptly expressed it, "The real and legitimate goal of the sciences is the endowment of human life with new inventions and riches." In a word, public education stops at the exact point where it should begin to apply the theories it has imparted. At this point the school of mental and manual training combined—the Ideal School—begins; not only books but tools are put into the hands of the pupil, with this injunction of Comenius; "Let those things that have to be done be learned by doing them.

CHAPTER III.

THE ENGINE-ROOM.

The Corliss Engine—A Thing of Grace and Power—The Growth
of Two Thousand Years—From Hero to Watt—Its Duty as a
School-master.—The Interdependence of the Ages.—The School
in Epitome.

LET us enter the Ideal School building and take a
bird's-eye view of the visible processes of the new edu-
cation.

The first object that attracts attention is the engine.
It is a "Corliss," fifty-two horse-power, and makes that
peculiar kind of noise which conveys to the mind of the
observer an impression of restrained power. When the
student, upon entering the school, is shown this beautiful
machine he is told that it, like all other inventions, is a
growth—the growth of at least two thousand years; that
the power of steam was known to the ancients — the
Egyptians, Greeks, and Romans; that Hero, a philoso-
pher of Alexandria, invented a crude steam-engine before
the beginning of the Christian era, and that the engine
before us, which throbs and trembles under the pressure
of its battery of steel boilers in doing duty as a school-
master, is the latest development of Hero's conception.
The educational idea underlying this fact is the inter-
dependence of the ages; each generation is a link be-
tween the past and the future. "To show," as Philarète
Chasles says, "that man can only act efficiently by asso-
ciation with others, it has been ordained that each in-
ventor shall only interpret the first word of the problem
he sets himself to solve, and that every great idea shall

be the *résumé* of the past at the same time that it is the germ of the future."

The first word of the solution of the steam-power problem came from Hero down the ages, through Decaus, Papin, Savory, Newcomen, Breighton, and Smeaton, to Watt. To Watt is awarded the honor of the invention of the modern steam-engine; but the first conception of his engine was derived from an atmospheric machine through the accident of it having been placed in his hands for repairs. Smeaton was the inventor of that atmospheric engine, and his mind was one of the links in the chain of intelligences extending back to Egypt, through whose united agency the steam-engine became a real thing of power in the cunning hands of James Watt, of whom the late Dr. Draper said, "He conferred on his native country more solid benefits than all the treaties she ever made and all the battles she ever won." This law governing great achievements is full of encouragement to the student of mechanics, for while the thought of compassing any great discovery or invention may well appall even the boldest, the most humble may hope through studious industry to contribute something to the sum of human knowledge.

The engine-room of our school is neater than that of the ordinary machine-shop, but the furnace roars like any other, its open mouth shows a bank of glowing coals, and the "stoker," with grimy hands, wipes the sweat from his sooty brow. The whole school is here seen in epitome: the "stoker" typifies the student toiling at the forge, and in the polished engine, exhibiting both grace and power in its automatic action, we see the student's graduating project, a machine, the joint creation of brain, eye, and hand.

CHAPTER IV.

THE DRAWING-ROOM.

Twenty-four Boys bending over the Drawing-board.—Analysis and
Synthesis in Drawing.—Geometric Drawing.—Pictorial Drawing.
—The Principles of Design.—The Æsthetic in Art.—The Funda-
mentals — Object and Constructive Drawing.— Drawing for the
Exercises in the Laboratories.—The Educational Value of Draw-
ing — The Language of Drawing. — Every Student an expert
Draughtsman at the end of the Course.

PASSING from the engine-room we enter the room as-
signed to drawing,—the first step in art education—
where twenty-four boys are bending over the drawing-
board, pencil in hand. Every school-day for three years
these boys will spend an hour in this room. Each divi-
sion of drawing — free-hand and mechanical — is thor-
oughly taught. Every graduate of the institution will
be an expert draughtsman. The room is very still, only
the scratching sound of twenty-four pencils is heard.
The instructor moves about among the students, with
here and there a hint, a suggestion, a correction, or a
word of commendation—"good."

Drawing is the representation on paper of the facts,
and the appearance to the eye of forms. The exercise
proceeds by both analysis and synthesis. A cube is di-
vided into all the geometric figures of which it is suscep-
tible, and these figures are imitated with the pencil on
paper. Then the figures are reunited, and the cube is
similarly imitated. As the child in the kindergarten is
taught several fundamental geometric facts through the

use of variously subdivided cubes, so the student of drawing is taught by a similar process how to represent these fundamental facts on paper. For example (1), the student is taught to draw the following (sketches 1, 2, and 3) geometric forms of the square, oblong, and circle; (2) he is taught (sketches 4, 5, 6, and 7) to represent the facts of the oblong block and cylinder; (3) these facts are expressed as follows (sketches 8 and 9) in working

drawings. .Sketches 8 and 9 are such drawings as would be placed in the hands of a mechanic as plans for the manufacture of the solids they represent; and the most elaborate working drawings for building and mechanical purposes are merely the complete development of this division of the art.

Another division of drawing consists in the representation of solids or objects as they appear to the eye or pictorially. The oblong block and cylinder, for example, appear to the eye very differently from their facts represented in the working drawings (sketches 8 and 9), as thus—(sketches 10 and 11).

The development of this division of drawing leads to general pictorial representation.

Finally the mastery of the art of drawing involves a study of the principles of design as applied to industrial articles with the purpose of enhancing their value, as designs for wall-paper, carpets, embroideries, tapestry, textiles generally, and decorative work in wood. This is the æsthetic element in the art which appeals to and develops the student's taste. It is an important feature of drawing, not less on this account than from the fact that the designer's profession is a very lucrative one, but it is less important than object and constructive drawing, because less fundamental. Besides, object and constructive work in drawing come first in the order of development, and it is an inexorable rule of the new education to follow implicitly the hints of nature.

The basis of the art of drawing is geometry, and its a, b, c consists in a knowledge of certain geometrical lines, curves, and angles. This knowledge is gained from examples on the black-board which are reproduced on paper. But to relieve the student of this school from the tedium of reproducing, hundreds of times in succession, the same lines, angles, and curves, object-drawing is introduced very early in the course; and to render the exercise more attractive, as well as to impress it more firmly upon the mind, the objects drawn during the day are made features of the construction lesson in the carpenter's laboratory, the wood or iron turning laboratory, or the laboratory of founding on the following day. At first the objects selected for this exercise are of a very simple character, as a piece of plain moulding—a piece of elaborate moulding; parts of a drawing-board—an entire drawing-board; parts of a table or desk—an entire table or desk; parts of a draughtsman's stool—an entire stool; parts of a chair—an entire chair.

As the student advances in the general course he advances in object and constructive drawing, from simple to complex forms. He draws, for example, various parts of the steam-heating apparatus, and from these draughts makes working drawings of patterns for moulding. These he works out in the Carpenter's Laboratory, and thence takes them to the moulding-room, where they are used in the lesson given in moulding for casting. This method of instruction leads to a critical analysis of the entire interior of the school building. Each article is resolved into the original elements of its construction, and each element or part is first represented on paper, then expanded into working drawings, and then wrought out in wood and iron. Finally the student reaches the engine, every part of which is made the subject of exhaustive study; the facts of every part are represented on paper, working drawings of every part are made, and every part is reproduced in steel and iron in miniature, and, as a triumph of drawing, a representation on paper of the completed engine is produced.

The value of drawing as an educational agency is simply incalculable. It is the first step in manual training. It brings the eye and the mind into relations of the closest intimacy, and makes the hand the organ of both. It trains and develops the sense of form and proportion, renders the eye accurate in observation, and the hand cunning in execution.

The students are intent upon their work. The eye is busy acting as interpreter between the mind and the hand. Having conveyed the impression of an object to the mind, under its direction it now photographs the object on paper, and the hand obeying the will traces it out in lines. Thus the power is gained of multiplying

forms of things with the pencil as words are multiplied by types.

Drawing is a language—the language in which art records the discoveries of science. It is not German, it is not French, it is not English—it is universal—common to all draughtsmen. The face of the student exhibits vivid flashes of intelligence as the picture reveals itself under his hand. Each line is a word, an angle completes the sentence; with a curve and a little delicate shading we have a paragraph. The picture begins to glow with thought. The student's face flushes, his heart beats quick and his hand trembles. But he restrains himself, and adds more lines, more angles and curves, more shading, and the picture is complete. It stands out in bold relief, and looks like a real thing. If the student knows the story of the brazen statue of Albertus Magnus he half expects his picture of a locomotive to move. He listens for the sound of the hissing steam, and a smile lights up his face as the illusion vanishes. Presently he will take his drawing to the shop, and at the bench, the lathe, the anvil, and the forge, reproduce it in iron and steel, and actually vitalize it with steam.

CHAPTER V.

THE CARPENTER'S LABORATORY.

The Natural History of the Pine-tree — How it is Converted into Lumber, what it is Worth, and how it is Consumed. — Where the Students get Information. — Working Drawings of the Lesson. — Asking Questions. — The Instructor Executes the Lesson. — Instruction in the Use and Care of Tools. — Twenty-four Boys Making Things — As Busy as Bees. — The Music of the Laboratory. — The Self-reliance of the Students.

PASSING from the Drawing-Room down a flight of stairs we enter the Carpenter's Laboratory. Here we find twenty-four boys seated before a black-board. At their left stands the instructor with a piece of white pine in his hand. The piece of pine is the subject of his lecture. He frequently breaks the thread of his remarks to ask questions, and he is as frequently interrupted by questions from members of the class. The scene closely resembles an animated discussion, of which a desire to learn by asking questions is the chief characteristic. The discussion is about pine-trees and pine lumber. A pale-faced, city-bred boy rises to describe the pine-tree. He describes a fir-tree, such as may be seen in well-kept urban grounds and parks, and describes it in well-chosen, almost poetic phrase. The instructor shakes his head, but with a genial smile, and recognizes a boy whose face is tanned brown, and who rises at the nod and stands rather awkwardly as he speaks. He has seen the pine in its native wilds, and he describes quite graphically its long, bare trunk and slender limbs. But he says

nothing of its narrow, linear leaves, of a dark green color, nor of its woody cones, nor of the Æolian-harp-like sound of the wind in its branches. Why, the instructor wants to know, and he propounds a series of questions, the answers to which afford a brief sketch of the boy's history. His father is a dealer in pine logs, and once this boy went with him into the pineries of Northern Michigan in mid-winter, when the landscape was white with snow, and there saw the huge trees sway back and forth under the woodman's axe, saw them topple over, and heard the loud crash of their fall, saw them trimmed and sawed into mill-logs. He took no note of the woody cones, nor of the narrow leaves of the pine, nor did the sound of the wind in its branches make any impression upon his mind. He saw the pine as his father saw it, with the eyes of a lumberman. He learned just one thing, and learned it so well that he is able to tell the story of the pine-tree from the moment of its fall from the stump in the great forest to its arrival at the mill, and thence, cut into boards, planks, and timber, to the raft or schooner bound for Chicago.

Then the different varieties of the pine-tree are enumerated, and the uses to which their woods are severally adapted mentioned. The countries which chiefly produce the pine-tree are named, and the climatic conditions most favorable to its growth briefly referred to. This discussion leads to the subject of commerce in pine lumber — quantity consumed, demand and supply, etc; and this in turn brings a boy to his feet with the statement that at the present rate of consumption the supply of pine in North America will be exhausted in fifty years. In answer to a question the boy says he read the statement in a newspaper. This leads to further inquiry as

THE LABORATORY OF CARPENTRY.

to the sources of information sought by the members of the class, whereupon it appears that fifteen boys have consulted the title "pine" in some encyclopedia with a view to the present lesson, and that eighteen boys have read the market report under the title "lumber" in a daily journal, in order to learn the value of white-pine boards. The value being stated by half a dozen boys, each member of the class computes the cost of the piece of pine in the hands of the teacher.

Ten minutes having been consumed in the inquiry into the nature and value of the wood in which the lesson of the day is to be wrought, the instructor makes working drawings of the lesson on the black-board. It may consist of a plain joint, a mitre joint, a dove-tail joint, a tenon and mortise, or a frame involving all these, and more manipulations. In the few minutes devoted to this exercise any question that occurs to the mind of the student may be asked, and no impatience is manifested or felt if the questions are numerous and reiterated. But as a matter-of-fact very few questions are asked during the black-board exercise, because each student, having gone over every step of it in his drawing-class the day previous, is perfectly familiar with the subject.

The instructor now quits the black-board for the bench, where, in the presence of the whole class, he executes the difficult parts of the lesson, still propounding and answering questions. If a new tool is brought into requisition, instruction is given in its care and use. Now the boys repair to their benches, throw off their coats, and seize their tools. In a moment the silence and repose of the recitation-room are exchanged for the noise and activity of the laboratory. A quarter of an hour ago we left twenty-four boys, with bowed heads, making drawings of

things ; for a quarter of an hour we have listened to a
peculiar kind of recitation involving much practical knowl-
edge on the subject of the pine-tree and its product, lum-
ber ; now we stand in the presence of twenty-four boys, in
twenty-four different attitudes of labor, making things.
They are literally as busy as bees, using the square, the
saw, the plane, and the chisel ; they are, as the journey-
man carpenter would say, "getting out stuff for a job."
The coarse, buzzing sound of the cross-cut saw resounds
loudly through the room ; above this bass note the sharp
tenor tone of the rip-saw is heard, and the rasping sound
of half a dozen planes throwing off a series of curling
pine ribbons comes in as a rude refrain. The faces of the
boys are ruddy with the glow of exercise ; the pale-faced
boy who mistook a fir-tree for a pine will have his revenge
on the angular boy from the Michigan pinery, for he is
doing a finer piece of work than the other.

In the midst of the harmonious confusion caused by the
use of saws, planes, mallets, and chisels, the instructor raps
on his desk, and silence is restored ; three or four boys
stand in a group about the instructor's desk, the others
pause and wipe the perspiration from their brows. It is
a picture full of interest—twenty-four boys, with flushed,
eager faces, lifting their eyes simultaneously to the face of
the instructor, waiting for the hint which is to come, and
which is sure in these now active minds to result in a
prompt solution of the main problem of the day's lesson.
A similar question from several boys shows the instruct-
or that the lesson has not been made clear ; hence the
general explanation which follows the call to order. So
the work goes on, with now and then an interruption.
There is a student trying to fit a tenon into its mortise ;
he is nervous and impatient ; the instructor observes him,

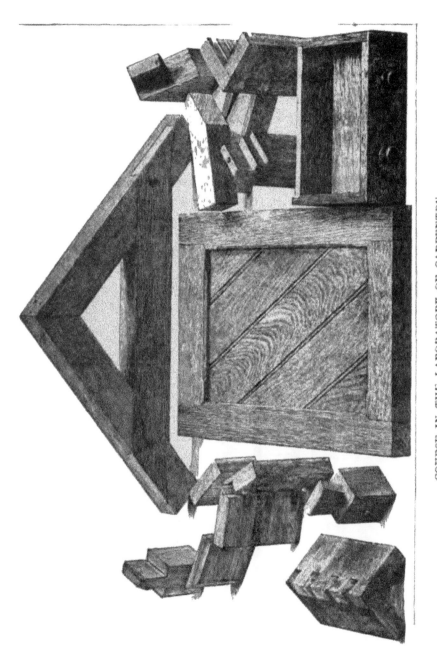

COURSE IN THE LABORATORY OF CARPENTRY.

foresees a catastrophe, and moves towards his bench. But it is too late! The tenon being forced the mortise splits, and the discomforted student makes a wry face. The instructor approaches with a word of good cheer, but with the warning aphorism that "haste makes waste." The student's face flushes, and he chronicles his failure as Huntsman, the inventor of cast-steel, did his, by burying the wreck under a pile of shavings, and commencing, as the lawyers say, *de novo*. Thus the lesson proceeds "by the usual laboratory methods employed in teaching the sciences;" the class learns the thing to be done by doing it. The students are at their best, because the lesson to be learned compels a close union between the three great powers of man—observation, reflection, and action. No student seeks aid from another, because such a course would be impossible without the knowledge of the whole class. A feeling of self-reliance is thus developed, the disposition to shirk repressed, and a sense of sturdy independence encouraged and promoted.

CHAPTER VI.

THE WOOD-TURNING LABORATORY.

A Radical Change — From the Square to the Circle; from Angles to Spherical, Cylindrical, and Eccentric Forms. - The Rhythm of Mechanics.—The Potter's Wheel of the Ancients and the Turning-lathe—The Speculation of Holtzapffels on its Origin.—The Greeks as Turners.—The Turners of the Middle Ages.—George III. at the Lathe.—Maudslay's Slide-rest, and the Revolution it wrought.—The Natural History of Black - walnut.—The Practical Value of Imagination—Disraeli's Tribute to it; Sir Robert Peel's Want of it.—The Laboratory animated by Steam.—The Boys at the Lathes —Their Manly Bearing.—The Lesson.

WHEN the twenty-four boys of the Carpenter's Laboratory have become expert in the use of the tools employed in carpentry they will be introduced to the Wood-turning Laboratory. The change is radical—from the square to the circle, from the prose to the poetry of mechanical manipulation. Carpentry is distinguished for its corners and angles, turnery for its spherical, cylindrical, and eccentric forms. In these forms Nature abounds and delights, and it is in these forms that the rhythm of mechanics exists. It is by the Turners that the arts are supplied with a thousand and one things of use and beauty. The machines, great and small, from the locomotive to the stocking-knitter—without which the work of the modern world could not be done —these wonderful contrivances, seemingly more cunning than the hand of man, owe their very existence to the turning-lathe.

The skilled instructor in this department of the school

THE WOOD-TURNING LABORATORY.

loves to dwell upon the history of turning. Its origin is
enveloped in the obscurity of early Egyptian traditions.
It is the subject of one of the oldest myths, which runs
thus: "Num, the directing spirit of the universe, and
oldest of created beings, first exercised the potter's art,
moulding the human race on his wheel. Having made
the heavens and the earth, and the air, and the sun and
moon, he modelled man out of the dark Nilotic clay, and
into his nostrils breathed the breath of life."

The Potter's Wheel of the ancients contained the germ
of the turning-lathe found in every modern machine-shop,
whether for the manipulation of wood or iron. Holtz-
apffels has an ingenious speculation as to the origin of
the invention of the lathe. In his elaborate work on
"Turning and Mechanical Manipulation" he says,

"It would appear probable that the origin of the lathe
may be found in the revolution given to tools for pierc-
ing objects for ornament or use. At first it may be sup-
posed that a spine, or thorn from a tree, a splinter of
bone or a tooth, was alone used and pressed into the
work as we should use a brad-awl. The process would
naturally be slow and unsuitable to hard materials, and
this probably suggested to the primitive mechanic the
idea of attaching a splinter of bone or flint to the end of
a short piece of stick, rubbing which between the palms
of his hands would give a rotary motion to the tool."

Of the steps of progress in invention, from the rude
turning-tools of the ancients down to the beginning of
the present century, when Maudslay's improvement made
the lathe the king of the machine-shop, little is known.
By the Greeks the invention of turning was ascribed to
Dædalus. Phidias, who produced the two great master-
pieces of Greek art, Athene and Jupiter Olympius, was

3

familiar with the then existing system of wood-turning.
In cutting figures on signets and gems in such stones as
agate, carnelian, chalcedony, and amethyst, the Greek
artificers used the wheel and the style. In the abundant
ornamentation of Roman dwellings — their elaborately
carved chairs, tables, bedsteads, sofas, and stools — there
is ample evidence of a knowledge of the art of turning
in wood. Improvements were made in turning-tools,
and fine ornamental work was done by the artisans of
the Middle Ages, to which the cathedrals and palaces
of the time bear witness. Later, during the sixteenth
and seventeenth centuries, turning became a fashiona-
ble amusement among the French nobility and gentry.
Louis XVI. was an expert locksmith, and spent much
of his royal time in that pursuit. The fashion extended
to England. George III. is said to have been an expert
wood-turner, to have been " learned in wheels and tread-
les, chucks and chisels ;" and as a matter of course a pur-
suit indulged by kings was followed by many nobles.
There is, however, no evidence that those distinguished
amateurs made any improvements in the tools they used ;
inventions and discoveries in this as in all departments
of art came from the other end of the social scale.
When the Spaniards sacked Antwerp in 1585 the Flem-
ish silk-weavers fled to England and set up their looms
there ; and a century later, upon the revocation of the
Edict of Nantes, the silk industry of England received a
new accession of refugee artisans consisting of persecuted
Protestants. Doubtless with the Flemish weavers there
crossed the British Channel representatives of all the
useful arts, including that of turning ; for in another
hundred years England took the front rank among na-
tions in nearly all industrial pursuits.

Among the great inventions and discoveries which distinguished the last quarter of the eighteenth century, Maudslay's slide-rest attachment to the lathe was one of the greatest, if not the greatest. Without it Watt's invention would have been of little more real service to mankind than the French automata of the first quarter of the same century—the mechanical peacock of Degennes, Vaucauson's duck, or Maillardet's conjurer. Mr. Samuel Smiles, in his admirable book on "Iron-workers and Tool-makers," declares that this passion for automata, which gave rise to many highly ingenious devices, "had the effect of introducing among the higher order of artists habits of nice and accurate workmanship in executing delicate pieces of machinery." And he adds, "The same combination of mechanical powers which made the steel spider crawl, the duck quack, or waved the tiny rod of the magician, contributed in future years to purposes of higher import—the wheels and pinions, which in these automata almost eluded the human senses by their minuteness, reappearing in modern times in the stupendous mechanism of our self-acting lathes, spinning-mules, and steam-engines."

That there was a logical connection between the two eras of mechanical contrivance — that of the ingenious automata and that of the useful modern machines—is extremely probable. That the refugee artisans from Antwerp and from France had a stimulating effect upon English invention and discovery there can be little doubt; and that the French automata, which were much written about, and exhibited as a triumph of mechanical genius, became known to and exercised an influence upon the minds of intelligent mechanics is equally probable. We are therefore surprised to find Mr. Smiles arriving at a

conclusion in such direct conflict with his general views
of the gradual growth of inventions, namely, "that
Maudslay's invention was entirely independent of all
that had gone before, and that he contrived it for the
special purpose of overcoming the difficulties which he
himself experienced in turning out duplicate parts in
large numbers."

But however this may be, Mr. Maudslay's invention
revolutionized the workshop. Before its introduction
the tool of the artisan was guided solely by muscular
strength and the dexterity of the hand ; the smallest varia-
tion in the pressure applied rendered the work imperfect.
The slide-rest acting automatically changed all that. With
it thousands of duplicates of the most ponderous, as well
as the most minute pieces of machinery, are executed
with the utmost precision. Without it the steam-engine,
whether locomotive or stationary, would have been hard-
ly more than a dream of genius ; for the monster that is
to be fed with steam can be properly constructed only by
automatic steam-driven tools ; or, as another has expressed
it, "Steam-engines were never properly made until they
made themselves."

Ten minutes are thus agreeably and profitably occu-
pied by the instructor in a review of the history of a
single invention, and its relations to the whole field of
mechanical work.

Another branch of the lesson consists of an inquiry into
the natural history, qualities, value, and common uses of
the wood which is to be the material of the day's ma-
nipulation—black-walnut. Holding a piece of the pur-
plish brown wood high in his hand the instructor dis-
charges, as it were, a volley of questions at the class,
"What is it called?" "Where is it found?" "How

large does the tree grow?" "For what is the wood chiefly used?" Up go a dozen hands. The owner of one of the hands is recognized, and he rises to tell all about it, but is only allowed to say "black-walnut." The next speaker is permitted to say that "the black-walnut is found all over North America;" the next that it is more abundant west of the Alleghanies, and most abundant in the valley of the Mississippi; the next that in a forest it has a limbless trunk from thirty to fifty feet high, but in the "open" branches near the ground; the next that it is extensively used in house-finishing, in furniture, for all kinds of cabinet-work, and especially for gunstocks.

Further inquiry elicits the information that the black-walnut is a quick-growing, large tree; that its wood is hard, fine-grained, durable, and susceptible of a high polish, and that through use and exposure it turns dark, and with great age becomes almost black. One student describes the leaves, another the fruit or nuts, and states that they are used in dyeing; a third states that the black-walnut is a great favorite for planting in the treeless tracts of the West, on account of its rapid growth and the value of its timber. When the subject appears to be nearly exhausted, a boy at the farther end of one of the forms rises timidly and tells the story of the late Mr. W. C. Bryant's great black-walnut-tree at Roslyn, Long Island. He concludes, excitedly, "It is one hundred and seventy years old and twenty-five feet in circumference."[*]

[*] "At Ellerslie, the birthplace of Wallace, exists an oak which is celebrated as having been a remarkable object in his time, and which can scarcely, therefore, be less than seven hundred years old. Near Staines there is a yew-tree older than Magna Charta (1215), and the yews at Fountains Abbey, in Yorkshire, are probably more than

The timid boy dwells upon his story of the "big" tree with evident fondness, and his eyes dilate with satisfaction as he resumes his seat. The circumstance of the great age no less than the enormous size of the tree has captivated his imagination. The discriminating instructor will not fail to note such incidents of the lesson. · It is through them that the special aptitudes of students are disclosed. The instructor will always bear prominently in mind that the purpose of the school is not to make mechanics but men. Nor will he forget, as Buckle remarked, that Shakespeare preceded Newton. Buckle pays a glowing tribute to the usefulness of the imagination. He says, " Shakespeare and the poets sowed the seed which Newton and the philosophers reaped. . . . They drew attention to nature, and thus became the real founders of all natural science. They did even more than this. They first impregnated the mind of England with bold and lofty conceptions. They taught the men of their generation to crave after the unseen."

Disraeli, in his matchless biography of Lord George Bentinck, in summing up the character of a great English statesman is equally emphatic in praise of the imagination as a practical quality. He says,

" Thus gifted and thus accomplished, Sir Robert Peel had a great deficiency — he was without imagination. Wanting imagination, he wanted prescience. No one was more sagacious when dealing with the circumstances before him; no one penetrated the present with more acuteness and accuracy. His judgment was faultless,

twelve hundred years old. Eight olive-trees still-exist in the Garden of Olives at Jerusalem which are known to be at least eight hundred years old."—"Vegetable Physiology." By William B. Carpenter, M.D., F.R.S., F.G.S. London: Bell and Daldy. 1865. p. 78.

provided he had not to deal with the future. Thus it happened through his long career, that while he always was looked upon as the most prudent and safest of leaders, he ever, after a protracted display of admirable tactics, concluded his campaigns by surrendering at discretion. He was so adroit that he could prolong resistance even beyond its term, but so little foreseeing that often in the very triumph of his manoeuvres he found himself in an untenable position."

The timid boy has imagination; if he has application and the logical faculty he may become an inventor, or he may become an artist—an engraver or a designer of works of art—or he may become a man of letters. To the man of vivid imagination and industry all avenues are open; Disraeli's wonderful career offers a striking illustration of the truth of this proposition. The true purpose of education is the harmonious development of the whole being, and the purpose of this turning laboratory is to educate these twenty-four boys, not to make turners of them.

The laboratory is a labyrinth of belts, large and small, of wheels, big and little, of pulleys and lathes. A student, at a word from the instructor, moves a lever a few inches, and the breath of life is breathed into the complicated mass of machinery. The throbbing heart of the engine far away sends the currents of its power along shafting and pulleys. The dull, monotonous whir of steam-driven machinery salutes the ear, and the twenty-four students take their places at the lathes. They are from fourteen to seventeen years of age, and range in height from undersize to "full-grown." They look like little men. Their faces are grave, showing a sense of responsibility. They are to handle edge-tools on wood rapidly revolved by the power of steam. There is peril in an

uncautious step, and death lurks in the shafting. Of these
dangers they have been repeatedly warned ; and there is
in their bearing that manifestation of wary coolness which
we call "nerve," and which in an emergency develops
into a lofty heroism capable of sublime self-sacrifice.

This is the very essence of education, its informing spir-
it. The student no longer thinks merely of becoming an
expert turner; he thinks of becoming a man! All the
powers of his mind are roused to vigorous action ;
imagination illumes the path, and reason, following
with firm but cautious step, drives straight to the mark.
Rapid development results from the combination of prac-
tice with theory—rapid because orderly, or natural. The
knowledge acquired is at once assimilated, and becomes
a mental resource, subject to draft like a bank account.
But unlike a bank account it increases in the ratio of the
frequency with which drafts are made upon it, and the
result is the student leaves school at seventeen years of
age with the reasoning experience of an ordinarily edu-
cated man of forty.

The lesson has been announced by the instructor, its
chief points stated and analyzed, its place in the scale (so
to speak) of the art of turnery defined, its educational
value to the mind, the hand, and the eye shown, and the
points of difficulty involved so emphasized as to lead to
painstaking care in the execution of crucial parts. The
new tool required by the lesson is handled in presence of
the waiting class by the instructor ; the time of its inven-
tion stated ; the name of its inventor given ; the method
of its manufacture described ; and how to sharpen, take
care of, and use it explained with such minuteness of de-
tail as to insure the making of a permanent impression
upon the minds of students.

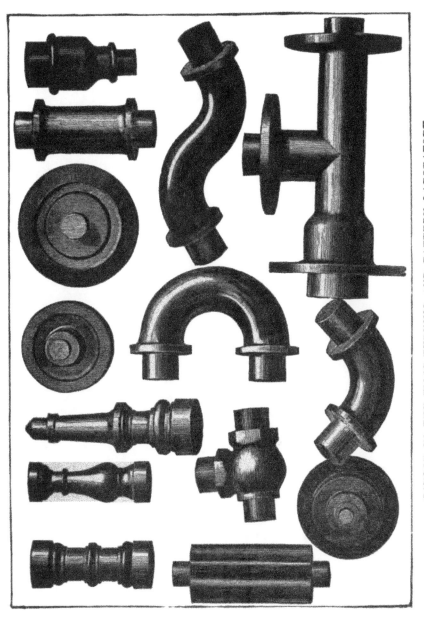

COURSE IN THE WOOD-TURNING AND PATTERN LABORATORY.

The wood-turner's case contains more than a hundred tools, perhaps a hundred and fifty, but not more than a score of them are fundamental; the others are subsidiary, and require very little if any explanation.

The lesson may be one in simple turning, as a table-leg, the round of a chair, or parts of a section of a miniature garden-fence; or it may be a set of pulleys, or patterns for various forms of pipe. The pieces of wood to be wrought or manipulated lie at the feet of the student, and the working drawing (drawn by the student himself) lies on the bench before him. The piece of wood to be turned first is adjusted, the student touches a lever over his head which sets the lathe in motion, takes the required tool in hand, and the work begins. Guided by the automatic slide-rest, the sharp point of the tool chips away the revolving wood until it assumes the form of the drawing lying under the eye of the operator. Thus the lesson proceeds to the end of the prescribed period—two hours. The master watches every step of its progress. If a student is puzzled he receives prompt assistance, so that no time may be lost. Indeed the relations between instructor and students are such, or ought to be such, that the question is asked before the puzzled mind falls into a rut of profitless speculation through revolving in a circle. But if the true sequential method of study is followed the student rarely fails, from the vantage ground of a step securely taken, to comprehend the nature of the next step in the regular order of succession. This is the Russian system, and it is the method of the wood-turnery as well as of every department of the Manual Training School. Hence a certain tool having been mastered, the next tool in the regular order of succession is more easily understood, because (1) each tool contains a hint of

the nature of its successor, and (2) each addition to the student's stock of knowledge confers an increased capability of comprehension.

When the lesson is concluded the whir of the machinery ceases, and a great silence falls upon the class as the students assemble about the instructor, each presenting his piece of work. This is the moment of friendly criticism. The instructor handles each specimen, comments upon the character of the workmanship, points out its defects, and calls for criticisms from the class. These are freely given. There is an animated discussion, involving explanations on the part of the instructor of the various causes of defects, and suggestions as to suitable methods of amendment. Then the pieces of work are marked according to the various degrees of excellence they exhibit, and the class is dismissed.

CHAPTER VII.

THE FOUNDING LABORATORY.

As we enter the Founding Laboratory we recall Locke's apothegm: "He who first made known the use of that contemptible mineral [iron] may be truly styled the father of arts and the author of plenty." We reflect, too, that the mineral that has given its name to an age of the world—our age—is worthy of careful study.

The Founding Laboratory, like all the laboratories of the school, is designed for twenty-four students. There are twenty-four moulding-benches, combined with troughs for sand, and a cupola furnace where from five hundred to one thousand pounds of iron may be melted.

The students we lately parted from in the Wood-turning Laboratory are here. Their training has been confined to manipulations in wood; they are now to be made acquainted with iron—iron in considerable masses. They should know something, in outline, of the history of the king of metals in the Founding Laboratory. The instructor speaks familiarly to them, somewhat as follows:

The art of the founder is fundamental in its nature. The arts of founding and forging are, indeed, the essential preliminary steps which lead to the finer manipulations entering into all metal constructions. Whether forging preceded founding or founding forging is immaterial; both arts are as old as recorded history—much older indeed. Moulding, which is the first step in the founder's art, should be among the oldest of human discoveries, since man had only to take in his hand a lump of moist clay to receive ocular evidence of his power to give it any desired form.

Moulding for casting is closely allied to the potter's art. The potter selects a clay suitable for the vessel he desires to mould, and the founder prepares a composition of sand and loam of the proper consistency to serve as a matrix for the vessel he desires to cast.

The art of founding was doubtless first applied to bronze. The ruins of Egypt and Greece abound in the remains of bronze castings, an analysis of which reveals about the same relative proportions of tin and copper in use now for the best qualities of statuary bronze. The bronze castings of the Assyrians show a high degree of art. Many specimens of this fine work of the Assyrian founder have been rescued from the ruins of long-buried Nineveh — buried so long that Xenophon and his ten thousand Greeks marched over its site more than two thousand years ago without making any sign of a knowledge of its existence, and Alexander fought a great battle in its neighborhood in apparent ignorance of the fact that he trod on classic ground. But there, delving beneath the rubbish and decayed vegetation of four thousand years or more, Layard found great treasures of art in the palaces of Sennacherib and other Assyrian mon-

archs—vases, jars, bronzes, glass-bottles, carved ivory and mother-of-pearl ornaments, engraved gems, bells, dishes, and ear-rings of exquisite workmanship, besides arms and a variety of tools of the practical arts.

In Greece, in the time of Praxiteles, bronze was moulded into forms of rare beauty and grandeur. The colossal statue of Apollo at Rhodes affords an example of the magnitude of the Greek castings. It was cast in several parts, and was over one hundred feet high. About fifty years after its erection it was destroyed by an earthquake. Its fragments lay on the ground where it fell, nearly a thousand years; but when the Saracens gathered them together and sold them, there was a sufficient quantity to load a caravan consisting of nine hundred camels. One of the finest existing specimens of ancient bronze casting is that of a statue of Mercury discovered at Herculaneum, and now to be seen in the museum at Naples.

During the era of church bells the founder exercised his art in casting bells of huge dimensions. Early in the fifteenth century a bell weighing about fifty tons was cast at Pekin, China. This bell still exists, is fourteen and a half feet in height and thirteen feet in diameter. But the greatest bell-founding feat was, however, that of 1733, in casting the bell of Moscow. This bell is nineteen feet three inches in height and sixty feet nine inches in circumference, and weighs 443,772 pounds. The value of the metal entering into its construction is estimated at $300,000. It long lay in a pit in the midst of the Kremlin, but Czar Nicholas caused it to be raised, mounted upon a granite pedestal, and converted into a chapel. The methods of casting employed by the founder of this king of bells are not known. The bell has outlived

the Works where it was cast. The melting and handling of two hundred and twenty tons of bronze metal certainly required appointments, mechanical and otherwise, of the most stupendous character; and the existence of such Works presupposes an intimate acquaintance with the most minute details of the founder's art, since the natural order of development is from the less to the greater. That is to say, the founder who could manipulate scores of tons of metal in a single great casting could doubtless manipulate a few pounds of metal; or, the founder who could cast a bell weighing two hundred and twenty tons, could cast pots and kettles and hundreds of other little useful things. What we hope to do in this school Founding Laboratory is to gain a correct conception of great things by making ourselves thoroughly familiar with many forms of little things in moulding and casting.

The lesson of the day is the moulding and casting of a plain pulley. In the Pattern Laboratory each student has already executed a pattern of the pulley to be cast, and the pattern lies before him on his moulding-bench. Now the instructor, at the most conspicuous bench in the room, proceeds to execute the first part of the lesson, which consists of moulding. Taking from the trough a handful of sand, he explains that it is only by the use of sand possessing certain properties, as a degree of moisture, but not enough to vaporize when the metal is poured in, and a small admixture of clay, but not enough to make of the compound a loam, that the mould can be saved from ruin through vaporization, and, at the same time, given the essential quality of adhesiveness and plasticity. In the course of this explanation he remarks that the sand used in some parts of the mould is mixed with pulverized bituminous coal, coke, or plumbago, in

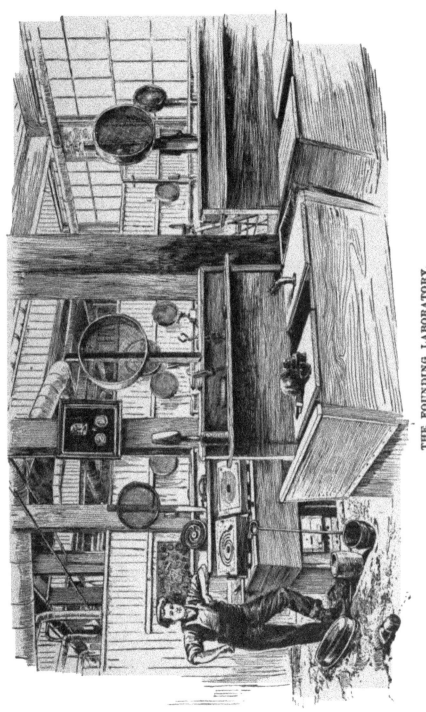

THE FOUNDING LABORATORY.

order to give a smoother surface. Now he takes the "flask"—a wooden apparatus containing the sand in which the mould is made—and explains its construction and use. From this point—the sifting of facing sand on the turn-over hoard, to the final one of replacing the cope and securing it with keys or clamps—every step of the process is carefully gone through with and explained.

Meantime, before the moulding lesson has proceeded far, a fire is kindled in the furnace and it is "charged;" that is to say, filled with alternate layers of coal and pig-iron, with occasional fluxes of limestone. During the process of charging the furnace the instructor explains the principle of its construction, and shows how it operates. At every subsequent rest in moulding the students surround the furnace to witness the progress of the fire, the position of the layers of coal, and the state of combustion. They pass the furnace in procession, and each peeps in through the isinglass windows upon the glowing fire, asks a question, or a dozen questions, perhaps, and gives place to the next student in line. In the intervals of these visits to the furnace the work of making twenty-four moulds goes on under the eye of the instructor, the students explaining each step in advance. He is omnipresent, answering a question here, preventing a fatal mistake there, cheering, inspiring, and guiding the whole class, but never insisting upon a slavish adherence to strict identity in processes. And it is to be noted that there is in moulding more latitude for independence than in almost any other mechanical manipulation. Certain essentials there are, of course, but these being secured, the student may exercise his ingenuity in the execution of many minor details. That there is considerable individuality in the class may be seen by obser-

vation of the different methods employed by the several
young moulders to compass various details of the same
general process.

The moulds are nearly completed. The instructor
assists a student who is found to be a little behind in his
work, and interposes a warning against haste at the criti-
cal moment. Within a period of ten minutes the twenty-
four patterns are " tapped," loosened, and lifted from
their beds, imperfections are carefully repaired with the
trowel, or some other tool, channels to the pouring holes
are cut in the surfaces, the pieces remaining in the copes
are removed, the particles of loose sand are blown from
the surfaces of the moulds, and the twenty-four copes
are replaced, and secured in their correct positions with
keys or clamps.

A final visit is now made to the furnace. The fusion
is found to be complete; the " pigs " are converted into
a molten pool. It only remains to pour the hot metal
into the moulds. The instructor seizes an iron ladle lined
with clay, holds it under the spout of the furnace reser-
voir until it is nearly filled with the glowing fluid, lifts
and carries it carefully across the room, and pours the
contents into a mould. Then the students, in squads,
after having been cautioned as to the deadly nature of
the molten mass they are to handle, follow the example
of their instructor. At this moment the laboratory ap-
peals powerfully to the imagination. The picture it pre-
sents is weird in the extreme. From the open furnace
door a stream of crimson light floods the room. The
students wear paper caps and are bare-armed; their faces
glow in the reflected glare of the furnace-fire; they march
up to the furnace one by one, each receiving a ladleful
of steaming hot metal, and countermarch to their benches,

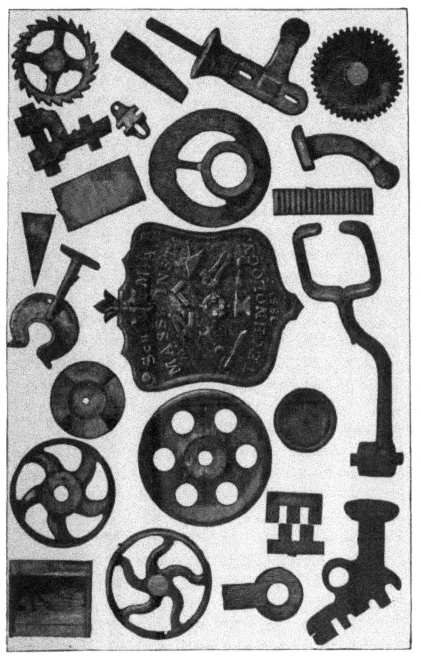

COURSE IN THE FOUNDING LABORATORY.

where they pour the contents of their ladles into the moulds.

Still holding his empty ladle in his hand, the instructor watches the progress of the lesson with keen interest until the last stream of metal has found its way into the throat of the last mould. He recalls the story of Vulcan, the God of Fire, and of all the arts and industries dependent upon it, and wonders why he was not depicted pouring tons of molten metal, in the foundery, rather than sledge in hand at the forge. Then he regards the class with a benignant expression of pride, begs for silence, and says, "Thus were the hundred brazen gates of ancient Babylon cast long before the beginning of the Christian era." Herodotus did not think to tell us much of the state of the useful arts in the early time of which he wrote, but the brazen gates attracted his attention, and he described them: "At the end of each street a little gate is found in the wall along the river-side, in number equal to the streets, and they are all made of brass, and lead down to the edge of the river." Could Herodotus have foreseen what a deep interest his readers of this remote time would take in the history of the useful arts, he would have written less about the walls, palaces, and temples of Babylon, and more about the artificers. He would have begged admission to the forges and founderies of the city; he would have visited the Assyrian founder at his work, questioned him about his processes, and set down his answers with painstaking care. Then he would have sought an introduction to the smithy, and from the grimy forger learned what he could tell of his art and of kindred arts. So the father of history might have made an enduring record of the real things which throughout all time have contributed

to the advancement of the human race, rather than of events growing out of the ambitions and passions of men —the rise and fall of kingdoms and empires, the varying fortune of battle, the treacheries, crimes, and brutalities of rulers, and the cringing submission of millions of subjects. But, alas, the founders and smiths, and all the other cunning artificers of the vast empire of Syria, were slaves! and through their ancestry for unnumbered generations the stigma of slavery had attached to labor. Ay, on the bare backs of the founders of Babylon's brazen gates the popular scorn of labor had doubtless left its livid brand.

With these pariahs of Assyrian society, these outcasts of the social circle, the great Greek historian could not even speak. Descended from a long line of noble Halicarnassian families, Herodotus felt all the prejudices of the hereditary aristocracy of his country. Hence he dilates upon the wonders of Babylon, but is silent as to its architects and artisans. He describes with great minuteness of detail the tower of Jupiter Belus, but gives no hint of the name of its designer and builder. He declares that Babylon was adorned in a manner surpassing any city of the time, but in regard to the artificers through whose ingenuity and skill such pleasing effects were produced he gives no sign.

The silence of Herodotus on the subject of the useful arts in Babylon does not indicate a want of appreciation of their value, but merely shows contempt of the Assyrian artisan, and this not because he was an artisan, but because he was. a slave. The story of Solon and Croesus, which antedates Herodotus, whether true or a myth, shows that iron and artisanship were appreciated by both Greeks and barbarians. When Croesus had

exhibited to the Greek sage his vast hoard of treasures, Solon said, "If another comes that hath better iron than you he will be master of all this gold." Here is a recognition of the immense value of the arts of smelting and forging, coupled with a contemptuous silence regarding as well the smelter and the smith as the rank and file of the armies who should wield the swords and spears drawn by science from the recesses of the earth, and by art wrought and tempered at the forge. Through all the early ages the brand and scorn of slavery adhered to labor, while the arts, the products of labor, were often deified. Thus the Scythian, who from a grinning skull drank the warm blood of his captive, regarded with superstitious awe as a god the iron sword with which he cut off his captive's head.

It was only with the revival of learning, after the intellectual and moral gloom of the Dark Ages, that labor began slowly to lift its bowed head and assert itself. But it does not yet stand erect. It still stoops as if in the presence of a master. Every now and then it winces and cringes as if the sound of the descending lash smote its ear. It remains for you, students in this school of the arts—all the arts that make mankind good and great —it remains for you to brush away from the tear-stained face of labor all the shadows accumulated there through all the dead ages of oppression and slavery. It remains for you to make labor hold by making it intelligent. It remains for you to dignify and ennoble labor by bestowing upon it the ripest scientific and artistic culture, and devoting to its service the best energies of body and mind.

CHAPTER VIII.

THE FORGING LABORATORY.

Twenty-four manly-looking Boys with Sledge-hammer in Hand--
their Muscle and Brawn.—The Pride of Conscious Strength.—
The Story of the Origin of an Empire.—The Greater Empire of
Mechanics.—The Smelter and the Smith the Bulwark of the Brit-
ish Government.—Coal—its Modern Aspects; its Early History;
Superstition regarding its Use.—Dud. Dudley utilizes "Pit-coal"
for Smelting—the Story of his Struggles; his Imprisonment and
Death.—The English People import their Pots and Kettles.—"The
Blast is on and the Forge Fire sings."—The Lesson, first on the
Black-board, then in Red-hot Iron on the Anvil.—Striking out the
Anvil Chorus—the Sparks fly whizzing through the Air.—The
Mythological History of Iron.—The Smith in Feudal Times—His
Versatility.—History of Damascus Steel.—We should reverence
the early Inventors.—The Useful Arts finer than the Fine Arts.—
The Ancient Smelter and Smith, and the Students in the Manual
Training School.

THIS is the Forging Laboratory. It is only a few steps
from the laboratory for founding, where we lately saw
twenty-four students taking off their leather aprons after
a two hours' lesson in moulding and casting. Here we
find, also, twenty-four students, but not the twenty-four
we saw in the laboratory for founding. This class is
more advanced. The boys are a trifle taller; they show
more muscle, more strength, and bear themselves with a
still more confident air.

In the Forging Laboratory there are twenty-four forges
with all essential accessaries, as anvils, tubs, and sets of
ordinary hand-tools.

THE FORGING LABORATORY.

The students, with coats off and sleeves rolled above their elbows, in pairs, as smith and helper, stand, sledge and tongs in hand, at twelve of the forges. They are manly-looking boys. Their feet are firmly planted, their bodies erect, their heads thrown a little back. Their arms show brawn; the muscles stand out in relief from the solid flesh. Their faces express the pride of conscious strength, and their eyes show animation.

As we regard the class with a sympathetic thrill of satisfaction, the story of the origin of the Turkish Empire is recalled: "A race of slaves, living in the mountain regions of Asia, are employed by a powerful Khan to forge weapons for his use in war. A bold chief persuades them to use the weapons forged for a master to secure their own deliverance. For centuries after they had thus conquered their freedom, the Turkish people celebrated their liberation by an annual ceremony in which a piece of iron was heated in the fire, and a smith's hammer successively handled by the prince and his nobles."

The greatest empire in the world to-day is the empire of the art of mechanism, and its most potent instrument is iron. Once the perpetuity of governments depended upon the mere possession of the dingy ore. When Elizabeth came to the throne, in the middle of the sixteenth century, England was almost defenceless, owing to the short supply of iron. Spain, much better equipped, hence relied confidently upon her ability to subdue the English. But the Virgin Queen, comprehending the nature of the crisis, imported iron from Sweden and encouraged the Sussex forges, and the Spanish Armada was defeated. Thus the smelter and the smith became the bulwark of the British government.

But at an earlier period the fraternity of smiths gave direction to the course of empire. The secret of the easy conquest of Britain by the Normans was their superior armor. They were clad in steel, and their horses were shod with iron. The chief farrier of William became an earl; and he was proud of his origin, for his coat of arms bore six horseshoes.

Iron and civilization are terms of equivalent import. Iron is king, and the smelter and smith are his chief ministers. It is not known when, by whom, or how the art of smelting iron was discovered. As well ask by whom and how fire was discovered? These are secrets of the early morning of human life—of that time when man made no record of his struggles.

In lieu of history the instructor resorts to tradition, repeating the following legend: "While men were patiently rubbing sticks to point them into arrows, a spark leapt forth and ignited the wood-dust which had been scraped from the sticks, and so fire was found."

Now the "helper" looks to his "blast" with keen interest; for the management of the forge-fire is one of the niceties of the smith's art. He stirs the fire a little impatiently. The instructor heeds the act, but not the movement of impatience. On the contrary he seizes the occasion to introduce the subject of coal. Question follows question in rapid succession, and the answers are prompt and satisfactory, touching all modern aspects of the subject, namely, the magnitude of the annual "output," the localities of heaviest production, the cost of mining; the uses, respectively, to which different qualities are applied, demand and supply, and market value or price. Here the instructor remarks that the mining, transportation, and sale of coal are conducted in this coun-

try by a number of large corporations, with an aggregate capitalization and bonded indebtedness of six or seven hundred million dollars, and that through combinations between these corporations the price is often arbitrarily advanced. "But," he concludes, "the discussion of that branch of the subject belongs more properly to the class in political economy."

The history of coal in its relation to iron smelting and manufacture forms a curious chapter in the vicissitudes of the useful arts. One hundred and fifty years ago not only all the smith's fires but the smelter's fires were kept up with charcoal. The forests of England were literally swept away, like chaff before the wind, to feed the yawning months of the iron mills. To make a ton of iron required the consumption of hundreds of cords of wood. To save the timber restrictive legislation was adopted, and the mills were gradually closed for want of fuel, until, in 1788, there was not one left in Sussex, and only a small number in the kingdom. Meantime the English iron supply came from Sweden, Spain, and Germany. England seemed to be following in the footsteps of the Roman Empire. The Romans accomplished in iron smelting and forging just what might be expected of a warlike people. They required iron for arms and armor, and in smelting skimmed the surface. This is proved by the cinder heaps, rich in ore, which they left in Britain. Archæologists trace the decline of Rome in her monuments, which show a steady deterioration in the soldier's equipment. Alison attributes this decline to the exhaustion of her gold and silver mines. A far more plausible conjecture is found in the waste of timber in fuel for smelting purposes, and the resulting failure of the iron supply.

The fall of the Roman Empire may be accounted for by her neglect of the useful arts. The nation that converts all her iron into swords and spears shall surely perish. Had the city of Seven Hills possessed seven men of mechanical genius like Watt, Stephenson, Maudslay, Clement, Whitney, Neilson, and Nasmyth, her fall might have been averted, or if not averted, it need not have involved the practical extinction of civilization, thus imposing upon mankind the shame of the Dark Ages.

At the beginning of the seventeenth century there was much ignorant prejudice against the use of mineral coal. It was believed to be injurious to health. All sorts of diseases were attributed to its supposed malignant influence, and at one time to burn it in dwellings was made a penal offence. But this prejudice did not extend to its use in smelting iron, and whatever there was of inventive genius was devoted to a solution of the problem of its adaptation to such purposes. Mr. Samuel Smiles has collected the names of the most prominent of these Dutch and German mechanics, namely, Sturtevant, Rovenzon, Jordens, Francke, and Sir Philibert Vernatt, and given each a niche in the temple of fame. Some of them had a true conception of the required processes, but they all failed to render the application practically available.

It remained for Dud. Dudley to succeed in making a thoroughly practical application of mineral coal to iron-smelting purposes, and then curiously enough to fail of success in introducing it into general use. Dudley was born in 1599, in an iron-manufacturing district. His father owned iron-works near the town of Dudley, which was a collection of forges and workshops where "nails, horseshoes, keys, locks, and common agricultural tools" were made. Brought up in the neighborhood of " twen

ty thousand smiths and workers in iron," young Dudley "attained considerable knowledge of the various processes of manufacture." At twenty years of age he was taken from college and placed in charge of a furnace and two forges in Worcestershire, where there was a scarcity of wood but an abundance of mineral coal. He began immediately to experiment, with a view to the substitution of the latter for the former, and in a year succeeded in demonstrating "the practicability of smelting iron with fuel made from pit-coal, which so many before him had tried in vain." But the charcoal iron-masters combined to resist the new method because it cheapened the product. They instigated mobs to destroy Dudley's furnaces one after another, as soon as they were completed, harassed him with lawsuits, and finally beggared and drove him to prison. Then they tried to wring his secret from him. To this attempt Cromwell, who was interested in furnaces in the Forest of Dean, is said to have been a party. But all these efforts failed, and Dudley died in 1684 carrying his secret with him to the grave, and there the secret slumbered nearly one hundred years.

The story of Dud. Dudley, as told by Mr. Smiles in his "Iron-workers and Tool-makers," is one of surpassing interest. It is worthy the careful perusal not only of every school-boy but of the philosophic student in search of the lessons of history, for it affords fresh evidence of the truth of the proposition that the progress of civilization depends upon progress in invention and discovery.

Under the influence of ignorance, prejudice, and superstition the iron industry of England continued to decline until the beginning of the eighteenth century, when the British people imported their pots and kettles. Fifty years later, at the Coalbrookdale iron-works in Shropshire,

4

when the furnaces had consumed all the wood in the
neighborhood and a fuel famine was imminent, smelting
with mineral coal was successfully resumed, and in 1766
two workmen of the "works"—the brothers Cranege—in-
vented the reverberatory furnace, which added immense-
ly to the application of coal to smelting purposes.

But while we are discussing the history of coal we are
consuming coal to little purpose, for the blast is on and
the furnace fires glow like miniature volcanic craters.
Let us to work. Before the black-board, chalk in hand,
the instructor stands and gives out the lesson. He pre-
sents it in the form of drawings, complete and in detail.
It may involve only the single process of "drawing," or
it may involve several processes, as "drawing," "bend-
ing," and "welding." The first sketch, for example, rep-
resents a flat bar of iron, the counterpart of the bars rest-
ing against the several forges. The second sketch shows
the bar wrought into the form of a cylinder. The third
sketch shows it "drawn" or lengthened, and hence re-
duced in size. The fourth sketch presents two rods the
united lengths of which equal the length of the original
rod. The fifth sketch represents the two rods "bent"
into the form of chain-links, and a sub-sketch shows the
proper shape of the ends of the links for "welding."
The sixth sketch shows the two links joined and welded.

The black-board illustrations may be omitted if the
school is provided with a complete set of samples. The
school of mechanic arts of the Massachusetts Institute of
Technology has a hundred samples representing the suc-
cessive steps in blacksmithing manipulation, including
welding, and the welding samples consist of two parts,
the first representing the details of the piece prepared
for welding, and the second the welded piece. These

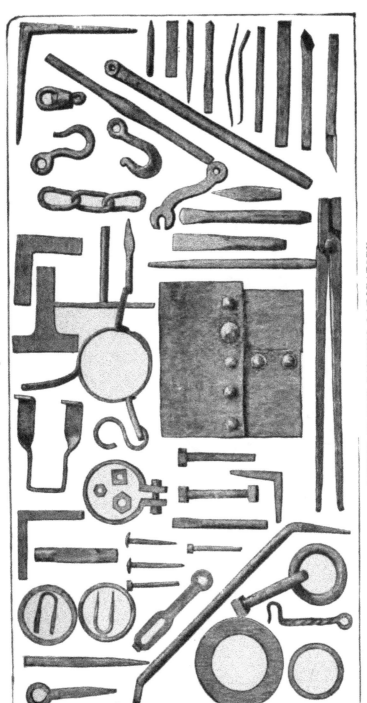

samples are part of a collection of three hundred and
twenty pieces of exquisite workmanship, covering every
department of a complete manual training course, pre-
sented to the Institute in 1877 by the Emperor of Russia.

The black-board illustrations or the samples having
been exhibited and explained as clearly as is possible in
words, the instructor takes his place at one of the forges,
and, surrounded by the class, goes through with the suc-
cessive steps of any manipulation contained in the lesson
which has not been actually wrought out in some pre-
vious lesson.

If the manipulation is a simple one the silence is only
broken by the sound of the blast and the stroke of the
hammer—the students understand every turn of the iron
and every blow struck by the instructor—but if the
manipulation is complicated, involving a fresh principle,
the instructor is saluted by a volley of questions, and he
often pauses to answer them. It is the time for ques-
tions; the more questions now, the fewer questions when
all the blasts shall be on, and all the sledges flying through
the air and making music on the anvils. A question now
may lead to the enlightenment of twenty-four students; a
question later is sure to cost the time of twenty-four stu-
dents, and the answer to it may enlighten only one student.

At last the instructor drops the sledge, straightens up
to his full height, and wipes the sweat from his brow.
If the students respect the instructor they will respect
labor, and they will respect the instructor if he is worthy
of respect.

Now the school-room is a smithy and yet it is not. It
is neither very hot nor very smoky, for there is an ex-
haust fan in operation which vitalizes the circulation.
But the atmosphere resounds with the clangorous strokes

of a dozen sledges, mingled with the sullen roar of as many forge-fires; and there are traces of soot on the walls, and pale smoke-wreaths creep along the ceilings, and hide in corners, and circle about columns in fantastic shapes. It is a smithy, but a smithy adapted, by its extraordinary neatness, to the manufacture of watch-springs, palate-arbors, and Damascus blades.

The faces of the students are aglow with the flush of health-giving exercise; their brows are "wet with honest sweat," their heart-beats are full and strong, and the crimson life-currents surge hotly through every vein to their very finger-tips. They strike out the anvil chorus in all the keys and in every measure of the scale, and the burning sparks fly whizzing through the air.

At a sign from the instructor there is a pause. The students stand at ease and the work is inspected. This is the time for more questions if any student is in doubt; and the rest of five minutes affords opportunity for a brief lecture on the subject of the early history of the fraternity of smiths.

Mythology gives the highest place in its pantheon to Vulcan, the God of Fire. For notwithstanding he is represented as bearded, covered with dust and soot, blowing the fires of his forges and surrounded by his chief ministers, the cyclops, he is given Venus to wife and made the father of Cupid. Among the Scythians the iron sword was a god. When Jerusalem was taken by the Babylonians they made captives of all the smiths and other craftsmen of the city — a more grievous act than the thousand million dollar tribute levied upon France by Germany at the close of the war of 1870. For to be deprived of the use of iron is to be relegated to a state of barbarism.

The vulgar accounted for the keenness of the first sword-blades on the score of magic, and the praises of the smiths who forged were sung with the chiefs of chivalry who wielded them. So highly was this mysterious power regarded by Tancred, the crusader, that in return for the present of King Arthur's sword, Excalibar, by Richard I., he paid for it with "four great ships and fifteen galleys."

The smith was a mighty man in England in the early time. "In the royal court of Wales he sat in the great hall with the king and queen, and was entitled to a draught of every kind of liquor served." His person was sacred; his calling placed him above the law. He was necessary to the feudal state; he forged swords "on the temper of which life, honor, and victory in battle depended." The smith, after the Norman invasion, gained in importance in England. He was the chief man of the village, its oracle, and the most cunning workman of the time. His name descended to more families than that of any other profession—for the origin of the name Smith is the hot, dusty, smoky smithy, and however it may be disguised in the spelling, it is entitled to the proud distinction which its representatives sometimes seek to conceal.

Mr. Smiles draws the following graphic picture of the versatility of the smith of the Middle Ages:

"The smith's tools were of many sorts, but the chief were his hammer, pincers, chisel, tongs, and anvil. It is astonishing what a variety of articles he turned out of his smithy by the help of these rude implements. In the tooling, chasing, and consummate knowledge of the capabilities of iron he greatly surpassed the modern workman. The numerous exquisite specimens of his

handicraft which exist in our old gate-ways, church doors, altar railings, and ornamented dogs and andirons, still serve as types for continual reproduction. He was, indeed, the most 'cunning workman' of his time. But besides all this he was an engineer. If a road had to be made, or a stream embanked, or a trench dug, he was invariably called upon to provide the tools, and often to direct the work. He was also the military engineer of his day, and as late as the reign of Edward III. we find the king repeatedly sending for smiths from the Forest of Dean to act as engineers for the royal army at the siege of Berwick."

But the most signal triumph of the art, both of the smelter and the smith, is found in the famous swords of Damascus, whose edge and temper were so keen and perfect that they would sever a gauze veil floating in the air, or crash through bones and helmets without sustaining injury. These Damascus blades, long renowned in the East, but first encountered by Europeans during the crusades, in the hands of the followers of Mahomet, were made of Indian steel or "wootz." This steel, produced in the form of little cakes weighing about two pounds each, in the neighborhood of the city of Golconda, in Hindostan, was transported on the backs of camels two thousand miles to the city of Damascus, and there converted into swords, sabres, and scimitars.

This smith's work has never been excelled, if equalled. Millions of dollars have been expended in efforts to produce the equal of Indian steel. Among the investigators of the subject the most noted was a Russian general, Anossoff, who died in 1851. His experiments were of a very elaborate and exhaustive character. They occupied a lifetime, and resulted in the establishment of

works in the Ural Mountains, on the Siberian border, for the production of Damascus steel by a process of his own invention. After General Anossoff's death the quality of the steel produced at his works deteriorated.

We should treat with reverence these obscure hints of the triumphs of the ancients in certain departments of art as suggestive of like great achievements in other directions, for without a knowledge of types they could neither teach the many what the few knew, nor preserve what they had acquired for the instruction of future ages. All art is the product of a sequential series of ideas, each idea containing the germ of the next; hence the preservation of each idea is essential to progress. The art of printing alone enables man to preserve such a record. It follows presumptively that the art of printing constitutes the predominant feature of difference between the civilization of the moderns and that of the ancients. And it is important to observe that the art of printing is far more necessary to progress in the useful arts than in the so-called fine arts. The ancient temples with their sculptured splendors—the Parthenon, the Jupiter Olympius, and scores of others—remained long to testify to the genius of Phidias, Praxiteles, and their gifted colleagues of the chisel. These souvenirs of Greek genius still serve as models for the architect and the sculptor. It needs no chronicle to prove that they mark the culmination of the fine arts. If the moderns have failed to excel, or even equal them, it is not because their conception, design, or construction involved occult processes. It is rather because there is a limit to the development of the so-called fine arts, and that limit in architecture and sculpture was reached in Greece more than two thousand years ago.

But with the Damascus blade, which typifies the useful arts, it is entirely different. It, too, is in itself a triumph of genius not less pronounced than the Athena of Phidias. But above and beyond this the arts of smelting and forging are so subtile as almost to elude the grasp of analysis. Not only the method of the fabrication of the Damascus blade but the processes involved in the production of the steel entering into its composition—all these are shrouded in impenetrable mystery. It follows that the useful arts are finer than the so-called fine arts. Their processes are more intricate, and hence more difficult of comprehension. To a solution of the questions presented in the course of their study an extended acquaintance with the sciences is essential. The highest departments of the fine arts, so-called, require only a study of the features, figure, and character of man, and of certain visible forms of nature, while the useful arts make incessant demands upon the resources of natural philosophy. The chemist toils in his laboratory, and the botanist and the geologist explore forest, field, and mine in search of new truths, with the single purpose of enlarging the sphere of the useful arts, and so of ministering more effectively to the ever increasing needs-of man. Hence there can be no limit to the development of the useful arts except the limit to be found in the exhaustion of the forces of nature.

We should, then, venerate the artisan rather than the artist. Let us invoke the shade of the dusky Indian smelter. See him in the dark recesses of the forest, bending in rapt attention over his furnace, or holding aloft a little lump of his matchless steel. Alas, he is dumb! His secret perished with him. But the Indian smelter and the Damascus smith are kin to all the invent-

ors and discoverers of all the ages. Across continents
and seas, over trackless wastes of history—epochs during
which ignorance and superstition prevailed and the intel-
lect of man slumbered — the ancient smelter and the
ancient smith extend their shadowy' hands to the stu-
dents in this school of the nineteenth century—extend
them in token of the fellowship of a common struggle
and a common hope of triumph — the struggle after
truth,' and the hope of the triumph of industry.

The instructor raps on the black-board, and the school-
room is at once transformed into a smithy. Again the
forge-fires roar, and again the anvils resound under the
stroke of the hammer. For half an hour the lesson goes
on, and then comes the wind-up, and the several tests
of excellence are applied to the completed task of each
student. Form, dimensions, finish—these are the tests.
The instructor marks the several pieces of work, makes a
record of the result, reads the record, and is on the point
of dismissing the class when an idea occurs to his mind
and he enjoins silence. Taking in his hand a heavy
sledge, and resting it on the anvil before him, he says,
" This is a baby-hammer, and all the forging we do here
is baby-forging. I hope soon to have an opportunity to
take you to the great works of Mr. Crane, in this city,
and there show you a steam-hammer which weighs a ton
striking fifty to one hundred blows a minute—blows, too,
that shame the fabled power of Vulcan, the God of Fire.
At Pittsburg, Pa., there is an anvil of 150 tons weight
which serves for forging with a 15-ton hammer. But
the monster steam-hammer is to be found in Krupp's cast-
steel works at Essen, Germany. The hammer-head is 12
feet long, 5½ feet wide, 4 feet thick, weighs 50 tons, and
has a stroke of 9 feet. The depth of the foundation

is 100 feet, consisting of three parts, masonry, timber, and iron, bolted together. Four cranes, each capable of bearing 200 tons, serve the hammer with material."

The steam-hammer was invented in 1837 by James Nasmyth, of England, in response to a demand for a hammer that would forge a steamship paddle-shaft of unprecedented size. The nature of the emergency being presented to his mind, Mr. Nasmyth conceived the idea of the steam-hammer instantaneously, as it were, and at once proceeded to sketch the child of his brain on paper. He was too poor to defray the cost of patenting his invention; nor was he able to procure the necessary funds for that purpose until he had seen in France a hammer made from his own original sketch in operation.

The steam-hammer came rapidly into use, superseding all others of the ponderous sort, increasing the quantity of products and reducing the cost of manufacture by fifty per cent. It was through the steam-hammer only that the fabrication of the immense wrought-iron ordnance and the huge plates for covering ships-of-war of modern times became possible. In the hands of the giant, steam, Mr. Nasmyth's hammer, even if it weigh fifty tons, is susceptible of more accurate strokes than the tack-hammer in the hands of the upholsterer, or the sledge in the hands of the most skilled blacksmith. It crushes tons of iron into a shapeless mass at one blow, and at the next drives a tack, or cracks an egg-shell in an egg-cup without injuring the cup.

Mr. Nasmyth, in 1845, applied the steam-hammer principle to the pile-driver. With this wonderful machine the "driving-block," weighing several tons, descends eighty times a minute on the head of the pile, sending it home with almost incredible rapidity. The saving of

time as compared with the old method is in the ratio of 1 to 1800; that is, a pile can be driven in four minutes that before required twelve hours.

The course in the Forging Laboratory extends from the making and care of forge-fires to case-hardening iron and hardening and tempering steel; and competent and experienced instructors declare that the student in the educational smithy gains as much skill in a day as the smith's apprentice gains in a year in the ordinary shop.

[1] The inquiry of truth, which is the love-making or wooing of it; the knowledge of truth, which is the presence of it; and the belief of truth, which is the enjoying of it—is the sovereign good of human nature."—Essays of Francis Bacon—"Truth," p. 2. London: Henry G. Bohn, 1852.

CHAPTER IX.

THE MACHINE-TOOL LABORATORY.

The Foundery and Smithy are Ancient, the Machine-tool Shop is Modern.—The Giant, Steam, reduced to Servitude.—The Iron Lines of Progress—They converge in the Shop; its triumphs from the Watch-spring to the Locomotive.—The Applications of Iron in Art is the Subject of Subjects.—The Story of Invention is the History of Civilization.—The Machine-maker and the Tool-maker are the best Friends of Man.—Watt's Great Conception waited for Automatic Tools; their Accuracy.—The Hand-made and the Machine-made Watch.—The Elgin (Illinois) Watch Factory.—The Interdependence of the Arts.—The Making of a Suit of Clothes.—The Ante-room of the Machine-tool Laboratory.—Chipping and Filing.—The File-cutter.—The Poverty of Words as compared with Things.—The Graduating Project.—The Vision of the Instructor.

THE transition from the laboratories for founding and forging to the Machine-tool Laboratory symbolizes a mighty revolution in the practical arts—a revolution so stupendous as to defy description, and so far-reaching as to appall the spirit of prophecy. The foundery and the smithy date back to the dawn of history; the machine-tool shop is a creation of yesterday. About the early manipulations of iron mythology wove a web of fancy: Vulcan forged Jove's thunderbolts, the iron sword of the savage was a god, and even far down the course of time, late in the Middle Ages, Tancred, the crusader, paid an almost fabulous sum for King Arthur's famous sword Excalibar—but the modern machine-tool shop is a huge iron automaton, without sentiment, and possessing no poetry except the rhythmic harmony of motion. In this

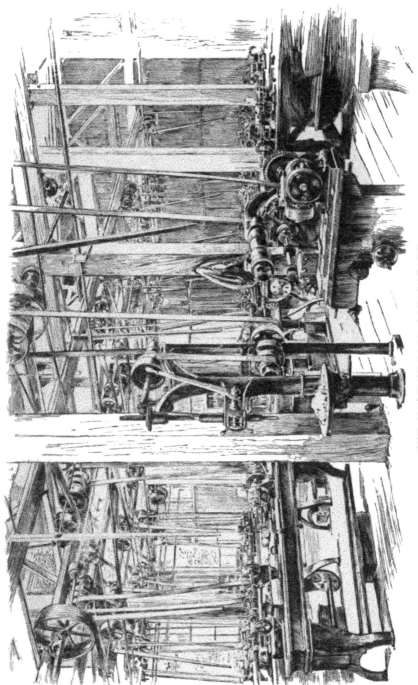

THE MACHINE-TOOL LABORATORY.

shop steam is reduced to servitude, and compelled with
giant hands to bore, mortise, plane, polish, fashion, and
fit great masses of iron, and, anon, with delicate fingers
to spin gossamer threads of burnished steel. With the
hot steam coursing through its steel-ribbed veins the
brain of this automaton thinks the thoughts foreordained
by its inventor; its hands do his bidding, its arms fetch
and carry for him, its feet come and go at his beck
and nod. This automaton feeds on iron, steel, copper,
and brass, and produces the watch-spring and the loco-
motive, the revolver and the Krupp gun, the surgeon's
lancet and the shaft of a steamship, the steel pen and the
steam-hammer, the vault-lock and the pile-driver, the
sewing-machine and the Corliss engine. The lever which
wakens this automaton to life, which endows its brain
with genius and its fingers with cunning, is the rod of
empire. All the lines of modern development converge
in the machine-tool shop, and they are all lines of iron,
whether consisting of a fine wire strung on poles in mid-
air or of huge bars resting on the solid earth. Iron is
the king of metals but the slave of man. Its magnetic
quality guides the mariner on the sea, and its tough fibre
and density sustain the weight of the locomotive on the
land. It constitutes the foundation of every useful art,
from the plough of the husbandman to the Jacquard
loom of the weaver. But it is only in the machine-tool
shop that the great steam-driven machines of commerce
and manufacture can be produced. The ancients pos-
sessed iron, which they cast in the foundery and forged
in the smithy; they knew the power of steam, and the
magicians of the time amused the populace with exhibi-
tions of it, but they had no machine-tool shops in which
steam could be harnessed for the journey across conti-

nents and seas. The thousand and one modern applica-
tions of iron to the needs of man have originated in the
machine-tool shop. It is through these applications of
iron, not through iron itself, that human pursuits have
been so widely diversified, and human powers so richly
developed and enlarged.

The contrasts presented by the development of the
useful arts during the last hundred years are startling:
The toilsome journey of a day reduced to an hour with
the maximum of comfort; the few yards of fabric pain-
fully woven by hand expanded into webs of cotton, lin-
en, woollen, and silk cloths, rolling from thousands of
steam-driven looms; the stocking once requiring hours
to make, now dropping second by second from the iron
fingers of the knitting-machine; the nails, screws, pins,
and needles, forged one by one in the old village smithy,
now flying from the hands of automatic machines by the
thousand million; the numberless stitches of the sewing-
machine as compared with the few of the olden time,
which made the fingers and the hearts of women ache;
the vast crop of cereals planted, cultivated, and gathered
into barns with iron hands in contrast with the toilsome
processes of even fifty years ago. These are only a
few of the many illustrations that might be given of
progress in the useful arts, and they all emanate from
the machine-tool shop.

At the threshold of the most important inquiry that
ever occupied the mind of man stand the twenty-four
students we have followed, with more or less regularity,
through the various laboratories which constitute the
preliminary steps in the manual training course. It is
the most important inquiry that ever engaged the atten-
tion of man, because it touches modern civilization at

more points than any other. It consists of an investiga-
tion into the subject of the diversity of the applications
of iron in art, a study both of the minute and the ponder-
ous in iron tools and machines, and it is by these tools
and machines that the bulk of the great enterprises of
the men of modern times are carried forward. These
students are familiar with the details of the laboratories
for founding and forging, but the manipulations of those
branches of iron manufacture are coarse and heavy as
compared with those of the Machine-tool Laboratory. In
a word, the difference between the iron manipulations of
the Machine-tool Laboratory and those of the founding
and forging laboratories is the exact measure of the dif-
ference between the modern and the ancient systems of
civilization.

The ancient civilizations culminated in that of Rome.
The Romans possessed iron, but confined their manipula-
tions of it to the foundery and the smithy. Under the
Roman empire the enterprises of man—commercial, man-
ufacturing, and industrial generally—reached the limit
marked by the applications of iron to the useful arts. It
is not important in this connection to inquire why in-
ventions and discoveries ceased. It is enough that they
ceased. There was a pause; man, risen to a giddy height,
looked backward instead of forward and upward; the
struggle to advance came to an end, ambition died out of
life, and a saturnalia of bloody crime and savage brutal-
ity ensued. Exhaustion followed, then stagnation, moral
and intellectual, and then the decay of all the arts. The
world stood still, and in that state of quiescence remain-
ed until printing was invented and America discovered.
Still it waited two hundred and fifty years before re-
ceiving the first hint of steam-driven machines and the

machines and the machine tool-shop, and during all that
time progress was painfully slow. Something was required
to give to human ambition a grand impulse, and to open to
human energy and industry a broad field. That something
did not come until the middle of the eighteenth century,
and it should never be forgotten that it came then through
the humble men of the workshop. To their inventive
genius mankind owes more than to all the philosophers,
litterateurs, professors, and statesmen of all time. These
men of the workshop—Huntsman, Cort, Roebuck, Watt,
Fulton, Mushet, Hargreaves, Neilson, Whitney, Bramah,
Maudslay, Clement, Murray, Roberts, the Stephensons,
father and son, and Nasmyth---invented machines which
seem to rival human intelligence, and in fact far excel
human precision in the execution of their work. In en-
dowing iron with the cunning of genius and the terrific
power of the fabled cyclops, the modern mechanic has
revolutionized the field of human effort, transferring it
from the foundery and the smithy to the machine-tool
shop. It is here, and here alone, that steam-driven
machines can be made. They may be conceived in the
mind of a Watt or a Stephenson, but they can be made
only by the automatic tools of a Maudslay, a Clement, a
Bramah, or a Nasmyth. Man was helpless without steam-
driven machines, and he could not have steam-driven ma-
chines until machine-made tools had been devised with
which to make them. The experience of Watt striking-
ly illustrates this point. When he had completed his in-
vention of the steam-engine, he found it nearly impossible
to realize his idea in a working machine, owing to the
incompetency of the workmen of that time. In reply
to the inquiry of Dr. Roebuck, " What is the principal
hinderance in erecting engines?" he responds, " It is al

ways the smith-work." His first cylinder, made of hammered iron soldered together by a whitesmith, was a complete failure. But even such workmen were so scarce that upon the death of this "white-iron man" Watt was reduced almost to a state of despair. '"His next cylinder was cast and bored at Carron, but it was so untrue that it proved next to useless. The piston could not be kept steam-tight, notwithstanding the various expedients which were adopted of. stuffing it with paper, cork, putty, pasteboard, and old hats." Smeaton, the best workman of the time, "expressed the opinion, when he saw the engine at work, that notwithstanding the excellence of the invention it could never be brought into general use because of the difficulty of getting its various parts manufactured with sufficient precision." Watt constantly complained of "villanous bad workmanship." "Machine-made tools were unknown, hence there were no good tools. Attempting to run an engine of the old regime, the foreman of the shop gave it up in despair, exclaiming, "I think we had better leave the cogs to settle their differences with one another; they will grind themselves right in time." Contrast with this clumsy machine of the hand-tool era the Corliss engine of the present day, whose every movement possesses the noiseless grace of a woman and the conscious power of a giant; and this giant springs full-armed from the machine-tool shop as Minerva sprang from the brain of Jupiter. Mr. Smiles says, "When the powerful oscillating engines of the *Warrior* were put on board that ship, the parts, consisting of some five thousand separate pieces, were brought from the different workshops of the Messrs. Penn & Sons, where they had been made by workmen who knew not the places they were to occupy, and fitted together with

such precision that so soon as the steam was raised and let into the cylinders the immense machine began as if to breathe and move like a living creature, stretching its huge arms like a new-born giant; and then, after practising its strength a little, and proving its soundness in body and limb, it started off with the power of above a thousand horses, to try its strength in breasting the billows of the North Sea."

The great and small tools, the automata of the machine-shop, are no less triumphs of mechanical genius than the "powerful oscillating engines of the *Warrior*." The prime difficulty of the hand-worker was to make two things exactly alike, then followed the impossibility of making *many* things—the narrow limit of human capacity to produce. At that point the inventor appeared with a machine which would make a thousand things in the time the hand-worker required to make one, and each one of them the exact counterpart of every other.

A hundred years ago John Arnold, the inventor of the chronometer, accomplished a marvel of patience and ingenuity in the form of a watch the size of twopence and the weight of sixpence. The workmanship was so delicate that he was compelled not only to fashion every part with his own hand, but to design and make the tools employed in its construction. The watch was presented to George III., of England, who showed his appreciation of Arnold's mechanical skill in a present of five hundred guineas. The Emperor of Russia offered Arnold $5000 for a duplicate of the wonderful little time-piece, which offer was, however, declined. It was so difficult for the expert watch-maker of a century ago to make two things exactly alike, that Arnold could not afford to undertake to make another miniature watch even for the exorbitant

price of $5000. But for ten dollars the Elgin (Illinois) National Watch Company will supply the Emperor of Russia with a machine-made watch more nearly perfect than Arnold's masterpiece, and on the same day turn out one thousand others exactly like it. Imagine yourself now in the watch factory of the Elgin Company; observe that artisan holding in his hand a coil of fine steel wire weighing a pound. He approaches a machine, places one end of the wire in its iron fingers, presses a lever, and in a few minutes the coil is converted into two hundred thousand minute screws, each and every one as perfect as the best that Arnold made for his George III. gem.

It is with the greatest effort of painstaking care that the expert sewing-woman draws two stitches closely resembling each other, yet while she is making the toilsome exertion of her utmost skill the sewing-machine sets hundreds of stitches so exactly alike that a microscopic examination would fail to detect the least dissimilarity.

The sewing-machine affords an admirable illustration of the interdependence of the practical arts. The sewing-woman was able to keep pace with the slow and toilsome processes of the distaff and loom, but upon the application of steam-power to spinning and weaving the demand for sewing was augmented a thousand-fold. If the sewing-machine has not emancipated woman from the drudgery so pathetically depicted by Tom Hood, it has multiplied the production of garments almost beyond the power of figures to express. Note this instance illustrative of the triumph of automatic machinery in its application to manufactures. "The Emperor of Austria was lately presented with a suit of clothes possessing this remarkable history: The wool from which the gar-

ments were made was clipped from the sheep only eleven hours before the suit was completed. At 6.08 in the morning the sheep were sheared; at 6.11 the wool was washed; at 6.37 dyed; at 6.50 picked; at 7.34 the final carding process was finished; at eight o'clock it was spun; at 8.15 spooled; at 8.37 the warp was in the loom; at 8.43 the shuttles were ready; at 11.10 seven and three-fourth ells of cloth were completed; at 12.03 the cloth was fulled; at 12.14 washed; at 12.17 sprinkled; at 12.31 dried; at 12.45 sheared; at 1.07 napped; at 1.10 brushed; and at 1.15 prepared and ready for the shears and needle. At five o'clock the suit, consisting of a hunting-jacket, waistcoat, and trousers, was finished."

There is a sort of anteroom to the Machine-tool Laboratory with which the students are thoroughly familiar. It is called the Chipping, Filing, and Fitting Laboratory, has twenty-four vises, a great assortment of cold-chisels and files, and is devoted to vise work. The course in the Chipping Filing and Fitting Laboratory consists of a score or more lessons involving various file and chisel manipulations, as, "filing to line," "dovetailing," "parallel fitting tongues and grooves," "ring-work and free-hand filing," "chipping bevels," "ward-filing and key-fitting," "screw-filing," "scraping," etc., each lesson being so devised as to insure the introduction of variously shaped tools, and their application to the forms of work for which they are designed.

This anteroom to the Machine-tool Laboratory is like most anterooms plain in its appointments, and it is also like the conventional anteroom, a place where the student does not desire to remain long. The witchery of the great laboratory beyond has already cast its spell over the boy

THE CHIPPING, FILING, AND FITTING LABORATORY.

at the vise. But there is excellent hand and eye training work in the Chipping, Filing, and Fitting Laboratory.

The file is a humble tool, but it is older than history, dating back to the Greek Mythological period. " From the smallest mouse-tail file used in the delicate operations of the watch and philosophical instrument maker, to the square file for the smith's heaviest work, there is a multifarious diversity in shape, size, and gauge of cutting." Some of the files made by the Swiss for the watch-maker "are of so fine a cut that the unaided eye cannot discern the ridges."

In no department of the useful arts did the hand-worker attain to greater dexterity than in file-cutting. With a sharp-edged chisel the file-cutter made from one hundred and fifty to two hundred " burs " a minute, and they were so fine as to be traced by the sense of touch alone, but as straight as though ruled by a machine. The hand-working file-cutter held his ground until 1859, when a Frenchman, M. Bernot, invented a file-cutting machine which superseded the old method of manufacture, except in cases requiring delicacy of manipulation, reducing the cost of files to one-eighth of their former price.

The lessons in the Machine-tool Laboratory will not be described in detail as in the other laboratories. The processes are so delicate and so intricate, and the resulting products in machines so closely approach the marvellous, as to beggar description. The poverty of words as compared with things asserts itself with unexampled force in the presence of a great variety of tools, each of which seems to be endowed with the power of reflection, and each of which, instead of whispering a word in your ear, drops into your hand a thing of use to man.

The laboratory is silent, the tools are dumb, but how

eloquently they proclaim the era of comfort and luxury!
They have no tongue, but through their lips you shall
speak across continents and under seas. They have no
legs, but through their aid you shall, in a race round the
world, outstrip Mercury. The machines they make shall
bear all your burdens; with their brawny arms they lift
a thousand tons, and with their fingers of fairy-like deli-
cacy pick up a pin; with the augur of Hercules they
bore a channel through the mountain of granite, and
with a Liliputian gimlet tunnel one of the hairs of your
head.

These ingenious tools are worthy of careful inspection
both on account of the marvels they perform and the
delicacy of their construction and adjustments. One
of them, a screw-engine lathe, for example, is taken to
pieces, and each piece described in order that the stu-
dents may be made familiar with the construction of the
tool, and so rendered capable of taking good care of it.
During this inspection the instructor outlines the history
of the tool. The main feature is the slide-rest, invented
by Maudslay while in the employ of Bramah, the lock-
maker. It is not too much to say that two things exact-
ly alike, or near enough alike, practically, to serve the
same purpose very well, were never produced on the old-
fashioned turning lathe. This the instructor endeavors
to make clear to the class. He also explains precisely
how Maudslay's improvement remedied the defects of
the old-fashioned lathe. Still there remained something
to be done to make it perfect, and putting the pieces to-
gether the instructor shows where Maudslay's work end-
ed and that of Clement began. Clement made two im-
provements in the slide-rest, one involving the principle
of self-correction, for which he received the gold Isis

medal of the Society of Arts in 1827, and the other consisting of the "self-adjusting double-driving centre check," for which he was awarded the silver medal of the same society in 1828. Thus improved or perfected, the slide-lathe became the acknowledged king of machine-tools, the self-adjusting two-armed driver taking the strain from the centre and dividing it between the two arms, and so correcting all tendency to eccentricity in the work.

The Machine-tool Laboratory contains a great variety of tools, of which the chief are lathes, drills, and planers; but there are many auxiliary tools, and in the advanced stages of the course a single lesson often affords opportunity for the introduction of several of them. And, as in the other school laboratories, each tool, upon its first presentation to the class, forms the subject of a brief lecture—a practical lecture too, for the instructor uses the tool while he sketches its history and perhaps that of its inventor, shows what place it holds in the order of machine-tool development, and how admirably it is adapted to its particular work, and makes suggestions as to its care. Sometimes a lesson involves the use of a drawing made by the students a year before, and the piece of iron in which it is wrought is the product of a previous lesson in forging; and it may also have been manipulated with the file or the cold-chisel, or both, in the Chipping, Filing, and Fitting Laboratory.

From the first lesson in the room devoted to drawing, to the last lesson in the Machine-tool Laboratory, the course of training is orderly, consecutive. Each step contains a hint of the nature of the next step, and each succeeding step consists of a further application of the principles and processes of the last preceding step. In

a word, the students follow their drawings through all the laboratories till the designs "are brought out in a finished state either in cast or wrought iron."

The lathe is the fundamental machine-tool, but a completely equipped machine-tool laboratory includes a great variety of supplementary or auxiliary tools, a thorough knowledge of which is essential to a good mechanical education. It does not follow, because these tools are in a large degree automatic, that skill may be dispensed with in their use. Many of them are very complicated in design and construction, and they can no more be made to do efficient service under an unskilled hand than a locomotive can be made to accomplish a series of successful "runs" by an unskilled "driver." Hence every tool in the laboratory is made the subject of an exhaustive study. The principle of mechanics involved in its construction is expounded, a practical illustration of its method of operation is given, its peculiar liability to injury is explained, and rules for its care are carefully formulated, and frequently repeated.

There is a prevalent theory that the wide application of so-called automatic tools to mechanical work largely decreases the legitimate demand for skilled mechanics, but it is fallacious. In the first place a thousand things are now made where one thing was made fifty years ago. In the second place the extensive use of steam and electricity greatly enlarges the sphere wherein accurate work becomes absolutely essential to human safety, and hence extends the field of operations of the inventive faculty. In the third place the cost of machine-tool made products having been greatly reduced, competition is proportionately intensified, thus narrowing the margin of profit, and so rendering any injury to machinery

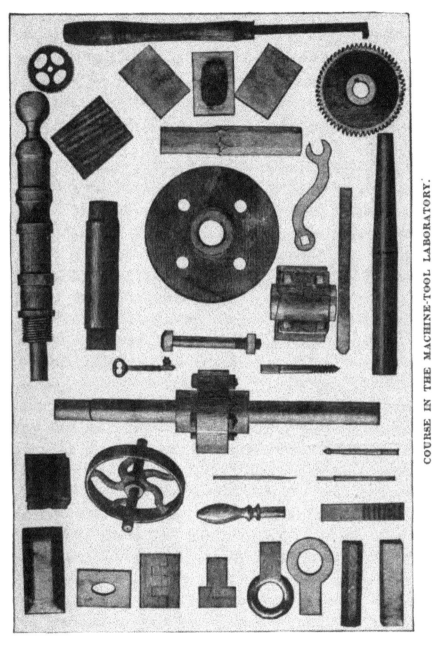

COURSE IN THE MACHINE-TOOL LABORATORY.

through want of skill in the operator relatively more disastrous. As a matter of fact a fine machine-tool is more liable than a watch to get out of order through careless handling, and it no more than a watch, can be properly repaired by a bungler. It follows that skill in the use of machine-tools is as essential to a successful mechanical career now, as skill in the use of hand-tools was formerly.

But another conclusion follows more irresistibly, namely—that the mechanical engineer who devotes his attention to the construction and management of massive machinery, such as pumps, hydraulic and lever presses, looms, and steam-engines, whether locomotive, marine, or other, must, in order to be master of his profession, be thoroughly familiar with every step of their construction ; and such familiarity can only be acquired by a course of practical study in the machine-tool shop. It is the province of the mechanical engineer to utilize certain forces of nature in the service of man, and it is only through the machine-tool shop that such utilization can be effected. It hence follows that a practical acquaintance with the manipulations of the machine-tool shop is an essential prerequisite to a successful career in the field of higher mechanics. The man who aspires to construct any great mechanical engineering work, like the Brooklyn Bridge, for example, must know the exact mechanical power of every piece of machinery he employs, as also the exact mechanical value of every piece of iron that enters into the structure; and these things he cannot know unless he is familiar with the entire series of iron manipulations, from those of the foundery to those of the machine-tool shop.

The aspect of the Machine-tool Laboratory when in re-

pose, so to speak, is dull and uninteresting, not to say repellant. There are twenty-four engine-lathes, as many adjustable vises, a milling machine, and a variety of auxiliary tools. The lathes are supported by dingy-looking cast-iron frames, and under each lathe there is a chest of drawers containing a set of tools. Overhead there is a wilderness of pulleys and shafting, which seems to the untrained eye to have very little relation to the machines below. The working parts of the lathes show burnished steel surfaces, which reflect coldly the glare of yellow sunlight flooding the room. If it were moonlight instead of sunlight one might summon the ghosts of those daring men who hundreds and thousands of years ago dreamed audaciously of the future of applied mechanics. Roger Bacon must have had a vision of the machine-tool shop when he said, "I will now mention some of the wonderful works of art and nature in which there is nothing of magic, and which magic could not perform. Instruments may be made by which the largest ships, with only one man guiding them, will be carried with greater velocity than if they were full of sailors; chariots may be constructed that will move with incredible rapidity without the help of animals;- a small instrument may be made to raise or depress the greatest weights; an instrument may be fabricated by which one man may draw a thousand men to him by force and against their will; as also machines which will enable men to walk at the bottom of seas or rivers without danger."

When steam is "turned on" the aspect of the Machine-tool Laboratory is completely changed. Steam is, indeed, the arch-revolutionist; it breathes the breath of life into inanimate things—makes them think, speak, and act. The low hum of unused machinery first salutes the ear; then

the students take their places. They are three years older than when we encountered them in the engine-room. They are from seventeen to twenty years of age. They are no longer boys; they are young men—robust, hearty-looking young men. Their bearing is very resolute—remarkably resolute; their attitude is erect. They are full-chested, muscular-armed, frank-faced young men. In the three years' course now drawing to a close they have learned how to do many things, and hence they show a good degree of confidence. But the dominant expression on all the interesting young faces is, after all, one of modesty; so true is it that every acquisition of knowledge, and especially useful knowledge, not only stimulates desire to learn more, but enlightens perception as to the magnitude of the field of further inquiry. As the addition of a useful thing to the world's stock of things creates a demand for a score more of useful things, so the addition of a fact to the student's stock of facts not only creates a desire for more facts, but strengthens the mind for further investigation.

It may be that there are vain statesmen, philosophers, priests, and kings, but we should as little expect to find a vain mechanic as a vain scientist.

These twenty-four students may go out into the world to-morrow to make their way. Some of them will enter upon the stage of active life, others will continue their studies in higher schools of literature, science, and art; but whether they go or stay, if they have made the most of their opportunities in the Manual Training School they will have learned the lesson of modesty, and learned to respect labor, not only as a means of earning one's daily bread, but as the most powerful and the most healthful mental and moral stimulant.

Steam is on, and the students standing at the lathes are impatient to begin. It is not a lesson in the ordinary sense. Each student works independently of special direction, for each is engaged in making a machine—the graduating project. The instructor is at hand, not to dictate but to advise, if requested. From his fund of experience as the elder scholar he will answer questions propounded by his younger fellow-students. In front of the students, parts of the working drawings may be seen. It is plain that there is to be variety in the exhibit of "projects." There are several steam-engines, differing in model; there is a steam-pump, a punching machine, a lathe, an electric machine, and a steam-hammer.

At a sign work commences—a dozen varieties of work, emitting a dozen tones of buzzing and whizzing. The instructor's face lights up with a pleased expression as he notes the progress of the work. There is no sign of hesitation in the class; no questions are asked; the students seem to be driving straight to the mark. The instructor's heart swells with pride; he can trust "his boys!" He has been regarding them with an expression of affection, but now his eyes wander—they have a far-away look. He no longer sees the students, he is looking beyond them. He drops into a reclining attitude, sighs, falls into a reverie, and dreams. In his dream he sees naked savages, emerging from caves, armed with clubs, pursuing animals. These are succeeded by men bearing rude stone implements — axes and hammers— and these in turn by men armed with bows and arrows, but half-clothed with skins of beasts, and crouching and shivering beneath the shelter of the branches of a tree pulled downward and secured by clods of earth. This picture disappears, and is replaced by a pastoral scene

—a vast plain covered with flocks and herds. In the foreground stands the shepherd, and in the distance his tent, consisting of skins of beasts stretched on poles, and in the tent door a woman sits pounding a fleece into felt. The shepherd, his flocks and herds, his tent, and the woman in the tent door, vanish like the mists of morning, and where the shepherd was, the husbandman is seen harvesting the golden grain; and in the shadow of the cottage which has replaced the tent a woman is grinding corn. The scene again changes—the plain has become the site of a great city. The city is protected by thick, high walls, surmounted with frowning battlements. Sentinels pace back and forth along the parapet. Huge helmets protect their heads, and their bodies are clothed in armor. Quivers full of bronze-tipped arrows depend from their shoulders; in their hands they carry long bows, and the clank, clank of their broad, two-edged, bronze swords breaks the dull, monotonous routine of their march. A brazen gate swings back noiselessly on brazen hinges, and, bowing to the sentinel, the dreamer as noiselessly glides into the city. Suddenly he feels the hot breath of the foundery furnace-fire, and is blinded by a glare of red light. Shading his eyes he sees dusky forms hurrying to and fro with ladles full of molten metal. Turning away he hears the heavy stroke of the sledge, and looking, beholds a dusty, smoky smithy. The stalwart smith drops the sledge at his side, rests one foot on the anvil-block, and wipes the sweat from his brow; the helper thrusts the cooling metal into the coals, bends to the bellows, and the forge-fire sings. At the sound of a bell the dreamer starts, the old Assyrian city falls into ruins, the ruins crumble into dust, and on this dust another city rises, flourishes, falls, and piles the dust of

its ruins. Over a waste of years—twenty centuries—the
dreamer's thought flashes, and he stands in the presence
of the Alexandrian mechanic-philosopher. He sees Hero
in the public street, gazing abstractedly at his condensed-
air fountain, and follows him into his shop or laboratory,
and observes him curiously as he toys with the model of
a queer little steam-engine. "This is the Iron Age, but
in its infancy," he exclaims under his breath, as his eyes
wander from a fine Damascus blade hanging against the
wall to some poor hand-tools lying on the working-bench.
"I will speak to this old man," he continues, "and ask
him to step into my Machine-tool Laboratory, and see my
boys make steam-engines; it will be a revelation to him.
Come, old friend — there — look!" And the dreamer
looks. Does he see double? The laboratory is un-
changed; steam is still on; the whir of machinery and
the buzzing sound of steam-driven tools salute the ear,
and the students are all busy at their benches finishing
parts of "projects" and adjusting them in their places.
But there are twenty-four other men—shades of men—in
the laboratory. Most of them are old; some are in work-
ing clothes, others in full dress, wearing ribbons and or-
ders of merit. Over each student one of these shades
bends with an air of absorbing attention. The dreamer
recognizes Papin, Fulton, Watt, and Stephenson shadow-
ing the students engaged in the construction of engines.
They beckon Hero, and he joins the group, threading his
way timidly between the lines of lathes, and looking
askance at the rapidly revolving wheels and flying belts.
Over the shoulders of other students are seen the faces
of Maudslay, Bramah, Clement, Roberts, Whitney, Na-
smyth, Huntsman, Cort, Murray, Dudley, Yarranton, Roe-
buck, and Whitworth, besides several unfamiliar faces.

Suddenly they all gather about a nearly completed project — a stationary engine. They witness the forcing home of the last screw; they see the miniature machine made fast to the bench. Steam is let into the cylinders. The student's flushed face is in sharp contrast with the colorless faces of the group of old men by whom he is surrounded. The piston-rod moves languidly—the machine trembles as if awaking from slumber, the shaft oscillates slowly, then faster, then regularly, like a strong pulse-beat. The project is a success—the first one completed! The student's face turns pale—as pale as the white faces of the old men at his side. They open their lips as if to cheer him, but no sound escapes them. He breathes quick—almost gasps; his heart beats loudly; he tries to shout but cannot utter a word. At last he claps his hands! The instructor starts from his chair, rubs his eyes, and stares round the laboratory. All the students are there, gathered in a group about the finished "project," but the ghostly shades of the old inventors have vanished like the unsubstantial fabric of a vision.

The "projects" are not all finished on the same day. Some of them are far more complicated than others, and some students are more skilled than others. All are very busy. It is not improper to ask questions relating to work on the graduating projects; the instructor is at hand to answer such questions. But it is a point of honor not to ask a question if the difficulty can possibly be otherwise overcome. Hence very few questions are asked.

The last week of the term is a very trying one to all concerned. The students are reticent and unusually silent; all are anxious, some are timid—the nervous tension is extreme. The instructor becomes taciturn under a painful sense of compulsory isolation from his

class, towards all the members of which he has, for three years, sustained fraternal rather than dictatorial relations. But as the projects are, one by one, completed, the atmosphere clears. When the student realizes that his project is certain to be a success, his face brightens and he is pleased to discuss its "points" with the instructor. The instructor is delighted to resume his former relations with the class, the feeling of constraint is dispelled, and the graduation-day exercises are contemplated with confidence.

CHAPTER X.

MANUAL AND MENTAL TRAINING COMBINED.

The new Education is all-sided — its Effect.—A Harmonious Development of the Whole Being.—Examination for Admission to the Chicago School.—List of Questions in Arithmetic, Geography, and Language. — The Curriculum. — The Alternation of Manual and Mental Exercises. — The Demand for Scientific Education — its Effect.—Ambition to be useful.

WE have now passed in review all the school laboratories, from the engine-room, or laboratory where power is generated, to the Machine-tool Laboratory where power is utilized, or harnessed, and compelled to do the work of man. We have observed the student, in his first effort over the drawing-board, struggling laboriously to make a straight line, and in the Laboratory of Carpentry, trying with varying success to make a tenon fit the mortise, and we have stood by his side in the Machine-tool Laboratory in the moment of his triumph exhibiting his graduating "project"—a miniature engine throbbing under the pressure of steam, and doing its work with admirable precision. But we have seen only the manual side of the curriculum. The mental side is still to be shown. The claim made in behalf of the new education is that it is better balanced than the old, that it is all-sided, that it produces a harmonious development of the whole being, that it makes of the student a man fully furnished for the battle of life, mentally, morally, and physically. Accordingly the curriculum of the Manual Training School combines with the laboratory exercises

a variety of mental exercises of quite a comprehensive
character; and first, certain mental requirements are nec-
essary to admission, as witness the following from the
first catalogue of the Chicago Manual Training School:

"Candidates for admission to the Junior year must be at
least fourteen years of age, and must present sufficient
evidence of good moral character. They must pass a
satisfactory examination in reading, spelling, writing, ge-
ography, English composition, and the fundamental oper-
ations of arithmetic as applied to integers, common and
decimal fractions, and denominate numbers. Ability to
use the English language correctly is especially desired."

The following questions were used at the first exami-
ation for admission to the Chicago school.

ARITHMETIC.

Transcribe work sufficient to show processes. No
credit given for results alone.

1. Change to decimals and find the sum of $\frac{1}{2}$. $\frac{2}{3}$. $\frac{1}{4}$. $\frac{3}{5}$. $\frac{1}{6}$.
2. Divide the product of $28\frac{4}{5}$ and $13\frac{1}{2}$ by the difference of $8\frac{1}{12}$
and $4\frac{4}{5}$.
3. Divide .00875 by $12\frac{1}{4}$.
4. Reduce .395 of a mile to integers.
5. If a locomotive move $\frac{5}{8}$ of a mile in $\frac{11}{12}$ of an hour, what is its
speed per hour?
6. A man invested $\frac{1}{4}$ of his money in land, .125 of it in stocks,
$12,000 in a vessel, and had $55,500 remaining. How much did he
invest in land?
7. Bought a square mile of land at $75 an acre. I reserved 160
acres of it for streets and alleys, and divided the remainder into lots
each 66 feet front by 200 feet deep, all of which I sold for $15 per
front foot. The expense of surveying, etc., was $2000. What did I
gain?
8. How many balls, each $\frac{1}{2}$ of an inch in diameter, are equal in
weight to a ball of the same material 1 foot in diameter?
9. Find cost of material for making box, inside measurement 4 by

THE STUDENTS WITH THEIR BOOKS.

2 by 3 feet, of inch lumber, worth $30 per M., $\frac{1}{25}$ of the lumber purchased being wasted. Include in the cost 7 dozen screws at $1.80 per gross.

10. What is the height of a rectangular cistern capable of containing 600 gallons, the bottom of which is 7 by 11 feet, inside measurement?

GEOGRAPHY.

1. Name the five most populous cities of the United States in order of population. On what water is St. Petersburg? Dublin? Rome? Calcutta? Cairo?

2. Locate the principal coal fields and iron regions of the United States. What minerals occur in Illinois?

3. Draw map of Illinois, showing by what States and by what waters bounded. Locate the capital and the largest city of Illinois.

4. Name the outlet of Lake Erie; of Lake Champlain; of Great Salt Lake; of the Black Sea; of Lake Victoria Nyanza.

5. Compare the latitude and climate of Spain and Illinois.

6. How does the island of Great Britain compare in area with the United States, or with any one of the United States which you may mention?

7. How do the Alps compare in height with the Rocky Mountains? Name the highest peak in Europe; in North America; in South America; in the world.

8. How does climate vary with altitude above the sea level? Illustrate by an example.

9. What is the cause of day and night? Of changes of seasons? What is latitude? Longitude?

10. When it is 11 A.M. by "Central Time" in Chicago, what is the hour by "Eastern Time" in New York City? What is the hour in London? Is "Central Time" in Chicago the true time? Why?

Or, in place of the last question: What are the termini of the Illinois and Michigan Canal? What waters are connected by the Suez Canal? Of what water route does the Suez Canal take the place?

LANGUAGE.

1. Correct in every particular, and give reason for each correction:

a. The man which was sick has went to his work.

b. Every person should attend to their own affairs.

c. Such expressions sound harshly.

d. Between you and I, this is a real easy examination.

e. The cause of the tides were not wholly unknown to the ancients.

2. "Pleasantly rose next morning the sun on the village of Grand Pré."

How is the idea of the rising of the sun modified?

3. "Flashed all their sabres bare,
 Flashed as they turned in air,
 Sab'ring the gunners there,
 Charging an army, while
 All the world wondered."

Change to good prose.

4. State the meaning of each prefix and suffix in the following words : Emigrate ; Immigrate ; Illegally ; Admissible ; Thoughtlessness ; Affixing.

5. *a.* Why is the final e of "service" retained in "serviceable?"

 b. Write the present participle of "befit;" of "benefit."
 What difference in spelling? Why?

 c. Define Ancient ; Venerable ; Obsolete.

6. Write an essay on Chicago, mentioning the rapid growth of the city; its land and water communications; its commerce and manufactures; its public buildings; its institutions of learning and charity, and any other items which may occur to you.

Having passed the ordeal of the foregoing battery of questions the student of the Ideal School finds his mental exercises alternated with manual exercises throughout the entire course in something like the following order, namely:

Junior Year.—(1.) *Mathematics.*--Arithmetic; Algebra. (2.) *Science.*--Physiology ; Physical Geography. (3.) *Language.* - English Language and Literature ; or Latin Reader. (4.) *Drawing.*—Freehand Model and Object ; Projection ; Machine; Perspective. (5.) *Shopwork.*—Carpentry, Joinery, Wood-Turning, Pattern-Making, Proper Care and Use of Tools.

Middle Year.—(1.) *Mathematics.*—Geometry. (2.) *Science.*- Physics. (3.) *Language.*—General History and Literature; or Cæsar. (4.) *Drawing.*--Orthographic Projection and Shadows; Line and Brush Shading; Isometric Projection and Shadows; Details of Machinery; Machine from Measurement. (5.) *Shopwork.*--Molding, Casting; Forging, Welding, Tempering; Soldering, Brazing.

Senior Year.—(1.) *Mathematics.* Plane Trigonometry; Mechanics; Bookkeeping. (2.) *Science.*—Chemistry; or Descriptive Geometry and Higher Algebra.

(3.) *Language, etc.*—English Literature, Civil Government, Political Economy; or Cicero, or French. (4.) *Drawing.*—Machine from Measurement ; Building from Measurement; Architectural Perspective. (5.) *Machine Shopwork.*—Such as Chipping, Filing, Fitting, Turning, Drilling, Planing, etc. Study of Machinery, including the Management and Care of Steam Engines and Boilers.

Latin and French may be taken instead of English Language, Literature, and History. Instruction will be given each year in the properties of the materials— wood, iron, brass, etc.—used in that year.

Throughout the course, one hour per day, or more, will be given to drawing, and not less than two hours per day to laboratory work. The remainder of the school day will be devoted to study and recitation. Before graduating, each pupil will be required to construct a machine from drawings and patterns made by himself. A diploma will be given on graduation.

The new education is a blending of manual and mental training. It recognizes the fact that science discovers and art utilizes, and that these two forces move the modern world.

At present the Manual Training School is a missionary enterprise. Its purpose is to create in the public mind an imperative demand for the incorporation of its scientific methods into the public-school course of instruction.

A vast majority of our people are employed in the useful arts, and distinction in every department of labor now depends upon scientific education. Without technical education or manual training the laborer of the future cannot hope to rise above the grade of a piece of automatic machinery. He falls into the routine of the shop like a cog or lever moved by steam. To avert this dire misfortune our common schools must be made institutions for manual as well as intellectual training. They must inculcate the dignity of labor. not by precept

merely, but by example. It is not enough that schools
of technology, polytechnic institutes, and manual train-
ing schools are being established here and there by pri-
vate subscription. The supply of these classes of edu-
cation is only a drop in the bucket to the public demand.
Technical and manual training must be made part of the
general public educational system. In our city high-
schools we now fit boys for college. In those schools
we must hereafter fit them for the colleges of art.
When this shall have become the fashion in education
there will be thousands of high-school graduates with
a grand passion for mechanical pursuits — boys with
more curiosity on the subject of the expansive force of
steam than on the subject of "Greek roots;" with more
ambition to invent something useful to man than to learn
how to draw a bill in chancery; with a stronger desire
to discover a new secret in electricity than to carry off a
prize for the best Latin oration.

CHAPTER XI.

THE INTELLECTUAL EFFECT OF MANUAL TRAINING.

Intelligence is the Basis of Character.—The more Practical the Intelligence the Higher the Development of Character.—The use of Tools quickens the Intellect.—Making Things rouses the Attention, sharpens the Observation, and steadies the Judgment.—History of Inventions in England, 1740–1840.—Poor, Ignorant Apprentices become learned Men.—Cort, Huntsman, Mushet, Neilson, Stephenson, and Watt.—The Union of Books and Tools.—Results at Rotterdam, Holland; at Moscow, Russia; at Komotau, Bohemia; and at St. Louis, Mo.—The Consideration of Overwhelming Import.

THE quality of all civilizations depends upon intelligence and character, or morality, in the order stated; for morality springs from intelligence, not intelligence from morality. This is an axiomatic deduction of historic analysis.* Nor would it be difficult to prove that prac-

* " But if we contrast this stationary aspect of moral truths with the progressive aspect of intellectual truths, the difference is, indeed, startling. . . . These are to every educated man recognized and notorious facts, and the inference to be drawn from them is immediately obvious. Since civilization is the product of moral and intellectual agencies, and since that product is constantly changing, it evidently cannot be regulated by the stationary agent; because when surrounding circumstances are unchanged, a stationary agent can only produce a stationary effect. The only other agent is the intellectual one, and that this is the real mover may be proved in two distinct ways: first, because being, as we have already seen, either moral or intellectual, and being, as we have also seen, not moral, it must be intellectual; and secondly, because the intellectual principle has an activity and a capacity for adaptation which, as I undertake to show, is quite sufficient to account for the extraordinary progress

tical intelligence is more conducive to a high develop-
ment of morals than mere theoretical intelligence. For
is it not true that the nations most skilled in the useful
arts are most highly cultured in morals? And if it be
true, it constitutes a potential argument in support of
joining to intellectual instruction in the schools a course
of training in the elements of the useful arts. And of
the fact which forms the basis of this argument there is
a logical explanation.

Nothing stimulates and quickens the intellect more
than the use of mechanical tools. The boy who begins
to construct things is compelled at once to begin to think,
deliberate, reason, and conclude. As he proceeds he is
brought in contact with powerful natural forces. If he
would control, direct, and apply these forces he must
first master the laws by which they are governed; he
must investigate the causes of the phenomena of matter,
and it will be strange if from this he is not also led to a
study of the phenomena of mind. At the very threshold
of practical mechanics a thirst for wisdom is engendered,
and the student is irresistibly impelled to investigate the
mysteries of philosophy. Thus the training of the eye
and the hand reacts upon the brain, stimulating it to ex-
cursions into the realm of scientific discovery in search
of facts to be applied in practical forms at the bench and
the anvil.

The history of invention and discovery in England af-
fords a striking confirmation of the truth of the propo-
sition that mechanical investigation, with tools in hand,
stimulates the intellectual faculties to the highest point

that, during several centuries, Europe has continued to make."—
Buckle's "History of Civilization," Vol. I., p 130. D. Appleton &
Co., 1864.

of activity and excellence. The germs of nearly all the great inventions in mechanics, the benefit of which the world is now enjoying in such ample measure, are directly traceable to the workshops of Great Britain during the period 1740–1840.

England had then no popular system of education, and the apprentices in her shops were poor, obscure, and, at the start, illiterate. But to those poor apprentices the honor of the great inventions and discoveries of that age is almost wholly due. And it is a notable fact that in the struggle to invent tools and machines, to master the art of mechanism, to steal from Nature her secret forces, and harness and use them for the benefit of man, the toiling workers not infrequently became highly educated, intellectual giants, familiar not alone with special studies, but masters of many branches of learning.

In 1770 the Russian Government, aware of the inferiority of English iron, and deeming Russian iron essential to England, directed the price of iron for export to be raised three hundred per cent. This arbitrary act stimulated invention. Henry Cort, the son of a brick-maker, entered upon a series of experiments, with a view to the improvement of English iron. They occupied several years, and were of a very expensive character—so expensive as eventually to bankrupt the man who made them. They were, however, so successful as to constitute a splendid epoch in the history of metallurgy. In 1786 Lord Sheffield declared that Cort's improvements in iron, and the steam-engine of Watt, were of more value to Great Britain than the thirteen colonies of America; and in 1862 it was estimated that those improvements had added three thousand million dollars to the wealth of England alone, to say nothing of the rest of the world of iron

manufacture throughout which they had been applied. But the only estate secured by this great man as a reward of his genius and a life of toil, as his biographer pathetically remarks, was "the little domain of six feet by two in which he lies buried in Hampstead church-yard."

In 1715 Sheffield contained two thousand inhabitants, of whom one-third were beggars. Its manufactures consisted of jews-harps, tobacco-boxes, and knives. Sheffield is now the chief seat of the steel manufacture of the world. The initial step in this great transformation scene was taken by Benjamin Huntsman. He was born in 1704, and bred to a mechanical calling. The early years of his life were spent in the occupation of clock making and repairing. He was shrewd, observant, and practical, and he gradually extended the scope of his profession to repairing, and finally to making hand-tools. In this branch of his trade he detected defects in the German steel in common use. He removed from Don-caster to Sheffield, and there in the privacy of his cottage studied metallurgy, and for years labored in secret over the furnace and the crucible. His numerous failures were subsequently found chronicled in masses of metal, in various stages of imperfection, buried in the earth. But when he emerged from his long seclusion he offered to his fellow-mechanics a piece of cast-steel so hard that they declined to work it. He sent the product of his works to France, and the French knives and razors made from it and imported into England drove the Sheffield cutlery from the market. Then the Sheffield cutlers sought to have the export of steel prohibited. Failing in that they stole Huntsman's secret. This was possible, since the process had not been patented. The story of

the theft is told in a little work entitled "The Useful Metals and their Alloys." It is in substance that one Walker, an iron-founder, "disguised himself as a tramp, and feigning great distress and abject poverty, appeared shivering at the door of Huntsman's foundery late one night when the workmen were about to begin their labors at steel-casting, and asked for permission to warm himself by the furnace-fire." He was permitted to enter, and when he left he carried away the secret of the inventor of cast-steel.

Huntsman was a member of the Society of Friends, and it was doubtless on that account that he declined a membership of the Royal Society tendered to him in honor of his great discovery or invention of cast-steel.

David Mushet's discovery of the extraordinary value of black-hand iron-stone in 1801 made Scotland a first-class iron-producing country; and Neilson's invention of the hot-blast in 1828 revolutionized the processes of iron manufacture by vastly cheapening them. Both these men sprang from the labor class, and both were self-educated. Through almost superhuman efforts they rose from poverty and obscurity to fame. Mushet's "Papers on Iron and Steel," in the language of Smiles, "are among the most valuable original contributions to the literature of iron manufacture that have yet been given to the world;" and Neilson was made a member of the Royal Society in recognition of his distinguished ability and the great services he rendered in the cause of the useful arts.

George Stephenson rose from the coal-mine to the summit of renown as a theoretical and practical mechanic. While employed in various collieries as "fireman" and "plugman," he acquired a thorough knowledge of

the engines then in use, taking them apart, repairing, and putting them together again. At eighteen years of age he could not read. In the course of two years attendance at night-schools he learned to read, write, and cipher.* Continuing to work in collieries, he employed his leisure hours in studying mechanics and engineering, and in mending clocks and shoes. When thirty-one years of age he was appointed "enginewright" at Killingworth Colliery, at a salary of £100 a year. From this point of time dates his career as an inventor. His first locomotive was completed in 1814, and the "Rocket" made its trial trip in 1829. During the intervening fifteen years Stephenson was largely engaged in the engineering department of railway enterprises as well as in the prosecution of experiments for the perfecting of locomotive engines. The most eminent engineers of the time doubted the practicability of the locomotive, and continued to recommend stationary engines, while Stephenson was leading up to the "Rocket." The success of the "Rocket" made its inventor the most famous mechanic in the world. For the next fifteen years he was the leading spirit in all the great railway enterprises of England, be-

* "In conclusion, we are of opinion that special instruction which can be applied to the material would be at once more fruitful in good results and more attractive if the pupil could go from the class-room to the workshop (laboratory) to practically demonstrate the theories to which he has just been listening. In support of this opinion we might add the observations made in our own evening-schools, where the most noteworthy and rapid progress is made in those cases where the pupil has occasion to put into actual practice on the material itself the instruction which he has received in the drawing-class."— " Report of Committee of Council of Arts and Manufactures of the Province of Quebec, created to Inquire into the Question of Practical Schools."

sides being called repeatedly to Belgium and Spain as consulting engineer. He was offered a fellowship of the Royal Society, also one in the Civil Engineers' Society, also knighthood by Sir Robert Peel. All these empty honors he declined. "I have to state," he said, in reply to a request for his "ornamental initials," "that I have no flourishes to my name, either before or after, and I think it will be as well if you merely say George Stephenson." He may justly be styled the founder of the existing railway system of the world, which undoubtedly exerts more influence upon civilization than any other one cause or set of allied causes; and to have risen from the humblest station in a colliery to the dignity of founding such a system is sufficient evidence of a gigantic intellectual growth.

James Watt was an extremely fragile child, and hence unable to join in the rude sports of robust children. Thus confined within-doors he early amused himself by drawing "with a pencil upon paper, or with chalk upon the floor." He was also supplied with a few tools from his father's carpenter's shop, "which he soon learned to handle with considerable expertness." Mr. Smiles, in his biography of Watt, says, "The mechanical dexterity he acquired was the foundation upon which he built the speculations to which he owes his glory, nor without this manual training is there the least likelihood that he would have become the improver and almost the creator of the steam-engine."* In the parrot-power of learning or mem-

* "I believe that well-advised practice in any of the constructive arts involving not more than one-third of the student's time will yield as much mental improvement as will result if the whole time be devoted to study from text-books."—Prof. Wm. F. M. Goss, six years

orizing Watt was a dull boy, and he left the grammar-school of his native town at an early age, never to return to the "halls of learning." But while engaged in humble mechanical employments he perfected his education, study-ing after work-hours. He nearly starved his body, but con-stantly added to his intellectual stores. He mastered the principles of engineering, civil and military, studied natu-ral history, criticism, art, and acquired several modern lan-guages. In a word, without the aid of the schools, but under the stimulating influence of mechanical investiga-tion and work, Watt became an accomplished and scien-tific man. When nearly eighty years of age he and Sir Walter Scott met. Referring to the occasion, and speak-ing of Watt, Sir Walter is reported to have said, "The alert, kind, benevolent old man had his attention alive to every one's question, his information at every one's com-mand. His talents and fancy overflowed on every subject. One gentleman was a deep philologist—he talked with him on the origin of the alphabet as if he had been coeval with Cadmus; another a celebrated critic—you would have said the old man had studied political econ-omy and belles-lettres all his life; of science it is un-necessary to speak—it was his distinguished walk."

These examples of remarkable intellectual development

Director of the Department of Practical Mechanics of Purdue Uni-versity.

"And reflect that he will learn more by one hour of manual labor than he will retain from a whole day's verbal instructions."—"The Emilius and Sophia" of J. J. Rousseau, Vol. II., p. 64. London: 1767.

"The things themselves are the best explanations. I can never enough repeat it, that we make words of too much consequence; with our prating modes of education we make nothing but praters."—Ibid., p. 46.

in connection with tool-practice are not phenomenal. From the annals of invention and discovery numerous instances might be cited in support of the proposition of this chapter, that tool-practice stimulates intellectual growth.

In the Artisan's School at Rotterdam, Holland, an experience of seven years has demonstrated that "boys who are occupied one-half the day with books in the school, and the remaining half with tools in the laboratories, make about as rapid intellectual progress as those of equal ability who spend the whole day in study and recitation." The testimony of Dr. Woodward, director of the St. Louis (Mo.) Manual Training School, is to the same effect. And in one of his reports he says, "Success in drawing or shop-work has often had the effect of arousing the ambition in mathematics and history, and *vice versa.* . . . The habit of working from drawings and to nice measurements has given the students a confidence in themselves altogether new. This is shown in the readiness with which they undertake the execution of small commissions in behalf of the school. . . . In fact, the increased usefulness of our students is making itself felt, and in several instances the result has been the offer of business positions too tempting to be rejected."

Of the results achieved by the Imperial Technical School, Moscow, Russia, M. Victor Della-Vos, director, speaks with the utmost confidence. He says, "And now (1878) we present our system of instruction, not as a project, but as an accomplished fact, confirmed by the long experience of ten years of success in its results." The methods of instruction of the school at Moscow were introduced into all the technical schools of Russia in 1870.

A similar degree of success has attended the Royal Mechanic Art School at Komotau, Bohemia. The management says, "The school has shown the most brilliant proofs of usefulness, and the ends gained have been acknowledged at home and abroad. One proof is that in spite of the hard times all the pupils from Komotau have found occupation in different manufacturing establishments; and another that England, a country unsurpassed in the manufactures of iron and steel, has already sent some students to the school."

If the pupil in the Manual Training School makes as rapid progress intellectually as the pupil in the public or private school of corresponding grade, it follows that whatever skill in the use of tools is acquired, and whatever knowledge of practical mechanics is gained—these stand for the net gain of the pupil of the new system of education. But much more follows by implication. For if the few pupils of the world's few manual training schools are making equal intellectual progress with the many pupils of the many schools of the old *régime*, and making such progress in a little more than half the study-hours, the consideration of overwhelming import is the loss sustained by the millions of pupils being trained under the old system.

CHAPTER XII.

THE EDUCATION OF WOMEN A NECESSITY.

The Difference between Ancient and Modern Systems of Education.
—Plato Blinded by Half-truths.—No place in the present order of
· things for Dogmatisms.—Education commences at Birth.—The In-
fluence of Woman extends from the Cradle to the Grave.—The
Crime of Crimes—Neglect to educate Woman.—The Superiority
of Women over Men as Teachers—Froebel discovered it.—Nature
designed Woman to Teach; hence the Importance of Fitting her
for her Highest Destiny.

This, from the lips of Plato, was the theory of the
ancients: "The earth is the common mother of the hu-
man race, but it has pleased the gods to mix gold in the
composition of some, silver in that of others, iron and
copper in that of others."* On this divinely established
principle of caste all the ancient educational systems were
founded. They were limited to the development of the
few in whose composition gold was supposed to be mixed.

The idea of a universal education is modern, and all
other differences between the ancients and moderns com-
bined are as nothing to this one fundamental difference
between the two civilizations. Plato's ideal republic was
based upon the assumption that the "guardians" might
be made just and wise by educating them; but that the
other classes might also be made just and wise by educa-

* "The Republic of Plato," p. 114. London: Macmillan & Co.,
1881.

tion, and the State be so rendered absolutely secure, did not occur to the great philosopher.

Plato was blinded by half-truths, as Rousseau was two thousand years later, when he said, "The poor stand in no need of education; that of their station is confined, and they cannot obtain any other."* That men are created unequal intellectually is only a half-truth in an educational view; the whole truth is that every child is susceptible of the developing influence of education, and hence the obligation of the State to educate relates to all children. Plato's simile of the gold, the silver, and the iron shows how autocratically even the greatest mind is controlled by its environment, and limited by the facts which constitute the basis of its generalizations. Were Plato teaching here, now, he would transpose the order of statement in his simile, since iron, not gold, is the king of metals. Each generation increases the world's stock of facts; hence there is no place in the modern order of things for the dogmatist—the dogmatisms of yesterday become apt themes for the satires of to-day, subjecting their authors to ridicule. This fact should impress upon professional teachers, and upon all persons engaged in seeking to promote the cause of education, the importance of a reverently studious habit of mind touching the progress of events. The tyranny of tradition is an ever-present, potent influence, and only the growing mind can resist it.

But there are certain principles upon which not only ancient and modern educators agree, but about which there is no dispute between existing rival schools, as, for example, this proposition of Plato—

* "Emilius and Sophia," Vol. I., p. 40. London: 1767.

" The beginning is the most important part, especially in dealing with anything young and tender, for that is the time when any impression which one may desire to communicate is most readily stamped and taken."*

And this proposition of Rousseau—

" The education of a man commences at his birth; before he can speak, before he can understand, he is already instructed. . . . Trace the progress of the most ignorant of mortals from his birth to the present hour and you will be astonished at the knowledge he has acquired."†

And this further proposition, also of Rousseau—

" The common profession of all men is humanity; and whoever is well educated to discharge the duties of a man cannot be badly prepared to fill up any of those offices that have a relation to him."‡

The truth of these propositions being admitted, some conception may be formed of the tremendous influence exerted by woman upon the destinies of the human race. It extends literally from the cradle to the grave. All other influences combined are less potent, less comprehensive than this single, persistent force that creates the very atmosphere in which the infant mind develops, holding the ground alone and undisturbed until the child's plastic character has been formed, receiving ineradicable impressions. What a crime, then, was the neglect of the people of past ages to educate woman! It is in vain that the education of man is attempted if that of woman is neglected. It was Rousseau who in despair exclaimed:

* " Plato," p. (- Macmillan & Co.,

" Vol. I : 1767.

"How can a child be properly educated by one who has not been properly educated himself?"

Since, therefore, the education of the man begins while he lies helpless in his mother's arms, and since the first steps in this direction are the most important, and since some sort of education proceeds with almost inconceivable rapidity through all the early years of life, it follows that the kindergarten fills a place in the educational field entirely unoccupied until the time of Froebel. He first applied the ideas of Rousseau to school life. But when the kindergarten receives the child, three or four of the most precious educational years have already passed away, and at the still tender age of seven the child is surrendered to a very different system of training. The kindergarten is therefore only a brief episode in the educational period of the child's life. But if it be the true education, it is susceptible of universal application. Throughout all nature the order of development is constant and harmonious, and the child-nature cannot in reason constitute an exception to this rule. Froebel said, "The end and aim of all our work should be the harmonious growth of the whole being." If his principle is the true one, his method is susceptible of such modification and expansion as to render it applicable to the whole educational period. All mothers should therefore be trained in the principles and methods of the new education — the kindergarten system should prevail in all schools, and the kindergarten curriculum should be extended and adapted to all ages and grades of pupils.

Several great minds, separated by considerable intervals of time, have united in condemning the old systems of education — Bacon, Comenius, Rousseau, Pestalozzi, and Froebel. Bacon, himself a university man, said,

"They learn nothing at the universities but to believe;" and he proposed that a college be appropriated to the discovery of new truth, "to mix like a living spring with the stagnant waters." Three of these great men—Comenius, Pestalozzi, and Froebel—were professional teachers. Theoretically they were in accord with and followers of Bacon, and in practice they were substantially agreed. Comenius said, "Let things that have to be done be learned by doing them." Pestalozzi said, "Education is the generation of power," and Froebel said, "The end and aim of all our work should be the harmonious growth of the whole being."

These are very high authorities, and they are buttressed by seemingly impregnable educational propositions. The record of Froebel's life is worthy of great weight in support of his theory. His devotion to the cause of education was absolute. He never knew a selfish aim. He struggled for the race, not for self. He was the victim of many misfortunes, but none disturbed the serenity of this great soul devoted to the greatest of great causes— the cause of education. And education to his apprehension was the thorough training of every faculty of the mind and every power of the body for the duties of actual practical life. His love embraced the world in its entirety and in all its parts. Dying, he said, "I love flowers, men, children, God! I love everything!" It was his profoundly philosophic conception of the innate lovableness of every natural object that made him shudder at the cruel distortion wrought in the natures of little children by false methods of education. Hence his intense de to the subject of infant training, and hence the e: n which bears his name.
 roebel's the fact of the

superiority of women over men, as teachers. Only an
honest, brave soul could have made this discovery, for
tradition stood like a lion in the way, and prejudice dis-
couraged investigation. But Froebel sought truth for
truth's sake, fearlessly defying tradition and ignoring
prejudice; and years of experiment convinced him that
the greatest measure of success in infant training was
surely attainable through women. That this discovery,
so simple, yet so big with grand possibilities, was not made
earlier is due to the fact that there is so little really
independent thought, so little investigation free from
the trammels of prejudice. Now that a great mind has
pointed the way it is obvious that Nature, having design-
ed that the years of early childhood should be spent
with the mother, must have also designed that women
should be the chief educators of children. And it fol-
lows, of course, that the education of women is more
important than that of men, since it is from them that
children receive their first impressions, and since first
impressions are indelibly stamped upon the infant mind,
giving it form, color, and substance.

In confiding to women this great trust, Froebel imposed
upon them an incalculable weight of responsibility. It
comprehends the destiny of the human race, involving
the problem of its progress or retrogression.

A common first conception of the kindergarten is—
a convenient asylum for the children of mothers who
desire to be relieved of their care. A more thoughtful
study reveals its poetry and sentiment, the innocent joy
of the assembly of pupils, the harmony of song, and the
grace of motion in the games and dances. A final, large
view discloses the true educational principle. The kin-
dergarten is more clearly comprehended after studying

the manual training school—moving from the effect to the cause; for as the child is father of the man, so the kindergarten is father of the manual training school. The kindergarten comes first in the order of development, and leads logically to the manual training school. The same principle underlies both. In both it is sought to generate power by dealing with actualities. The corner-stone of both is object-teaching—teaching through things instead of through signs of things. This principle, common to both, is the concrete as opposed to the abstract. The theory of both is that, in teaching, ideas should never be isolated from the objects they represent.[1] The kindergarten and the manual training school, being one in principle, should have common methods of instruction, varied sufficiently to adapt them to the whole range of school life.

[1] "This method of object teaching is perhaps the greatest service which the naturalistic school has rendered to the cause of education. Hinted at by Rabelais and Locke, still more largely developed by Rousseau, it has received, in the last century, a more accurate and scientific form, and is probably destined to become the source of a new curriculum in which literature will only hold a secondary place." —"Educational Theories," p 109 By Oscar Browning, M.A. New York: Harper & Brothers, 1895.

CHAPTER XIII.

THE MORAL EFFECT OF MANUAL TRAINING.

Mental Impulses are often Vicious ; but the Exertion of Physical
 Power in the Arts is always Beneficent — hence Manual Training
 tends to correct vicious mental Impulses. — Every mental Impres-
 sion produces a moral Effect.—All Training is Moral as well as
 Mental.—Selfishness is total Depravity; but Selfishness has been
 Deified under the name of Prudence.—Napoleon an Example of
 Selfishness.— The End of Selfishness is Disaster ; but Prevailing
 Systems of Education promote Selfishness.—The Modern City an
 Illustration of Selfishness.—The Ancient City.—Existing Systems
 of Education Negatively Wrong.—Manual Training supplies the
 lacking Element. — The Objective must take the Place of the Sub-
 jective in Education. — Words without Acts are as dead as Faith
 without Works.

EDUCATION, or training, has two immediate and contin-
uous effects—the development of innate mental qualities
or aptitudes and the formation of character. In an or-
derly logical system of training the development would
be harmonious, and the resulting formation of character
symmetrical. These are, however, ideal conditions re-
quiring a perfect system of training, and students free
from the perversions and deformities growing out of
the law of heredity. But under any system of training
there is progress—development and character formation.
The aphorism, "An idle brain is the devil's workshop,"
expresses only a half-truth. What it means is this: if
the mind is not well employed it will be ill employed; or
if it is not occupied with good thoughts it will be occu-
pied with evil thoughts. The mind of man is never at

rest, in equilibrium, even in a state of barbarism. Indeed this is obvious, since all civilizations are growths from states of savagery. But the barbaric line once passed, development is greatly accelerated, assuming with the evolution of the ages the form of a geometrical progression. The distinguishing characteristic of modern civilization is action. In so far as this action, which may be called the impulsive force of the spirit of the age, is natural and orderly, it constitutes an aid to the processes of education; if otherwise, it is obstructive, hindering them.

The law of mental development is not the exact correlative of the law of physical development. The direct aim of physical training is muscular power; of mental training the aim is mental power and rectitude. Physical power is not intrinsically vicious; it becomes vicious only when exerted under a vicious intellectual impulse. But this is not necessarily true of mental power; for mental power may be gained quite apart from the element of rectitude, in which event it is vicious, and may be exerted in scorn of the accepted standards of right, truth, and justice. As a matter of fact it is often so exerted, and the fact that it is so exerted accounts for the crimes of individuals, the faults of society, and the errors of governments. The constitution of mental power is, then, complex, while that of physical power is simple. If mental power consists of sense perception, or understanding, and moral perception, or rectitude, in due proportion, the issue is a noble character; but if rectitude is wanting, the issue is an evil character. If, on the other hand, there is no interference with the orderly development of physical power, the issue of its exertion is always sk⋯ ⋯ applied in innumerable forms to the uses of through a mental impulse rendered vicio⋯

sence of the element of rectitude can physical power be diverted from its naturally beneficent mission.

It follows that most of the evils of civilization flow from an ill-balanced mental constitution—a mental constitution wanting the essential element of rectitude. Since, then, mental development, under certain widely prevailing conditions, is so prolific of evil, and physical development or skill so universally prolific of good, it is obvious that the beneficent influence of the latter should, if practicable, be brought to bear upon the former in educational systems. In a word, may not the two systems of training be so connected in the schools as to cause the manual to react upon the mental, with the effect of greatly stimulating the ethical side of the mind?

It is not essential to our purpose to inquire whether a perfect system of education, and hence an ideal state of society, is possible. It will be sufficient if we are able to show wherein pervailing systems of education can be improved.

In a former chapter we sought to show that the use of mechanical tools stimulates the intellect; in the present chapter it is our purpose to endeavor to show that manual training tends to the promotion of rectitude, to the up-building of character.

For purposes of culture the mind consists of divisions, as the body consists of members. It is susceptible of development in the line of the application of mental training, as any member of the body is susceptible of development through physical training or use. For example, the memory may be invigorated by the constant application of certain kinds of mental training, as the arm is strengthened by the constant use of the sledge-hammer. But if the mental training which stimulates the memory

is applied to the neglect of other lines of training, the memory will be strengthened at the expense of some other faculty of the mind, as the excessive use of the sledge-hammer strengthens the arm at the cost of other members of the body. In the one case the mind, and in the other the body will be deformed. In the case of the sledge-hammer training the muscles of the arm will stand out like whip-cords, while those of the legs will shrivel and become attenuated. In the case of the training of the memory that faculty will show an abnormal develop-ment, while some other faculty, as the power of ratioci-nation, probably, will become weak.

It is not necessary in this connection to inquire into the origin of moral sentiments, or to consider the rival theories on the subject. However men may differ as between the two schools of moral philosophers — the sentimentalists and the utilitarians—they will agree that the moral side of the mind, so to speak, consists of divi-sions like the mental side; that these divisions are the source, respectively, of good and evil tendencies, and that these tendencies are susceptible of cultivation; that the evil may be restrained and the good developed, and *vice versa.* Nor will it be disputed that there is such a blending of the moral with the mental nature in the mind of man as to render any consideration of the sub-ject irrational and incomplete which does not compre-hend both, and treat them, practically, as one and the same. Man is so constituted, and his relations to society are such, that every mental impression he receives pro-duces a moral effect, the character of which is, of course, largely dependent upon the accepted standards of right, truth, and justice. Hence all scholastic training is both mental and moral. It is moral as well as mental, whether

the instructor will it so or not; and that it is moral is well, since it is obviously true, as Galton pertinently remarks, that "Great men have usually high moral natures, and are affectionate and reverential, inasmuch as mere brain without heart is insufficient to achieve eminence."

Selfishness is the arch enemy of virtue; from it all forms of immorality spring, and its last analysis is total depravity. But literature, which is the fruitage of education, is full of maxims in honor of selfishness. Said the Dauphin to the French king, "Self-love, my liege, is not so vile a sin as self-neglecting." Said Herbert, "Help thyself and God will help thee." "A penny saved is as good as a penny earned," said Franklin; and the grasping "Yankee" stretches the maxim a point in saying to his son, "Make money honestly if you can, but make money."

The following, also, are current maxims: "Every man is the architect of his own fortune;" "Every tub must stand upon its own bottom;" "In the race of life the devil takes the hindmost;" "Look to the main chance;" and, "Keep what you have got, and catch what you can." To the same purpose is the famous old aphorism of which Napoleon the First was so fond, "God always favors the heaviest battalions." Emerson declared that Napoleon represented "the spirit of modern commerce, of money, and material power," and he certainly was the very incarnation of selfishness.* He had a hand of iron, and he

* "'God has granted,' says the Koran, 'to every people a prophet in its own tongue.' Paris, and London, and New York, the spirit of commerce, of money, and material power, were also to have their prophet; and Bonaparte was qualified and sent. Every one of the million readers of anecdotes, or memoirs, or lives of Napoleon de-

laid it heavily on all who opposed him. If it became necessary to imprison his enemies he imprisoned them; if it became necessary to kill them he cut off their heads. When charged with the commission of great crimes, he retorted, "Men of my stamp do not commit crimes!" "I have always marched with the opinion of great masses and events," he exclaimed, with the insolence of a butcher exhibiting his bloody hands. Old-fashioned codes of morals were for those who opposed his plans, not for him. But the end of selfishness is disaster. It is as dangerous to assume to rise above moral laws as to sink below them; in the one case they crush, and in the other they undermine. "The half" is, after all, "more than the whole," for "the half" may be retained, but "the whole" is sure to slip from the fingers of grasping avarice. Napoleon, who defied all mankind, expiated his crimes on a rock in mid-ocean. There, whining, protesting, and prating of injustice, he died miserably, a colossal example of the folly of selfishness.

Selfishness seeks to wring from society a support without giving to it an equivalent return. What industry creates and saves to society, selfishness seeks to misappropriate to its own use; hence selfishness is in conflict with the true spirit of civilization, which is the compact of all to protect each in his rights. Selfishness caused the destruction of all the governments of ancient times, and it has been the cause of all the revolutions of modern times. There can be no stability in government until altruism takes the place of selfishness in the world's code

lights in the page, because he studies in it his own history."—"Representative Men," p. 221. Boston: Phillips, Sampson & Co., 1858.

It would be impossible more severely to arraign existing educational methods; for men are what education makes them.

of ethics. The sole condition of the stability of the State
is a disposition on the part of its people to conform to
justice and correct moral principles in all social rela-
tions.

Any system of education that does not tend to produce
a state of morals conformable to this high standard is not
merely defective; it is radically wrong, and therefore
positively vicious. The true purpose of education is the
harmonious development of all the powers of the man—
mental, moral, and physical. But harmony in a selfish
character is impossible, for selfishness is blind of one
eye, so to speak; it considers only one side of a cause—
the side that relates to its interest, regardless of all other
interests. Let not prudence be confounded with selfish-
ness. Prudence and selfishness are as wide apart as the
poles. Extreme prudence is perfectly consistent with
entire rectitude, while extreme selfishness is the syno-
nym of depravity; hence the first step in education is to
eliminate selfishness from the mind, and the next step is
to put rectitude in its place.

Prevailing systems of education no doubt promote the
spirit of selfishness :* witness the character of the struggle
for self-aggrandizement. It is more intense and more
widely extended than at any period of the world's his-

* "In small, undeveloped societies, where for ages complete peace
has continued, there exists nothing like what we call Government;
no coercive agency, but mere honorary headship, if any headship at
all. In these exceptional communities, unaggressive, and from special
causes unaggressed upon, there is so little deviation from the virtues
of truthfulness, honesty, justice, and generosity, that nothing beyond
an occasional expression of public opinion by informally assembled
elders is needful."—"Political Institutions," ¶¶ 437, 573; "The Sins
of Legislators," in "The Man versus the State," p. 44. By Herbert
Spencer. New York : D. Appleton & Co.

tory. That it is more intense is shown by the more and more rapid concentration of populations in cities, where the struggle assumes its most intense form, and exhibits itself in its most threatening aspect.

Cities have always been plague-spots on the body politic, and they are not less so now than in ancient times. It is in cities that all dangers to the State originate; and the sole, fundamental reason why cities are a standing menace to the integrity of the social compact is the fact that they are dominated by selfishness. It is in cities that the unnatural, unwholesome desire to live without labor, to live by speculative enterprises, becomes a consuming passion, inoculating with a deeper and darker degree of selfishness an ever-widening circle of people; and selfishness at last inevitably leads to anarchy. It leads to anarchy and chaos because both classes of society become depraved—the rich and powerful through indolence and sensual indulgence, and the poor and wretched through ignorance and privation and their attendant mean vices.

The modern city is the despair of the political economist. It grows relatively faster in population than the rural district, and it would be the extreme of optimism to declare that it grows better.[1] It does not matter that the city is the centre of learning, the nursery of all the active intelligences which are achieving fresh triumphs daily in every department of science, literature, and art. It is also the centre of vice, and the nursery of every variety of crime.

The difficulty—nay, the despair—of the situation is not relieved or mitigated by the undisputed fact that the ancient city was much worse morally and politic
the modern city, and hence that as

Chicago there is an immense moral and political advan-
tage in favor of the latter. If Chicago is retrograding
morally and politically, what is to prevent it from sinking
to the moral and political status of Rome under the in-
famous emperors of the period of its decadence? If the
modern American city is rapidly degenerating, both as a
moral force and a political institution, what is to arrest
its downward progress? What influence is to intervene
to reverse the order and nature of its development?

Rome, in the very agonies of political dissolution, pos-
sessed all the then known arts, a splendid literature, and
a school of philosophy whose ethical code was more lofty,
if less human, than that of the new system which was
struggling to replace the old. That the inconceivably
atrocious gladiatorial games should have developed into
such huge proportions in conjunction with the sublime
moral teachings of Seneca, Plutarch, Marcus Aurelius,
and a score of others, is the despair of students of Roman
history. While they taught, emperors and people alike
feasted their eyes on bloody orgies of men and beasts,
on scenes of the most horrible barbarity. Caligula took
special delight in watching the countenances of the dy-
ing, "for he had learned to take an artistic pleasure in
observing the variations of their agony." Criminals
dressed in the skins of wild beasts were thrown to bulls
which were maddened with red-hot irons. " Four hundred
bears were killed in a single day under Caligula; three
hundred on another day under Claudius. Under Nero,
four hundred tigers fought with bulls and elephants; four
hundred bears and three hundred lions were slaughtered
by his soldiers. In a single day, at the dedication of the
Colosseum by Titus, five thousand animals perished. Un-
der Trajan the games continued for one hundred and

twenty-three successive days. Lions, tigers, rhinoceroses, hippopotami, giraffes, bulls, stags, even crocodiles and serpents, were employed to give novelty to the spectacle."

And yet the civilization that produced these games gave to the world, forever, the moral precepts of the stoics and philosophers. Cicero had maintained the doctrine of the universal brotherhood of man. "Nature ordains," he says, "that a man should wish the good of every man, whoever he may be, for this very reason: that he is a man." Menander maintained that "man should deem nothing human foreign to his interest." Lucan looked forward to the time when "the human race will cast aside its weapons, and all nations learn to love." In a letter on the death of his slaves Pliny exhibited feelings of strong human affection, and Plutarch, in a letter of consolation to his wife on the death of his daughter, left a touching record of the tenderness of his heart in the recital of a simple trait of the child: "She desired her nurse to press even her dolls to the breast. She was so loving that she wished everything that gave her pleasure to share in the best that she had." Says Seneca, "The whole universe which you see around you, comprising all things both divine and human, is one. We are members of one great body." And Epictetus, "You are a citizen and a part of the world. The duty of a citizen is in nothing to consider his own interest distinct from that of others."

The contrast between these noble moral sentiments and the actual life of the Roman people is truly startling.[2] It is plain that the profession of lofty moral sentiments by a class, the possession of high literary attainments, and an extensive acquaintance with the arts, do not always afford protection against national degradation and

decay. Nor is it by any means certain that the Christian religion is destined to effect more in this regard than the pagan code of morals. Rome embraced religion, but its conversion was powerless to avert political and commercial destruction.

The modern city has for guides the example of all the ancient civilizations and political and moral systems, and in addition it has, in its most vital form, the Christian system of morals and faith. But notwithstanding all these helps it is politically corrupt and morally depraved. Its streets are the scenes of vice scarcely less revolting than those of ancient Rome. It harbors an army of criminals which grows with its growth, and is without any systematized effort either to reform or abolish it. Indeed this army of criminals is constantly reinforced in an increasing ratio to the whole population from the ranks of the rising generation, which is to a degree enforced to ignorance by the inadequacy of educational facilities.* Its power to accumulate wealth is increasing, but this power is confined to relatively fewer hands, and this is one of the most alarming features of the situation. For the increase of ignorance, vice, and crime is sure to keep pace with the abnormal growth of estates, stimulated to the highest degree by dishonest business practices and gigantic schemes of speculation.

It does not follow because prevailing methods of edu-

* In support of the truth of these propositions it is sufficient merely to allude to the late disclosures by the *Pall Mall Gazette* of the prevalence of revolting crimes in London, England. It is also pertinent to remark the attitude of hostility maintained by the higher classes (so called) of the English people towards the editor of the journal in which the disclosures were made, as significant of an alarming degeneration of the moral sense of the British public.

cation promote the spirit of selfishness, and hence contain the seeds of social and moral decay, that they are wholly vicious; but it does follow, if they are not positively wrong, that they are negatively wrong. Let us assume that they are only negatively wrong, that they lack an essential element in all mental and moral training—the manual element; and let us try to discover what would be the effect of the incorporation of this element into the curriculum of the schools.

A system of education consisting exclusively of mental exercises promotes selfishness because such training is subjective. Its effects flow inward; they relate to self. All mental acquirements become a part of self, and so remain forever, unless they are transmuted into things through the agency of the hand.

It is through the hand alone that the mind finally impresses itself upon matter. In other words, thought and speech must be incarnate in things or they are dead. The orator appeals to the people to strike for their rights; the people rend the air with shouts and subside into silence. The orator cries, "To Arms!" Again the people shout, and again subside into silence. The orator's thoughts are of carnage, his words of flames, but they are as dead as if never uttered because no hand is raised to embody them in deeds.

Manual training, on the other hand, promotes altruism because it is objective. Its effects flow outward; they relate not to self but to the human race. The skilled hand confers benefits upon man, and each benefit so conferred exerts the natural reflex moral influence of a good act upon the mind of the benefactor.[3]

Morality is not a ant, a barren ideality. It is true there is a consists in

refraining from the commission of wrongful acts. But
the morality of the great ethical teachers is positive; it
consists in doing. Christ said, "Inasmuch as ye have
done *it* unto one of the least of these my brethren, ye
have done *it* unto me." Words without acts are as dead
as faith without works. Paul said, "Though I have all
faith, so that I could remove mountains, and have not
charity, I am nothing."

Morality is a vital principle whose exemplification con-
sists in doing justice; and justice is that virtue "which
consists in giving to every one what is his due; practical
conformity to the laws and to principles of rectitude in
the dealings of men with each other; honesty, integrity
in commerce or mutual intercourse." It follows that
morality can no more be acquired by memorizing a series
of maxims than the art of using tools can be acquired by
studying the laws of mechanics and of mechanism.

[1] "No city was ever so deeply disgraced by its municipal govern-
ment as the city of New York. Fourteen years ago the exposure of
the Tweed Ring revealed a corruption in that government which had
mastered Legislatures and courts, and was plotting to control the na-
tional administration; and as we write, all of the living ex-members
of the late Board of Aldermen, except two, are held for trial for
bribery and corruption, or are in hiding.

"Such a shame is unprecedented. It is in itself a sharp satire
upon popular elections, as well as upon the character and public
spirit of New York; and the worst of it is that, bad as it is, no citi-
zen probably feels himself to be humiliated, or is conscious of any
personal responsibility. To the most stupid man, however, such
facts forecast a constant deterioration of the situation."—"Harper's
Weekly," April 24, 1886.

[2] The morality of the present age, like that of the Romans, is a
mere theory, entirely destitute of vital force. Selfishness is still, as
it always has been, the controlling element in human conduct, and
selfishness and morality are utterly incompatible. Moral precepts
are inculcated in a perfunctory way, as Greek is taught because it is

the fashion, but with no more idea that they will be adopted as the rule of life, than that the language of Homer will again be used as the instrument of speech. The contempt in which morality is commonly held is well shown by the remark of a popular lecturer, who said of Peter the Great, that, "viewed morally he was a monster, and by the gauge of decency, a brute, but a giant from the lofty heights of statesmanship and civilization." How vain is the hope of reform while leaders of men deem it possible for statesmanship to be rendered lofty by a moral monster, or that the cause of civilization may be advanced by a brute!

[8] "The artisan stands between every man, woman, and child and the crude materials embodied in the three kingdoms of Nature, and by the magic of his skill they are transformed into means serviceable for use. The wood in the forest, the marble in the quarry, the clay in the bank, the metal in the mine pass through his hands, take on the form of his thought, become arranged by his intelligence, and the product is the modern dwelling. Is there any fancy in fairy tale more wonderful than this? By the skill of the tanner and the shoe-maker the raw skin is transformed into the useful shoe. Do you ever think of your indebtedness to these humble toilers for your protection and comfort? Do they ever think of the service they are rendering you?—a service which cannot be compensated by dollars and cents. The jewels which sparkle in royal crowns and add lustre to queenly beauty, the silks and precious stuffs which clothe and give new charms to the loveliness of women, owe their beauty, their lustre, their value to the artisan. He stands between the worm, the mine, and the wearer, and by the transforming power of his skill and patient labor they become robes of beauty and gems of light. But of far greater importance is the service he is rendering to our common humanity. He takes the material which our Heavenly Father has provided in such abundance, puts his thought, his intelligence, and he has every conceivable motive for putting his love and good-will toward men, into them and passing them on as tokens of his love and fidelity to human good. Everything he touches becomes a message not only of his knowledge and his skill but a fit embodiment of his regard for his fellow-men."—"Mechanical Employments as Means of Human Culture." Rev. Chauncey Giles. Eleventh Series Tracts, p. 15. Philadelphia: New Church Tract and Publication Society.

CHAPTER XIV.

THE MIND AND THE HAND.

The Mind and the Hand are Allies; the Mind speculates, the Hand
tests its Speculations in Things.—The Hand explodes the Errors of
the Mind—it searches after Truth and finds it in Things.—Mental
Errors are subtile; they elude us, but the False in Things stands self-
exposed.—The Hand is the Mind's Moral Rudder.—The Organ of
Touch the most Wonderful of the Senses; all the Others are Pas-
sive; it alone is Active.—Sir Charles Bell's Discovery of a "Muscular
Sense."—Dr. Henry Maudsley on the Muscular Sense.—The Hand
influences the Brain.—Connected Thought impossible without Lan-
guage, and Language dependent upon Objects; and all Artificial
Objects are the Work of the Hand.—Progress is therefore the Im-
print of the Hand upon Matter in Art.—The Hand is nearer the
Brain than are the Eye and the Ear.—The Marvellous Works of
the Hand.

A PURELY mental acquirement is a theorem — some-
thing to be proved. As to whether the theorem is sus-
ceptible of proof is always a question until the doubt is
solved by the act of doing. Hence Comenius's definition
of education—" Let those things that have to be done be
learned by doing them" — is profoundly philosophical,
since nothing can be fully learned without the final act
of doing, owing to the fact of the incompleteness of all
theoretical knowledge.

The mind and the hand are natural allies. The mind
speculates; the hand tests the speculations of the mind by
the law of practical application. The hand explodes the
errors of the mind, for it inquires, so to speak, by the act
of doing, whether or not a given theorem is demonstra-

ble in the form of a problem. The hand is, therefore, not only constantly searching after the truth, but is constantly finding it.* It is possible for the mind to indulge in false logic, to make the worse appear the better reason, without instant exposure. But for the hand to work falsely is to produce a misshapen thing—tool or machine —which in its construction gives the lie to its maker. Thus the hand that is false to truth, in the very act publishes the verdict of its own guilt, exposes itself to contempt and derision, convicts itself of unskilfulness or of dishonesty.

There is no escaping the logical conclusion of an investigation into the relations existing between the mind and the hand. The hand is scarcely less the guide than the agent of the mind. It steadies the mind. It is the mind's moral rudder, its balance - wheel. It is the mind's monitor. It is constantly appealing to the mind, by its acts, to " hew to the line, let the chips fly where they may."

Dr. George Wilson says, " In many respects the organ of touch, as embodied in the hand, is the most wonderful of the senses. The organs of the other senses are passive; the organ of touch alone is active. . . . The hand selects what it shall touch, and touches what it pleases. It puts away from it the things which it hates, and beckons towards it the things which it desires. . . . More-

* " In other cases, even by the strictest attention, it is not possible to give complete or strict truth in words. We could not, by any number of words, describe the color of a ribbon so as to enable a mercer to match it without seeing it. But an ' accurate ' colorist can convey the required intelligence at once, with a tint on paper."— "The Laws of Feesole," Vol. I., p. 7. By John Ruskin, LL.D. New York: John Wiley & Sons, 1879.

over, the hand cares not only for its own wants, but when
the other organs of the senses are rendered useless takes
their duties upon it. . . . The blind man reads with
his hand, the dumb man speaks with it; it plucks the
flower for the nostril, and supplies the tongue with ob-
jects of taste. Not less amply does it give expression to
the wit, the genius, the will, the power of man. Put a
sword into it and it will fight, a plough and it will till, a
harp and it will play, a pencil and it will paint, a pen and
it will speak. What, moreover, is a ship, a railway, a
light-house, or a palace—what indeed is a whole city, a
whole continent of cities, all the cities of the globe, nay
the very globe itself, so far as man has changed it, but
the work of that giant hand with which the human race,
acting as one mighty man, has executed his will."*

There is a philosophical explanation of the versatility
of the hand so graphically portrayed in the foregoing
passage, and it is found in Sir Charles Bell's great discov-
ery of a "muscular sense." The principle of this discov-
ery is that "there are distinct nerves of sensation and of
motion or volition—one set bearing messages from the
body to the brain, and the other from the brain to the
body."

In his work on the hand, after reviewing the line of
argument which led to his discovery, Sir Charles says,
"By such arguments I have been in the habit of show-
ing that we possess a muscular sense, and that without it
we could have no guidance of the frame. We could not
command our muscles in standing, far less in walking,
leaping, or running, had we not a perception of the con-

* "The Five Gateways of Knowledge," p. 121. By George Wil-
son, M.D., F.R.S.E. London: Macmillan & Co., 1881.

dition of the muscles previous to the exercise of the will. And as for the hand, it is not more the freedom of its action which constitutes its perfection, than the knowledge which we have of these motions, and our consequent ability to direct it with the utmost precision."[*]

On the influence of the muscular sense, Dr. Henry Maudsley has these pertinent observations:

"Those who would degrade the body, in order, as they imagine, to exalt the mind, should consider more deeply than they do the importance of our muscular expressions of feeling. The manifold shades and kinds of expression which the lips present—their gibes, gambols, and flashes of merriment; the quick language of a quivering nostril; the varied waves and ripples of beautiful emotion which play on the human countenance, with the spasms of passion that disfigure it—all which we take such pains to embody in art — are simply effects of muscular action. . . . Fix the countenance in the pattern of a particular emotion—in a look of anger, of wonder, or of scorn—and the emotion whose appearance is thus imitated will not fail to be aroused. And if we try, while the features are fixed in the expression of one passion, to call up in the mind a quite different one, we shall find it impossible to do so. . . . We perceive, then, that the muscles are not alone the machinery by which the mind acts upon the world, but that their actions are essential elements in our mental operations. The superiority of the human over the animal mind seems to be essentially connected with the greater variety of muscular action of which man is capable;

* "The Hand: its Mechanism and Vital Endowments as Evincing Design," p. 151. By Sir Charles Bell, K.G.H., F.R.S., L. and E. Harper & Brothers, 1864.

were he deprived of the infinitely varied movements of hands, tongue, larynx, lips, and face, in which he is so far ahead of the animals, it is probable that he would be no better than an idiot, notwithstanding he might have a normal development of brain."*

It is through the muscular sense that the hand influences the brain. According to Sir Charles the hand acts first. It telegraphs, for example, that it is ready to grasp the chisel or the sledge-hammer, or seize the pen, whereupon the brain telegraphs back precise directions as to the work to be done. These messages to and fro are lightning-like flashes of intelligence, which blend or fuse all the powers of the man, both mental and physical, and inform and inspire the mass with vital force.†

Through constant use the muscular sense is sharpened to a marvellous degree of fineness, and the hand, permeated by it, forms habits which react powerfully upon the mind. If, now, during the period of childhood and youth, the hand is exercised in the useful and beautiful arts, its muscular sense will be developed normally, or in the di-

* "Body and Mind," p. 32. By Henry Maudsley, M.D. New York: D. Appleton & Co., 1883.

† The goldsmith's art was one of the finest among the ancients, and so continued far into the Middle Ages. The cutting of cameos, for example, required the highest skill and produced the most exquisite results. Mr. Ruskin calls attention to the fact that "all the great early Italian masters of painting and sculpture, without exception, began by being goldsmiths' apprentices," and that "they felt themselves so indebted to, and formed by, the master craftsman who had mainly *disciplined their fingers*, whether in work on gold or marble, that they practically considered him their father, and took *his* name rather than their own." —"Fors Clavigera," Part III., p. 291. By John Ruskin, LL.D. New York: John *Wiley & Sons*, 1881.

rection of rectitude, and the reflex effect of this growth upon the mind will be beneficent.

It is thus that the trained hand comes at last to foresee, as it were, that a false proposition is surely destined to be exploded. The habit of rectitude gives it prescience. It invariably discovers, sooner or later, that a false proposition, when embodied in wood or iron, becomes a conspicuous abortion, involving in disgrace both the designer and the maker. A false proposition in the abstract may be rendered very alluring; a false proposition in the concrete is always hideous. One of the chief effects of manual training is, then, the discovery and development of truth; and truth, in its broadest signification, is merely another name for justice; and justice is the synonym of morality.

It has been shown that thought and speech are dead unless embodied in things. It may also be asserted with confidence that man would lose the power of speech almost wholly if his words should cease to be realized in things. Mr. Darwin declares that "a complex train of thought can no more be carried on without the aid of words, whether spoken or silent, than a long calculation without the use of figures or algebra."* And Dr. Maudsley says, "But neither these instances nor the case of Laura Bridgman can be used to prove that it is possible to think without any means of physical expression. On the contrary the evidence is all the other way. The deaf and dumb man invents his own signs, which he draws from the nature of objects, seizing the most striking outline, or the principal movement of an action, and using

* "The Descent of Man," p. 88. By Charles Darwin, M.A. New York: D. Appleton & Co., 1881.

them afterwards as tokens to represent the objects. The
deaf and dumb gesticulate also as they think; and Laura
Bridgman's fingers worked, making the initial movements
for letters of the finger alphabet, not only during her
waking thoughts, but in her dreams. If we substitute
for 'names' the motor intuitions, or take care to com-
prise in language all the modes of expressing thoughts,
whether verbal, vocal writing, or gesture language, then
it is unquestionable that thought is impossible without
language."*

As connected thoughts are impossible without words,
or signs of words, so words are dependent upon objects
for their existence. Says Dr. Maudsley, "Words cannot
attain to definiteness save as living outgrowths of reali-
ties."† And Heyse says, "Thought is not even present
to the thinker till he has set it forth out of himself."

It follows that language has its origin not less in ex-
ternal objects than in the mind. Objects make impres-
sions upon the mind through the senses, and words serve
as the means of preserving a record of such impressions
and of communicating them to other minds. If, now,
the mind should cease to receive impressions, language
would no longer be required, since there would be noth-
ing to express; and the occasion for the use of language
ceasing to exist, the power of speech would ultimately be
lost. The power of speech, then, depends upon a con-

* "Physiology of the Mind," p. 480. By Henry Maudsley, M.D.
New York: D. Appleton & Co., 1883.

† "I therefore declare my conviction," says Max Müller, "whether
right or wrong, as explicitly as possible, that thought in one sense
of the word, i. e., in reasoning, is impossible without language."—
"Physiology of the Mind," p. 480. By Henry Maudsley, M.D.
New York: D. Appleton & Co., 1883.

tinuous succession of impressions made upon the mind
by its contact, through the senses, with matter in its
various forms, whether in nature or in art.

It may also be claimed that the power of speech de-
pends almost entirely upon the endless succession of
fresh objects presented to the mind by the hand. These
form the subject as well as the occasion of speech. If
the hand should cease to make new things, new words
would cease to be required. The principal changes in
language arise out of new discoveries in science and new
inventions in art, each fresh discovery of science giving
rise to many new things in art. Art and science react
upon each other.* The growth of a State, its advance
in the scale of civilization, depends upon progress in the
practical arts. Hence the fact that, when a State ceases
to advance, its language ceases to grow, becomes station-
ary, stagnates. In such a State there would be no occa-
sion for new words. If a constantly diminishing number
of objects were presented to the mind, speech would
become less and less necessary. If no new objects were
presented, no fresh impressions upon the mind would be
made, and speech would degenerate into a mere iteration.
If the hands should cease to labor in the arts, should
cease to make things, should cease to plant and gather,
the scope of speech would be still further restricted,
would be confined to an expression of the wants of sav-
ages subsisting on the native fruits of field and forest.

It comes to this, that progress can find expression only

* "And the great advances in science have uniformly corresponded
with the invention of some instrument by which the power of the
senses has been increased, or the range of action extended."—"Phys-
iology of the Mind," p. 8. By Henry Maudsley, M.D. New York:
D. Appleton & Co., 1883.

in the concrete. Guttenberg had an idea that he could employ movable types in the production of books. Suppose he had been content with the mere promulgation of his theory in words, and that those who came after him had been similarly content? There would have been no printing-presses down to the present time. Suppose that Watt and Stephenson and Fulton had been content with the declaration, in words, of the discoveries they made in regard to the application of the power of steam to useful purposes, and that those who came after them had been similarly content? There would have been neither railways, nor steamships, nor steam-driven machinery of any kind down to the present time.

As words are essential to the processes of thought, so objects are essential to words or living speech. And as all objects made by man owe their existence to the hand, it follows that the hand exerts an incalculable influence upon the mind, and so constitutes the most potent agency in the work of civilization. It was not without good reason that Anaxagoras characterized man as the wisest of animals because of his having hands. And what is it to be wise? To be wise is "to have the power of discerning and judging correctly, or of discriminating between what is true and what is false; between what is fit and proper and what is improper." The hand is used as the synonym of wisdom because it is only in the concrete that the false is sure of detection, and it is through the hand alone that ideas are realized in things.* Again we have the hand as the discoverer of truth.

* "Let him [the youth] once learn to take a straight shaving off a plank, or draw a fine curve without faltering, or lay a brick level in its mortar, and he has learned a multitude of other matters which no

The assertion of the majesty of the hand by the Ionic philosopher of the fifth century B. C. contained the germ of the manual training idea of this latter part of the nineteenth century. Anaxagoras was unconsciously, no doubt, struggling toward the light, toward the inductive method of investigation, toward the sole avenue through which it is possible to study the mind, namely, through the body. The ignorance of the ancients on the subject of physiology was so dense as to leave them no resource save speculative philosophy. The progress made in the study of anatomy, and organic and inorganic chemistry at Alexandria, was, however, considerable. The foundations of a systematic physiology were being securely laid by Hippocrates, Herophilus, and their compeers of the medical profession, and the way was thus being opened to an intelligent study of the mind. It is highly probable that this growing disposition to investigate things, together with the increasing importance to civilization of the useful arts, would soon have reacted destructively upon the speculative philosophy of the time had not a series of national disasters, involving the fall of Greece and Rome, overwhelmed both arts and philosophy in one common ruin.

From the fall of Rome to the time of Bacon speculative philosophy dominated the world. Progress dates from the beginning of the seventeenth century, but it was very slow until within a hundred years. Philosophy has now, however, found a scientific basis. Instead of speculating about the " theory of vitality," it concerns itself with " the natural phenomena of living bodies, so

lips of man could ever teach him."—" Time and Tide," p. 145. By John Ruskin, LL. D. New Y Wiley & Sons, 1883.

far as they are appreciable by the human senses and in-
telligence."

But the schools have not moved forward with events.
Their methods are unscientific; they are still dominated
by the mediæval ideas of speculative philosophy. One
of the ablest educators in this country has well observed
that "there has been very little change in the ideas
which have controlled our methods of education, and
these ideas were formed something like four hundred
years ago. Like nearly all the great agencies of modern
civilization, the established system of education dates
from the Renaissance, and the direction given to the
schools at that time has been followed with but slight
modification ever since."*

The justice of this arraignment of the schools for ex-
treme conservatism is shown by the remark of a promi-
nent educator who opposes the incorporation of manual
training in the curriculum of the public schools. He
says, "Some even go so far as to regard the fingers as a
new avenue to the brain, and think that great pedagogic
advantages will be given by the new method, so that
boys may make equal attainments in arithmetic, read-
ing, and grammar in less time. . . . They [teachers] will
still find the eye and ear nearer to the brain than the
hand." No assumption could be more false than this,
that the eye and the ear are more important organs than
the hand because they are located, physically, nearer the
brain. The attribute of mobility with which the hand is
endowed confers upon it not only the potency of the

* Mr. James MacAlister, Superintendent of Schools of the City of
Philadelphia, before the American Institute of Instruction at Sarato-
ga, July 13, 1882,

closest possible proximity, but each of the countless po-
sitions it may assume, together with its flexibility and
adaptability, multiplies its powers in the order of a geo-
metrical ratio.

This disposition to undervalue the hand is an inheri-
tance from the speculative philosophy of the Middle
Ages, which was based on contempt of the body and all
its members. The effect of this false doctrine has been
vicious in the extreme. Contempt for the body has gen-
erated a feeling of contempt for manual labor, and repug-
nance to manual labor has multiplied dishonest practices
in the course of the struggle to acquire wealth by any
.other means than manual labor, and so corrupted society.

That man should feel contempt for the most efficient
member of his own body is, indeed, incomprehensible,
since contempt for the hand leads logically to contempt
for its works, and its works comprise all the visible
results of civilization. To enumerate the works of the
hand would be to describe the world as it at present ex-
ists in contradistinction to the world in a state of nature.
Everywhere we behold with admiration and wonder the
marvellous triumphs of the hand, from the iron bridge
that spans the torrent of Niagara to the steel microm-
eter that measures the millionth part of an inch. It
matters not whether the hand is nearer or farther from
the brain than the eye and the ear, it is able to afford
powerful aid to them.

Man would explore the planetary system; he lifts his
longing eyes to the starry vault, but in vain; it is a
sealed book! The hand fashions the telescope, adjusts
it, places it at a convenient angle, and the milky way is
resolved into millions of stars, "scattered like glittering
dust on t k ground of the general heavens," the

lunar mountains are measured, and the spots on the sun
revealed. Man would study the anatomy and habits of the
myriads of insects in which the teeming earth abounds.
Impossible! The mechanism of the eye is not adapted
to such a delicate operation. But the hand presents the
microscope, and a world of hitherto unknown minute ex-
istences is revealed with a distinctness which permits the
most exhaustive investigation. Thus, through the aid of
the hand, the eye now contemplates with philosophic
interest the ever-changing aspect of the spots on the sun
at a distance of ninety million miles, and now imprisons
the red ant, measuring only $\frac{8}{100}$ of an inch in length, and
studies its physiology, counting its pulsations, classifying
its nerves and muscles, and weighing its brain. Man
would speak with his friend or business correspondent
miles away. Neither the voice nor the ear is adapted to
the task. But the hand fashions and presents the tele-
phone, and the conversation proceeds even in a whisper.
It will be said that the mind devises the telescope, the mi-
croscope, and the telephone. True, but their construction
would be impossible without the hand. And is it at all
probable that the mind would have devised these admira-
ble instruments if man had been made without hands?*

* "The hand is the most marvellous instrument in the world; it is
the necessary complement of the mind in dealing with matter in all
its varied forms. It is the hand that 'rounded Peter's dome;' it is
the hand that carved those statues in marble and bronze, that painted
those pictures in palace and church, which we travel into distant
lands to admire; it is the hand that builds the ships which sail the
sea, laden with the commerce of the world; it is the hand that con-
structs the machinery which moves the busy industries of this age of
steam; it is the hand that enables the mind to realize in a thousand
ways its highest imaginings, its profoundest reasonings, and its most
practical inventions." — Mr. James MacAlister, Superintendent of
Schools of the City of Philadelphia, before the American Institute of
Instruction at Saratoga, July 13, 1882.

CHAPTER XV.

THE POWER OF THE TRAINED HAND.

The Legend of Adam and the Stick with which he subdued the Animals.—The Stick is the Symbol of Power, and only the Hand can wield it.—The Hand imprisons Steam and Electricity, and keeps them at hard Labor.—The Destitution of England Two Hundred Years ago: a Pen Picture.—The Transformation wrought by the Hand: a Pen Picture.—It is due, not to Men who make Laws, but to Men who make Things.—The Scientist and the Inventor are the World's Benefactors.—A Parallel between the Right Honorable William E. Gladstone and Sir Henry Bessemer.—Mr. Gladstone a Man of Ideas, Mr. Bessemer a Man of Deeds.—The Value of the latter's Inventions.—Mr. Gladstone represents the Old Education, Mr. Bessemer the New.

IT has been remarked that man is the wisest of animals because he has hands. It is equally true that he is the most powerful of animals because he has hands. It is with the hand that man has subdued all the animals. There is a legend to the effect that on the day when Adam revolted against his Maker, the animals, in their turn, revolted against him, and ceased to obey him. "Adam called on the Lord for help, and the Lord commanded him to take a branch from the nearest tree and make of it a weapon, and strike with it the first animal that should refuse to obey him. Adam took the branch, the leaves fell from it of their own accord, and he found himself furnished with a stick proportioned to his height. When the animals saw this weapon in the hands of the man they were seized with an instinctive fear mingled with wonder, and they did not dare to attack

him. A lion alone, bolder than the rest, leaped upon
him to devour him, but Adam, who stood upon his
guard, swift as lightning whirled his stick and felled him
to the earth with a single blow! At this sight the terror
of the other animals was so great that they approached
him trembling, and in token of their submission licked
the stick that he held in his hand."*

Throughout all the early ages the stick was both the
symbol and the instrument of power; and it is only the
hand that can grasp and wield the stick. The early
kings reigned by virtue of the strong arm and the supple
hand. They claimed to be descended from Hercules,
and their emblem of power was a knotty stick. Nor
does empire depend less upon the hand now than it did
in the morning of time.

The hand no longer grasps the knotty stick; it no
longer menaces mankind. But it wields the mechanical
powers. It imprisons steam and electricity, and keeps
them at hard labor. It makes ploughs, planters, harvest-
ers, sewing-machines, locomotives, and steamships. It
digs canals, opens mines, builds bridges, makes roads,
erects mills and factories, constructs harbors and docks,
reclaims waste lands, and covers the globe with tracks of
steel over which the commerce of the world is borne.

Two hundred years ago England was destitute of
most of these things. It had then no good dirt roads
even, no good bridges, no canals, no public works
worth mentioning, and scarcely any manufactories of
importance. The post-bags were carried on horseback

* "The Story of the Stick," p. 2. Translated and Adapted from
the French of Antony Réal [Fernand Michel]. New York: J. W.
Bouton. 1875

once a week. The highways were besieged by robbers.
One-fifth of the community were paupers. Mechanics
worked for from sixpence to a shilling a day. The chief
food of the poor was rye, barley, or oats. The people
were ignorant and brutal—masters beat their servants,
and husbands beat their wives. Teachers used the lash as
the principal means of imparting knowledge. The mob
rejoiced in fights of all kinds, and shouted with glee
when an eye was torn out or a finger chopped off in
these savage encounters. Executions were favorite pub-
lic amusements. The prisons were full, and proved to be
fruitful nurseries of crime.

From little better than a wilderness, and almost a
state of savagery, England has been transformed into a
fruitful field, and its people raised in the scale of civ-
ilization. Its public works are the admiration of the
world ; its coffers are full of gold ; its strong boxes are
piled high with evidences of the indebtedness of other
nations ; its ships plough the billows of every sea, and
bear the commerce of every land ; and its manufactories,
of vast extent, are monuments of inventive genius, in-
dustry, perseverance, and skill, more imposing far than
the pyramids of Egypt or the temples of Greece and
Rome.

To whom do the people of England and of the world
owe this national progress, this progress in the useful
arts on a scale so colossal as, by comparison, to dwarf
the achievements of all the earlier epochs of history?
Not to statesmen or legislators. They neither dig ca-
nals, open mines, build railways, lay ocean cables, nor
erect factories. The pen in their hands may be mightier
than the sword ; but it is no match for the plough and
the reaper, the · battery and imprisoned steam.

Legislators make laws but mechanics make things. On this subject, after an exhaustive investigation, Buckle says, "Seeing, therefore, that the efforts of government in favor of civilization are, when most successful, altogether negative, and seeing, too, that when these efforts are more than negative they become injurious, it clearly follows that all speculations must be erroneous which ascribe the progress of Europe to the wisdom of its rulers. This is an inference which rests not only on the arguments already adduced, but on facts which might be multiplied from every page of history. . . . We have seen that their laws in favor of industry have injured industry, that their laws in favor of religion have increased hypocrisy, and that their laws to secure truth have encouraged perjury. . . . But it is a mere matter of history that our legislators, even to the last moment, were so terrified by the idea of innovation that they refused every reform until the voice of the people rose high enough to awe them into submission, and forced them to grant what, without much pressure, they would by no means have conceded."*

It is, then, clearly not to the men who make laws that we are indebted for progress in civilization, but to the men who make things. The scientist who discovers a new principle in physics is a public benefactor. The inventor who devises a new machine helps forward the cause of progress. Whitney's cotton-gin trebled the value of the cotton-fields of the South. The mechanic who constructs a machine that will make ten or a hundred things in the time before required to make one

* "History of Civilization in England," Vol. I., pp. 204, 205, 361. *By Henry Thomas* Buckle. New York : D. Appleton & Co.

thing is in the front rank of the civilizers of the human race.*

Inventors, not statesmen, rule the world through their machines, which augment the powers of man and sharpen his senses. Steam has made all civilized countries prosperous and great by vastly increasing man's powers—by making him hundred-handed.†

In 1809 there was born to a distinguished baronet of Liverpool, England, a son. The boy was educated at Eton and Christ Church College, Oxford, graduating in 1831. In 1832 the young man entered parliament. In 1834 he took office under Sir Robert Peel. The name of the young man who commenced life under such auspicious circumstances was William Ewart Gladstone. For nearly half a century Mr. Gladstone was a prominent figure in English politics and administration. During that long period of time he was in the eye of the world, so to speak. He moulded the laws of an empire, repealed old statutes and made new statutes, largely influenced both the domestic and the foreign policy of a great nation, and exerted a considerable degree of con-

* "Your wealth, your amusement, your pride, would all be alike impossible, but for those whom you scorn or forget. . . . The sailor wrestling with the sea's rage; the quiet student poring over his book or his vial; the common worker, without praise, and nearly without bread, fulfilling his task as your horses drag your carts, hopeless, and spurned of all: these are the men by whom England lives."— "Sesame and Lilies," p. 68. By John Ruskin, LL.D. New York: John Wiley & Sons, 1884.

† "The causes which most disturbed or accelerated the normal progress of society in antiquity were the appearance of great men; in modern times they have been the † inventions." —"History of European Morals," ʼm Edward Hartpole Lecky, M.A. Ne

trol over the international affairs of the continent of
Europe.

In 1813, four years after the birth of Mr. Gladstone,
at Charlton, in Hertfordshire, England, Henry Bessemer
was born. His father, Anthony Bessemer, had fled to
England in 1792, a refugee from France. Henry Besse-
mer's early training consisted of the rudiments of an
ordinary education received in the parish school of the
neighboring town of Hitchin. His father was a skilled
mechanic and inventor, and Henry inherited the invent-
ive faculty. He studied and practised the art of wood-
turnery, producing, before arriving at the age of man-
hood, the most difficult patterns known to the art.

At the age of eighteen, in the year 1831—the year in
which Mr. Gladstone completed his education — young
Bessemer appeared in London, an obscure, unknown
stranger. He, however, secured employment as a mod-
eller and designer. His attention was soon directed to
the imperfections of government stamps, in which there
had been no improvement since the time of Queen Anne.
He was informed by Sir Charles Persley, of the Stamp-
office, that the frauds in stamps probably aggregated
one hundred thousand pounds per annum. In the even-
ings of a few months he invented and made an im-
proved stamp which obviated the objections to the one
then in use. The invention was at once adopted by the
Stamp-office, and in lieu of a stipulated sum in payment
therefor, young Bessemer was asked " whether he would
be satisfied with the position of superintendent of stamps,
with five hundred or six hundred pounds per annum?"
The suggested appointment he agreed to accept. Mean-
time, before the contemplated change occurred in the
Stamp-office, the young inventor devised a further im-

provement in the new stamp, which not only made it much more perfect, but rendered it unnecessary for the government to employ a superintendent of stamps. In perfect good faith young Bessemer exhibited to the chief of the Stamp-office his new stamp, which was so palpably an improvement on the other that it was at once preferred and promptly adopted. What is more, the government not only declined to appoint the inventor to a place, but declined to give him a penny for his invention. This was in 1834, the year in which Mr. Gladstone began his long career as a representative of the British Crown. As young Mr. Gladstone entered the Treasury, its "junior lord," young Mr. Bessemer retired from it an unsuccessful suitor for the just reward of genius and toil. He says, "Thus sad and dispirited, and with a burning sense of injustice overpowering all other feelings, I went my way from the Stamp-office, too proud to ask as a favor that which was indubitably my right."[*]

From this point, both of time and event, there is a very wide divergence in the lives of these great men. The one is a man of ideas, the other a man of deeds. Mr. Gladstone thinks, talks, makes treaties and laws. He is constantly in the public eye, and his name ever on the public tongue. He is regarded as a great financier; he is certainly a great orator. He sways the multitude with his eloquence. He takes distinguished part in the wordy contests which occur every now and then in Parliament. These debates are much talked of. At the conclusion of one of them there is a vote of want of confidence, and Mr. Gladstone goes out of office and Mr. Dis-

[*] "The Creators of the Age of Steel," p. 20. By W. T. Jeans. New York: Charles Scribner's Sons, 1884.

raeli comes in. At the conclusion of another of them
there is a vote of want of confidence, and Mr. Disraeli
goes out of office and Mr. Gladstone comes in. But
whether Mr. Gladstone goes out and Mr. Disraeli comes
in, or Mr. Disraeli goes out and Mr. Gladstone comes in,
makes very little difference with the trade and commerce
of the kingdom. The railway traffic continues in the
one event or the other; the steamers continue to cross
and recross the ocean; the "post" comes and goes; the
electric current continues to act as messenger-boy; the
telephone brings us face to face with our business corre-
spondent or friend. There is, indeed, no reason why a vote
of want of confidence in Mr. Gladstone or Mr. Disraeli
should imply a want of confidence in steam or electricity,
because neither Mr. Gladstone nor Mr. Disraeli ever had
anything to do with the application of these great forces
to the uses of man. They were entirely absorbed, the
one in promoting the advancement of Liberalism, and
the other in promoting the advancement of Toryism.
And it is a curious fact, as showing the mutability of
political opinion, that Mr. Disraeli entered public life as
a Liberal, and subsequently became a great Tory leader;
and Mr. Gladstone entered public life as a Tory, and sub-
sequently became a great Liberal leader.

For twenty-two years after he retired empty-handed
from the government Stamp-office Mr. Bessemer con-
tinned his career as an inventor and manufacturer,
without, however, attracting any great share of public
attention. But in 1856 he announced that he had made
a discovery of vast importance in the process of steel
making.* For a hundred years previously the Huntsman

* "The first patent of Sir H. Bessemer in which air is mentioned

process had held the field. It yielded excellent steel but was very expensive. Mr. Bessemer announced that he could produce splendid cast-steel at about the cost of making iron! The announcement was received with much incredulity; but the "Bessemer converter" was exhibited, the new process shown, and the result seemed to confirm the verity of the claim of the inventor. Practical difficulties, however, postponed its complete success till 1860, when the new process supplanted all others.

Mr. Bessemer now stood at the head of the inventors of the world, and Mr. Gladstone, as Chancellor of the Exchequer under Lord Palmerston, had come to be regarded as one of the most skilful governmental financiers in Europe, which meant that he was an adept in devising schemes of taxation calculated to yield the most revenue with the least popular discontent. When it is considered that it is necessary for the English Minister of Finance to draw from the British people more than a million dollars every morning of the year, including Sundays, before either the English lord or the English peasant can indulge in a free breakfast, the extreme delicacy of the duties devolving upon him will be understood and appreciated. If he proposes the repeal of the soap tax in order to extinguish the slave-trade, he must impose an additional penny in the pound on malt liquors in order to put an end to the vice of drunkenness. He is constantly between Scylla and Charybdis — in keeping

as the oxidizing agent is dated October 17, 1855, and other three months were spent in experimenting before the idea of introducing the air from the bottom of a large converter struck him. The patent embodying the latter idea is dated February 11, 1856."—"The Creators of the Age of Steel," note to p. 38. By W. T. Jeans. New York: Charles Scribner's Sons, 1884.

off the one he is in danger of being swallowed up in the other. And if he can, at the end of the fiscal year, find a million dollars to apply to the liquidation of the public debt, he is extremely fortunate. From 1836, about the time Mr. Gladstone began his public career, down to 1877, the several chancellors of the English Exchequer, including Mr. Gladstone, contrived to save, in the aggregate, about twelve million pounds sterling for this purpose.

Let us recur a moment to the subject of the invention of Mr. Bessemer. It went into operation in 1860. The temptation to reproduce Mr. Bessemer's own description of his process, which revolutionized the manufacture of steel, is irresistible. It is as follows:

"The converting vessel is mounted on an axis at or near its centre of gravity. It is constructed of boiler-plates, and is lined either with fire-brick, road-drift, or gannister, which resists the heat better than any other material yet tried, and has also the advantage of cheapness. The vessel, having been heated, is brought into the requisite position to receive its charge of melted metal, without either of the tuyeres (or air-holes) being below the surface. No action can therefore take place until the vessel is turned up (so that the blast can enter through the tuyeres). The process is thus in an instant brought into full activity, and small though powerful jets of air spring upward through the fluid mass. The air, expanding in volume, divides itself into globules, or bursts violently upward, carrying with it some hundred-weight of fluid metal, which again falls into the boiling mass below. Every part of the apparatus trembles under the violent agitation thus produced; a roaring flame rushes from the mouth of the vessel, and as the process advances it changes its violet color to orange, and finally

to a voluminous pure white flame. The sparks, which
at first were large, like those of ordinary foundery iron,
change into small hissing points, and these gradually
give way to soft floating specks of bluish light as the
state of malleable iron is approached. There is no
eruption of cinder as in the early experiments, although
it is formed during the process; the improved shape of
the converter causes it to be retained, and it not only
acts beneficially on the metal, but it helps to confine the
heat, which during the process has rapidly risen from
the comparatively low temperature of melted pig-iron to
one vastly greater than the highest known welding heats,
by which malleable iron only becomes sufficiently soft
to be shaped by the blows of the hammer; but here it
becomes perfectly fluid, and even rises so much above
the melting point as to admit of its being poured from
the converter into a founder's ladle, and from thence
to be transferred to several successive moulds." *

What is the value of this process? What is the ex-
tent of the service rendered by Mr. Bessemer to man?
It is estimated that in the twenty-one years first elapsing
after the successful working of the Bessemer process, the
production of steel by it, notwithstanding its necessarily
slow progress, amounted to twenty-five million tons. At
$200 a ton, the alleged saving in cost as compared with
the old process, this represents an aggregate saving of
$5,000,000,000. In 1882 the world's production was
four million tons, which at the rate named yielded a
saving of the enormous aggregate of $800,000,000 in a
single year.[1] These sums seem almost fabulous, especial-
ly so since they result from simply blowing air through

* "The Creators of the Age of Steel," p. 71. By W. T. Jeans.
New York : Charles Scribner's Sons, 1884.

crude melted iron for a quarter of an hour! But the
radical character of the change wrought in the metal by·
the air-blowing process is shown by the fact that a steel
rail is worth as much as twenty iron rails.*

All the governments of Europe honored Mr. Bessemer
for his great invention, some by medals and orders of
merit, and others by appropriating without compensa-
tion his process of steel-making. Of these latter Prussia
stood in the front rank. England alone stood aloof.
"A prophet is not without honor save in his own coun-
try and among his own kin." From 1860 to 1872 Eng-
land continued to load Mr. Gladstone and Mr. Disraeli
with honors, but not until the latter year did the govern-
ment recognize Mr. Bessemer, when the Prince of Wales
presented him with the Albert gold medal, and in 1879
he was knighted by the Queen.

A comparison between the lives and services to man
of two of the most distinguished statesmen of England,
with the life and services, to man, of Sir Henry Bessemer,
cannot fail to be of great value to every young man who
possesses the power of just discrimination. But can just
discrimination be expected of any young man entering

* "At the Birmingham meeting of the British Association in 1865,
Sir Henry Bessemer explained that at Chalk Farm steel rails were
laid down on one side of the line and iron rails on the other, so that
every engine and carriage there had to pass over both steel and iron
rails at the same time. When the first face was worn off an iron rail
it was turned the other way upward, and when the second face was
worn out it was replaced by a new iron rail. When Sir Henry ex-
hibited one of these steel rails at Birmingham only one face of it was
nearly worn out, while on the opposite side of the line eleven iron
rails had in the same time been worn out on both faces. It thus ap-
peared that one steel rail was capable of doing the work of twenty-
three iron ones."—'The Creators of the Age of Steel,' p. 98'. By
W. T. Jeans. New York: Charles Scribner's Sons, 1884.

upon the stage of active life when such discrimination is not possessed by the public at large? For example: The question being propounded, What is the value of the combined services to man of Mr. Gladstone and Mr. Disraeli, as compared with those of Sir Henry Bessemer? ninety-nine out of a hundred men of sound judgment would doubtless say, "The value of the services of the two statesmen is quite unimportant, while the value of the services of Mr. Bessemer is enormous, incalculable." But how many of these ninety-nine men of sound judgment could resist the fascination of the applause accorded to the statesmen? How many of them would have the moral courage to educate their sons for the career of Mr. Bessemer instead of for the career of Mr. Disraeli or of Mr. Gladstone?* Not many in the present state of public sentiment. It will be a great day for man, the day that ushers in the dawn of more sober views of life, the day that inaugurates the era of the mastership of things in the place of the mastership of words.

Mr. Gladstone stands for politics and statesmanship at their best, and his career is the product of the old system of education at its best. Mr. Bessemer stands for science and art united, and his career is the product of the new education.

[1] But the pecuniary value of Mr. Bessemer's discovery is not the consideration of chief import Its social influence extends to the remotest bounds of civilization, and includes the whole human race, because it abridges the period of labor necessary to the production of a given quantity of useful things, thereby enhancing the sum of life's comforts and pleasures.

CHAPTER XVI.

THE INVENTORS, CIVIL ENGINEERS, AND MECHANICS
OF ENGLAND, AND ENGLISH PROGRESS.

A Trade is better than a Profession.—The Railway, Telegraph, and
Steamship are more Potent than the Lawyer, Doctor, and Priest.—
Book-makers writing the Lives of the Inventors of last Century.—
The Workshop to be the Scene of the Greatest Triumphs of Man.
—The Civil Engineers of England the Heroes of English Progress.
—The Life of James Brindley, the Canal-maker; his Struggles and
Poverty.—The Roll of Honor.—Mr. Gladstone's Significant Admis-
sion that English Triumphs in Science and Art were won without
Government Aid.—Disregarding the Common-sense of the Savage,
Legislators have chosen to learn of Plato, who declared that "The
Useful Arts are Degrading."—How Improvements in the Arts have
been met by Ignorant Opposition.—The Power wielded by the
Mechanic.

THE young man with a mechanical trade is better
equipped for the battle of life than the young man with
a learned profession. The prizes may not be so dazzling,
but they are more numerous, and they are within reach.
The skilled mechanic, with industry and prudence, is sure
of a cottage, and the cottage may grow into a mansion,
while the man of letters struggles so often in vain to
mount the steps of a palace. The railroad, the telegraph,
and the steamship exert a more potent influence upon
the destinies of mankind than the lawyer, the doctor, and
the priest. The giants, steam and electricity, which bear
the great burdens of commerce, have to be harnessed to
enable them to do their work; and to make this harness,
the furnace, the forge, and the shop are brought into

requisition. The railroad alone taxes to the utmost nearly every department of the useful arts. To the construction of the passenger-coach, for instance, more than a hundred trades contribute the varied cunning and skill of their workmanship.

This is the age of steel, and he who knows how to mould the king of metals into puissant forms has his hand nearest the rod of empire. Who would not rather be able to construct a Corliss engine than learn the trick of drawing a bill in chancery?

There was a time, not long ago, when inventors and discoverers were little recognized and poorly compensated for their splendid achievements. But that time is past. The book-makers of to-day are groping about the old shops where the inventors of last century worked, and the cottages where they lived, in order to tell the simple story of their lives, and write their names in the temple of fame. Huntsman, who emerged from long seclusion over the furnace and crucible, and presented to his fellow-workmen a piece of steel which rivalled that of old Damascus, and drove from the British markets all other steels—how resplendent his name is now! How every incident in the life of Watt is sought for— his struggles, his disappointments, and his final success! And so of Mushet, Neilson, Bramah, Maudslay, Clement Murray, Nasmyth, Stephenson, and Fulton. When Watt had devised his engine he found no workmen expert enough to make it. Then Maudslay, Clement, and Murray invented automatic iron hands and fingers, and endowed them with almost human intelligence, and far more than human precision, and Watt's difficulty was removed.

The "greasy mechanics" did more to hasten the world's progress in a century—1740 to 1840—than had been ac-

complished up to that time by all the statesmen of all
the dead ages. But those heroes of the workshop had
none of the opportunities afforded by the manual train-
ing school of the present age. They toiled many hours
each day for a shilling or two, and lived in stuffy hovels,
and puzzled over the *a b c* of mechanics by the light of
a tallow-candle. Some of them gained fortunes, while
others were robbed of the fruits of genius, and slept in
unknown graves; but all their names are treasured and
honored now. The world moves, and in this age it
moves always toward a higher appreciation of the value
of the useful arts. This country is destined to become
a vast workshop, and in this workshop the best energies,
the strongest vital forces of the American people are
eventually to be exerted. How necessary, then, to edu-
cate the hands as well as the brain of the youth of the
country.[1]

Mr. Smiles, in his "Lives of the Engineers," has shown
us the true springs of English greatness. In telling the
story of the struggles and triumphs of the canal-makers,
the bridge-builders, the coal-miners, the millwrights, the
road-makers, the harbor and dock makers, the ship-build-
ers, the iron and steel makers, and the railway-builders—
in telling this story of persistence, of nerve, and "pluck,"
he has sketched the career of the real heroes of English
progress. A brief sketch of the life of James Brindley
will serve to show how these noble men wrought, how
they suffered, and how they conquered.

James Brindley was born in 1716. His parents were
poor. His father was a ne'er-do-well. His mother taught
him to be honest and industrious. James worked as a
common laborer till he was seventeen years of age. In
1733 he became a millwright's apprentice — bound for

seven years. He was a dull boy, learning slowly, but
before the end of his "bound" term he became the best
workman in the neighborhood. He helped the now cel-
ebrated Wedgwoods out of a difficulty by inventing and
constructing flint - mills for their works. He invented
and constructed pumps for clearing the Clifton coal-
mines of water—an entirely new device that opened coal
chambers which had long been completely drowned out.
His compensation for this class of work—the work of
genius—was two shillings a day!

In 1755 he built a silk-mill, in which he made several
important improvements in machinery, etc. But this
man, who possessed inventive genius of a high order and
large executive ability, could neither write legibly nor
spell correctly, and his charge for almost inestimable serv-
ices was still, in 1757, only two to four shillings a day.
His struggles to improve the steam-engine form a curious
chapter in the story of his life. It was to him that the
Duke of Bridgewater owed his success in canal-making.

The duke was born in 1736. He was a weak and sick-
ly child, his mental capacity being apparently defective
to a degree sufficient to debar him from his inheritance
of the family title and estates. An affair of the heart
which resulted unfavorably rendered him morose, and
changed his whole course of life. He abruptly quitted
the race-track, where he had condescended even to play
the rôle of "jockey," and turned his attention to the im-
provement of his estates. They contained coal depos-
its, which he undertook to develop through cheapening
transportation, and Brindley became his engineer. His
first canal, consisting largely of aqueducts, was called
"Brindley's castle in the air," and his "river hung in
the air." It was this "river hung in the air"—the first

English canal—that made the Manchester of to-day pos-
sible. Another canal enterprise of the duke cost more
than a million dollars—that connecting Liverpool with
Manchester. This latter canal yielded £80,000 per an-
num income, and it was constructed by Brindley at a
salary of 3s. 6d. a day!

Brindley was obstinate, and often quarrelled with his
employer about the methods of construction of great
works; and what is more, the duke always · yielded.
He humbly submitted to every demand made by his
engineer except a demand for compensation. Brindley's
"wage" rate during the many years occupied in the
duke's great canal enterprises was 3s. 6d. per day. This,
at all events, is the price named by Smiles in his life
of Brindley. In a note to the work it is, however, stated
that his stipulated pay was a guinea a day. It is agreed
on all hands, however, that whatever the rate agreed
upon was, Brindley was not paid, and that his heirs were
begging unsuccessfully for his just dues long after his
death. In a word, Brindley's honor as an engineer being
at stake, and it being dearer to him than any money
consideration, he worked for nothing rather than allow
the enterprise to fail. And the duke was parsimonious
enough to take the engineer's services for nothing, and
his heirs were mean enough to refuse payment for such
services when demanded by his widow.

In a literary point of view Brindley was ignorant, but
in no other respect. This was said of him by one of his
contemporaries:

"Mr. Brindley is one of those great geniuses whom
Nature sometimes rears by her own force, and brings to
maturity without the necessity of cultivation. His whole
plan is admirable, and so well calculated that he is never

at a loss; for if any difficulty arises he removes it with a facility which appears so much like inspiration that you would think Minerva was at his fingers' ends."*

The life of Brindley is typical of a score of biographies presented in the "Lives of the Engineers," among which the following are especially worthy of mention: William Edwards, John Metcalf, John Perry, Sir Hugh Myddelton, Cornelius Vermuyden, Andrew Yarranton,† Andrew Meikle, John Rennie, John Smeaton, Thomas Telford, William Murdock, Dr. D. Papin, Thomas Savery, Dud Dudley, Matthew Boulton, and William Symington. These, and their natural coadjutors, the discoverers of new forces in nature and the inventors of new things in art, the iron-workers and tool-makers—these are *the* great names in English history. They are the names without which there would have been no English history worth writing. Mr. Gladstone once said of them, naming Brindley, Metcalf, Smeaton, Rennie, and Telford, "These men who have now become famous among us had no mechanics' institutes, no libraries, no classes, no examinations to cheer them on their way. In the greatest poverty, difficulties, and discouragements their energies were found sufficient for their work, and they have written their names in a distinguished page of the history of their country."

* "Lives of the Engineers." By Samuel Smiles. London: John Murray, 1862. Vol. I., "Life of James Brindley."

† "He was the founder of English political economy, the first man in England who saw and said that peace is better than war, that trade is better than plunder, that honest industry is better than martial greatness, and that the best occupation of a government is to secure prosperity at home, and let other nations alone."—"Elements of Political Science." By Patrick Edward Dove. Edinburgh: 1854.

The admission of Mr. Gladstone that the great achieve-
ments of these heroes of invention and discovery were
won without any aid whatever, either from the govern-
ment or the people of England, is a pregnant fact. It is
the key-note of this work, the reason why it is written
and published.

The neglect of the useful arts by all the governments
of the world, from the dawn of civilization down to the
present time, is an impeachment of the common-sense of
mankind as shown in the conduct of public affairs. The
civilized man might have learned wisdom from the sav-
age, who is taught to fight, to hunt, and to fish, the brain,
the hand, and the eye being trained simultaneously. But
he chose to learn of Plato, who in the "Republic" says to
Glaucon, "All the useful arts, I believe, we thought de-
grading." And further in the same work: "We shall
tell our people, in mythical language, you are doubtless
all brethren as many as inhabit the city, but the God
who created you, mixed gold in the composition of such
of you as are qualified to rule, which gives them the
highest value, while in the auxiliaries he made silver an
ingredient, assigning iron and copper to the cultivators of
the soil and the other workmen. Therefore, inasmuch as
you are all related to one another, although your children
will generally resemble their parents, yet sometimes a
golden parent will produce a silver child, and a silver
parent a golden child, and so on, each producing any.
The rulers, therefore, have received this in charge first
and above all from the gods, to observe nothing more
closely, in their character of vigilant guardians, than the
children that are born, to see which of these metals en-
ters into the composition of their souls; and if a child
be born in their class with an alloy of copper or iron,

they are to have no manner of pity upon it, but giving
it the value that belongs to its nature, they are to thrust
it away into the class of artisans or agriculturists. And
if, again, among these a child be born with an admixture
of gold or silver, when they have assayed it they are to
raise it either to the class of guardians or to that of aux-
iliaries, because there is an oracle which declares that
the city shall then perish when it is guarded by iron or
copper."*

So ingrained in the public mind has this contempt for
the artisan and laborer become in the course of ages, that
notwithstanding the fact of the admitted kingship of
iron among metals, and notwithstanding the fact that
without iron the world would almost sink into a state of
barbarism, still the opposition to the introduction of tool
practice into the public schools is violent, and most vio-
lent among those classes who would be most benefited
by it. Pending consideration of a bill by the Massachu-
setts Assembly in 1883, providing for the admission of
manual training to the public-school curriculum, an op-
ponent of the measure said: "The introduction of the
use of tools is only another attempt to deprive the poor-
er classes of a good education. It is simply an attempt
to overload the course of studies in the schools so that
children shall not learn anything; so that the poor may
be made poorer, while the children of the rich having a
good time in the public schools may have their thought
and health preserved for higher or special education."

This is a repetition of the old answer of the Inquisition
to Galileo upon the announcement and defence of his

* "The Republic of Plato." p. 114. London: Macmillan & Co.,
1881.

great discovery. He was summoned to Rome, and "ac-
cused of having taught that the earth moves, that the
sun is stationary, and of having attempted to reconcile
these doctrines with the Scriptures." Bruno had been
driven to and fro over the face of the civilized world,
and finally burned in the year 1600 for teaching the sys-
tem of Copernicus. Having the fear of Bruno's fate be-
fore his eyes, Galileo recanted, and promised neither to
publish nor defend his theories. But his love of science
overcame his fear of oppression, and in 1632 he pub-
lished his "System of the World." Again he was sum-
moned before the Inquisition, which was destined forever
after to torment and persecute him. He was driven to
his knees before the cardinals, consigned to prison, and
tortured to blindness. After his death in a prison of the
Inquisition at the age of seventy-seven years, his right to
make a will was disputed, his body was denied burial in
consecrated ground, and his friends were prohibited the
privilege of raising a monument to his memory in the
Church of Santa Croce in Florence.

Eighteen hundred years ago a Roman emperor refused
to sanction the use of improved machinery in the prose-
cution of a great public work, on the ground that it
would deprive the poor of employment.

In 1663 a Dutchman erected a saw-mill in England,
but the hostility of the workmen compelled its abandon-
ment. More than a hundred years elapsed before the
second saw-mill was put in operation in England, and
that was destroyed by hand-sawyers.

The Flemish weavers who introduced improved weav-
ing machinery into England in the seventeenth century
were met by protests. One of these protests, addressed
to Parliament, represented that the Flemish weavers had

"made so bould as to devise engines for working of tape, lace, ribbin, and such like, wherein one man doth more among them than seven Englishe men can doe, so as their cheap sale of commodities beggereth all our Englishe artificers of that trade and enricheth them."

A little more than a hundred years ago, in England, when the Sankey Canal, six miles long, was authorized, it was upon the express condition that the boats plying upon it should be drawn by men only.

Illustrations of the *vis inertiœ* of ignorance might be multiplied indefinitely. Ignorance reverences the past. Ignorance never doubts. Ignorance is content; perfectly satisfied with its own knowledge, if the paradox may be allowed, it never seeks to increase it. But it is suspicious. In every effort to enlighten it discovers a conspiracy to undermine. Incapable of the intellectual effort of inquiry, it stagnates, and regards as a deadly enemy those who seek to disturb the serenity of its muddy pool.

When labor was only another name for a state of slavery, to teach men to labor skilfully was merely to raise them to a little higher grade of servitude. Hence it is only at a very recent period that it has occurred to mankind to teach skilled labor in the schools. All educational systems, our own among the rest, seem to have been intended to make lawyers, doctors, priests, statesmen, *littérateurs*, poets. But this is the age of steel, the age of machines and machinery. Tremendous forces in nature have been discovered and utilized, and these discoveries and their utilization have so multiplied vast enterprises that the importance of the mere ornamental branches of learning is dwarfed in their presence. This is the practical age, and an educational system which is not practical is nothing. We shall still have our Tenny-

sons, and our Longfellows, and our doctors of abstract
philosophy; but there is little time to sentimentalize with
the poets or speculate with the philosophers. There is
work to do.* The mine is to be explored and its treasures
brought to the surface; more and more powerful ma-
chines are to be constructed to bear the burdens of com-
merce; new elements of force are to be discovered and
applied to the constantly increasing wants of mankind.*

On the subject of the demand for a more comprehen-
sive educational system, Col. Augustus Jacobson says,
with great force, "Youth is the 'expensive period of
man's existence. Youth produces nothing and eats all
the time. If the youth is not trained there can hardly
be a profit to mankind on his existence. As mankind is
liable for, and bound to pay, his expenses, he should be
so trained that he may repay them. He can only become
a profitable investment by training. If he is left un-
skilled, the money spent on him is wasted. There is
no profit on a whole generation of Spaniards or Turks.
Mankind should be wise enough to reap the profit there
always is in finishing raw material, by making human
raw material into a highly finished product."

There are millions of intelligent little children in
the public schools of the United States, receiving,

* "To know the 'use' either of land or tools you must know what
useful things can be grown from the one and made with the other.
And therefore to know what is useful, and what useless, and be skil-
ful to provide the one, and wise to scorn the other, is the first need
for all industrious men. Wherefore, I propose that schools should
be established wherein the use of land and tools shall be taught con-
clusively—in other words, the sciences of agriculture (with associated
river and sea culture), and the noble arts and exercises of humanity.—
"Fors Clavigera." p. 302. Part III. By John Ruskin, LL.D. New
York: John Wiley & Sons, 1881.

doubtless, excellent intellectual or mental training. But they are not being trained for the actual duties of life as the savage child is taught to fight, to fish, and to hunt. They are not taught to labor with their hands, either skilfully or unskilfully. They are not given instruction in any department of the useful arts, notwithstanding the fact that in the case of a vast majority of them the alternative of earning their bread by the labor of their unskilled hands, or resorting to their wits for a support, will be presented immediately on their entrance upon the stage of active life. The apprentice system gave skilled mechanics to England, and her splendid manufacturing establishments are the result. The trained English apprentice became an inventor, and his inventions and art discoveries studded the island with workshops filled with automatic product-multiplying machinery.

The savage of Australia in Captain Cook's time could kill a pigeon with a spear at thirty yards, but he couldn't count the fingers on his right hand. The Southern Esquimau turns a somersault in the water in his boat with ease. But his more Northern brother has no canoe, and is ignorant of the existence of a boat; he has no use for a boat, because the sea in the latitude of his home is frozen the entire year. The savage is taught what he needs to know in his condition, and is taught nothing else; hence his skill in the few avocations he pursues.

The civilized boy in school is taught many theories, but is not required to put any of them in practice; hence he enters upon the serious duties of life unprepared to discharge any of them.* It may be said that he is in

* Discussion of the subject of technical education at a meeting of the Society of Arts, London, England, 1885.

Dr. Gladstone, F.R.S.: "It should be their aim in [elementary

real danger of the penitentiary until he learns a profession or a trade. "Of four hundred and eighty-seven convicts consigned to the State Prison for the Eastern District of Pennsylvania in 1879, five-sixths had attended public schools, and the same number were without trades." It is noticeable also that during the same period "not five were received who were what are called mechanics." In the penitentiary of the State of Illinois four out of five of the convicts have no handicraft. The fact that the skilled workman is far more likely than the common laborer to keep out of the penitentiary is a powerful argument in favor of joining manual training to the mental exercises of our common schools.

The general adoption of a comprehensive system of mechanical education in the public schools would quickly dispel the unworthy prejudice against labor which taints the minds of the youth of the country. The splendid career which this age opens to the educated mechanic should be made clear to the vision of every boy in the land, and he will see, in the tools he is taught to

schools] to give such a notion of the value of materials and the use of tools as could afterwards be turned to use in any required direction. There were two great difficulties in the way of doing this. The first and greatest was the inveterate notion that education consisted of book-learning. . . . Another difficulty was the ignorance of teachers in this respect. If an endeavor were made to introduce some knowledge of science into schools, they generally found that the teachers had some kind of theoretical knowledge, but it had been obtained mainly from books; and what was chiefly wanted was that things should be taught as well as words and before words."

Prof. Guthrie, F.R.S.: "This method of bringing the hand and the mind to work together really lay at the basis of all true technical instruction; where the mind alone was employed the knowledge acquired passed away, but when the mind and the hand had been educated together the knowledge was never forgotten."

handle, the key not only to fair success, but to wealth and fame. Professor Thurston, President of the American Society of Mechanical Engineers, thus sums up the mighty power wielded by the mechanic:

"The class of men from whose ranks the membership of this society is principally drawn direct the labors of nearly three millions of prosperous people in three hundred thousand mills, with $2,500,000,000 capital; they direct the payment of more than $1,000,000,000 in annual wages; the consumption of $3,000,000,000 worth of raw material, and the output of $5,000,000,000 worth of manufactured products. Fifty thousand steam-engines, and more than as many water-wheels, at their command turn the machinery of these hundreds of thousands of workshops that everywhere dot our land, giving the strength of three million horses night or day."*

* Inaugural address, as President of the American Society of Engineers, New York, November 4, 1880.

[1] "Deeds are greater than words. Deeds have such a life, mute but undeniable, and grow as living trees and fruit-trees do; they people the vacuity of Time, and make it green and worthy."— "Past and Present," p. 139. By Thomas Carlyle. London: Chapman & Hall.

[2] "Natural science is the point of interest now, and I think it is dimming and extinguishing a good deal that was called poetry. These sublime and all-reconciling revelations of nature will exact of poetry a correspondent height and scope, or put an end to it." —Letter of R. W. Emerson to Anna C. L. Botta, "Memoirs of —. By her friends," 8vo, pp. 459. J. Selwin, Tait & Sons.

CHAPTER XVII.

POWER OF STEAM AND CONTEMPT OF ARTISANS.

A few Million People now wield twice as much Industrial Power as all the People on the Globe exerted a Hundred Years ago.—A Revolution wrought, not by the Schools and Colleges, but by the Mechanic.—The Union between Science and Art prevented by the Speculative Philosophy of the Middle Ages.—Statesmen, Lawyers, Littérateurs, Poets, and Artists more highly esteemed than Civil Engineers, Mechanics, and Artisans.—The Refugee Artisan a Power in England, the Refugee Politician worthless.—Prejudice against the Artisan Class shown by Mr. Galton in his Work on " Hereditary Genius."—The Influence of Slavery: it has lasted Thousands of Years, and still Survives.

WHAT the civil engineers and mechanics of England have done for that country the same classes here have done for America. It is by these classes that all civilized countries have been made prosperous and great. And the agent through which the power of man has been augmented a thousand-fold is steam. " In the manufactures of Great Britain alone, the power which steam exerts is estimated to be equal to the manual labor of four hundred millions of men, or more than double the number of males supposed to inhabit the globe."* This is the most significant fact of all time, namely, that a few millions of people in a small island now wield twice as much industrial power as all the people on the globe exerted one hundred years ago. And it is a fact of the utmost

* "Brief Biographies: James Watt," p. 1. By Samuel Smiles. Chicago: Belford, Clark & Co., 1883.

significance that the public educational institutions of
England contributed scarcely anything to this industrial
revolution, whose influence now comprehends all civilized
countries. The men by whom it was wrought came not
from the classic shades of the universities, but from the
foundery, the forge, and the machine-shop. There has
been very little change in educational methods since the
time when Bacon said, "They learn nothing at the univer-
sities but to believe." He proposed that a college be es-
tablished and devoted to the discovery of new truth. No
such college has, however, been established, but many new
truths have been discovered. Suppose all the universities
of England, of the United States, and of all other highly
civilized countries had, from the time of Bacon, been
conformed to his ideas, and devoted to the discovery of
new truths? Such a course would have united science
and art, and insured vastly greater progress, no doubt,
than that which has actually taken place. The union of
science with art has thus far been rendered impossible
by reason of the wide prevalence of purely speculative
views. The speculative philosophy of the Middle Ages
still projects its baleful influence over our institutions of
learning. Abstract ideas are still regarded as of more
vital importance than things. Statesmen, lawyers, litté-
rateurs, poets, and artists are more highly esteemed than
civil engineers, machinists, and artisans. Mr. Smiles, in
his excellent work on the Huguenots, has shown that
England owes to the French and the Flemish immigrants
"almost all her industrial arts and very much of the most
valuable life-blood of her modern race."* Commenting

* "In short, wherever the refugees settled they acted as so many
missionaries of skilled work, exhibiting the best practical examples
diligence, industry, and thrift, and teaching the English people in

upon this fact in his work on "Hereditary Genius," Mr. Francis Galton says,

"There has been another emigration from France of not unequal magnitude, but followed by very different results, namely, that of the revolution of 1789. It is most instructive to contrast the effects of the two. The Protestant emigrants were able men, and have profoundly influenced for good both our breed and our history; on the other hand, the political refugees had but poor average stamina, and have left scarcely any traces behind them."*

This is the testimony of a distinguished student of biology; and it is to the effect that the refugee artisan is of immense value to the country where he finds an asylum, while the refugee politician is of no value at all. We should naturally say, our author having made this important discovery will enlarge upon it. First of all, he will deduce the conclusion that if the refugee politician is of no value to the country where he finds an asylum, the home politician is an equally unimportant factor in the social problem. Then he will make an exhaustive study of the industrial class as the chief basis of his propositions and speculations on the subject of the science of life. Not at all. Mr. Galton, in his work on "Hereditary Genius," offers another striking illustration of the repressive force of habit and the influence of popular prejudice. In his classifications of men according to

most effective manner the beginnings of those various industrial arts in which they have since acquired so much distinction and wealth."— "The Huguenots," p. 107. By Samuel Smiles. New York: Harper & Brothers, 1867.

* "Hereditary Genius," p. 360. By Francis Galton, F.R.S., etc. New York: D. Appleton & Co., 1880.

their professions, with a view to the inquiry whether
"genius, talent, or whatever we term great mental ca-
pacity, follows the law of organic transmission—runs in
families, and is an affair of blood and breed"—in such
classifications Mr. Galton forgets for the time being that
there is an industrial class. He runs through the entire
social scale, from "the judges of England between 1660
and 1865," not omitting Lord Jeffreys, down through
statesmen, commanders, literary men, poets, musicians,
men of science, painters, divines, the boys in Cambridge,
oarsmen, and wrestlers of the North Country, but has
no word to say of the civil engineers, or of the invent-
ors — those immortal men whose monuments in stone
and iron exist in every corner of England.

Buckles's caustic remark, "the most valuable addi-
tions made to legislation have been enactments destruc-
tive of preceding legislation, and the best laws which
have been passed have been those in which some former
laws have been repealed," does not apply to the works
of the civil engineers, inventors, and mechanics of Eng-
land or of any other country. Their works live after
them and never fail to reflect honor upon them. The
"acts" of the inventor may be amended but they are
never repealed. Each inventive step, however short and
apparently unimportant, constitutes a substantial link in
the chain of progress; and it is a substantial link, be-
cause it invariably contains a hint of the next sequen-
tial step.

Mr. Galton is an original thinker of great power, and
an untiring investigator. In contrasting the politician
with the artisan he discriminates admirably. He finds
that the politician is of no value, practically, to the com-
munity, while the artisan is of almost in

and this conclusion he states curtly, without appearing to
care a rush for the public sentiment which reverences
politics and so-called statesmanship. But when he "makes
up his jewels," so to speak, on the subject of "hereditary
genius," Mr. Galton, as already remarked, forgets that it
is worth while to consider the class of men who in the
last hundred years have literally almost created a new
world. Why is this? The late Mr. Horace Mann an-
swered the question long ago, and he answered it so well
that his answer is here reproduced *in extenso:* "Man-
kind had made great advances in astronomy, in geome-
try, and other mathematical sciences, in the writing of
history, in oratory and in poetry, in painting and in
sculpture, and in those kinds of architecture which may
be called regal or religious, centuries before the great
mechanical discoveries and inventions which now bless
the world were brought to light; and the question has
often forced itself upon reflecting minds why there was
this *preposterousness*, this inversion of what would ap-
pear to be the natural order of progress? Why was it,
for instance, that men should have learned the courses
of the stars and the revolution of the planets before they
found out how to make a good wagon-wheel? Why was
it that they built the Parthenon and the Coliseum be-
fore they knew how to construct a comfortable, healthful
dwelling-house? Why did they build the Roman aque-
ducts before they framed a saw-mill? Or why did they
achieve the noblest models in eloquence, in poetry, and
in the drama before they invented movable types? I
think we have arrived at a point where we can unriddle
this enigma. The labor of the world has been performed
by ignorant men, by classes doomed to ignorance from
sire to son; by the bondmen and the bondwomen of the

Jews, by the helots of Sparta, by the captives who passed under the Roman yoke, and by the villeins and serfs and slaves of more modern times."

When the great educational reformer of Massachusetts thus graphically pointed out slavery as the cause of the contempt in which the useful arts had been held from the dawn of history, four millions of men were kept in bondage and compelled to toil under the lash by one of the most enlightened nations of the earth. Later thirteen millions of people pledged "their lives, their fortunes, and their sacred honor" to the perpetuation of slavery, and half a million soldiers marched repeatedly to battle to do or die in behalf of the right (?) of one man to buy and sell the bodies of his fellow-men.

There is, then, a logical reason for Mr. Galton's neglect of the artisan class. Slavery in its most odious form not only existed in the heart of a so-called "free" nation twenty-five years ago, but dared Liberty to a deadly contest. Nor were the upholders of slavery without moral support among the governments and peoples of the world. The government of England, of which Mr. Galton is a subject, under cover of a pretended neutrality aided the American slaveholders' Confederacy in sweeping Freedom's ships from the sea; and the great families of England, the families cited by Mr. Galton in support of his proposition that genius "is an affair of blood and breed"—those great families were well pleased when Freedom's ships went down and Freedom's armies retreated before the assaults of the slave confederacy.

This somewhat extended reference to Mr. Galton is not intended to impugn his good faith as an author. Its design is simply to show that the influence of slavery is not yet extinct; that it still moulds ideas, controls hal

of thought, inspires literary men, and permeates literature. In a word, the cause of the contempt in which the useful arts were held in Babylon in the time of Herodotus was in full force in this country down to the date of the issuance of Mr. Lincoln's proclamation of emancipation; and it is scarcely necessary to observe that the British Constitution grew out of the feudal system, which was only another name for slavery. It is a proverb in England to this day that it is safer to shoot a man than a hare; and the sentiment of the proverb is a complete justification of human bondage, since it implies that property rights are more sacred than the rights of man. Thus slavery has kept its brand of shame upon the useful arts for thousands of years, and the mind of man has been so deeply impressed thereby that it does not react now that slavery is extinct. Like the slave released from bondage, who still feels the chain, still winces and shrinks from the imaginary scourge, the mind of man continues to revolve automatically in the old channels.[1]

[1] "It is related of the Scythians that they became involved in a contest with the descendants of certain of their slaves, who successfully resisted them in several battles, whereupon one of them said: 'Men of Scythia, what are we doing? By fighting with our slaves, both we ourselves by being slain become fewer in number, and by killing them we shall hereafter have fewer to rule over. Now, therefore, it seems to me that we should lay aside our spears and bows, and that everyone, taking a horsewhip, should go directly to them; for so long as they saw us with arms, they considered themselves equal to us, and born of equal birth; but when they shall see us with our whips instead of arms, they will soon learn that they are our slaves, and being conscious of that will no longer resist.' The Scythians, having heard this, adopted the advice; and the slaves, struck with astonishment at what was done, forgot to fight and fled."—Herodotus, "Melpomene," IV. §§ 3, 4. New York: Harper & Brothers, 1882.

CHAPTER XVIII.

AUTOMATIC CONTRASTED WITH SCIENTIFIC
EDUCATION.

The Past tyrannizes over the Present by Interposing the Stolid Re-
sistance of Habit. — Habits of Thought like Habits of the Body
become Automatic. —There is much Freedom of Speech but very
little Freedom of Thought : Habit, Tradition, and Reverence for
Antiquity forbid it.—The Schools educate Automatically.—A glar-
ing Defect of the Schools shown by Mr. John S. Clark, of Boston.
—The Automatic Character of the Popular System of Education
shown by the Quincy (Mass.) Experiment. — Several Intelligent
Opinions to the same Effect.—The Public Schools as an Industrial
Agency a Failure. — A Conclusive Evidence of the Automatic
and Superficial Character of prevailing Methods of Education in
the Schools of a large City.—The Views of Colonel Francis W.
Parker.—Scientific Education is found in the Kindergarten and
the Manual Training School. — "The Cultivation of Familiarity
betwixt the Mind and Things."—Colonel Augustus Jacobson on
the Effect of the New Education.

ALL reforms must encounter the stolid resistance of
habit. It is not less tyrannical because it is a negative
force. It braces itself and holds back with all its might.
It is in this manner that the past dominates the present.[1]
This automatic habit of mind is precisely like certain
automatic habits of the body which operate quite inde-
pendently of any act of volition. For example: "When
we move about in a room with the objects in which we
are quite familiar, we direct our steps so as to avoid
them, without being conscious what they are or what we
are doing; we *see* them, as we easily discover if we
to move about in the same way with one

we do not *perceive* them, the mind being fully occupied
with some train of thought."* In the same way the
mind under certain conditions becomes an automaton,
constantly revolving old thoughts after the causes that
gave rise to them have ceased to operate. Piano-forte
playing affords an excellent illustration of this automatic
action of the mind. "A pupil learning to play the piano-
forte is obliged to call to mind each note, but the skil-
ful player goes through no such process of conscious
remembrance; his ideas, like his movements, are auto-
matic, and both so rapid as to surpass the rapidity of
succession of conscious ideas and movements."†

Freedom of speech and freedom of thought are catch-
penny phrases. There is much of the former, but very
little of the latter. Speech is generally the result of au-
tomatic thought rather than of ratiocination. Independ-
ent thought is of all mental processes the most difficult
and the most rare; habit, tradition, and reverence for
antiquity unite to forbid it, and these combined influ-
ences are strengthened by the law of heredity. The ten-
dency to automatic action of the mind is still further
promoted by the environment of modern life. The
crowding of populations into cities, and the division and
subdivision of labor in the factory and the shop, and
even in the so-called learned professions, have a tenden-
cy to increase the dependence of the individual upon the
mass of society. And this interdependence of the units
of society renders them more and more imitative, and
hence more and more automatic both mentally and phys-
ically.

* "Body and Mind," p. 22. By Henry Maudsley, M.D. New
York: D. Appleton & Co., 1883.
† Ibid., p. 26.

Another powerful influence contributes to the same end. The schools educate automatically. They train the absorbing powers of the brain, but fail to cultivate the faculties of assimilation and re-creation, and neglect almost wholly to develop the power of expression. Mr. John S. Clark, of Boston, has made this point of the failure of the schools to train the brain-power of expression to its utmost, so plain that it is here reproduced in full, as follows:

"Studying the functions of the brain, we find that for educational purposes it may be likened to an organism with a threefold form of working, an organism with a power of absorption, a power of assimilation and re-creation, and a power of expressing or giving out. The force or character of a brain is measured entirely by its expressing power, by what comes out of it. Examining a little closer, we find that the brain absorbs through all the five senses, while for expressing purposes it makes use of but two of these senses, or rather of but two organs of these senses— the tongue and the hand. *Fig.* 1 is a simple diagram representing a brain with the five senses placed on one side, as means of absorbing power, while on

Fig. 1.

the other side the tongue and the hand are placed as organs of expressing power. The other function of the brain, that of assimilation and re-creation, cannot of course be graphically represented. It may, however, be said to be the result of the action of the other two functions. Now, the equipping of a brain, or the healthy education of a brain, consists in giving it expressing

power through the tongue and the hand, coextensive with the power of absorption and the power of re-creation.

Applying our popular schemes of education to the brain, and especially those based on the 3-R idea of education, we find what is indicated in *Fig.* 2, that provision has been made for greatly distending the absorbing side of the brain, while for the expressing side, the practical side, provision has been limited to the use of the tongue in speech and to the hand in writing. If now we follow the result of this brain equipment into practical life, we find that speech and writing, as means for expressing

Reading.
Mathematics.
Geography.
Grammar.
History.
Languages.
Physiology.
Literature.
Natural History.
Theoretical Sciences.

Five Senses.

Tongue.
Speech.
Hand.
Writing.

Fig. 2.

thought, have their applications mainly in the commercial and financial employments and the professions, and only incidentally in the industrial and mechanical employments. With such an inadequate and one-sided brain equipment it is not possible in any broad, practical way to bring thought or brain-power to the service of industry. The fact so generally admitted, that we are getting so few intelligent artisans or mechanics from our scheme of public education, that we turn out pupils of both sexes with a decided repugnance to industrial labor, is an attestation to the truth of this statement. The simple fact is that our education is not broad enough on the expressing side of the brain, that too much attention has been given to the absorbing side of

this organ, that no adequate provisions have been made whereby it can discharge its power in work connected with the industries.

"In *Fig.* 3 a remedy for this defect is indicated in the addition of the study of graphic and æsthetic art, through drawing, and of training in the manual arts, to the previous brain equipment. Observe where these features come in the scheme—on the expressing side of the brain and in the service of the hand, thus giving the brain ample power to discharge thought in its most complete form for use or for beauty. With these features added to the brain equipment its power of expressing thought

Reading.
Mathematics.
Geography.
Grammar.
History.
Languages.
Physiology.
Literature.
Natural History.
Theoretical Sciences.
Practical Sciences.

Five Senses.

Tongue.
Speech.
Hand.
Writing.
Drawing.
Manual Arts.

Fig. 3.

in all practical directions will be coextensive with its absorbing and re-creating powers; and just as soon as the public can clearly see that in the outcome of our public education there is no respecting of persons or of classes, that pupils are trained for honest labor with their hands as well as to living by their wits, are taught to produce something, to *create values* by the action of their brain through the work of their hands, a much deeper interest in public education will not only be manifested, but generous provisions for its support will also be given."*

The charge that the schools educate automatically

* Address delivered before the Philadelphia Board of Trade and the Franklin Institute, June 6, 1881.

rather than rationally is of such vital importance that
it should be sustained by the best attainable proof.
Strong proof is at hand in the history of the so-called
Quincy (Mass.) experiment.

In 1878 doubt of the efficiency of the schools of Nor-
folk County, long indulged, culminated in action by the
Association of School Committees and Superintendents.
It was insisted by certain members of the committee that
the existing methods were "about as good as human in-
telligence could devise," and by others that the people
were getting "no adequate returns for the money ex-
pended under the system in general use." It was re-
solved to institute a searching investigation, and the
standard for the measurement of the acquirements of
pupils adopted was, "a reasonable degree of ability to
read, to write legibly, correctly, and grammatically, and
to deal readily with simple mathematics after about eight
years of schooling."

The association selected Mr. George A. Walton, an
experienced educator, to make the examination of the
schools of the county, and the number of pupils exam-
ined exceeded three thousand. In their preface to Mr.
Walton's report the gentlemen of the association say:

" Publicity, discussion, and discontent are wholesome
things to apply to school management in Massachusetts.
That this is a fair sample of the results now accomplished
cannot be questioned. But though they may not be flat-
tering to our pride, we yet believe that they are as good
as can be obtained in any other county in Massachusetts,
or, indeed, of any other State where similar tests are
applied in a similar manner. If any school authorities
elsewhere doubt the truth of this statement, let the ex-
periment be tried in the schools of their county.

"The questions naturally arise, What is the cause of this lamentable ignorance? and what is the remedy? The answer to the former suggests the reply to the latter. Too much has been attempted in the schools. There has been a slavish adherence to text-books, and no room given for freedom and originality of thought. Rules have been memorized, and the children taught to recite from the text-book, while they have not had the slightest conception of the true meaning of the subject. . . .

"The rules and exceptions in grammar are faithfully committed to memory, and most intricate sentences can be successfully analyzed, the phrases separated, and the modifiers named in true grammatical style, while the pupils who have undergone such severe training in this respect are unable to present their own thoughts concisely or clearly, or even *correctly*, upon paper. The *memory* is cultivated, and the *reason* allowed to slumber.

"In arithmetic the pupils show a readiness to solve a problem when they are able to fit it to some rule that they have learned; but when they are given a simple question out of the regular course, they are like a ship at sea without rudder or compass."

This is the severest and most sweeping criticism ever passed upon our American common-school system, and it emanates from its friends and the friends of universal education.

Mr. Walton says of reading, as taught in the Norfolk County schools, "As for any systematic analysis by which the pupil learns to make a careful and independent study of his piece, it is but little practised in the schools even of the grammar grade;" and he declares that reading, without comprehending the ideas of which the words are mere signs, "is not merely useless, but dangerous,

just in proportion to the facility with which the words
are called."

Of the results of his examinations in penmanship Mr.
Walton says, "Most of the faults in the writing indicate
imperfect teaching." Of his examinations in spelling he
says that "the commonest words are misspelled when used
in sentences or composition, while words of difficult or-
thography are spelled with accuracy when dictated for
spelling." For example, he says, "The words 'whose,'
'which,' and 'father,' when spelled orally, were generally
correct, but when written in sentences they were fre-
quently, in many schools, in a majority of cases, errone-
ous." No test could more clearly demonstrate the purely
mechanical character of the methods of instruction than
this of a comparison between the pupils' oral and written
spelling. The average of excellence in spelling the three
simple words "which, whose, scholar," of the primary
grade for the whole county of Norfolk, as found by Mr.
Walton, was the exceedingly low one of 55.9, the basis
being 100.

The ingenuity in bad spelling of this grade of pupils,
who had been at least four years in school, is well illus-
trated by the example of the word "carriage," written
as follows : "Carage, carrage, craidge, caradg, carege, car-
riag, carrige;" and of the word "sleigh," written "saly,
slay, slaig, slaigh, slagh, slaw, sleig, sleugh, sleight, sligh,
sley, slew, slave, sleygh;" and of the word "Tuesday,"
written "Tusgay, tuestay, toesday;" and of the word
"Wednesday," written "wanesday, wedenyday, Wederns-
day, wednest, Wenday, Wendsday, wensday, wenesday,
wensdaw, wenze, Wenzie, Wendsstay, wenstday, Wesday,
Whensday, winday, Windday, Winsday," etc.

The word "scholar" presented one hundred and sixty

different erroneous spellings; that of "depot" fifty, among which were the following: "Deappow, deppowe, deaphow, deapohoe, teapot, doopo," and "bepo." An exercise in spelling by both grades of pupils, the "primary," composed of pupils from eight and a half to ten and a half years old, and the "grammar," composed of pupils from twelve and a half to fifteen and a half years old, showed errors of which the following are examples: *Any*, spelled ane and enny; *along*, alond and alon; *amongst*, amunt; *animals*, anables; *arithmetic*, rithmes; *asked*, asted; *beautiful*, beuful; *been*, ben, bene, and bin; *by-and-by*, bimeby; *coat*, coot, coth, cote, goat, and coate; *Boston*, bostone; *boy*, poy, and bou; *city*, sitty; *eggs*, ages; *custard-pie*, cnsted puy; *coming*, comin, commun, gomming, and comming.

An exercise in composition developed the following specimen errors: "The was two boys; They was two boys; How is all the boys? Things that was good; They is not many here I know; He come to school; I see him yesterday; He asked cyrus what he done that day; I had saw him; he had wore a coat," etc.

The examinations in mathematics yielded similar results to those developed in reading, writing, spelling, and composition. Mr. Walton says, "If instead of this [the routine method of the school] the pupil should be compelled to deal with real things, and to find his answer by studying the conditions of his problem, the fiction which arithmetic now is to most pupils would become to them a reality."*

* "The New Departure in the Common Schools of Quincy," by Charles F. Adams, Jr., and the "Report of Examination of Schools in Norfolk County, Mass.," by George A. Walton. Boston: Estes & Lauriat, 1881.

The prime difficulty is here stated. The schools deal in "fictions." In the language of the Norfolk County committee, "The *memory* is cultivated and the *reason* allowed to slumber." Now, if to every fact memorized the pupil were required to apply the test of reason to analyze it and find out its relation to other facts, and fix it with all its relations in his mind, he would possess certain solid information of an ascertained practical value. It is very simple. It is making the pupil think for himself by showing him how to think for himself instead of thinking for him. Of course this is object-teaching. In the reading-lesson the pupil is required to know the meaning of the words of which it is composed in order to read with correct expression. When required to spell a word orally he is also required to write it. In the study of arithmetic he is shown certain objects, blocks of cubical and other forms, and required to apply the rules of the book to the ascertainment of their contents. In grammar the analysis of the sentence is followed by the writing of it, and the construction of other sentences involving similar principles in the art of composition, and so on.

This is the kindergarten system now rapidly coming into high favor as an essential preliminary step in education. It is also the system of the manual training school. Under this system the pupil is not merely told that the saw is a thin, flat piece of steel with teeth used for cutting boards and timbers; a saw is placed in his hand and he is taught to use it: and so of all the hand and machine tools of the trades. He stands at the forge, bends over the moulding-form, shoves the plane in the carpenter-shop, presides at the turning-lathe, that ingenious invention of Mandslay—an automaton truer than the human

eye, more cunning and more accurate than the human hand; executes plans for patterns and then makes the patterns, and finally, from the faint lines he has traced on paper, constructs a machine, breathes the breath of life (steam) into its veins, and with it moves mountains!

In further support of the charge that the schools educate automatically, and hence superficially, the following intelligent opinions are cited:

Charles Francis Adams, Jr., remarks that the common schools of Massachusetts cost $4,000,000 a year; and adds, "The imitative or memorizing faculties only are cultivated, and little or no attention is paid to the thinking or reflective powers. Indeed it may almost be said that a child of any originality or with individual characteristics is looked upon as wholly out of place in a public school. . . . To skate is as difficult as to write; probably more difficult. Yet in spite of hard teaching in the one case and no teaching in the other, the boy can skate beautifully, and he cannot write his native tongue at all."*

Mr. Edward Atkinson says, "We are training no American craftsmen, and unless we devise better methods than the old and now obsolete apprentice system, much of the perfection of our almost automatic mechanism will have been achieved at the cost not only of the manual but also of the mental development of our men. Our almost automatic mills and machine-shops will become mental stupefactories."†

Prof. Barbour, of Yale College, says, "Our schools are

* "Scientific Common-school Education."—*Harper's Magazine*, November, 1880, (see note 2 at end of chapter).

† "Elementary Instruction in the Mechanic Arts."—*Scribner's Monthly*, April 1881, p. 902.

suffering from congestion of the brain: too much thought
and too little putting it in practice."

An English observer of our public schools says, "They
teach apparently for information, almost regardless of de-
velopment. This system develops no special individual-
ity or power, forms few habits of observation, benefits
little except the memory, and herein lies its great weak-
ness."

The late Mr. Wendell Phillips said, "Our system stops
too short, and as a justice to boys and girls as well as to
society it should see to it that those whose life is to be
one of manual labor should be better trained for it."

Mr. Wickersham, late Superintendent of Public In-
struction for the State of Pennsylvania, says, "It is
high time that something should be done to enable our
youth to learn trades and to form industrious habits and
a taste for work."

Dr. Runkle, of the Massachusetts Institute of Tech-
nology, says, "Public education should touch practical
life in a larger number of points; it should better fit all
for that sphere in life in which they are destined to find
their highest happiness and well-being."

Opinions of this character might be multiplied almost
indefinitely. They reflect the general sentiment that, as
an industrial agency, the public school is a failure; but
its value as an enlightening and civilizing agency is not
therefore underestimated. It was not established as an
industrial agency; it was established as a bulwark of lib-
erty, and nobly did it fulfil its mission. The colonial
fathers had a horror of ignorance, and as a barrier against
it they raised the public school. But they were without
industrial interests in the higher departments of skilled
labor, and without commerce in a large way. Lord Shef-

field said that the American colonies were founded with
the sole view of securing to England a monopoly of their
trade, and Lord Chatham declared that they had no right
to manufacture even a nail or a horseshoe. Even after
the Revolution, in 1784, the commerce of the country
was so insignificant that eight bales of cotton shipped
from South Carolina were seized by the customs authori-
ties of England on the ground that so large a quantity
could not have been produced in the United States!

These humble conditions no longer exist, and to object
to the expansion of the public-school system to meet
the requirements of new exigencies is to ignore the logic
and march of events. The nations are running an in-
dustrial race, and the nation that applies to labor the
most thought, the most intelligence, will rise highest in
the scale of civilization, will gain most in wealth, will
most surely survive the shocks of time, will live longest
in history. In the race for industrial supremacy we are
not at the front. It is a fact to be pondered that we are
exchanging the products of unskilled for skilled labor
with the nations of Europe. In the course of a year, for
example, England exports of raw material and food only
about $150,000,000 in value, while her exports of manu-
factures aggregate about $850,000,000 in value. On the
other hand, our exports consist almost entirely of raw
material and food, their annual value being about
$800,000,000, while of manufactures we export only a
beggarly $75,000,000 worth, and our imports of manu-
factures are of the annual value of about $250,000,000.
In crude, uneducated, unskilled labor capacity, we have
grown much more rapidly than in the departments of
educated, skilled labor; and in the exact ratio of this
growth of unskilled over skilled labor, we are behind the

age. We are industrially ill-balanced. We are selling brawn and buying thought—cunning, invention, genius; exhausting our physical manhood and impoverishing a virgin soil. We are suffering from a paucity of skilled labor, and we hesitate to apply the needed and obvious-ly adequate remedy—the training of the youth of the country in the elements of the useful arts, in the public schools.

A final and conclusive evidence of the verity of the charge that prevailing methods of education are auto-matic, and hence superficial in their character, is found in an examination test recently made in one of the public schools in a large American city, in the department of mathematics. The superintendent begins to distrust his own system of abstract instruction, and resolves to test the acquirements of certain classes of pupils ranging from ten to twelve years of age. He submits a series of ques-tions in number, which are promptly solved either orally or in chalk on the black-board, showing a complete mas-tery of the subject from the abstract side, or point of view. To test the practical value of the knowledge thus exhibited the superintendent repeats his series of ques-tions, applying them to things. For example: He passes six cards to a pupil, and requests that one-half of them be returned. This question having been promptly and cor-rectly answered by the return of three of them, and the six cards being again placed in the hands of the pupil, the second question is propounded, namely, " Please give me one-third of one-half of the cards in your hand." The pupil is puzzled; he fumbles the cards nervously, blushes, and returns a wrong number or becomes entirely helpless and "gives it up." This question, or some other question of similar general import, is submitted to each

member of the class with a like unfavorable result in
eight or nine cases in a total of ten cases. The superin-
tendent is astonished ; he is more than astonished, he is
deeply chagrined ; for he knows that the kindergarten
child of six or seven years of age, with the blocks, would
answer his series of questions correctly eight or nine
times in a total of ten.

It is impossible to conceive of a more striking illustra-
tion of the prime defects of automatic education than is
afforded by the foregoing described experiment. It sus-
tains and justifies the severe criticism of the schools by
Mr. Charles Francis Adams, Jr., in his magazine article
of 1880, in the course of which he says,

"From one point of view children are regarded as
automatons; from another, as india-rubber bags; from
a third, as so much raw material. They must move in
step and exactly alike. They must receive the same
mental nutriment in equal quantities and at fixed times.
Its assimilation is wholly immaterial, but the motions
must be gone through with. Finally, as raw material,
they are emptied in at the primaries, and marched out
at the grammar grades—and it is well !"*

The testimony of Col. Francis W. Parker, of the Cook
County (Illinois) Normal School, is to the same effect.
He says,

"The most important work of to-day is to collect, rec-
oncile, and apply all the principles and methods of edu-
cation that have been discovered in the past, into one
science and art of teaching. This would certainly radi-
cally change all our school work in this country. When

* " Scientific Common-school Education."—*Harper's New Monthly
Magazine*, November, 1880, p. 937.

this is done the ground will be made ready for new ad-
vances in the incomplete science of education. Because
a complete science has not yet been discovered is a very
poor reason for not applying what we already know.
What specific changes would the application of known
mental laws, in teaching about which all psychologists are
in agreement, bring about? For it is only by a sharp
comparison of what is now done according to tradition
and custom in our schools, with that which can be done
by the application of the simplest principles of teaching,
that the value of the true art of instruction may be in
some degree appreciated.

"To illustrate this it may be mentioned that little
children have been taught to read, in the past, and a great
majority of them are now taught, by a method that is
utterly opposed to a mental law, about which there can
be no dispute among those who know anything of the
science of teaching. I refer to the A B C method. Near-
ly three hundred years ago Comenius discovered a rule
of teaching which may be said to embrace all rules in its
category—'Things that have to be done should be learned.
by doing them.' This rule is so simple and plain that
every one, except the teachers, has adopted and used it
since man has lived upon the earth. If I am not very
much mistaken, the school-master for the last fifty years
has been incessantly inventing ways of doing things in
the school-room by doing something else. We try to
teach the English language by rules, definitions, analyses,
diagrams, and parsing. Before the poor innocent child
can write a single sentence correctly, we teach the painful
pronunciation of words without the grasping of thought
as reading. We vainly endeavor to give children a
knowledge of number by teaching figures, the signs of

number. We cram our victim's mind full of empty, meaningless words, instead of inspiring and developing it by the sweet and strong realities of thought. This futile struggle to do things by doing something else is to-day costing the people of this country millions and millions of hard-earned dollars; and it is much to be feared that it will one day cost their children the blessings of free government. This is a serious charge.

"The three hundred thousand teachers of this country are as faithful, honest, and earnest as any other class of active workers. If, then, these great truths in education be at the doors of our educators, why do they not acquire and use them? The answer is not far to seek. Not one teacher in five hundred ever makes a practical, thorough study of the *history* of education, to say nothing of the science.

"The tremendous projecting power of tradition stands stubbornly in the way of progress in education. It can only be met and overcome by the most thorough searching and indefatigable study of the child's nature, and of the means by which the possibilities for good in God's greatest creation may be realized."*

The change from automatic to scientific education ought not to be very difficult. It has been made in the kindergarten. It consists in substituting things in place of signs of things. The boys should be taught to read in school as he will be required to read; to write as he will be required to write; and to cipher as he will be required to cipher, when he becomes a man.

In teaching chemistry, for example, there should be

* Letter to the author under date of April, 1883, and by him reproduced in a communication published in the *Chicago Tribune,* April 23, 1883.

a laboratory with the necessary illustrative apparatus. In teaching geography, in addition to the books and the globe, the form of the continent should be moulded in sand, with coast lines, mountain ranges, rivers, canals, harbors, cities, etc. In teaching number the pupil should have the things and parts of things, represented by signs, in his hands. In teaching mechanics the pupil should handle the saw, the plane, the file, the hammer, and the chisel, and stand at the bench, the forge, and the turning-lathe. It is in this way only that the pupil can be taught the power of expressing, as Mr. Clark puts it, " what has been absorbed on the receptive side."

Mr. MacAlister illustrates the force of Mr. Clark's diagrams in a sentence: " We must not close our eyes to the fact that by far the larger number of men in every civilized community are workers to whom a skilled hand is quite as important as a well filled head."* The prevailing methods of teaching fill the head but do not provide for assimilation, re-creation, and expression. Now to assimilate, to reduce to practical value and put to use facts memorized, and to create, the power of expression is an essential prerequisite; creating is expressing ideas in concrete form. But under the old *régime* of education only two modes of expression are provided—speech and writing. A third mode—drawing—has been very generally adopted. Drawing, however, is only the first step, an incomplete step, so to speak, of expression. It is a sign, an outline, of a thing. What we want is the thing itself. That thing can only be produced at the forge, the bench, or the lathe; and this is manual training in the arts.

* Mr. James MacAlister, Superintendent of Schools of the City of Philadelphia, Pa., at the meeting of the American Institute of Instruction, Saratoga, N. Y., July 13, 1882.

What manual training will do for the pupil is ex-
pressed in the following terse paragraph by Col. Augus-
tus Jacobson:

"The boy leaving school should carry with him me-
chanical, business, and scientific training, fitting him for
whatever it may become necessary for him to do in the
world. I would secure for society the advantage of all
the brain capacity that is born and all the training it can
take. It is possible and practicable to let every child of
fair capacity start in life from his school a skilled worker,
with the principal tools of all the mechanical employ-
ments, an athlete with the maximum of health possible
to him, and thoroughly at home in science and literature.
The child so trained would, when grown, be to the ordi-
nary man of to-day what Jay-Eye-See is to an ordinary
plough-horse."

[1] "Fortunately the past never completely dies for man. Many
may forget it, but he always preserves it within him. For, take him
at any epoch, and he is the product, the epitome, of all the earlier
epochs. Let him look into his own soul, and he can find and dis-
tinguish these different epochs by what each of them has left within
him."—"The Ancient City," p. 13. By Fustel De Coulanges. Bos-
ton: Lee & Shepard, 1882.

[*] "In fact, memory comes from interest. What children are
deeply interested in they will never forget. A boy who can never
say his lesson by heart will remember every detail of the cricket or
football matches in which his heart really lives."—"Educational
Theories," p. 116. By Oscar Browning, M.A. New York: Harper
& Brothers, 1885.

CHAPTER XIX.

AUTOMATIC CONTRASTED WITH SCIENTIFIC EDU-CATION—*Continued*.

The Failure of Education in America shown by Statistics of Railway and Mercantile Disasters.—Shrinkage of Railway Values and Failures of Merchants.—Only Three Per Cent. of those entering Mercantile Life achieve Success.—Business Enterprises conducted by Guess: Cause, Unscientific Education.—Savage Training is better because Objective.—Mr. Foley, late of the Massachusetts Institute of Technology, on the Scientific Character of Manual Education —Prof. Goss, of Purdue University, to the same Effect—also Dr. Belfield, of the Chicago Manual Training School.—Students love the Laboratory Exercises. — Demoralizing Effect of Unscientific Training.—The Failure of Justice and Legislation as contrasted with the Success of Civil Engineering and Architecture.

A STRIKING illustration of the defective character of both public and private systems of education, in the United States, is afforded by the statistics of commercial, railway, and other business failures. In 1877 a careful compilation of figures in regard to the shrinkage of railway values showed the following result:

"In round numbers, *eighteen hundred millions of dollars*, or thirty-eight per cent. of the capital reported as invested in two hundred of our railway companies alone, is wholly unproductive to the investors, and the greater part is wholly lost to them. This is sufficiently appalling, but when we consider how many companies that have managed to keep up the interest on their bonds have wholly, or almost, ceased to pay any interest on their capital stock, which stock, in turn, has shrunk to seventy-

five, fifty, twenty-five, ten, in some cases *five* per cent. of its par value, it will seem to be a reasonable conclusion that the actual shrinkage and loss to *somebody* on the face value of railway investments in the United States has been fully fifty per cent. !"*

In view of this startling exhibit it is evident that in the projection, construction, and management of the railways of the United States there has been gross incompetency.

In 1881 Messrs. R. G. Dun & Co., the well-known commercial agents, showed that of the wholesale merchants doing business in the city of Chicago in 1870 fifty per cent. had failed, suspended, or compromised with their creditors.

Forty years ago Gen. Dearborn, a prominent citizen of Chicago, declared that not more than three per cent. of the individuals who embark in trade end life with success. The success meant, doubtless, is unbroken solvency during the business experience of the merchant, and the final accumulation of a competence. The mercantile ranks in the United States afford many instances of individual merchants and firms who have settled or compromised with their creditors several times, and finally succeeded—succeeded at the expense of their creditors. But this is not the success meant by Gen. Dearborn. This statistical information, furnished by Messrs. R. G. Dun & Co., tends to confirm, approximately, the verity of the common remark that in trade not one in a hundred succeeds.

Let us suppose that three merchants in a hundred so conduct their business as never to ask their creditors for

* *The Chicago Railway Age.*

a favor, never to "settle" for 50 or 25 cents, but always
pay "dollar for dollar," and come out in the end rich.
This is strictly legitimate success. It would be very in-
teresting to learn what becomes of the other ninety-seven
merchants. Most of them go down after a few years,
never again to emerge above the surface of commercial
affairs. They live on salaries, enter the ranks of the
speculative class, or become genteel paupers. But doubt-
less seven at least of the ninety-seven "compromise" and
"settle" themselves over the breakers, and finally achieve
success. So that of the ten successful merchants out of
a hundred those who succeed at the expense of their cred-
itors are as seven to three of those who win success by
the highest degree of mercantile merit.

With ninety utter failures, seven successes which in-
volve the misfortune or wreck of others, and only three
untarnished successes in a hundred, the general ambition
to enter mercantile life is simply unaccountable. Of
course the small number of successful merchants have to
calculate upon the failures which will inevitably occur.
They must discount the losses they are sure to incur
through those failures—provide for them by increasing
the otherwise sufficient profit of each transaction. In
this way the public pays the cost of each failure. In
other words, the consumer is taxed to pay the expense
of ninety complete failures, and seven partial failures, in
every hundred mercantile experiments. This expense
aggregates scores of millions of dollars in this country
alone, every year. The sum of losses by the failure of
merchants in good seasons is very large, and in seasons
of commercial depression it is vast.

It is evident that ninety-seven in every hundred mer-
chants mistake their avocation. Only three in a hundred

are exactly fitted for the business they undertake. They are morally the "fittest" who survive by virtue of ability and integrity; the seven who survive by levying contributions on their creditors may also be regarded as the "fittest" according to the Darwinian theory. Of the ninety who go down without even a struggle to "settle" or "compromise," they answer to the received definition of dirt—"matter out of place."

The investigation made by Messrs. R. G. Dun & Co., which resulted in the statistical information here reproduced and commented upon, was brought about by the assertion in 1881 of a life-insurance agent that fifty per cent. of the wholesale merchants doing business in the city of Chicago in 1870 had meantime failed, suspended, or compromised with their creditors. Out of this investigation the question logically springs, "Is not failing in business made too easy?"* If "compromises," "settlements," and "failures" carry with them no disgrace, it is but natural that thousands should take the risk of them in the contest for the great prizes which are the reward of success. The distinction in the public mind between the three merchants in a hundred who succeed legitimately and the seven who succeed by questionable "compromises" or "settlements" is very slight; and too many of the

* "Mercantile honor is held so high in some countries that the calamity of bankruptcy drives men mad. In France there are numerous instances of almost superhuman struggles on the part of ruined merchants to regain, by patient effort and pinching economy, their lost station in the business community. César Birotteau, Balzac's hero of such a struggle, dies from excess of emotion in the hour of his triumph. 'Behold the death of the just!' the Abbé Loraux exclaims, as he regards, with lofty pride, the expiring merchant."— "Ten-minute Sketches," p. 220. By Charles H. Ham. Chicago and New York : Belford, Clark & Co., 1884.

ninety who fail utterly retire with large sums of money which belong honestly to their creditors. Doubtless the life-insurance agent, in depicting the perils of mercantile ventures, urged the propriety of the merchant fortifying himself against disaster by insuring his life for the benefit of his family. This is a legitimate argument when addressed to the merchant in solvent condition; but the life-insurance agent's intimate acquaintance with the shaky finances of nine-tenths of the commercial community teaches him that a large share of the money he receives in premiums, comes not from the merchant, but from the merchant's creditors, who will soon be called upon, in the natural course of events, to consent to a composition of his claim, while the shaky merchant will retire with a paid-up policy of insurance in favor of his family.

It is quite plain that in nine cases out of ten the merchant who carries a large policy of insurance on his life actually pays for it out of his creditors' instead of his own money. To be sure, it may be said that the nine merchants hope and expect to succeed, as well as the one. But is not it the duty of the merchant who owes large sums of money to think more of providing means for the payment of his immediate debts than of laying up a support for himself and family in the event of failure? Some disgrace ought to attach to failure in business; that is to say, disgrace enough to make the merchant cautious and economical, with a view, not to his own protection in the event of failure, but to the protection of his creditors, and of his own reputation as a business man.

These failures, on so vast a scale, of railway enterprises, and the almost total wreck of mercantile ventures, show that the business of this country is done, as a Yankee

might say, "by guess," or as the mechanic of the old *régime* would say, "by the rule of thumb." The conclusion is hence irresistible that the youth of the United States are not so educated as to fit them for the conduct, to a successful issue, of great business enterprises. And this is an impeachment of what is regarded, on the whole, as the best system of popular education in operation in the world. A system of education which turns out ninety-three or ninety-seven men who fail, to three or seven men who succeed in business, must be very unscientific. If the savage system of education were not better adapted to the savage state, the savage would perish from the earth in the process of civilization. The savage bends his ear to the ground and robs the forest of its secrets, not three times in a hundred, but ninety and nine times. Ninety-nine times in a hundred he traces the footsteps of his enemy in the tangled mazes of the pathless wood.

In "Aborigines of Australia"* Mr. G. S. Lang states that "one day while travelling in Australia he pointed to a footstep and asked whose it was. The guide glanced at it without stopping his horse, and at once answered, 'Whitefellow call him Tiger.' This turned out to be correct; which was the more remarkable as the two men belonged to different tribes, and had not met for two years." Among the Arabs it is asserted that some men know every individual in the tribe by his footstep. Besides this, every Arab knows the printed footsteps of his own camels, and of those belonging to his immediate neighbors. He knows by the depth or slightness of the impression whether a camel was pasturing, and therefore

* "Aborigines of Australia," p. 24.

not carrying any load, or mounted by one person only,
or heavily loaded. The Australian will kill a pigeon
with a spear at a distance of thirty paces. The Esqui-
mau in his kayak will actually turn somersaults in the
water. After giving many illustrations of the skill of
various races of savages, Sir John Lubbock says,

"What an amount of practice must be required to ob-
tain such skill as this! How true, also, must the weapons
be! Indeed it is very evident that each distinct type of
flint implement must have been designed for some dis-
tinct purpose." He adds, "The neatness with which the
Hottentots, Esquimaux, North American Indians, etc., are
able to sew is very remarkable, although awls and sinews
would in our hands be but poor substitutes for needles
and thread. As already mentioned (in page 332), some
cautious archæologists hesitated to refer the reindeer
caves of the Dordogne to the Stone Age, on account of
the bone needles and the works of art which are found in
them. The eyes of the needles especially, they thought,
could only be made with metallic implements. Prof.
Lartet ingeniously removed these doubts by making a
similar needle for himself with the help of flint; but
he might have referred to the fact stated by Cook in his
first voyage, that the New Zealanders succeeded in drill-
ing a hole through a piece of glass which he had given
them, using for this purpose, as he supposed, a piece of
jasper."*

The education which enables the savage to make these
extremely nice adjustments of means to ends is scientific.
The observation, for example, of the Arab who draws

* "Prehistoric Times," pp. 544, 548. By Sir John Lubbock, Bart.,
M.P. New York: D. Appleton & Co., 1875.

such accurate conclusions from the "printed footstep of the camel," if applied to the problems of civilized life, would result in success, not failure.

The excellence of this savage training consists in its practical character, in its perfect adaptation to the end in view. For example, the Esquimau boy is not instructed in the theory of turning somersaults in the water, in his kayak. He sees his father perform the feat; he is given a kayak and required to perform it also. The result is early and complete success. So of the Arab. In traversing the desert it is important for him to read every sign, to translate every mark left in the sand. Upon the accuracy of his observation his life may often depend. The print of the camel's footstep may tell him whether he is, soon or late, to meet friend or foe. Hence from early childhood his faculty of observation is trained until it soon becomes as delicate and nice as the sense of touch of a blind, deaf mute. Sir John Lubbock thinks that a great amount of practice must be required to achieve so much skill; but the results are due, probably, more to the nature, than to the extent, of the practice. It is the excellence of the training that produces results which excite wonder and admiration. The savage is indolent; he works only that he may eat, and he works well, simply because he has been taught objectively, instead of subjectively.

The difference in results between the best and the poorest methods of instruction is very great, as witness the testimony of Mr. Thomas Foley, late instructor in forging, vise-work, and machine-tool work in the school of mechanic arts of the Massachusetts Institute of Technology. He says,

"It is a great waste of time to spend two or three

years in acquiring knowledge of a given business, profession, or trade, that can be acquired in the short space of twelve or thirteen days, under a proper course of instruction. Twelve days of systematic school-shop instruction produces as great a degree of dexterity as two or more years' apprenticeship under the adverse conditions which prevail in the trade-shop."* The manual training methods are the same as those which enable the savage to perform such feats of skill. They are the natural and hence most efficient methods of imparting instruction.

The manual training school is a kindergarten for boys fourteen years of age. Miss S. E. Blow, in formulating the theory of the kindergarten, describes the methods of the savage's school, and those of the manual training school, as follows :

"It is a truth now universally recognized by educators that ideas are formed in the mind of a child by abstraction and generalization from the facts revealed to him through the senses ; that only what he himself has perceived of the visible and tangible properties of things can serve as the basis of thought; and that upon the vividness and completeness of the impressions made upon him by external objects, will depend the clearness of his inferences and the correctness of his judgments. It is equally true, and as generally recognized, that in young children the perceptive faculties are relatively stronger than at any later period, and that while the understanding and reason still sleep, the sensitive mind is receiving those sharp impressions of external things which, held fast by memory, transformed by the imagination, and

* Report on "The Manual Element in Education," p. 30. By John D. Runkle, Ph.D., LL.D., Walker Professor of Mathematics, Institute of Technology, Boston, Mass.

finally classified and organized through reflection, result in the determination of thought and the formation of character.

" These two parallel truths indicate clearly that the first duty of the educator is to aid the perceptive faculties in their work by supplying the external objects best calculated to serve as the basis of normal conceptions, by exhibiting these objects from many different stand-points —that variety of interest may sharpen and intensify the impressions they make upon the mind, and by presenting them in such a sequence that the transition from one object to another may be made as easy as possible."*

This admirable exposition of the theory of scientific education solves the mystery which has always enveloped savage skill. It also affords a philosophic explanation of the fact discovered by Mr. Foley, namely, that the student of the manual training school acquires as much knowledge in one hundred and twenty hours as the apprentice of the machine-shop does in two years. In a word, it shows exactly why scientific education is so incomparably superior to automatic education. Mr. Foley asserts, in substance, that the scientific methods of the manual training school are twenty times as valuable to the student as the unscientific methods of the trade-shop are to the apprentice.

In a familiar letter to the author, Prof. Goss† shows why the methods of the manual training school are so very valuable. He says :

* " The Kindergarten. An address, delivered April 3, 1875, before the Normal Teachers' Association, at St. Louis, Mo."

† Prof. William F. M. Goss, a graduate of the school of mechanic arts of the Massachusetts Institute of Technology, and at present instructor in the mechanic arts department of the Purdue University.

"In such a school, or course, a student is taught to perform a series of operations, involving practice with a variety of tools, on pieces of suitable material. It is not to be supposed that his ability to make a certain piece is directly valuable, for the experience of a lifetime may never require him to make it again. It is not expected that while making the piece he will learn a number of formulated facts relating to his work, and its application to other work, for that is not the best way to learn. Nor can we expect him to acquire a high degree of hand skill (accuracy and rapidity of movement combined), for this his limited time will not permit. But he does this: he works out a practical mechanical problem with every piece he makes. He sees how the tool should be handled, and how the material operated on behaves. He comes to understand why the tool cuts well in some directions and not so well in others; and all the time he queries to himself where it was that he saw a joint like the one he is making. He is an investigator—as much so as a student in chemistry. His mind must always guide his hand; his reasoning opens new fields of thought with every stroke of the chisel.

"A boy ten years old, who was a member of a class under my direction in Indianapolis in 1883, is reported to have said, 'Why, mother, I never looked at the doors and windows so much in all my life as I have since I began at the wood-working school.'

"I tell my students how to go to work, when they are likely to make mistakes, and how mistakes may be avoided. In operating along the line directed they thoroughly understand what they are doing, and why they do it. They see on all sides of their work.

"If I have several different tools for doing work of

the same character, I frequently give a student first one and then another, until he has tried them all. Then I ask him which he likes best, and why. Suppose we are to make a drawing-board. The class having already been made familiar with the principles governing the shrinkage and warping of woods, is asked in what way the cleats, to prevent warping, may best be fastened to the ends. The question is left open for a day or two, and sketches are submitted and views exchanged on the subject.

"I frequently ask my students to pass to me, in writing, as many facts (not in the form of a composition) as they can think of - regarding certain stated features of their work — not facts to be obtained from books, but from things they have seen and with which they are familiar. The replies are often remarkable for accuracy and force of statement. . . .

"The manual training school that does not by its work inspire thought and encourage investigation is poor indeed ; the school that assumes its work to be *mind training by hand practice* is the ideal school, and the school that will succeed. . . .

"My answer to your second and third questions is already evident. I consider an hour in the shop as valuable for its intellectual training as an hour of book-study, and two hours in the shop as valuable as two hours of study. I do not think that a student can take two hours of shop-work in addition to a full course of outside study ; but I am convinced that two hours in the shop can be made to take the place of one hour of study without extra burden to the student. Therefore, this being done, the student will get as much again intellectual benefit from the shop as he would get if the shop-work equivalent in time were given to book-study."

This description of the mental operations which accompany the laboratory exercises of the manual training school shows the intimacy of the relations existing between the brain and the hand. It shows how they act and react upon each other, and affords an explanation of the remark of Dr. Belfield,* that the laboratory exercises are in fact a great strain upon the mental constitution of the student. This observation of Dr. Belfield, one of the most distinguished teachers of the old *régime* in the United States, entirely justifies the claim made in behalf of the scientific character of manual training as an educational agency, for it shows that such training is in no sense automatic. If manual training is a great strain upon the mental faculties, it must be because the use of tools stimulates such faculties to great activity. And if this is true, the mental discipline derived from manual training must be proportionally great. This is a pivotal point; for if the observation of Dr. Belfield is well founded in fact and reason, it proves to a demonstration the high educational value of manual training—proves its superiority over all the methods of the old *régime*.

Prof. Goss says, " The manual training school student is an investigator—as much so as a student in chemistry. His mind must always guide his hand, his reasoning opens new fields of thought with every stroke of the chisel. He sees on all sides of his work."† And Dr.

* Henry H. Belfield, A.M., Ph.D., Director of the Chicago Manual Training School.

† "No extent of acquaintance with the meanings of words can give the power of forming correct inferences respecting causes and effects. The constant habit of drawing conclusions from data, and then of verifying those conclusions by observation and experiment, can alone give the power of judging correctly."—" Education," p. 88. By Herbert Spencer. New York : D. Appleton & Co., 1883.

Belfield says that these varied operations of the mind cause a severe mental strain. It would be difficult to find a better exemplification of scientific education than a course of training which exercises simultaneously the powers of both body and mind, a course which with every fresh burden put upon the mind puts new vitality into the body. This is, indeed, the very opposite of automatic education, and we may well call it scientific education.

Another leaf from the experience of Dr. Belfield is worthy of reproduction here. On the 20th of February, 1884, he took the sense of the students in his school on the question whether or not they should indulge in a vacation on Washington's birthday anniversary. Somewhat to his surprise the vote was almost unanimous in the affirmative. He acceded to the wishes of the students, but no sooner was the announcement made, than he was besieged with applications from nearly all of them for permission to convert the holiday into a work-day in the laboratories! Dr. Belfield has been compelled to post a peremptory order against the occupancy of the school laboratories by the students on Saturdays, which are regular vacation days.

Natural training is scientific training. The fondness of the student for the manual training school is evidence of its scientific character. He is fond of it because it is natural. Miss Blow says of the child: "Only what he himself has perceived of the visible and tangible properties of things can serve as the basis of thought, and upon the vividness and completeness of the impressions made upon him by external objects will depend the clearness of his inferences and the correctness of his judgments." This is the education both of the kinder-

garten and the manual training school, and it brightens,
stimulates, and develops, while automatic education stu-
pefies.

Mr. Foley, formerly of the Massachusetts Institute of
Technology, declares, as the result of his experience, as
already stated, that the scientific methods of the manual
training school are twenty times as valuable to the stu-
dent as the unscientific methods of the trade-shop are to
the apprentice. But we have shown in a former chapter
that the training of the trade-shops of England, during
the past one hundred and fifty years, has been better than
that of the English schools and universities; in a word,
that England is more indebted for her greatness to her
apprentice system than to her school system. It follows
that the school system of England must have been almost
indescribably poor.

That the system of popular education in the United
States, which is much more comprehensive, and presum-
ably better, than that of England, is very poor indeed in
results, is shown by the statistics of railway and mercan-
tile disasters; and it is scarcely necessary to remark that
these disasters show prevailing methods of education to
be as defective morally as they are mentally. The rea-
son of this is that, being automatic, they lead neither to
the discovery of truth nor to the detection of error. It
is easy to juggle with words, to argue in a circle, to make
the worse appear the better reason, and to reach false
conclusions which wear a plausible aspect. But it is not
so with things. If the cylinder is not tight the steam-
engine is a lifeless mass of iron of no value whatever. A
flaw in the wheel of the locomotive wrecks the train.
Through a defective flue in the chimney the house is set
on fire. A lie in the concrete is always hideous; like

murder, it will out. Hence it is that the mind is liable to fall into grave errors until it is fortified by the wise counsel of the practical hand.

It is obvious that the reason of the demand for the manual element in education is not so much that industrial interests require to be promoted, as that mental operations may be rendered more true, and hence more scientific. What we need more than we need a better class of mechanics is a better class of men—men of a higher grade both morally and intellectually. The study of things so steadies and balances the mind that the attention being once turned in that direction great results soon follow, as witness, the history of discovery and invention in England.

The world moves very fast industrially, but very slow morally and intellectually. Mechanics stand the test of scrutiny far better than merchants. Civil engineers and architects are more competent than railway presidents, lawyers, judges, and legislators. The reason of this fact is that mechanics, civil engineers, and architects are educated practically in the world's shops and the world's technical schools. They are trained in things, while merchants, railway presidents, lawyers, judges, and legislators have only the automatic word-training of the schools. It is notorious that criminals are not punished in this country. Suppose there were such a failure of bridges as there is of justice. That is to say, suppose nine-tenths of the bridges constructed, whether for railway or other purposes, should fall within a few months of their completion. What would be thought of the technical schools whence the civil engineers graduate?

Ninety-seven merchants in a hundred fail. Suppose ninety-seven buildings in a hundred, constructed under

the direction of architects, should tumble down over the
heads of their occupants six months after their erection.
The education of the architects would no doubt be regard-
ed as defective.

Buckle says of English legislation, "The best laws
which have been passed have been those by which some
former laws were repealed."* It will be admitted that
the same is true of American legislation.† In other
words, the average legislator is wiser in the statutes he

* "History of Civilization in England," Vol. I., p. 200. By Henry
Thomas Buckle. New York : D. Appleton & Co., 1864.

"In a paper read to the Statistical Society in May, 1873, Mr. Jan-
son, Vice-president of the Law Society, stated that from the statute of
Merton (20 Henry III.) to the end of 1872 there had been passed
18,110 public acts, of which he estimated that four-fifths had been
wholly or partially repealed. He also stated that the number of pub-
lic acts repealed wholly or in part, or amended, during the three years
1870–71–72 had been 3532, of which 2759 had been totally repealed.
To see whether this rate of repeal has continued I have referred to
the annually issued volumes of the 'Public General Statutes' for the
last three sessions. Saying nothing of the numerous amended acts,
the result is that in the last three sessions there have been totally re-
pealed, separately or in groups, 650 acts *belonging to the present reign*,
besides many of preceding reigns. . . .

"Seeing, then, that bad legislation means injury to men's lives,
judge what must be the total amount of mental distress, physical
pain, and raised mortality which these thousands of repealed Acts of
Parliament represent."—"The Man *versus* the State," pp. 50, 51. By
Herbert Spencer. New York: D. Appleton & Co.

† "So thoroughly have the conscience and intelligence of the North
apprehended these facts [neglect to educate and enlighten the freed-
men], that while the Nation has done nothing they have given in pri-
vate charity, intended to remedy this evil, nearly a million dollars a
year for nearly twenty years. This is the instinct of a people *versus*
the stupidity of their legislators. . . . Of the true character of the South
he [the author] was, like all his class, profoundly ignorant, almost as
ignorant as the men who made the Nation's laws."—"An Appeal to
Cæsar," pp. 52, 56. By A. W. Tourgée.

repeals than in the bills he enacts. What if the incompetency of the legislator were paralleled by that of the machinist? Suppose ninety-seven in every one hundred locomotives should break down on the "trial-trip," and be returned to the builder's shop for remanufacture. Such a result would be an impeachment of the education of the locomotive builder.

Ninety-seven in every hundred boys who graduate from the public schools and embark in mercantile pursuits fail. Suppose ninety-seven in every hundred watches made in the American watch factories should prove to be worthless. The watch companies would, no doubt, soon be in the hands of the sheriff. But, as a matter of fact, the Elgin National Watch Company, for example, makes twelve hundred watches a day, and each and every one of them is an almost perfect timekeeper.

There is, then, no such failure of the arts as there is of justice; no such failure of mechanics as of merchants; no such failure of locomotives and watches as of legislation. It follows that the education of artisans is better, more scientific, than that of merchants, judges, lawyers, and legislators. And this is a very significant fact when it is considered that the State does much for education in *belles-lettres* and scarcely anything for education in the arts and sciences.*

* The reason why statutes fail more frequently than steam-engines and bridges is not wholly because the legislator has to deal with human nature and the mechanic with inanimate matter. Steam and electricity are subtle forces, but man has quickly mastered them and successfully applied them to a variety of uses.

It is not to the interest of any one that the machinist should make a defective locomotive, for example; but it is often to the interest of

some one that the legislator should enact vicious laws. Vicious
statutes are enacted with a design to injure the public in order that
certain individuals may be benefited thereby.

If the mind should act as honestly in legislation as the hand does
in construction, statutes would not have to be repealed yearly.

We have fallen into the habit of regarding education as a polite
accomplishment having very little to do with the real business of
life ; but this is not the fact. Education begins in the cradle and
continues through life ; and it makes the man what he is. If he
goes to the penitentiary it is his education that sends him there. If
he is sent to the General Assembly of the State or to the Congress of
the Nation, and there helps to enact vicious laws, it is his education
that is responsible for such laws. If the man as a citizen sells his
franchise at the polls, or his vote in the legislative hall, for money, it
is the education he has received that is responsible for his baseness.

It will be said that the explanation of the greater apparent accu-
racy of the work of the hand is to be found in the fact that it
operates upon matter while the mind deals with metaphysical sub-
tilties. The contention will not be that mind is less plastic than
matter, but that it is more difficult of comprehension. But how do
we know this to be the fact? Where has the experiment been tried
of honest contact mind with mind? It was not tried by the ancients.
It is not on trial in any part of the world to-day. There is, hence,
no place in which to seek evidence as to how mind would act upon
mind if treated honestly, as matter is treated by the hand. But if
the quality of selfishness is eliminated, there will be no difficulty in
bringing all minds to an agreement, as the parts of a watch are
brought into harmonious and useful action. And it is through the
hand that this beneficent union is destined to be effected; for the
hand is the source of wisdom, which is simply the power of dis-
criminating between the true and the false.

CHAPTER XX.

AUTOMATIC CONTRASTED WITH SCIENTIFIC EDU-
CATION—*Continued.*

The Training of the Merchant, the Lawyer, the Judge, and the Leg-
islator contrasted with that of the Artisan.—The Training of the
Merchant makes him Selfish, and Selfishness breeds Dishonesty.—
Professional Men become Speculative Philosophers, and test their
Speculations by Consciousness.—The Artisan forgets Self in the
Study of Things.—The Search after Truth.—the Story of Palissy.
—The Hero is the Normal Man; those who Marvel at his Acts are
abnormally Developed.—Savonarola and John Brown.—The New
England System of Education contrasted with that of the South.—
American Statesmanship—its Failure in an Educational Point of
View.—Why the State Provides for Education ; to protect Prop-
erty.—The British Government and the Land Question.—The Thor-
oughness of the Training given by Schools of Mechanic Art and In-
stitutes of Technology as shown in Things.—Story of the Emperor
of Germany and the Needle-maker.—The Iron Bridge lasts a Cen-
tury, the Act of the Legislator wears out in a Year.—The Cause
of the Failures of Justice and Legislation.—The best Law is the
Act that Repeals a Law; but the Act of the Inventor is never Re-
pealed.—Things the Source and Issue of Ideas; hence the Neces-
sity of Training in the Arts.

THERE is a cause for the failure of the merchant, the
lawyer, the judge, and the legislator, as well as for the
success of the artisan. And the cause must be sought in
the courses of training, respectively, of the two classes.
Let us assume that the artisan and the merchant, the
lawyer, the judge, and the legislator, graduate at the same
time from the public high school, or from Harvard or
Yale. The merchant at once begins to trade, to buy and
sell. He concerns himself with things only as they have

a value, either naturally arising from the law of demand
and supply, or arbitrarily imposed by circumstances. His
consideration of the relations of things is confined to the
single question of the percentage of profit which may
accrue to him from traffic in them. These are subjective
processes of thought, and the merchant becomes absorbed
in them to the exclusion of all other topics. It goes
without saying that he becomes intensely selfish. The
struggle is one of mercantile life or death—ninety-three
to ninety-seven in a hundred die; three to seven survive.

Among merchants there is, hence, very little thought
of the subject of justice, and no effort to discover truth.
There must, at the end of the year, be a favorable bal-
ance on the right side of the ledger, or the balance on the
wrong side unerringly points the way to ruin. This is
the post-school training of the merchant. That neither
it nor his previous education renders him skilful we know,
since he fails ninety-three to ninety-seven times in a hun-
dred trials. That subjective training does not and never
can promote rectitude has been shown in a former chap-
ter of this work. That merchants who compromise with
their creditors, and subsequently accumulate fortunes, very
rarely repay the debt formerly forgiven is a notorious
fact. A Chicago merchant who himself repaid such a
composition debt early in his career, states, at the end of
twenty-five years' experience, that of compromises involv-
ing several hundred thousand dollars, made by him in fa-
vor of debtors, not one dollar has ever been repaid.

Upon leaving school or college the lawyer, the judge,
and the legislator at once apply themselves to books;
their subsequent training is exclusively subjective. Their
ideas receive color from, and are verified only by refer-
ence to, consciousness. Subjective truths have no rela-

tions to things, and hence are susceptible of verification only through consciousness. They are, therefore, mere speculations after all, often ingenious but always problematical. The result of such training is selfishness—selfishness of a very intense character; and, as has been already shown, selfishness is merely another name for injustice.

On the other hand the artisan devotes himself to things. His training is exclusively objective. His ideas flow outward; he studies the nature and relations of things. In this investigation he forgets self because his life becomes a grand struggle in search of truth; and the discovery of truth in things, if not easy, is ultimately sure of attainment, since harmony is its sign, and its opposite, the false, is certain of exposure through its native deformity; for however alluring a lie may be made to appear in the abstract, in the concrete it is a monster unmasked.

From the false the artisan intuitively shrinks. He can only succeed by finding the truth, and embodying it in some useful or beautiful thing which will contribute to the comfort or pleasure of man. Hence his watchword is utility, or, beauty in utility. Of the engrossing character of this struggle the story of Bernard Palissy affords a splendid illustration. Palissy was an artist, a student, and a naturalist, but poor, and compelled to follow the profession of surveying to support his family. At the age of thirty he saw an enamelled cup, of Italian manufacture, which fired his ambition. Ignorant of the nature of clays, he nevertheless resolved to discover enamel, and entered upon a laborious course of investigation and experiment with that end in view. After many years of Herculean effort and indescribable privation, which beggared and estranged his family, and rendered him an ob-

ject of ridicule among his neighbors, he achieved a grand
success. At a critical period of his experiments, in the
face of the indignant protests of his almost starving fam-
ily, having exhausted his credit to the last penny, he con-
signed to the flames of his furnace the chairs, tables, and
floors of his humble cottage, and continued to watch his
chemicals with all-absorbing attention, while his wife in
despair rushed through the streets making loud proclama-
tion of the scandal.

But Palissy was more than a potter; he was a Chris-
tian, a philosopher, and an austere reformer. Notwith-
standing he had been petted and patronized as an inge-
nious artisan by the royal family of France, he was final-
ly cast into prison under charge of heresy. It was there
that the remarkable interview with King Henry III. oc-
curred, which immortalized Palissy as a hero. "My good
man," said the king, "you have been forty-five years in
the service of the queen, my mother, or in mine, and we
have suffered you to live in your own religion, amid all
the executions and the massacres. Now, however, I am
so pressed by the Guise party and my people that I have
been compelled in spite of myself to imprison these two
poor women and you." "Sire," answered the old man,
"the count came yesterday on your part, promising life
to these two sisters upon condition of the sacrifice of
their virtue. They replied that they would now be mar-
tyrs to their own honor as well as for the honor of God.
You have said several times that you feel pity for me;
but it is I who pity you, who have said, 'I am compelled!'
That is not speaking like a king. These girls and I, who
have part in the kingdom of heaven—we will teach you
to talk royally. The Guisarts, all your people, and your-
self, cannot compel a potter to bow down to images of

clay!"* And Palissy the potter and heretic, at the age of seventy, died in the Bastile, proudly defying a king.

The more absorbing the struggle for the discovery of truth the less room there is in the mind for selfishness; and as selfishness recedes, justice assumes its appropriate place as the controlling element in human conduct. The hero is an honest man, that's all,—

> "Though love repine, and reason chafe,
> There comes a voice without reply;
> 'Tis man's perdition to be safe,
> When for the truth he ought to die."

If all men were heroes—honest—there would be no occasion for heroism. If all education can be made scientific, all men can be made honest. The struggle to find truth is more natural than the struggle to succeed regardless of, or against, truth. The reason why what we call heroism appears so grand is this: the standards of public judgment have become so perverted by long custom in the abuse of truth, that normal conduct appears strange.

When Palissy burned his chairs and tables in the cause of art, his family and his neighbors derided him, and denounced him as a madman, and in prison the king urged him, as a friend, to save himself from death by recanting his assertion of the right of freedom of religious opinion. Palissy was a hero neither to his family, his friends, nor his king;† but he was right, and his discovery and his

* "Palissy the Potter," Vol. II., pp. 187, 188. By Henry Morley. Boston : Ticknor, Reed & Fields, 1853.

† "I had nothing but reproaches in the house ; in place of consolation, they gave me maledictions. My neighbors, who had heard of this affair [the failure of an experiment], said that I was nothing but a fool, and that I might have had more than eight francs for the things that I had broken ; and all this talk was brought to mingle

firmness rendered him immortal. We now know, three hundred years farther down the course of time, that Palissy's struggle over the furnace in the cause of art was mentally and morally normal, while the opposition he encountered was abnormal; and that his defiance of the king was mentally and morally normal, while his persecution was abnormal and cruel.

Palissy's mind was trained naturally in the direction of rectitude, while the minds of the millions of men who permitted him to die unfriended, a prisoner in the Bastile, were developed unnaturally. Their education was unscientific, and their characters were hence deformed. The one symmetrical character was that of Palissy, the lover of truth, who was ready to starve, if need be, for his art, and ready to die for his faith. The thin ranks of the so-called heroes of the ages of history constitute the measure of the poverty of the systems of education that have prevailed among mankind. These so-called heroes are merely normally developed men — men who search for the truth, and having found it, honor it always and everywhere. They are peculiar to no clime, to no country, to no age. They are cosmopolitan, and the fact that they are honored, after death, by succeeding ages is proof positive of the world's progress, or rather of the progress of moral ideas.

The civilization of Italy in the middle of the fifteenth century presents the most violent possible contrast to that of America in the last half of the nineteenth century. But the one produced Savonarola, the hater of abuses in the Roman Catholic Church, and the other

with my grief."—"Palissy the Potter," Vol. I., p. 190. By Henry Morley. Boston: Ticknor, Reed & Fields, 1853.

John Brown, the stern, uncompromising hater of human bondage. Four hundred years is a long period in the history of civilization; but the priest of the fifteenth century, and the farmer of the nineteenth, are as near of kin in spirit, as if they had been born of the same mother, and reared in the same moral atmosphere.

The true hero is always inexorable—as Savonarola in the presence of the majesty of a dying, remorse-stricken, half-repentant prince, and John Brown in the presence of his exultant but half-terrified captors. When Lorenzo di Medici lay terror-stricken, on his death-bed, Savonarola demanded of the dying prince, as the price of absolution, a restoration of the liberties of the people of Florence; and this being refused, the priest departed without one word of peace.

When John Brown, wounded and bleeding, lay a captive at Harper's Ferry, listening to the taunts of angry Virginians, he said, calmly and firmly, " You had better —all you people of the South—prepare yourselves for a settlement of this question. It must come up for settlement sooner than you are prepared for it, and the sooner you commence that preparation the better for you. You may dispose of me very easily—I am nearly disposed of now—but this question is still to be settled—this negro question, I mean. The end of that is not yet."*

There is nothing grander in history, whether real or mythological, than the picture of the humble priest of the fifteenth century, with no power except the justice of his cause, shaking thrones and making proud prelates, and even the Pope himself, tremble with fear ! And the

* "The Public Life of Captain John Brown," p. 283. By John Redpath. Boston : Thayer & Eldridge, 1860.

exact parallel of this picture is found, four hundred years
down the stream of time, in the person of the farmer,
John Brown, defying the Constitution, law, and public
sentiment of his country in the interest simply of the
cause of justice.

It has been shown through citations from the Walton
report, as well as by the opinions of many competent
witnesses, that the New England system of education,
whether correct in theory or not, is, in actual operation,
very defective. But at the time of its establishment it
was the best system in existence. To it this country owes
the quality of its civilization. The neglect of education
by the Government of the United States is the most as-
tonishing fact of its history. It is incomprehensible how,
with a comparatively excellent educational system in op-
eration, and in full view in the New England, Middle,
and Western States, the National Government could calm-
ly and inactively contemplate the almost entire neglect
of popular education in the States of the South, and ig-
nore, from year to year, the steadily accumulating hor-
rors of ignorance and vice which were destined to lead
to such deplorable political and social results.

The difference between the civilization of New Eng-
land and that of South Carolina, for example, is exactly
measured by the difference between their respective edu-
cational systems. New England undertook, at a very
early day, to educate every class of its citizens; South
Carolina made a monopoly of education, confining it to
a single class.

It must be admitted that the American statesmanship
of the whole period of our history has been scarcely less
short-sighted than that of England under the Georges,
which resulted in saddling upon her people a debt that

they can never pay. If England had provided a comprehensive and scientific system of popular education at the beginning of the eighteenth century, who doubts that the wars through which her debt was incurred would have been averted? If the Government of the United States had compelled the adoption of a scientific educational system by the States of the South, who doubts that slavery would have peaceably passed away, and the occasion for war passed away with it?

The conspicuous failure of American statesmanship consists in a failure to appreciate the value of scientific education. It shows that good citizenship is impossible without good education—for good education and good citizenship are convertible terms. And it is easy to show, by the past, that to hesitate on the subject of education is to be lost.*

Why do we provide for popular education? Is it out of pure generosity that the rich citizen consents to be taxed to pay for the education of his poor neighbor's children? Does the man who has no children willingly surrender a portion of his estate for the education of the children of others, as an act of benevolence? Not at all. There is no security for property in a community devoid of education and consequent intelligence. Intelligence alone confers upon property a sacred character. In one

* "If you examine into the history of rogues, you will find that they are as truly manufactured articles as anything else, and it is just because our present system of political economy gives so large a stimulus to that manufacture that you may know it to be a false one. We had better seek for a system which will develop honest men than for one which will deal cunningly with vagabonds. Let us reform our schools, and we shall find little reform needed in our prisons."— "Unto This Last," p. 50. By John Ruskin. New York: John Wiley & Sons, 1883.

of two ways only can property be rendered secure in the
owner's hands. It may be protected by a hired soldiery,
through the force of arms,' or through the force of pub-
lic sentiment enlightened by education. The reason why
the poor but educated citizen would not lay violent hands
on the rich citizen's property is the fact that he indulges
the intelligent hope of himself acquiring property. Be- .
sides, the morals of a community are in the ratio of its
intelligence. The indulgence of hope promotes self-
esteem, and self-respect, and these qualities react ethi-
cally.

It should be borne in mind that while one of the
main purposes of all governments is to preserve property
rights, nearly all the governments of history have been
shattered in pieces in the effort to fulfil this function of
their existence. It may be said that there is never any-
thing sacred about property unless it is honestly acquired.
All the force of our own government was exerted in a
vain effort to protect property in slaves. England has
been compelled to disturb the property rights of the
Irish landlords, and this is only the prelude to an attack
upon the property rights of her own landlords. It was
the ignorance of the English people hundreds of years
ago that permitted the establishment of a land system
which is now about to crumble in pieces, and in its fall
wreck certain property rights.

There is nothing sacred about property unless it is hon-
estly acquired and honestly held ; and property can only
be honestly acquired and honestly held, in communities
intelligent enough to guard its acquisition, and continued
possession, by just and adequate laws. It follows that edu-
cation is the sole bulwark of the State, and so of property.

The question of the first consequence is, therefore,

always, What is the best system of education? It is obvious, also, that the subject of cost should not enter into the discussion; that the best education is the cheapest, is an indisputable proposition. We have seen that the New England system of education, which has spread over the whole country, is very much better than the system which prevailed in those States of the Union where slavery continued to exist down to 1864. But we have seen, also, that that system is very defective; that it is automatic, and hence not natural, not practical, not scientific. It does not produce great merchants, great lawyers, great judges, or great legislators. That it does not, is abundantly shown by the fact that in mercantile life there are ninety-three to ninety-seven failures in every one hundred experiments; by the fact that there is notoriously a general failure of justice; and by the fact that here, as in Great Britain, the chief business of statesmen is the undoing of vicious legislation.

There is a system of training which produces a much higher average of culture than that of the public schools and the universities. We allude to the training received by the students of special mechanical and technical institutions, and by the apprentices in trade-shops. The proof of this is found in the world's railways, ships, harbors, docks, canals, bridges, telegraph and telephone lines, and in a thousand and one other manifestations of skill in art. In the adaptation of means to an end, and in nicety of construction, the mechanic and the civil engineer show, in innumerable ways, with what thoroughness both their minds and their hands have been trained. If mercantile operations were governed by such excellent rules in projection, and by such precision in execution, ninety-seven merchants in a hundred would not go to the wall.

A story has lately gone the round of the public prints to the effect that, during a visit to a needle factory by the Emperor of Germany, a workman begged a hair of his head, bored an eye in it, threaded it, and handed it back to the monarch, who had expressed surprise that eyes could be bored in the smaller sizes of needles. It does not matter whether or not this story is literally true; it illustrates the delicacy of modern mechanical operations. Hundreds of similar illustrations might be given, showing how marvellously skilful the hand has become.

It is not claimed that the hand is a nicer instrument than the mind. As a matter of fact, in drilling the hole in the hair the mind and the hand work together— the mind directs the hand, we will say. The mind devises or invents a watch—every wheel, pinion, screw, and spring—and directs the hand how to make it, and how to set it up, and it ticks off the time. Why does the mind succeed so admirably when it employs the hand to execute its will, but so ill when it devises and attempts, itself, to execute? How is it that the mind invents a watch which, being made by the hand, records the hour to a second, ninety-nine times in a hundred, but fails ninety-three to ninety-seven times in a hundred to devise and carry into execution a mercantile venture? How is it that the mind invents a steam-engine consisting of a hundred pieces, so that, each piece being made by a different hand, the machine shall, when set up, ninety-nine times in a hundred, at once perform the work of five hundred horses without strain or friction, but when it grapples with law and fact in the chair of lawyer or judge produces a most pitiable wreck of justice? How is it that the mind devises and the hand executes with such nice adaptation of means to the end in view, a bridge, that re-

sembles a spider's web, and yet bears thousands of tons and endures for ages, but when it undertakes to legislate evolves statutes that wear out in a year? The first iron bridge constructed spanned the Severn, in England. It was opened to traffic a hundred years ago, but it is still a stanch structure likely to stand for centuries. Where are the English statutes of that time? Repealed to give place to a long line of others which in turn have been repealed. When the famous iron bridge across the Severn was constructed, English legislators were passing bills to compel the American colonies to trade only with the mother country, and to tax them without their consent. Lord Sheffield said, with charming frankness, that the colonies were founded with the sole view of securing to England a monopoly of their trade; and Lord Chatham declared that they would not be permitted to make even a nail or a horseshoe.

In 1516 Sir Thomas More denounced the criminal law of England, declaring that " the loss of money should not cause the loss of man's life."* But this humane and enlightened sentiment had so little weight that during the reign of Henry VIII. seventy-two thousand thieves were hanged—at the rate of two thousand a year. In 1785 twenty men were executed in London at one time for thefts of five shillings. The Lord Chief-justice and the Lord Chancellor agreed that it would be dangerous to repeal the law punishing pilfering by youths. In 1816 the Commons passed a bill abolishing capital punishment for shoplifting—stealing the value of five shillings—but the Lords defeated it, Lord Ellenborough, Chief-justice,

* "The History of England," Vol. II., p. 83. By Harriet Martineau. Philadelphia : Porter & Coates.

observing, peevishly, "They want to alter these laws
which a century has proved to be necessary, and which
are now to be overturned by speculation and modern
philosophy."*

The cause of these failures—of mercantile ventures, of
justice, and of legislation — is this: Subjective mental
processes are automatic, and hence they neither generate
power nor promote rectitude; they enfeeble rather than
energize the brain. Men whose characters are formed
by such educational processes never originate anything.
They become selfish, they venerate the past, their eyes
are turned backward; hence, if they sometimes make a
feeble effort to move forward they stumble. The law-
yer, the judge, and the legislator are examples of this
class. Their guide-books are musty folios in a dead lan-
guage; they look for "precedents" in an age whose civ-
ilization perished with its language, and whose maxims
and rules of life were long ago exploded. Such men can
be compelled to move forward only by the lash of public
opinion. Buckle, speaking of the reforms extorted from
the legislators of England, says,

"But it is a mere matter of history that our legisla-
tors, even to the last moment, were so terrified by the
idea of innovation that they refused every reform until
the voice of the people rose high enough to awe them
into submission, and forced them to grant what without
such pressure they would by no means have conceded."†

On the other hand, the inventor, the discoverer, and
the artisan are always in the advance, and always moving

* "The History of England," Vol. II., p. 85. By Harriet Mar-
tineau. Philadelphia : Porter & Coates.

† "History of Civilization," Vol. I., p. 361. By Henry Thomas
Buckle. New York : D. Appleton & Co., 1864.

forward. They never look back except to catch the vital principle of the invention or discovery of yesterday for utilization in the improved machine of to-day. Their acts are never repealed because they never become odious. They never become odious because they contain the germs of imperishable truth. They are never false; they are suitable to their time and the stage of development; they constitute links in the chain of progress. While the legislator is horrified at the thought of innovation, the inventor, the discoverer, and the artisan are electrified by the discovery of a new principle in physics, and delighted at its application in a new invention, and its practical operation in a new and useful machine.

The difference in effects upon the mental and moral nature, between purely mental training and mental and manual training combined, is susceptible of logical explanation. It is only in things that the truth stands clearly revealed, and only in things that the false is sure of exposure.* Hence exclusively mental training stops far short of the objective point of true education. For if it be true that the last analysis of education is art, progress can find expression only in things—in the work of men's hands. And it is true; for ideas are mere vain speculations until they are embodied in things. Nor is

* "To know the truth it is necessary to do the truth." . . .

"We rightly seek the meaning of the abstract in the concrete, because we cannot *act* in relation to the abstract, which is only a representative sign; we must give it a concrete form in order to make it a clear and distinct idea ; until we have done so we do not know that we really believe—only believe that we believe it. A truth is best certified to be a truth when we live it and have ceased to talk about it."—"Body and Will," p. 49. By Henry Maudsley, M.D. New York : D. Appleton & Co., 1884.

this materialism unless all civilization is material; for
the prime differénce between barbarism and civilization
consists in the presence, in a state of civilization, of more
things of use and beauty than arc found in a state of bar-
barism. To exalt things is not materialistic; they are
both the source and issue of ideas, and the measure of
civilization. Ideas and things are hence indissolubly
connected; and it follows that any system of education
which separates them is radically defective.* Exclusive-
ly mental training does not produce a symmetrical char-
acter, because at best it merely teaches the student how
to think, and the complement of thinking is acting. Be-
fore thoughts can have any influence whatever upon the
world of mind and matter external to the mind origi-
nating them they must be expressed. They may be ex-
pressed feebly, through the voice, in words; more dura-
bly, and therefore more forcibly, with the pen, on paper;
more forcibly still in drawing—pictures of things; and,
with the superlative degree of force, in real things.

The object of education is the generation of power.

* "Prof. Huxley seems to hold that zoology cannot be learned with
any degree of sufficiency unless the student practises dissection. In
support of this position there are strong reasons. In the first place,
the impression made on the mind by the actual objects, as seen, han-
dled, and operated upon, is far beyond the efficacy of words or de-
scription. And not only is it greater, but it is more faithful to the
fact. While diagrams have a special value in bringing out links of.
connection that are disguised in the actual objects, they can never
show the things exactly as they appear to our senses ; and this full
and precise conception of actuality is the most desirable form of
knowledge ; it is truth, the whole truth, and nothing but the truth.
Moreover, it enables the student to exercise a free and independent
judgment upon the dicta of the teacher."—"Education as a Science,"
p. 308. By Alexander Bain, LL.D. New York: D. Appleton & Co.,
1884.

But to generate and store up power, whether mental or physical, or both, is a waste of effort, unless the power is to be exerted. Why generate steam if there is no engine to be operated? Steam may be likened to an idea which finds expression through the engine — a thing. Why store the mind with facts — historical, philosophical, or mathematical—which are useless until applied to things, if they are not to be applied to things? And if they are to be applied to things, why not teach the art of so applying them? As a matter of fact, the system of education which does not do this is one-sided, incomplete, unscientific. Rousseau says, "Education itself is certainly nothing but habit." If this be true, it will be conceded that the habit of expressing ideas in things should be formed in the schools, because the chief way in which man is benefited is through the expression of ideas in things. The system of education which tends to form this habit is that of the kindergarten and that of the manual training school. These systems are one in principle. They are not new; they at least date back to Bacon, who declared that he would " employ his utmost endeavors towards restoring or cultivating a just and legitimate familiarity betwixt the mind and things." The kindergarten and the manual training school exactly realize Bacon's idea. The idea of the manual training school was in the mind of Comenius when he said, " Let things that have to be done be learned by doing them." It was in the mind of Pestalozzi when he said, " Education is the generation of power." It was in the mind of Froebel, not less than the kindergarten, when he said, " The end and aim of all our work should be the harmonious growth of the whole being."

These are excellent definitions of education, and they

are sequential. If things that have to be done are learned by doing them, there will be in the course of the process a wholesome exercise of both body and mind, and this exercise will result in the generation of power —power to think well, and to do well ; and the process being continued, the result cannot fail to be the harmonions growth of the whole being. This is scientific, as opposed to automatic, education.*

* "Intellectual progress is of necessity from the concrete to the abstract. But regardless of this, highly abstract subjects such as grammar, which should come quite late, are begun quite early. Political geography, dead and uninteresting to a child, and which should be an appendage of sociological studies, is commenced betimes, while physical geography, comprehensible and comparatively attractive to a child, is in great part passed over. Nearly every subject dealt with is arranged in abnormal order—definitions and rules and principles being put first, instead of being disclosed, as they are in the order of nature, through the study of cases. And then, pervading the whole, is the vicious system of rote learning—a system of sacrificing the spirit to the letter. . . .

"A leading fact in human progress is that every science is evolved out of its corresponding art. It results from the necessity we are under, both individually and as a race, of reaching the abstract by way of the concrete, that there must be practice and an accruing experience with its empirical generalizations before there can be science."—"Education," pp. 61, 134. By Herbert Spencer. New York: D. Appleton & Co., 1883.

¹ But the protection to property afforded by arms is only temporary. An increase of the standing army involves an increase of ignorance and poverty, and the last analysis of ignorance and poverty is anarchy. The anarchists of Chicago [1886] were of foreign birth. They came to the United States from the standing-army-ridden countries of Europe. They were the product, the victims, of the European governmental system. Hence, the proposal to adopt arms as a remedy for anarchy is a proposal to abandon the American idea of government for that of Europe. To preserve the society of to-day from violent dissolution, it is necessary to shoot the anarchist. But to assure the permanence of society it is necessary to educate the child of the anarchist.

CHAPTER XXI.

EDUCATION AND THE SOCIAL PROBLEM—HISTORIC.

EGYPT AND GREECE.

Fundamental Propositions.—Selfishness the Source of Social Evil;
Subjective Education the Source of Selfishness and the Cause of
Contempt of Labor; and Social Disintegration the Result of Con-
tempt of Labor and the Useful Arts.—The First Class-distinction
—the Strongest Man ruled; his First Rival, the Ingenious Man.—
Superstition.—The Castes of India and Egypt—how came they
about?—Egyptian Education based on Selfishness.—Rise of Egypt
—her Career; her Fall; Analysis thereof.—She Typifies all the
Early Nations: Force and Rapacity above, Chains and Slavery
below.—Their Education consisted of Selfish Maxims for the Gov-
ernment of the Many by the Few, and Government meant the Ap-
propriation of the Products of Labor.—Analysis of Greek Charac-
ter—its Savage Characteristics.—Greek Treachery and Cruelty.—
Greek Venality.—Her Orators accepted Bribes.—Responsibility of
Greek Education and Philosophy for the Ruin of Greek Civiliza-
tion.—Rectitude wholly left out of her Scheme of Education.—
Plato's Contempt of Matter: it led to Contempt of Man and all
his Works.—Greek Education consisted of Rhetoric and Logic; all
Useful Things were hence held in Contempt.

IT is a fundamental proposition of this work that self-
ishness is the essence of depravity, and hence the source
of all social evil; and in previous chapters it has been
shown, argumentatively, that exclusively subjective proc-
esses of education tend, in a high degree, to promote self-
ishness. Another fundamental proposition of this work
is that the useful arts are the true measure of civilization,
and that, as they are the product of labor, contempt of
the laborer leads inevitably to social disintegration and

the destruction of the State. If these propositions are
true, the solution of all social problems is to be sought
through a radical change in educational methods. If
they are true, it is of the first importance that they be
proved, not only by argument, but by the citation of such
facts of history as bear upon the subject. Civilization is
the product of education.[1] If the education is good the
product will be good, if evil the product will be evil. The
purpose of this and the four following chapters is, there-
fore, to trace the progress of civilization, to sketch in bold
outline the social history of man.

The aphorism, all men are created equal, is a fine
phrase, but its truth is reserved for realization by the
civilization of the future. A tendency to the formation
of class-distinctions in human society, whether savage or
civilized, is disclosed by all history.

The first class-distinction sprang from the physical su-
periority of one savage over his fellows. He whose power-
ful frame and commanding eye enabled him best to cope
with the beasts of field and forest became chief of the
tribe. He held the first place by virtue of his brawny
arm, and the less athletic, and more timid, became his
subjects. But he was not long without rivals. His first
rival was the dwarf, or hunchback, who, struggling to over-
come the misfortune of his deformity, in the seclusion of
his mud hut, invented the stone hatchet and stone-point-
ed arrow-head. His next rival was the puny, pale-faced
youth who converted pantomimic signs and rude gest-
ures into a language of sounds, and so armed communi-
ties with the power of combination for mutual protection.
Those who soonest mastered the first alphabet took high
rank in the social circle, while those who could still only
make themselves understood by grimaces and gestures

fell to the grade of ciphers in the body politic, and came to be looked upon as dunces in society. Thereafter the women, who had previously been won as wives by personal prowess, were more equally parcelled out. The savage who had invented the bow and the arrow was exempted from the toils of the chase, and from the general contention at the courting season ; a wife was assigned to him, and his tent was supplied with game in the hope that he would invent some other useful thing. Thus mind began to assert its empire over matter, the division of labor commenced, and a class-distinction was formed. Doubtless the youth who invented language cultivated superstition among the ignorant, and so, increasing his already considerable influence, secured the first social rank. Hence the castes of India and Egypt, consisting, in their order, of the priesthood, the army, the mercantile class, and, at the bottom of the scale, the servile laborer.

Of the long period of social progress from a state of savagery to the proud civilization of historic Egypt the record is faint and fragmentary. Ages passed, during which men struggled, and died, and left no sign — neither hieroglyphic character, monument, nor buried city. Through what mental alchemy was the savage chief transformed, in the course of hundreds of generations, into the learned, accomplished, and astute Egyptian priest, from whose courtly lips Herodotus received the chronicles of the Egyptian kings and the romantic story of the residence in Egypt of Helen of Troy ?* How were the members of the savage tribe converted, one into an obedient soldier, another into an adroit, self-seeking merchant, and

* "Herodotus, 'Euterpe,'" II., §§ 112–116. New York: Harper & Brothers, 1882.

another into a cringing slave? These are secrets of an-
tiquity, destined, doubtless, to remain forever unrevealed.
We do know, however, that the civilization of Egypt,
like all other civilizations, was the product of training or
education; and the nature of the education may be in-
ferred from the character and fate of the civilization.

Of the Egyptian system of education selfishness was
the basis. Given chains and slavery for the lowest class
and there were force and rapacity in the highest class.*
Before the free-born savage was reduced to slavery and
made to toil under the lash, whole hecatombs of lives
were sacrificed. Before the mind of the savage was de-
graded to the baseness of slavery, his body, hacked and
hewn, bent submissively to the scourge. For the Egyp-
tian boy there was, doubtless, a "Poor Richard's Alma-
nack," which taught him that he must "look to the main
chance;" that "in the race of life the devil takes the
hindmost;" and that "self-preservation is the first law of
nature." Thus trained he entered the ranks of the priest-
hood, one of his brothers took a commission in the army,
and the others embarked in mercantile life. For the
servile class there was no education beyond their sever-
al occupations. Each man was compelled to follow the
trade of his father, to marry within his own class, to die
as he was born.

Ruled by the priests, and the army, Egypt grew rich.
Her commerce, conducted by means of caravans, embraced
the whole civilized world and included all its products.
She became a great military and naval power, her armies
overrunning Asia, and her fleets sweeping the Indian

* "The Martyrdom of Man." p. 18. By Winwood Reade. New
York : Charles P. Somerby. 1876.

Ocean. Her victorious campaigns opened new markets
to her commerce, and through these channels wealth
poured into the empire. In the track of the wheels of
the Egyptian war-chariots the Egyptian merchant quick-
ly followed. At the point of the arrows of her archers
she offered her linen goods to conquered peoples, as Eng-
land, at the point of the bayonet, subsequently offered
her cotton goods to prostrate India.

In Egypt all the learning of the time was concentrated.
It was the university of Greece. Every intellectual Greek
made a voyage to Egypt; it was regarded as a part of
education, as a pilgrimage to the cradle-land of their my-
thology.' The possession of great wealth led to habits
of luxury. The house of the Egyptian gentleman was a
palace adorned with the triumphs of art, and devoted to
pleasure. Its walls, its floors, and its furniture reflected
the skill, not to say genius, of slaves—for all the manual
labor of Egypt was performed by slaves. At the end of
the fashionable dinner, given in the palace by its rich
master, a mummy, richly painted and gilded, was present-
ed to each guest in turn by a servant, who said, "Look
on this; drink and enjoy thyself, for such as it is now
so thou shalt be when thou art dead."*

One day when the priests were sacrificing in the tem-
ples, and the chief officers of the army were dining with
a contractor for army supplies, a band of mountaineers
rushed out of the recesses of Persia and swept like a
wind across the plains. They were dressed in leather;
they had never tasted fruit nor wine; they had never
seen a market; they knew not how to buy or sell. They

* "Herodotus, 'Euterpe,'" II., p. 78. New York: Harper &
Brothers, 1882.

were taught three things—to ride on horseback, to hurl the javelin, and to speak the truth.* All Asia was covered with blood and flames. The allied kingdoms fell at once, and India and Egypt were soon afterwards added to the Persian empire.

Egypt typifies all the early nations. In its rise, progress, and fall, the course of the others may be traced. First there is a band of hardy men whose prowess renders them irresistible. They are inured to toil; they practise all the manly virtues; they are trained to labor with their hands; they are taught to speak the truth. They lay the foundations of the State in industry[3] and prudence; their children develop its resources; their children's children, through many generations, gradually accumulate wealth. The arts flourish, and luxuries are multiplied. There are many great estates, and those who inherit them cease to labor, and, ceasing to labor, they become a charge upon the public; for the value of an estate created one hundred years ago, or one year ago, can be maintained in no other way than by the labor of to-day.† The idlers increase in number, and the struggle for existence, of the workers, becomes more intense. Idle-

* "Herodotus, 'Clio,'" I., §§ 71, 136, 153. New York: Harper & Brothers, 1882.

† "It is not equitable that what one man hath done for the public should discharge another of what it has a right to expect from him; for one, standing indebted in himself to society, cannot substitute anything in the room of his personal service. The father cannot transmit to his son the right of being useless to his fellow-creatures. . . . The man who earns not his subsistence, but eats the bread of idleness, is no better than a thief. . . . To labor, then, is the indispensable duty of social or political man. Rich or poor, strong or weak, every idle citizen is a knave."—"Emilius and Sophia," Vol. II., pp. 92, 93. By J. J Rousseau. London: 1767.

ness breeds vice, and the public morals are debauched.[4] We see this class at the feast of Belshazzar and at the dinner of the Egyptian *bon vivant*. On the wall of every such banqueting room there is an ominous handwriting, provided, only, that there is a Daniel to interpret it. It means that the nation that degrades labor, tolerates idleness, and deifies vice, is ripe for annihilation. If, now, there is on the frontier of the effete nation a virile people, it is only a question of time and opportunity, when they will make slaves of the revellers, and spoil of their inherited estates. The worn-out, exhausted nation disappears in blood and flames. The rich idler, the poor sycophant, the rulers and the ruled, the slave and his master, the priest, the soldier, the merchant, and the laborer, all go to destruction together.

In the ancient nations there was always force and rapacity above, and chains and slavery below. Education was confined to a small class, and consisted of selfish maxims for the government of the many, and government was only another name for the appropriation of the products of their labor. Selfishness bred injustice, and the practice of injustice undermined the State. Whether the State survived or fell was a matter of indifference to the slave. A slave he remained in any event — if not of the Egyptian then of the Persian. But the importance of labor is shown by those bloody revolutions. The battles of antiquity were contests for the possession of the labor class. Which nationality — the Egyptian or the Persian—should drive the toilers to their daily tasks; which should reap the fruit of the sweat of their brows; which should buy and sell them; which scourge them to their dungeons? These were the questions which agitated the minds of ancient rulers. They were the questions

which agitated the mind of Xerxes when he invaded
Greece, with millions of followers, to encounter defeat
at the hands of a few thousand men of a superior type.

The Greek civilization sprung from mythology and
ended in anarchy. In the East the Greeks were called
the people of youth. Their religion was of the savage
type. Their gods were immortalized men; they loved
and hated, transgressed and suffered; they resorted to
stratagems to compass their ends; they were a kind of
exalted but unscrupulous aristocracy.

Greek patriotism was narrow; each city was politically
independent, and the citizen of one city was an alien and
a stranger in the territory of every other. The Greeks
were superstitious. If the omens were unfavorable the
general refused to give battle; the plague was a visible
sign of the wrath of the gods; the priests sacrificed per-
petually; the oracle of Apollo outlived Grecian indepen-
dence hundreds of years.*

Grecian national festivals were childish, consisting of
wrestling, boxing, running, jumping, and chariot-racing.
But the victor in those games conferred everlasting glory
upon his family and his country, and was rewarded with
distinguished honors.

Like savages, the Greeks were treacherous. The des-
tiny of Greece was controlled by renegades. There was
disloyalty in every camp, a Greek deserter in every op-
posing army, and a traitor, or a band of traitors, in every
besieged Greek city.* They were cruel; of their captives
they butchered the men and enslaved the women, and
they stripped and robbed the bodies of the slain, on the
battle-field. Like savages they assassinated ambassadors,
and like savages surrendered prisoners to their personal
enemies to be massacred.' Their sense of honor was dull.

Xenophon, after winning imperishable renown, in con-
ducting the famous retreat of the "Ten Thousand," led a
detachment of them on a pillaging expedition, and so
amassed a fortune. "My patriotism," says Alcibiades,
"I keep not at a time when I am being wronged."
"For there was neither promise that could be depended
on, nor oath that struck them with fear," exclaims Thu-
cydides.*

Venality was the predominating trait in Greek charac-
ter, and venality unrestrained is savagery. In the Greek
Pantheon the highest niche was reserved for the God of
Gain. The early Greeks were pirates; they plundered
one another; they sometimes actually sold themselves
into slavery, so great was their lust of gold. The richest
cities ruled the poor cities. Pericles boasted that he
could not be bribed, but he robbed all Greece to embel-
lish Athens, and was accused of peculation, tried, con-
victed, and fined. The Athenians declared that the
Spartans were taught to steal, and the Spartans retorted
that the best Athenians were invariably thieves. When
Persia could no longer fight she defended her territory
against Greek invasion with gold coins.

The Greek orators never refused a bribe, and oratory
ruled Greece.' Greek oratory was very persuasive. A
discriminating writer declares that, with their fine phrases
and rhetorical expressions, the Greek orators swindled his-
tory, obtaining a vast amount of admiration under false
pretences.†

For these defects in Greek character, and for the re-

<hr/>

* "The History of the Peloponnesian War," Vol. I., p. 210. Lon-
don: George Bell & Sons.

† "The Martyrdom of Man," p. 88. By Winwood Reade. New
York: Charles P. Somerby, 1876.

sulting decay of Greek civilization, Greek philosophy and
Greek education must be held responsible. Metaphysics
and rhetoric ruined Greece. It was in the schools of
rhetoric that the young Greeks received their training
for the duties of public life. There they were taught
the art of oratory; there they learned how to make the
worse appear the better reason. There they were taught,
not to expound the truth, but to indulge in the arts of
sophistry. It was in those schools that the young Greek
was trained to be eloquent, to win applause in the courts
of law, not to convince the judgments of judge, or juror;
for judicial decisions were notoriously subjects of the
most shameful traffic.

The element of rectitude was wholly left out of the
Greek system of education, and hence wholly wanting in
Greek character. The Greeks had a profound distrust
of one another. They were dishonest; they were treach-
erous; they were cruel; they were false; and all these
vices are peculiar to a state of savagery.' In ethics they
never emerged from the savage state, and hence in poli-
ties their failure was complete; for the prime condition
of the most simple form of civil society is mutual confi-
dence. But the mutual distrust of the Greeks, based on
want of integrity, was so absolute that political unity was
impossible, and the failure to combine the several cities
under one government led, eventually, to the destruction
of Greek civilization.

To this result Greek philosophy also contributed.
Plato's contempt for matter was so profound that he re-
garded the soul's residence in the body as an evil. He
taught that the philosopher should emancipate himself
from the illusions of sense, devoting his life to reflection,
and surrendering his mind " to communion with its kin-

dred eternal essences."[10] Contempt of matter led logically to contempt of the physical man, and hence to contempt of things, the work of man's hands. Such a philosophy was necessarily "in the air." It afforded no aid to the sciences; for science is the product of generalizations from matter. It scorned art; for the arts are applications of the sciences in useful things. With the Greek schoolmaster rhetoric was the chief part of education; with the Greek philosopher dialectics was the science *par eminence.*

Thus the Greek system of education was confined to rhetoric and logic—the art of speaking with propriety, elegance, and force, and the power of deducing legitimate conclusions from assumed premises.[1] In the Greek schools of rhetoric there was no struggle to find the truth; in the schools of philosophy there was no respect for the evidence of the senses. The Greek orator harangued the jury eloquently while his client bargained with the court for the price of justice! The Greek philosopher confounded his audience with the force of his unanswerable logic, and appealed to his inner consciousness in support of the soundness of his premises!

The explanation of Greek duplicity is found in Greek metaphysics. To scorn things is to disregard facts, and disregard of facts is contempt of the truth. Greek education was confined to a consideration of the subject of the nature and relations of abstract ideas, while the subject of the nature and relations of things was wholly neglected. Such a system of education led logically to selfishness, and out of selfishness grew inordinate ambition and greed; and these passions led, through treachery and dishonesty, to factional contests, which, eventuating in bloodshed, could only end in anarchy. Distracted

by the jealousies and rivalries of States constantly in hostile conflict, and enfeebled by the never-ending strife between the rich and the poor, Greece fell a prey to the rapacity, and lust of power, of her unscrupulous Roman neighbor.

[1] "All the happiness of families depends upon the education of children, and houses rise or sink according as their children are virtuous or vicious."—Plato's "Divine Dialogues," p. 262. London: S. Cornish & Co., 1839.

[2] "The Egyptians were, in the opinion of the Greeks, the wisest of mankind."—Herodotus, "Euterpe," II., § 160. New York : Harper & Brothers, 1882.

"For my part, I think that Melampus, being a wise man, both acquired the art of divination, and having learned many other things in Egypt, introduced them among the Greeks, and particularly the worship of Bacchus."—Ibid, "Euterpe," II., § 49.

"And indeed the names of almost all the Gods came from Egypt into Greece."—Ibid, "Euterpe," II., § 50.

"The manner in which oracles are delivered at Thebes in Egypt and at Dodona, is very similar; and the art of divination from victims came likewise from Egypt."—Ibid, "Euterpe," II., § 57.

"The Egyptians were also the first who introduced public festivals, processions, and solemn supplications: And the Greeks learned these from them."—Ibid, "Euterpe," II., § 57.

To the same effect, see also:

Ibid, "Euterpe," II., § 64.
 " " " § 109.
 " " " § 123.
 " " " § 160.
 " " " §§ 164-166.
 " " " § 171.

And Ibid, "Melpomene," IV., § 180.

[3] "Amasis it was who established the law among the Egyptians that every Egyptian should annually declare to the governor of his district by what means he maintained himself; and if he failed to do this, or did not show that he lived by honest means, he should be punished with death. Solon, the Athenian, having brought this law from Egypt, established it at Athens; and that people still continue to observe it, as being an unobjectionable regulation."—Herodotus, "Euterpe," II., § 177. New York: Harper & Brothers, 1882.

⁴ "Lysimachus, son of Aristides the Just, and Melesias, son of Thucydides, to the Athenian generals, Nicias and Laches:

"Both he and I have entertained our children with thousands of brave actions done by our fathers both in peace and war, while they headed the Athenians and their allies; but to our great misfortune we can tell them no such thing of ourselves. This covers us with shame; we blush for it before our children, and are forced to cast the blame upon our fathers; who, after we grew up, suffered us to live in effeminacy and luxury; while they were employing all their care for the interest of the public."—Plato's "Divine Dialogues," p. 256. London: S. Cornish & Co., 1839.

⁵ "After the encounter between the cavalry had taken place, Agesilaus, on offering sacrifice the next day with a view to advancing, found the victims inauspicious, and in consequence of this indication turned off and proceeded toward the coast."—Xenophon, "Hellenics," p. 369. London: George Bell & Sons, 1881.

See, also, Thucydides, Vol. II., p. 348. London: George Bell & Sons, 1880.

And Ibid, Vol. II., p. 484.

And, "Plutarch's Lives [Timoleon]," p. 177. New York: Harper & Brothers, 1850.

⁶ Alcibiades to the Lacedæmonians: "And now, I beg that I may not be the worse thought of by any among you, because I am now strenuously attacking my country with its bitterest enemies, though I formerly had a reputation for patriotism."—Thucydides, Vol. II., p. 439. London: George Bell & Sons, 1880.

Of Pausanias and Themistocles, who were both traitors, Thucydides says: "Such was the end of Pausanias the Lacedæmonian and Themistocles the Athenian, *who had been the most distinguished of all the Greeks in their day*."—"History of the Peloponnesian War," Vol. I., pp. 75-83.

See also Ibid, Vol. I., p. 288.
" " " pp. 292-293.
" " " p. 304.
" " " pp. 306-307.
" " " p. 241.
" " Vol. II., p. 510.

See also Herodotus, "Melpomene," IV., § 142. New York: Harper & Brothers, 1882.

⁷ "When the Corcyræans had got possession of them [prisoners surrendered by their allies the Athenians] they shut them up in a large building, and, afterward taking them out by twenties, led them

through two rows of heavy-armed soldiers posted on each side; the
prisoners being bound together were beaten and stabbed by the men
ranged in the lines, *whenever any of them happened to see a personal
enemy;* while men carrying whips went by their side, and hastened
on the way those that were proceeding too slowly."—Thucydides,
Vol I., pp. 256–257. London: George Bell & Sons, 1880.

Ibid, Vol. I., p. 62
" II., p. 376.
" II., p. 468.
" II., p. 495.
" II., pp. 510–511.
" II., p. 523.

See also Herodotus, "Terpsichore," V., § 6.

Ibid. "Terpsichore." V., § 21.

Ibid, "Urania," VII., §§ 104. 105. 106.

See also Xenophon, "Hellenics," p. 328. London : George Bell
& Sons, 1882.

See also "Plutarch's Lives [Lycurgus]," p. 42. New York : Harper & Brothers, 1850.

[8] "For the Grecians in old time. . . . turned to piracy, . . .
and falling upon towns that were unfortified, . . . they rifled
them, and made most of their livelihood by this means." . . .
"For through desire of gain the lower orders submitted to be slaves
to their betters; and the more powerful, having a superabundance
of money, brought the smaller cities into subjection."—Thucydides,
Vol. I., pp. 3, 4, 5. London : George Bell & Sons, 1880.

"Yet that the boys might not suffer too much from hunger, Lycurgus, *though he did not allow them to take what they wanted without trouble,* gave them leave to steal certain things to relieve the
cravings of nature; *and he made it honorable to steal as many cheeses
as possible.*"—Xenophon's "Minor Works," p. 208. London: George
Bell & Sons, 1882.

"Demosthenes could not resist the temptation; it made all the
impression upon him that was expected; he received the money, like
a garrison into his house, and went over to the interest of Harpalus.
Next day he came into the Assembly with a quantity of wool and
bandages about his neck ; and when the people called upon him to get
up and speak, he made signs that he had lost his voice, upon which
some that were by said, ' it was no common hoarseness that he got
in the night; it was a hoarseness occasioned by swallowing gold and

silver.'"—"Plutarch's Lives [Demosthenes]," pp. 594–595. New York: Harper & Brothers, 1850.

See also, "Plutarch's Lives [Agesilaus]," p. 431. New York: Harper & Brothers, 1850.

Ibid [Demosthenes], p. 591.

" [Aristides], p. 232.

"And Plato, among all that were accounted great and illustrious men in Athens, judged none but Aristides worthy of real esteem."—"Plutarch's Lives [Aristides]," p. 243. New York: Harper & Brothers, 1850.

But it was Aristides who said of a public measure : "It is not just, but it is expedient."

"As to the proceedings in courts of law they [the Athenians] have less regard to what is just than to what is profitable to themselves."—Xenophon's "Minor Works," pp. 235–236. London : George Bell & Sons, 1882.

Ibid, pp. 243, 244.

When Mardonius the Persian consulted with the Thebans how to subdue Greece, they said: "Send money to the most powerful men in the cities, and by sending it you will split Greece into parties, and then, with the assistance of those of your party, you may easily subdue those who are not in your interest."—Herodotus, "Calliope," IX., § 2. New York: Harper & Brothers, 1882.

Ibid, "Urania," VIII., §§ 128–134.

" "Calliope," IX., § 44.

See also "Plutarch's Lives [Pericles]," p. 123. New York: Harper & Brothers, 1850.

Ibid, "Pericles," p. 118.

" "Pericles," p. 115, *note.*

"Accordingly, as the Athenians state, these men while staying at Delphi, prevailed on the Pythian by money, when any Spartans should come thither to consult the oracle, either on their own account or that of the public, to propose to them to liberate Athens from servitude."—Herodotus, "Terpsichore," V., § 63. New York : Harper & Brothers, 1882.

Ibid, "Erato," VI., §§ 72, 100.

[9] Euripides makes Andromache say: "O, ye inhabitants of Sparta, most hated of mortals among all men, crafty in counsel, king of liars, concoctors of evil plots, crooked and thinking nothing soundly, but all things tortuously, unjustly are ye prospered in Greece. And what evil is there not in you ? Are there not abundant murders ? Are

ye not given to base gain? Are ye not detected speaking ever one thing with the tongue but thinking another? A murrain seize you!"—"The Tragedies of Euripides [Andromache]," Vol. II., p. 138. New York: Harper & Brothers, 1857.

[10] "Is it not by reasoning that the soul embraces truths? And does it not reason better than before when it is not encumbered by seeing or hearing, by pain or pleasure? When shut up within itself it bids adieu to the body, and entertains as little correspondence with it as possible; and pursues the knowledge of things without touching them. . . . Is it not especially upon this occasion that the soul of a philosopher despises and avoids the body and wants to be by itself? . . . Now, the purgation of the soul, as we were saying just now, is only its separation from the body, its accustoming itself to retire and lock itself up, renouncing all commerce with it as much as possible, and living by itself, whether in this or the other world, without being chained to the body."—Plato's "Divine Dialogues," pp. 180, 181, 182. London: S. Cornish & Co., 1839.

[11] "During most of the flourishing age of Hellenistic culture the rhetor was the acknowledged practical teacher; and his course, *which occupied several years,* with the interruption of the summer holidays, comprised first a careful reading of classical authors, both poetical and prose, with explanations and illustrations. This made the student acquainted with the language and literature of Greece. But it was only introductory to the technical study of expression, of eloquence based on these models, and of accurate writing as a collateral branch of this study. When a man had so perfected himself, he was considered fit for public employment."—"Old Greek Education," p. 137. By J. P. Mahaffy, M. A. New York: Harper & Brothers, 1882.

CHAPTER XXII.

EDUCATION AND THE SOCIAL PROBLEM—HISTORIC.

ROME.

Vigor of the Early Romans—their Virtues and Vices; their Rigorous
Laws; their Defective Education; their Contempt of Labor.—Slav-
ery: its Horrors and Brutalizing Influence.—Education Confined
to the Arts of Politics and War; it transformed Courage into
Cruelty, and Fortitude into Stoicism.—Robbery and Bribery.—The
Vices of Greece and Carthage imported into Rome.—Slaves con-
struct all the great Public Works; they Revolt, and the Legions
Slaughter them.—The Gothic Invasion.—Rome Falls.—False Phi-
losophy and Superficial Education promoted Selfishness.—Deifica-
tion of Abstractions, and Scorn of Men and Things.—Universal
Moral Degradation.—Neglect of Honest Men and Promotion of
Demagogues.—The Decline of Morals and Growth of Literature.—
Darwin's Law of Reversion, through Selfishness, to Savagery.—
Contest between the Rich and the Poor. — Logic, Rhetoric, and
Ruin.

IN the city of the Seven Hills there was no statue to
Pity, as at Athens. In the long line of Roman conquer-
ors there was no one possessing the title to fame, of
which, on his death-bed, Pericles boasted, namely, that
" no Athenian had ever worn mourning on his account."

The dominion of Rome was logical. In the legend of
Romulus and Remus, suckled by the she-wolf, there is a
hint of the rugged vigor which characterized the Roman
people, and distinguished them from the earlier nationali-
ties. In all the civilizations anterior to that of Rome there
was an element of pliability or softness which belongs to
the youth of man. But from the day on which Romulus,

with the brazen ploughshare, drew a furrow around the
Palatine, both the sinews and the souls of his followers
hardened into maturity. The rising walls of the city, so
the legend runs, were moistened with the life-drops of
Remus, whose derisive remark and act cost him his life,
his slayer exclaiming, haughtily, "So perish all who dare
to climb these ramparts." The rape of the Sabines, the
conflicts which ensued with that outraged people, their
incorporation with the conquerors, their subsequent joint
conquests, and the shrewdness displayed in the conserva-
tion of the fruits of victory—these events show that man
had attained his majority. Under the shadow of the
walls of the Eternal City all the great races were associ-
ated and mingled—Latins, Trojans, Greeks, Sabines, and
Etruscans. The Roman civilization was the product of
all that had gone before, as it was destined to be the fa-
ther of all that should follow it. The Roman had no
peer either in courage or fortitude. Aspiring to uni-
versal dominion, he toughened himself to achieve it.
Dooming his enemy to death or slavery, he was not less
self-exacting, his own life, through the cup of poison,
the sword, or the opened vein, becoming the forfeit
equally of misfortune and shame. The tragic fate of
Lucretia, the resulting revolution, the banishment of the
Tarquins, and the abolition of the kingly government
show the swiftness of Roman retribution and the terrible
force of Roman resolution. Roman persistence in the
path of conquest for many centuries is typified by Cato in
his invocation of destruction upon Carthage. The mas-
culine character of the Roman vices finds illustration in
the struggle of Appius, the Decemvir, to possess the per-
son of Virginia by wresting the law from its true pur-
pose, the conservation of justice, and converting it into a

shield for lust; and the vigor of Roman virtue is exemplified in the act of Virginius plunging the knife into the heart of his beloved daughter to save her honor. The rigorous laws of Rome testify to the stamina of her people. The father to whom a deformed son was born must cause the child to be put to death, and any citizen might kill the man who betrayed the design of becoming king.

A scientific system of education would have conserved and developed the noble and eliminated the ignoble traits of Roman character. But neither Roman education, philosophy, nor ethics inculcated either respect for labor or reverence for human rights; and hence the laborer was reduced to slavery, and the slave made the victim of every known atrocity. Slavery became the corner-stone of the Roman State, and slavery and labor were synonymous terms. The Roman supply of laborers was maintained by depopulating conquered countries. In the train of the legions, returning to Rome in triumph, there were not only statues, paintings, and other works of art, but thousands of men, women, and children destined to slavery. And the laws in regard to slaves were terrible, as laws touching slavery must always be — for a state of slavery is a state of war. It was a law of Rome that if a slave murdered his master the whole family of slaves should be put to death; and Tacitus relates an instance of the execution of four hundred slaves for the murder of a citizen, their master. In the course of the servile rebellion in Sicily a million slaves were killed; and it should be borne in mind that they were valuable laborers — many of them skilled artisans. Vast numbers of them were exposed to wild beasts in the arena, for the popular amusement. The rebellion of the gladiators was put down only by a resort to awful atrocities, among

which was the crucifixion of prisoners. The revolt of
the allies was quelled at the cost of half a million lives.
But slaves were plenty, for Rome had her bloody hand
at the throat of all mankind, and her hoarse cry was,
" Your life or your liberty !"

Every Roman freeman was a soldier, and the cultiva-
tion of the land, manufactures, and all the pursuits of in-
dustry, were carried on by slaves. Slave labor was cheap-
er than the labor of animals; cattle were taken from
the plough and slaughtered for beef that slaves—men—
might take their places. Labor fell to the lowest degree
of contempt, and the laborer was a thing to be spurned
—for the free citizen to labor with his hands was more
disgraceful than to die of starvation. Hence there was a
class of citizen paupers to whom largesses of corn were
doled out by the demagogues of the Senate and the army.
Ultimately these citizen-paupers became so vile and filthy
that they engendered leprosy and other loathsome dis-
eases, as they dragged their palsied limbs through the
streets of the city, crying, " Bread and circuses ! bread
and circuses !"

Roman education was confined almost exclusively to
the training of the sons of rich citizens in the arts of
politics and war; and in a State where labor was de-
spised, and whose corner-stone was slavery, and whose
shibboleth was conquest, the baseness of these arts may
be imagined but hardly described. It promoted selfish-
ness, and in the course of centuries selfishness transform-
ed Roman courage into cruelty, and Roman fortitude
into brutal stoicism. The Roman sense of justice was
swallowed up in Roman lust of power. Rome became
the great robber nation of the world. She was on the
land what Greece had once been on the sea—a pirate.

She made the streets of the cities she conquered run
with blood. Thousands of captives she doomed to death ;
other thousands graced the triumphs of her generals, and
the spoil saved from the fury of the flames, and the more
ungovernable fury of the licentious soldiery, was carried
home to the Eternal City, there to fall into the hands of
the most cunning among the demagogues, for use in the
bribery of courts, senators, and the populace.

Tacitus deplored the decline of public virtue. He de-
clared, mournfully, that "Nothing was sacred, nothing
safe from the hand of rapacity." His environment blind-
ed him to the true cause of the depravity he so elo-
quently deplored—selfishness. Had he been familiar with
the inductive method he would have found in a defective
system of education the cause of Roman venality and cor-
ruption. He might thus have realized the weakness of a
community of men who wanted the necessary force and
virtue to depose a Tiberius and elevate to his place a
Germanicus ; or to dethrone a Domitian and crown in
his stead an Agricola.

Education in Rome deified selfishness, and hence real-
ized its last analysis—total depravity. Of course noth-
ing was sacred in a community where men were ruth-
lessly trampled underfoot! Of course nothing was "safe
from the hand of rapacity" where the laborer was de-
graded to a place in the social scale below the leprous
pauper whose filthy person provoked disgust, and whose
poisonous breath, as he cried for bread, spread abroad
disease and death !

It was inevitable that the nation that grew rich through
plunder should grow poor in public and private virtue.
And such was the fact. The eagles that protected rob-
bers abroad, spread their sheltering wings over defaulters,

bribers, and thieves at home. There had been a time in
Rome when bribery was punishable with death, but now
candidates for office sat at tables in the streets near the
polling-places and openly paid the citizens for their votes.
The change in the habits of the people was as pronounced
as the change in the laws. The early triumphs of the
Romans were industrial — flocks and herds; their tro-
phies, obtained in single combat, consisted of spears and
helmets. When Cincinnatus was sent for to assume
the dictatorship he was found in his field following the
plough. Valerius, four times consul, and by Livy char-
acterized as the first man of his time, died so poor that
he had to be buried at the public charge. But with the
fall of Greece and Carthage, and the reduction of Asia,
there was a great social change at Rome. The Roman
legions not only carried home the wealth of the coun-
tries they conquered but the vices of the peoples they
subdued. An ancient writer summarizes the situation
in the following graphic sentence: " The only fashiona-
ble principles were to acquire wealth by every means of
avarice and injustice, and to dissipate it by every method
of luxury and profusion."

The end is not far off. The story of Persia, of Egypt,
and of Greece is the story equally of Rome. Avarice
and injustice, luxury and profusion do their sure work.
The Roman civilization is more than a thousand years
old. Asiatic wealth, the luxury and false philosophy of
Greece, and a vicious system of education, promoting
selfishness, have united to sap its foundations. Society
is divided into three classes—an aristocracy based solely
upon wealth, cruel and profligate, a mob of free citizens,
otherwise paupers, who live by beggary and the sale of
their votes, and laborers who are slaves.

On the occasion of the presentation of spectacles, among a variety of presents slaves (laborers) are thrown into the arena to be scrambled for by the free citizens! But men are cheap. In Asia they sell for sixpence apiece, and Rome has only to send an army there to get them for nothing. To this class, to these slaves, however, the Roman people are indebted for all the arts which make life agreeable. They construct all the great public works. They build the splendid roads over which the Roman legions follow their generals in triumph home to Rome. They make the aqueducts, dig the canals, and construct the buildings, public and private, whose remains still attest their magnificence — the Forum, the amphitheatres, and the golden house of the Cæsars. They build the villas overlooking the Bay of Naples, in which the nobles live in riot and wantonness; they cook the dinners given in those villas; they make the clothes the nobles wear, and the jewels that adorn their persons. They cultivate the fields, follow the plough, train and trim the vine, and gather in the harvest. They raise the corn that is distributed by the nobles among the soldiery, and given as a bribe to the diseased and debauched free citizens for their votes. They feel deeply the injustice of their lot, and, like men, strike for liberty. But the Roman legions are set on them like blood-hounds, and hundreds of thousands of them are slaughtered and made food for birds of prey, and other thousands are thrown into the arena to be torn by wild beasts, and still others are bestowed as gifts upon the populace at the games.

The contest between the rich and the poor is at an end; the rich are millionaires, the poor are beggars. It is the story of Dives and Lazarus over again. The rich are clothed in purple and fine linen, and fare sumptuous-

ly every day; the poor are full of sores, and live upon the crumbs that fall from the tables of the rich. Rome topples to her fall. The Gothic invader is at her gates, and there is no army to defend them. The barbarian demands a ransom. To obtain it the statues are despoiled of their ornaments and precious stones, and the gods of gold and silver are melted in the fire. The ransom is given, and Alaric retires. But he returns, and this time to pillage. The city is sacked; rich and poor, bond and free, are whelmed in one common ruin. At last the diabolic wish of the infamous Caligula is realized. The Roman people have but one neck, and the Goth puts his foot upon it. Rome falls, the victim of her own crimes, strangled by her own gluttony. Thus ends the first period of the world's manhood—ends in exhaustion, and a syncope which is destined to last a thousand years.

Long before the fall of the republic Rome had become the seat of all the world's learning. In robbing conquered countries she not only took their gold and silver, a share of their people for slaves, and their works of art, but their libraries, their philosophy, and their literature. But neither the Greek nor the Roman philosophy contributed in the least to a solution of the pressing social problems of the time. The wise men of Rome were powerless to help either themselves or their fellow-men, because their philosophy was false. It was purely speculative; it had no body of facts to rest upon.

The Roman educators and philosophers were almost as ignorant of physiology as Plato was hundreds of years before, hence they were unable to study the mind in the sole way in which it is intelligently approachable, namely, through its bodily manifestations. In studying the mind as an independent entity there could be no general

rules of investigation. The metaphysical philosopher did not study the mind of man; he explored his own mind merely—consulted his own inner consciousness. Hence there were, in Rome, as many systems of philosophy, more or less clearly defined and distinct, as there were philosophers. But they were merely metaphysical speculations, dreams, dependent upon purely subjective processes; and those processes were in turn dependent upon the ever-changing states of mind of each philosopher.

It is obvious that these systems of philosophy could exert no influence upon the community at large, for the community formed no part of the subject matter of their speculations. But they did exert an influence, and a very pernicious one, upon the philosophers themselves, and indeed upon all the cultured men of Rome; for they were thereby made thoroughly selfish, and so rendered incapable of forming a just judgment of public affairs. In considering the mind apart from the body, the body naturally fell into utter contempt. This was the great crime of speculative philosophy; for in engendering a feeling of contempt for the human body it furnished an excuse for slavery. And this contempt logically included manual labor, for the only manual laborer was a slave; and it also extended to the useful arts, for all those arts were the work of slaves. Hence the laborer, being a slave, was placed lower in the social scale than the pauper who sold his vote for a glass of wine. And thus it came about that a factitious right—the right of suffrage—was more highly esteemed by the public than the cardinal virtue of industry, upon which alone the perpetuity of the social compact depends.

And, as a wretched state of public morals may be that the right of suffrage, through

which the idle, leprous pauper was elevated above the industrious laborer and above the useful arts, was notoriously the subject of open traffic in the streets of Rome on every election day. Thus Roman philosophy landed the Roman people in the last ditch, for it led to the deification of abstract ideas and to scorn of things. That this utter perversion of the truth and wreck of justice was the cause of the decline of the Roman Empire there is no doubt.

It is equally plain that the noted men of Rome were utterly ignorant of the cause of the disorders which afflicted the body politic. There is no evidence, either in their lives or their works, that they brought to the consideration of the great social problems of the time any practical philosophy whatever. Suetonius, with a graphic pen, portrays the cruelties of the Cæsars, but hints at no cause therefor inherent in the social system. Cicero forecasts the doom of the republic, but has no remedy to propose except that of the elevation of Pompey rather than Cæsar. Livy and Tacitus deplore the decay of public and private virtue, but are silent on the subject of the infamy of slavery and on the shame of degrading labor. The moral sentiments of Seneca and Aurelius are of the most elevated character, but the fact that they ignore slavery, the slave, the laborer, and the useful arts, shows either that they never thought upon those fundamental social questions, or that their thoughts ran in the popular channel; in a word, that their philosophy was so shallow as to render them callous to the great crimes upon which the Roman State rested.

That the subjective philosophy and the defective educational system of the Romans rendered them selfish, and hence corrupt, there is abundant evidence. Cicero

professed the most lofty patriotism, but he was without
moral courage. It was he who congratulated the public
men of Rome, after the usurpation of Cæsar, upon the
privilege of remaining "totally silent!" He regarded
Pompey as "the greatest man the world had ever pro-
duced," but deserted him in his extremity, which was
equally the extremity of his country. He denounced
Cæsar as the cause of the culminating misfortunes of
Rome, but went down upon his knees to him, and rose
to his feet only to exhaust all the resources of his match-
less eloquence in fulsome adulation of the destroyer of
the Republic.

Seneca's moral precepts are sublime, but his political
maxims are atrocious. Witness this pretence of an all-
embracing love for man—"Whenever thou seest a fel-
low-creature in distress know that thou seest a human
being." Contrast with this exalted sentiment of the
great stoic his political maxim — "Terror is the safe-
guard of a kingdom"—and reflect that he lived under
the reigns of Claudius and Nero. The millions of slaves
in the Roman dominions were "human beings," but
Seneca had no practical regard for them as "fellow-
creatures in distress." His beautiful humanitarian sen-
timent was a barren ideality—it bore no fruit; but his
brutal political maxim caused him to thrive. Under the
favor of Claudius he amassed a vast fortune. His
palace in the city was sumptuously furnished, his coun-
try-seats were splendidly appointed, and he possessed
abundance of ready money. "There can be no happiness
without virtue," exclaims this prosperous Roman citizen.
But while he pens this lofty sentiment he is accused of
avarice, usury, and extortion, charged wit' " ity in
the Piso conspiracy, and banished for the

The debasing influence of the Greek philosophy, upon the Roman people, is shown by contrasting the characters of the distinguished men who were honored by the public at widely separated periods of time. Thus, during the period 400–350 B.C., Camillus, noted above all his contemporaries for the purity of his public life, was uninterruptedly honored with the highest offices in the State, and loved and respected by all classes of the community. But three hundred years later Cæsar, who involved the country in civil war to compass his ambition, and in which struggle liberty perished — he was preferred, in all the political struggles preliminary to his assumption of supreme power, to Cato, whose patriotism was unquestioned, and whose rigid virtue was proverbial throughout the Roman Empire. So also of a still later period, Agricola and Germanicus were renowned for the possession of the highest qualities of true manhood, joined to the practice in public life of the most austere and self-sacrificing virtue. Both served the State with courage, ability, and zeal; but the one, after a brilliant career in the West, was forced into retirement, and the other, after splendid services in the East, was exiled and poisoned.

Previous to the introduction of the Greek philoso. phy, and the Greek education and social habits, the Roman people were worthy of their noblest representative —Camillus. At that early period of their history they rewarded virtue and punished vice. But during the Empire, after the invasion of Greek manners, they were unworthy of their best representatives—Cato, Germanicus, and Agricola. To those great and good men they preferred Cæsar, Caligula, and Nero: they rewarded vice and punished virtue. There is in this circumstance un-

questionable evidence of a great declension in character. But the remarkable fact in regard to this period of Roman history is that the declension in character was accompanied by a species of great mental growth or power.

During this period a literature was created which has ever since been famous, and which still exerts a considerable influence upon man. Cæsar's Commentaries, the Orations of Cicero, the Annals of Tacitus, Livy's History, the Odes and Satires of Horace, the Meditations of Aurelius, and the Morals of Seneca are in all the world's libraries, and, in the universities, are placed in the hands of the most favored youth of all the civilized countries of the world, as models of style and exponents of a civilization whence all modern civilizations sprung. But this literature possessed no saving quality, because in so far as it was elevated in morals it did not represent the Roman people, not even the authors themselves generally, as has been shown. As a matter of fact, during the period of the creation of the great literature of Rome, Darwin's law of "reversion" was in active operation. There was a "black sheep" in every noble Roman family. Bad men appeared, not now and then, at long intervals, as in all civilizations, but every day and everywhere; and these men were political and social leaders. They moulded the policy of the State and set the fashion in society. Under their direction the Roman people retrograded towards a state of savagery, and savagery is but another name for selfishness. Selfishness in its worst estate is the essence of human depravity, and to that condition the Roman people fell, at the time when their moralists were inditing those sublime sentiments which still challenge the admiration of all great and good men.

That the Roman people were as dead to the influence

of high moral sentiments as the Britons were when first
encountered by Cæsar, shows that they had degener-
ated to a similar condition of savagery, or to a condi-
tion of absolute selfishness, which is its moral equivalent.
Given a savage state, two savages and one dinner; the
savages will fight to the death for the dinner. Given a
state of civilization absolutely selfish, two contestants and
one prize; each contestant will exhaust all the resources
of artifice, duplicity, and falsehood to secure the prize.
To this deplorable condition the Roman people were re-
duced by subjective educational processes. Selfishness
causes the individual to seek his own interest in total dis-
regard of the interest of others. Hence it tends directly
to the disintegration of society, since the essence of the
civil compact is the pledge of each member of the com-
munity that he will do no injury to his fellows. Selfish-
ness violates this pledge; for to gain its end it ruthlessly
crushes whatever appears in its path.

In Rome selfishness did its complete work. It trans-
formed the government from a pure democracy into an
oligarchy composed of wealthy citizens, who called them-
selves nobles. By this class wealth was made the sole
standard of social and political distinction, and in its
presence, and through its influence, the old strife between
the patricians and the plebeians gave way to a state of
hostility between the rich and the poor—always the last
analysis of social disorder. The contest was distinguished
by assassinations, embezzlements of the public money,
the quarrels of rival demagogues, and civil wars, and it
culminated in Cæsar and the empire.

The nobles, or aristocrats, who wrought the work of

ners, and accomplished in the tricks of finance

nicalities of the law, and the arts of oratory. They were the product of the Roman schools of rhetoric and logic, whose subjective methods obscured the truth, promoted vanity, and deified selfishness. All the guards of honor and rectitude having been swept away by Cæsar, a savage contest for supremacy ensued among the aristocrats. The prize for which they contended consisted of the spoil of the Roman legions and the product of the labor of the Roman slaves. This was the Roman patrimony — the price of blood and of the sweat of enforced toil. For this prize the Roman aristocrats struggled like savages fighting for the one dinner.

It is the old struggle, the struggle witnessed by each, in turn, of the nations of antiquity—the struggle in which selfishness vanquishes itself. But this is a struggle of giants, is on a grander scale, and is more conspicuous, for the historian, pen in hand, records its bloody scenes. It is the last act in a great drama, a drama that has lasted a thousand years. It is the conclusion of the long struggle of a few large-brained, unscrupulous individuals, to grasp the fruits of the toil of all men. The conspirators are about to fail, as such conspiracies have always failed and must always fail, and like Samson in his blind fury they will pull down upon their own devoted heads the pillars of the temple. The struggle culminates in a hand-to-hand conflict for the mastery between the baffled chiefs of the conspiracy to enslave mankind—the supreme effort of selfishness—and it involves the authors and their victims in one common disaster. Once more it is proved that a false system of education, a system which exalts abstract ideas and degrades things, promotes selfishness; that selfishness is the equivalent of savagery, and that savagery, however refined, wrecks society.

CHAPTER XXIII.

EDUCATION AND THE SOCIAL PROBLEM—HISTORIC.

THE MIDDLE AGES.

The Trinity upon which Civilization Rests: Justice, the Arts, and
 Labor; and these Depend upon Scientific Education.—Reason of
 the Failure of Theodoric and Charlemagne to Reconstruct the
 Pagan Civilization.—Contempt of Man.—Serfdom.—The Vices of
 the Time: False Philosophy, an Odious Social Caste, and Igno-
 rance.—The Splendid Career of the Moors in Spain, in Contrast.—
 Effect upon Spain of the Expulsion of the Moors.—The Repressive
 Force of Authority and the Atrocious Philosophy of Contempt of
 Man.—The Rule of Italy—a Menace and a Sneer.—The work of
 Regeneration.—The Crusades.—The Destruction of Feudalism.—
 The Invention of Printing.—The Discovery of America.—Investi-
 gation.—Discoveries in Science and Art.

CIVILIZATION languishes in an atmosphere of injustice,
and if the injustice is gross, as slavery, for example, and
long continued, the State perishes in the social convul-
sion which ensues. Thus perished the nations of an-
tiquity. Civilization depends upon the useful arts; in
them it had its origin, and with them it advances. The
savage, in his most primitive state, is ignorant of all the
arts; the most highly civilized man is familiar with, and
under obligations to, all of them. The useful arts de-
pend upon labor. If the laborer is degraded, the use-
ful arts decline, as he sinks, in the social scale; if he is
honored, they advance, as he rises. The trinity upon
which civilization rests is, therefore, justice, tl
arts, and labor; and this trinity of saving force
in turn upon the scientific education of mar

held all these things in contempt, and Rome perished. Anarchy ensued, and, from a state of governmental chaos, the feudal system was evolved. A brief analysis of the history of the mediæval period will show that education was unscientific, and consequently that justice was scorned, the useful arts neglected, and labor despised.

Theodoric strove to stem the tide of demoralization which succeeded the overthrow of the pagans in Italy. He was a semi-barbarian, but a man of genius, and ten years of his youth, spent at Constantinople, taught him the value of civilization. Under his reign there was a restoration of the common industries, work on internal improvements was resumed, and there was a revival of polite literature and the fine arts. But there was no general prosperity because there was no general system of education. Polite literature must rest upon a basis of general culture, or it is valueless to the country in which it flourishes. So of the fine arts; they can exist legitimately only as the natural outgrowth and embellishment of the useful arts.* In the due order of development the useful precede the fine arts. Theodoric began the reconstruction of the exhausted Roman civilization from the top, and his work was a complete failure,

* "But it is one thing to admit that æsthetic culture is in a high degree conducive to human happiness, and another thing to admit that it is a fundamental requisite to human happiness. However important it may be, it must yield precedence to those kinds of culture which bear more directly upon the duties of life. As before hinted, literature and the fine arts are made possible by those activities which make individual and social life possible; and manifestly is made possible must be postponed to that which makes "Education," p. 72. By Herbert Spencer. New York: Co., 18

of course, because it had no foundation. It was like the
Greek and Roman philosophy, it had no basis of things
to rest upon. Hence the order evoked from chaos by
the great Ostrogoth to chaos soon returned.

Charlemagne also attempted to reconstruct a worn-out
civilization through the revival of polite literature and
the fine arts. He assembled at his court distinguished
littérateurs from all parts of the world, with the view
of reviving classical learning. He established a normal
school called "The Palatine," whence classically trained
teachers were sent into the provinces. He constructed
gorgeous palaces, some of which were ornamented with
columns and sculptural fragments, the spoil of the earlier
architectural triumphs of Italy. But he did not found
schools for the education of the common people. The
common people were serfs. The theory of Plato still
prevailed, namely, that the majority is always dull, and
always wrong; that wisdom and virtue reside in the
minority. In pursuance of this theory, which happens,
curiously enough, to inure to the exclusive benefit of its
inventors and supporters, education was confined to a
small class. The training of the masses was wholly neg-
lected, and they were poor, ignorant, and brutal. The
state of mediæval society is graphically summarized by a
modern historian :

"In the castle sits the baron, with his children on his
lap, and his wife leaning on his shoulder; the troubadour
sings, and the page and the demoiselle exchange a glance
of love. The castle is the home of music and chivalry
and family affection; the convent is the home of relig-
ion and of art. But the people cower in their wooden
huts, half starved, half frozen, and wolves sniff at them
through the chinks in the walls. The convent prays and

the castle sings; the cottage hungers and groans and dies."*

Enterprise was the slave of superstition and ignorance. Some monks in Germany desired to erect a corn-mill, but a neighboring lord objected, declaring that the wind belonged to him. The useful arts were unknown and unstudied except by the monks, and their practice of them was confined chiefly to fashioning utensils for the use of the altar. Mankind lay in a state of intellectual and moral paralysis. Feudalism emasculated human energy. One art only flourished—the art of war. The pursuit of any of the useful arts, beyond that of agriculture, by the serfs, was impracticable, since sufficient time could not be spared from feudal strife for the proper tillage of the soil. The vassal was always subject to summary call to arms. If in the spring the noble wished to fight, the fields remained unplanted; if he wished to fight in the fall, the harvest remained ungathered. The serf, therefore, led a precarious life. If he escaped death in battle, he was still quite likely to die of starvation. In the fertile plains of Lombardy, in the first half of the thirteenth century, there were five famines!

Nothing happens without due cause. The misfortunes suffered by the people of Europe during the Middle Ages did not fall upon them from the clouds. The moral darkness which veiled the face of justice, and the intellectual stupor which prevented scientific and art researches, are not inexplicable mysteries. The vices, the cruelties, the poverty, and the pitiable superstitions of that time were the product of a false phi-

* "The Martyrdom of Man." By Winwood Reade. New York: Charles P. Somerby, 1876.

losophy, an odious social caste, and a state of general ignorance.

It happens that for hundreds of years of this period of wretchedness and crime there was in the heart of Europe an industrious, cultured, prosperous, and happy people. Their religion forbade the taking of usurious interest under terrible moral penalties; it also forbade "all distinctions of caste," and enjoined full social equality. They were the friends of education. "To every mosque was attached a public school, in which the children of the poor were taught to read and write." They established libraries in their chief cities, and were the patrons of the sciences and of the useful arts in all their forms. In a word, to the general prevalence of superstition and ignorance in Europe the Moors in Spain constituted a glowing exception.

Wherever the Saracen went he carried science and art. He honored labor, and genius and learning followed in his footsteps. Taught by learned Jews, he studied the works of the ancient philosophers, and preserved and extended their knowledge of astronomy, chemistry, algebra, and geography. Cordova was the abode of wealth, learning, refinement, and the arts. Its mosques and palaces were models of architectural splendor, and its industries employed 200,000 families. Seville contained 16,000 silk-looms, and employed 130,000 weavers. The banks of the Guadalquivir were thickly studded with those gems of free labor, manufacturing villages. The dyeing of silk and wool fabrics was carried to great perfection, and the Moorish metal-workers were the most expert of the time. The Saracen invented cotton paper, introduced into Spain cotton and leather manufactures, and *promoted* the cultivation of sugar-cane, rice, and the mul-

berry. Nor did he neglect agriculture in any of its
branches ; he created a new era in husbandry. His king-
dom in Spain was the richest and most prosperous in the
Western world ; indeed, its prosperity was in striking
contrast with the poverty and misery of the peoples by
whom it was surrounded. Under the third caliph its
revenue reached £6,000,000 sterling, a sum, as Gibbon
remarks, which in the tenth century probably surpassed
the united revenues of all the Christian monarchs. But
these industrious, cultured people were the descendants
of invaders, and the Spaniards, under the influence of a
blind and unreasoning impulse of religious and patriotic
zeal, drove them from the soil they had literally made to
" blossom like the rose," and themselves relapsed into a
state of indolence, ignorance, and poverty.

From the effects of the persecution of a race of artif-
icers, and the proscription of the useful arts, Spain has
never recovered. She has since always been, and is to-
day, a striking exemplification of the verity of the prop-
osition that stagnation in the useful arts is the death of
civilization. In the last half of the seventeenth century
the people of Madrid were threatened with starvation.
To avert the impending calamity the adjacent country
was scoured by the military, and the inhabitants com-
pelled to yield supplies. There was danger that the
Royal family would go hungry to bed. The tax-gath-
erer sold houses and furniture, and the inhabitants were
forced to fly ; the fields were left uncultivated, and mul-
titudes died from want and exposure. During the sev-
enteenth century Madrid lost half its population ; the
looms of Seville were silenced ; the woollen manufact-
ures of Toledo were transferred by the exiled Moriscoes
to Tunis ; Castile, Segovia, and Burgos lost their manu-

factures, and their inhabitants were reduced to poverty and despair.*

Two leading causes contributed to reduce the people of Europe during the Middle Ages to a state of moral obliquity, intellectual torpor, and physical incapacity— the repressive force of authority and the atrocious philosophy of contempt of man formulated by Machiavelli. The one forbade scientific investigation, the other strangled the spirit of invention in the grip of enforced ignorance. Authority chilled courage, and contempt withered hope. Italy governed the world, and her rule consisted of a menace and a sneer. Under this *régime* of cruelty and cynicism man shrunk into a state of moral cowardice and intellectual lethargy.

The political maxims which bear the name of Machiavelli were not invented by him. When he formulated them, in 1513, they had been in force in Italy a thousand years. These maxims explain the fact of the existence of a period of the world's history known as "the Dark Ages." The chief of them divides the human race into three classes, the members of the first of which understand things by their own natural powers; the second when they are explained to them; the third not at all. The third class embraces a vast majority of men; the second only a small number; the first a very small number. The first class is to rule both the other classes, the second by craft and duplicity, the third by authority, and, that failing, by force. Other maxims assume the despicable character of all men, and justify falsehood,

* "The Intellectual Development of Europe." Vol. II., Chap. II. By John William Draper, M.D., LL.D. New York: Harper & Brothers; "History of Civilization in England," Vol. II., Chap. I. By Henry Thomas Buckle. New York: D. Appleton & Co., 1864.

duplicity, cruelty, and murder, in the ruling class. A single proposition shows the infamy of the whole system, namely, "There are three ways of deciding any contest —by fraud, by force, or by law, and a wise man will make the most suitable choice."* These are maxims not of civilization but of barbarism. They involve a state of slavery, and where slavery exists the useful arts decline, and ultimately perish. And so it was in the Middle Ages.

Several great events led to the emancipation of the people of Europe from the joint reign of authority and contempt. The learning of the Jews and Saracens— their knowledge of the arts and sciences — gradually spread, and. occupied the minds of cloistered students, giving to them an intellectual impulse. The Crusades, pitiful and prolific of horrors as they were, shed a great light upon Europe. They brought the men of the West face to face with a practical progressive civilization—a civilization that "filled the earth with prodigies of human skill." The Crusaders were told that they would be led against hordes of barbarians. What astonishment must have seized them when they stood under the walls of Constantinople and beheld its splendors! Nor was their surprise less, doubtless, in the character of the foe they encountered. They had expected to meet with treachery and cruelty; they found chivalry, courtesy, and high culture.†

These surprises and contrasts profoundly impressed the Crusaders, and they returned to Europe relieved of

* "The Prince." Chap. XVIII. By Niccolo Machiavelli.
† "The Intellectual Development of Europe," Vol. II., pp. 135, 136. By John William Draper, M.D., LL.D. New York: Harper & Brothers.

many illusions, and notably of the fallacy that the wealth
of Eastern princes was destined to supply the waste of
their own squandered estates. They returned, too, to
find a new civilization in process of development. Two
hundred years of comparative freedom from the repres-
sive force of feudalism changed the face of the country
and the character of its people. During the absence of
the nobles, in the Holy Land, a middle class sprung into
existence, possessing the qualities which always distin-
guish that class—thrift and prudence. The mortgaged
estates of the Crusaders had fallen partly into their
hands, and partly into the hands of the Crown. Towns
had sprung up, and a commercial class and a manufact-
uring class had been formed. The artisan became a fac-
tor in the social problem. He offered his wares to the
lords and ladies of the castles, and they bought them-
selves poor. As Emerson says, "The banker with his
seven per cent. drove the earl out of his castle." In the
eleventh century nobility was above price, in the thir-
teenth it was for sale, and soon afterwards it was offered
as a gift.

The invention of printing, the art preservative of all
arts, removed the seal from the lips of learning. The
desire to conceal is no match for the desire to print.
Thenceforth, through the medium of types, the voice of
genius was destined to reach to the ends of the earth;
and, more important still, every discovery in science, and
every invention in art, became the sure heritage of future
ages.

The discovery of America was the crowning act of
man's emancipation. In sweeping away the last vestige
of the theory on which patristic geography was based,
Columbus freed mankind. In the cry of "land ho!"

with which he greeted the new continent, he sounded the death-knell of intellectual slavery. His was the last act in a series of acts which struck off the shackles of thought, and let in upon the long night of the Middle Ages the clear light of day. Leonardo da Vinci took up the interrupted work of Archimedes, and the science of mechanics made rapid progress. At last it was correctly observed that "experiment is the only interpreter of nature," and the development of natural philosophy began. Bruno was still to be burned, and Galileo imprisoned. But the persecutors of those great men were no longer moved by mere blind zeal. They believed and trembled, and in seeking to drown the truth in the blood of the votaries of science, they rendered it more conspicuous. By the light of the flames which consumed the body of the too daring philosopher a thousand scientists studied the stars, the earth, and the air.

The invention of printing paralyzed authority, and the discovery of America gave wings to hope. A few manuscripts could be locked in vaults or burned, but millions of books must inevitably, ultimately, find their way to the people. Books were, therefore, the sure promise of universal culture—the precursor of the common school. The discovery of another continent startled the people of Europe from the deep sleep of a thousand years, and sent a fresh current of blood surging through their veins. It seemed like a sort of new creation, and appealed powerfully to the imagination. And it is always the imagination that "blazes" the path to glorious achievements. It is through the imagination that men are moved to "crave after the unseen," and through the imagination that the human mind becomes big with "bold and lofty conceptions." A new world discovered by one man,

it was natural that all men should be put upon inquiry. Hence the era of investigation, the resulting discoveries of science, and their innumerable applications, through the useful arts, to the fast multiplying needs of man.

CHAPTER XXIV.

EDUCATION AND THE SOCIAL PROBLEM—HISTORIC.

EUROPE.

The Standing Army a Legacy of Evil from the Middle Ages.—It is the Controlling Feature of the European Situation.—Its Collateral Evils: Wars and Debts.—The Debts of Europe Represent a Series of Colossal Crimes against the People; with the Armies and Navies they Absorb the Bulk of the Annual Revenue.—The People Fleeing from them.—They Threaten Bankruptcy; they Prevent Education.—Germany, the best-educated Nation in Europe, losing most by Emigration.—Her People will not Endure the Standing Army.—The Folly of the European International Policy of Hate. —It is Possible for Europe to Restore to Productive Employments 3,000,000 of men, to place at the Disposal of her Educators $700,000,000, instead of $70,000,000 per annum, and to pay her National Debts in Fifty-four Years, simply by the Disbandment of her Armies and Navies.—The Armament of Europe Stands in the Way of Universal Education and of Universal Industrial Prosperity.—Standing Armies the Last Analysis of Selfishness; they are Coeval with the Revival during the Middle Ages of the Greco-Roman Subjective Methods of Education. —They must go out when the New Education comes in.

THE mediæval period conferred upon man two great blessings—a new continent and the art of printing. It also left a legacy of evil. With the partition of Europe into great States the modern age began, and it began with this inheritance of evil from the Middle Ages—the standing army.

The feudal lords wrecked their estates and sacrificed their lives during the Crusades, and a middle class arose and united with the kings in the government of the

State. But this alliance was of short duration; it soon gave way to an alliance which proved to be enduring— an alliance between the aristocracy and the kings.

By the ruin of feudalism thousands of serfs were set free. Trained to arms, it was easy to make soldiers of them. They were accordingly converted into mercenary troops—mustered into the service of the new alliance as guards of the modern State. Thus the standing armies of the "great powers" originated. This legacy of evil has so increased in magnitude that it is, to-day, the dominant feature of European public economy, and the portentous fact of the social problem.

The standing armies of Europe number two million five hundred thousand men, and their naval auxiliaries consist of three thousand vessels, thirty thousand guns, and two hundred thousand men. This is the mammoth evil bequeathed to Europe by the Middle Ages, and out of it many collateral evils have sprung, as wars, debts, and exorbitant tax levies.[1]

Thirty years ago the national debts of the governments of Europe had risen to $9,000,000,000. Since that time they have almost trebled! The cause of this vast increase is easy to find. It consists chiefly of four great wars, namely, the Crimean war of 1854–56, the Franco-Sardinian war against Austria in 1859, the German-Italian war of 1866, and the Franco-Prussian war of 1870–72. These wars were waged to maintain what is termed the balance of power; they involved no principle affecting the rights of man. Whatever their issue, no gain could hence accrue to the people of Europe. And this is the nature of most of the wars in which the standing armies of Europe have been employed since their organization. *But the* European budget shows that they are the over-

shadowing feature of the European governmental sys-
tems.

The annual revenue of the States of Europe is about
$1,725,000,000. Of this sum $700,000,000 is devoted to
the support of the standing armies and navies, and as
much more is required to meet the interest charge on
the debts created in the prosecution of wars waged to
maintain the balance of power! Thus, of the aggregate
of European revenue, the sum of $1,400,000,000 is de-
voted to the purely supposititious theory that the sub-
jects of the great powers are inflamed with an intense
desire to cut one another's throats, while the small sum
of $325,000,000 is left for the support of the civil serv-
ice, comprising all the strictly legitimate objects of gov-
ernment, and including education! ·

The national debts of Europe represent a series of
colossal crimes against the people. They were incurred
in the prosecution of unnecessary wars, and for the sup-
port of unnecessary standing armies. With relation to
these debts the people are divided into two classes—one
class owns them and the other class pays interest on
them. This relationship comprehends future generations
in perpetuity. Every child born in Europe inherits
either an estate in these debts or an obligation to con-
tribute towards the payment of the interest upon them.
Thus the fruits of a great crime have been transmuted
into a vested right in one class of people, and into a
vested wrong in another class.*

* "For instance, I have seven thousand pounds in what we call
the Funds or Founded things; but I am not comfortable about the
founding of them. All that I can see of them is a square bit of
paper, with some ugly printing on it, and all that I know of them is
that this bit of paper gives me the right to tax you every year, and

If the European standing armies and navies had not
been raised and kept up, and if the revenue devoted to
their support had been expended for schools, there would
not now be an uneducated person in Europe. If these
standing armies and navies were now disbanded, and the
revenue at present expended for their support diverted
to the support of schools, and so applied continuously
for half a century, there would not be, at the end of that
period, an illiterate person in Europe.

Under existing conditions the debts of the European
nations cannot be paid. But vast as the sum of them is,
their payment is not only possible, but practicable in a
very short time. Disband the standing armies and navies,
and continue the present rate of taxation, and there would
be an annual surplus revenue of $700,000,000. Apply
this sum, together with the surplus of the interest appro-
priation, accruing through the resulting yearly decrease
of the interest charge, to the liquidation of these debts,
and they would be extinguished in about twenty years.[2]
But if the period during which provision is made for
the extinguishment of these debts be extended to fifty-
four years, and, meantime, the present rate of taxation be
maintained, there would be released and rendered avail-

make you pay me two hundred pounds out of your wages; which is
very pleasant for me ; but how long will you be pleased to do so ?
Suppose it should occur to you, any summer's day, that you had bet-
ter not ? Where would my seven thousand pounds be ? In fact,
where are they now ? We call ourselves a rich people ; but you see
this seven thousand pounds of mine has no real existence—it only
means that you, the workers, are poorer by two hundred pounds a
year than you would be if I hadn't got it. And this is surely a very
odd kind of money for a country to boast of."—" Fors Clavigera,"
Part I., p. 67. By John Ruskin, LL.D. New York: John Wiley
& Sons, 1880.

able for educational purposes, annually, the sum of $600,000,000.

What is the purpose, it may be inquired, of these calculations? Their purpose is to show what the armies and navies of Europe cost, and what they stand in the way of. They cost so much that not a dollar of the national debts of Europe can be paid while they continue to exist. They cost so much that the people who are taxed to support them are fleeing from them as from a scourge. They cost so much that the decline of the nations which support them has already begun, and this decline can be arrested only by their disbandment.

That the nations of Europe are declining is shown by the statistics of emigration. The foundation of national prosperity is manual labor. There must be a solid basis of industrial growth for the superstructure of elegance, refinement, luxury, and culture. Manual labor is as essential to triumphs in literature, music, and the fine arts as the foundations of the Brooklyn Bridge, buried in the earth, are to the beautiful arch which spans the great river. And in the strife for supremacy between the nations of the world the maintenance of these triumphs depends, also, upon manual labor.* The real flower of a

* "Now, therefore, see briefly what it all comes to. First, you spend eighty millions of money in fireworks [war], doing no end of damage in letting them off.

"Then you borrow money to pay the firework-maker's bill, from any gain-loving persons who have got it.

"And then, dressing your bailiff's men in new red coats and cocked hats, you send them drumming and trumpeting into the fields, to take the peasants by the throat, and make them pay the interest on what you have borrowed, and the expense of the cocked hats besides.

"That is 'financiering,' my friends' — as the mob of the money-makers understand it. And so ... well. For that is

population is, therefore, its labor class. All other classes depend upon it, and all national triumphs spring from it. Hence a drain upon the labor class of a nation is a drain upon its most vital resource. The nation that suffers such a drain continuously is in its decadence. It loses some of its vigor, some of its productive power, and the loss is not supplied. True, the poor emigrant takes with him no part of the splendors of the country he leaves, but his brawny arm and skilled hand have contributed to the support of national pomp and social elegance, and as he steps aboard the steamer he withdraws that support forever.

Napoleon the Infamous plundered the conquered capitals of Europe to beautify and enrich the art treasuries of Paris. The art treasures of Europe are destined to cross the ocean, in the track of the column of emigration, if the flower of her labor class continues to flee from her standing armies and navies, as the statues of Rome followed the army of the modern Cæsar. For where the flower of the world's labor class gathers, there wealth most abounds. Labor, not gold and silver, is the source of wealth, hence it is to the laborer that art triumphs are due, and this is the order of their development. The laborer provides for immediate, pressing wants; he is prudent, and accumulates a surplus; he hungers for education; he develops a love of the beauti-

what it always comes to, finally—taking the peasant by the throat. He *must* pay—for he only *can*. Food can only be got out of the ground, and all these devices of soldiership, and law, and arithmetic, are but ways of getting at last down to him, the furrow-driver, and snatching the roots from him as he digs."—" Fors Clavigera," Part II., p. 27. By John Ruskin, LL.D. New York: John Wiley & Sons, 1882.

ful; he seeks to dignify his life and adorn his home; he patronizes art; he draws to himself the art treasures of the world.

The standing armies and navies of Europe have cost the European laborer the sacrifice of all these pleasing and noble aspirations.' Beyond the point of providing for "immediate pressing wants" he has not been able to pass. His surplus goes to the tax-gatherer, to feed and clothe the army and the navy. His desire for education, his love of the beautiful, his hope of a dignified life, and of a home adorned by art — these all are dreams, illusions, which vanish into thin air in the presence of the substantial fact of the annual European budget—for the support of the standing armies and navies $700,000,000!

In the way of the payment of the national debts of Europe her standing armies and navies rear themselves like an impassable wall. Against any general educational system they have hitherto constituted an insurmountable barrier; and in the future, as in the past, their maintenance dooms the masses to illiteracy. They stand in the way especially of the incorporation, in the curriculum of the public schools, of the manual element in education, because it is the most expensive, as it is the most important part of instruction.

Germany affords an admirable example of the power of education, even though defective in character, and of the disgust with which standing armies inspire an intelligent people. The Germans are the best-educated people in Europe. The educational system of Germany was established by Prussia as a politico-economic measure after the humiliation of the German States by Bonaparte. Said Frederick William, "Though territory, pow-

er, and prestige be lost, they can be regained by ac-
quiring intellectual and moral power." The outcome
of the Franco-Prussian war of 1870 verified the truth
of this prediction. Her freedom from debt enabled
Prussia to inaugurate and carry forward a comprehen-
sive educational system, which in turn enabled her not
only to vanquish her ancient enemy, but to make France
pay the cost of her own humiliation. Thus at a single
stroke Prussia avenged the defeats suffered at the hands
of the first Napoleon, and permanently weakened France
by compelling her vastly to increase her national debt.

The alacrity with which the French people subscribed
for the new bonds was much remarked upon, at the time,
as evincing both financial soundness and patriotism. But
the really grave feature of the situation—the vast aug-
mentation of the public burdens of France—was scarcely
mentioned, and was, perhaps, philosophically considered
only by that astute statesman, Prince Bismarck. The
war with Germany cost France $2,000,000,000, and com-
pelled an enormous increase of taxation. The debt state-
ment for 1877 was $4,635,000,000 — the expenditures
$533,000,000; and of this latter sum $373,000,000 were
absorbed by the army, the navy, and the national debt!

The significant feature of the European situation is
the freedom from debt of Germany. It is by virtue of
this fact that she holds the first place in Europe. Her
rate of taxation is as low as that of little Switzerland.
All the other Great Powers are hampered by great debts.
Spain is bankrupt; she does not pay the interest on her
debt. Austria increases her debt every year; she is prac-
tically bankrupt. It is only a question of time, if stand-
ing armies and navies continue to be maintained and
wars to occur, when all .the debtor nations will be re-

duced to bankruptcy.* The nation sinks as the column of debt rises. France cannot double her debt again and make her people pay interest on it. England draws from her citizens a larger *per capita* revenue than any other nation of Europe, except France, and she has nearly touched the limit of their capacity to pay taxes. A sudden and considerable increase of her debt would strain the Government, and might shatter it.

Thus, the more searching the analysis of the European situation, the more clear does the exceptional strength of Germany appear. But out of her abundant strength a weakness has been evolved. The system of education that rendered the Germans so powerful against France as soldiers, has made them thoughtful citizens. It has revolutionized the public sentiment of Germany on the subject of government. In the place of passion it has substituted reason. The Prussian "subject" for whom the king thought, has become a German citizen who thinks for himself, and one of his earliest reflections is that, in modern civilization, a standing army is a solecism. The ignorant Prussian hated the French because hatred of them was enjoined upon him as the correlative of the duty of blind devotion to his king. But the educated German knows that the sole motive of the continuance of the standing army is the maintenance of the balance of power, which is merely a tacit agreement between the European rulers, by divine right, to perpetuate their own lease of power. Hence the "in-

* "The progress of the enormous debts which at present oppress, and will in the long run probably ruin, all the great Nations of Europe, has been pretty uniform."—"Wealth of Nations," Vol. III., p. 392. By Adam Smith, LL.D., F.R.S. Edinburgh, 1819.

tellectual and moral power" conferred upon the German
people, by education, reacts upon Germany in the form
of a drain of the flower of her population by emigra-
tion.

The citizenship of Germany is more valuable, in an
economic sense, than that of any other country of Eu-
rope—more valuable because Germany is the most pow-
erful nation of the European family of States; more
valuable because of them all she alone is free from debt;
more valuable by reason of her more moderate scale of
taxation. But she still furnishes the heaviest contingent
to the column of emigration steadily moving towards
the United States. In a word, the most valuable citi-
zenship in Europe—that of Germany—is least regarded
and most freely surrendered. Why? Because the Ger-
mans are the best-educated people in Europe. Poor as
the German primary school system is, it is universal, and
it has destroyed what it was founded chiefly to promote
and perpetuate, namely, reverence for, and loyalty to,
government by Divine right. German intelligence re-
volts from taxation for the support of a standing army.
It revolts from the theory and policy of hate upon which
standing armies are based. It comprehends perfectly
that the standing army is a menace to the freedom
of the citizen, at home, rather than a defence against
pretended danger from abroad. It scorns, as absurd,
the threadbare assumption that Englishmen, Frenchmen,
Italians, Russians, and Germans desire to fly at one an-
other's throats, and that they can be restrained only by
a cordon of bayonets.' It realizes that the perpetuation
of the era of hate, through the standing army, retards
the mental and physical progress of the human race,
which would be greatly promoted by the free intermin-

gling of the various nationalities of Europe.* That it is
from the standing army that the emigrant flees is shown
by the records of the military department of the Ger-
man government.

In the year 1883 twenty-nine thousand men were ar-
rested for attempting to emigrate from Germany to avoid
the required military service, and more than a hundred
thousand others, from whom service was due, refused,
both to report for duty, and to furnish the required ex-
cuses for the failure to enroll themselves.

The law of Germany requires every male citizen, capa-
ble of bearing arms, to serve three years in the standing
army—to devote three of the best years of his life to the
preservation of the balance of power in Europe! In ad-
dition, he must serve four years in the reserve, and five
years in the landwehr. And this service is regarded as
a debt due the government. Every male child born in
Germany contracts this debt, in contemplation of law, in
the act of drawing his first breath, and nothing but death
releases him from the obligation. Having been taught
in the emperor's schools to love the emperor, when he
reaches the military age, a musket is placed in his hands,

* The multiplicity of languages is due to the policy of interna-
tional hate, inaugurated by the nations of Europe to promote the
selfish purposes of rulers. Barbarism is diversity; civilization is
unity. The human race is one, provided it is civilized, and it should
have but one language. Language is a tool, and time consumed in
acquiring skill in the use of more than one tool designed for the
same end, is wasted. The standing armies of Europe obstruct the
way to unity of language. The time will come when all civilized
peoples will speak one tongue, probably the English. Then language
will cease to be a mere vain accomplishment, and become what it
ought always to have been, the simple means of famili-
mind with things, and of the communication of know

and he is taught to shoot the emperor's enemies. If he refuses to enter the army he is fined; if he refuses to pay the fine he is imprisoned.

The German emperor attributes the decline in the military organization to the negligence of his military staff, but its true cause is the German educational system. The steady augmentation of the rolls of military delinquents is the measure of the growth of German intelligence. The ease with which Germany conquered France flattered the vanity of the educated German, but it did not prevent him from emigrating to America. To the cultured mind the army that wins the contest in which no principle is involved is as odious as the army that loses. To the cultured mind all standing armies are odious, because they are an embodied assumption of the barbarism of man, and a denial of the efficacy of reason. The great stream of German emigration attests the superiority of German culture. The educated German declines to learn the art of shooting the emperor's enemies, but he knows that Germany is, in fact, governed by its standing army—by muskets—and he quits the country.

Thus the chief power of Germany becomes her chief weakness. A system of education which has made her the first nation in Europe produces wide-spread discontent among her people, because she is governed by obsolete ideas. Nor can the loss in virile force suffered by Germany, through emigration, be made good by a counter movement of immigrants from the less favored countries of Europe. The economic condition of Germany—her freedom from debt and her comparatively low rate of taxation—invite such a movement. But the European policy of international hate, created and perpetuated by standing armies, forbids Germany to recoup her losses of

men to America, through corresponding gains of men
from the overtaxed populations of neighboring coun-
tries. The grinning skeletons of a hundred battles in
which the rival nationalities of Europe have been pitted
against one another, rise to challenge the social inter-
mingling of peoples separated for centuries by the arts
of diplomacy, traditions of blood and flames, and the ser-
ried ranks of standing armies.

The disposition of Germans to emigrate irritates the
emperor and his prime-minister. The loss of numbers
might be borne, for notwithstanding the steady outward
flow of emigrants there is a slight increase of popula-
tion in Germany. But it is the quality of the exodus
that annoys the emperor and his·chancellor. The Ger-
man emigrants are strong men and women—strong men-
tally and physically. All the weaklings, all the paupers,
all the imbeciles, the aged, and the infirm remain, only
the young and vigorous go. Those who go have been
taught at the expense of the State to love the emperor
and hate his enemies, but they do neither. The German
system of education, from the point of view of rulers by
divine right, is, hence, a conspicuous failure. It makes
better men but poorer subjects. The more thoroughly
the man is educated the more valuable he is to himself
and to the community, but the less valuable to his king.
His growth in intelligence is the measure of his decline
in reverence for rulers by divine right, and the standing
armies by which they are alone supported. This is the
cause of German emigration, and its effect is to weaken
the German Empire. Germany is not so strong as she
was when her armies swept over France; she declines in
power each year, through the loss of men—the sole sup-
port of a State. They flee from her standing army to

the United States, a republic with only a handful of soldiers.

The system of education established to increase the power of Prussia in Europe has accomplished its purpose. But it has done much more — something never thought of by its founders. It has produced a widespread feeling of intelligent discontent; and discontent is an inarticulate cry for reform. The cultured German scorns the standing army, refuses to serve in it, protests against its longer existence, and demands more and better education for his children. His protest is unheeded, and he quits the country. But the demand for higher education is not, cannot be, disregarded. Intelligence is contagious; it infects with a thirst for knowledge all with whom it comes in contact. Education is the arch-revolutionist whose onward march is irresistible. Soon a riper culture will make the German Protestants more courageous and more imperative in their demands, and they will remain in the country to enforce them. Education made Germany the first military power in Europe; but education could not have been put to a more ignoble service. The desire of intelligent Germans is that Germany shall become the first industrial power in Europe, and this desire can be realized by the disbandment of her standing army.

This review of the situation in Europe shows that it is practicable for her to restore, at once, to productive employments three millions of men — the flower of her population—now not only idle, but a public charge. It shows, also, that it is practicable for Europe to place, at once, at the disposal of her educators $700,000,000 per annum instead of $70,000,000 per annum, as at present. The corollary of these two propositions is a third, name-

ly, that it is practicable for Europe to extinguish her national debts in fifty-four years. It follows that the regular armies of Europe alone stand in the way of universal education, and of universal industrial prosperity.

Standing armies everywhere within the lines of advanced civilization must soon disappear before the march of education.* Social questions cannot much longer be settled by emigration. The world's virgin soil is being rapidly appropriated. When the surface of the whole earth shall have become occupied, barbarisms of every nature will be intolerable. Man must then be highly civilized, and the only highly civilizing influence is education. The age of force is passing away; the age of science and art—the age of industrial development—has begun, and standing armies are as abnormal in Europe

* "This nation to-day is in profound peace with the world; but in my judgment it has before it a great duty, which will not only make that profound peace permanent, but shall set such an example as will absolutely abolish war on this continent, and by a great example and a lofty moral precedent shall ultimately abolish it in other continents. I am justified in saying that every one of the seventeen independent Powers of North and South America is not only willing but ready—is not only ready but eager—to enter into a solemn compact in a congress that may be called in the name of peace, to agree that if, unhappily, differences shall arise — as differences will arise between men and nations—they shall be settled upon the peaceful and Christian basis of arbitration.

"And, as I have often said before, I am glad to repeat, in this great centre of civilization and power, that in my judgment no national spectacle, no international spectacle, no continental spectacle, could be more grand than that the republics of the Western world should meet together and solemnly agree that neither the soil of North nor that of South America shall be hereafter stained by brothers' blood."
—Extract from the Speech of Hon. James G. Blaine at the Delmonico Dinner, October 29, 1884.

now as slavery was in the United States twenty-five years
ago.*

Standing armies are the instruments of tyranny; they
are the last analysis of selfishness, the incarnation of de-
pravity; for they do not reason — they strike. It is
worthy of note that the standing armies of Europe are
coeval with the revival of learning, and the revival of
learning was a revival of the Greco-Roman subjective
educational methods. The logical effect of those meth-
ods was the promotion of selfishness, and the standing
armies conserved the selfish designs of the rulers of the
newly-formed States. It is hence not a mere coincidence
that standing armies and the revival of learning through
subjective processes of thought are of common origin.
The Machiavellian philosophy of cruelty, duplicity, and
contempt of man sprung logically from egoism, and as
logically led to the formation of standing armies—bodies
of armed men, trained, under compulsion, to kill, burn,
and destroy.

The synonyms of the standing army are selfishness
and its vile issue, feudalism, serfdom, slavery, ignorance,
and contempt of man. These conditions are passing
away, and the standing army, the worst, as it is the most
costly relic of savagery, must pass away with them. It
cannot withstand the advance of the new education,
whose mission is peace, whose quest is the truth, whose
premise is a fact, whose conclusion is a thing of use and
beauty, and whose goal is justice.

* "It is only slowly, and after having been long in contact with
society, that man becomes more indulgent towards others and more
severe towards himself."—"Suicide: an Essay on Comparative Moral
Statistics," p. 226. By Henry Morselli, M.D. New York: D. Ap-
pleton & Co., 1882.

¹ War is not merely a relic of barbarism; it is barbarism triumphant. It is evidence of the presence, active and malignant, of all the bad passions of man. Nor are idle armies less infamous than armies in deadly conflict. Carlyle well says that the one monster in the world is the idle man; and the standing army is a vast horde of idle men quartered on the community. The standing armies of Europe, on parade, in barracks, and in forts, are as unmixed an evil as the legions of Rome were in Gaul, in Greece, or before Carthage. It is a shame to civilization that arbitration did not long ago take the place of the coarse brutality of war. The *duello* between Nations is not less absurd, and it is a thousand-fold more wicked, than the *duello* between individuals. It is savagery pure and simple, the child of selfishness, and not less inconsistent with a high state of civilization than slavery.

² Of the British funding system when it was in its infancy, as early as 1748, Lord Bolingbroke said: "It is a method by which one part of the nation is pawned to the other, with hardly any hope left of ever being redeemed."

See, also, in the *North American Review* for September, 1886, an exhaustive article on the impolicy of national debt perpetuation, by N. P. Hill, in which it is alleged that "great interests are at work to prevent the payment of the national debt of the United States."

³ In his recent great work—"The Wonderful Century"—Mr. Alfred Russel Wallace, on the authority of "The Statesman's Year Book" for 1897, states that the standing armies and navies of Europe number three millions of men; cost 180,000,000 pounds sterling per annum, and withdraw from useful employments ten millions of men engaged in repairing the waste of war.—"The Wonderful Century," pp. 335–336. New York: Dodd, Mead & Co., 1898.

⁴ "I know now that my fellowship with others cannot be shut off by a frontier, or by a government decree which decides that I belong to some particular political organization. I know now that all men are everywhere brothers and equals. When I think now of all the evil I have done, that I have endured, and that I have seen about me, arising from national enmities, I see clearly that it is all due to that gross imposture called patriotism—love for one's native land." . . .
"I understand now that true welfare is possible for me only on condition that I recognize my fellowship with the whole world."—"My Religion," p. 256. By Count Leo Tolstoi. New York: Thomas Y. Crowell & Co.

⁵ There is another cause of the decline of Germany: War degrades;

it is a reversion toward barbarism. Not only is the soldier brutalized by martial exercises and scenes of carnage, but the moral and mental fibre of the people of a nation which indulges in war is rendered coarser. The remark of M. Renan on the subject is profoundly philosophical:

"The man who has passed years in the carriage of arms after the German fashion is dead to all delicate work whether of the hand or brain."—"Recollections of my Youth," p. 159. By Ernest Renan. New York : G. P. Putnam's Sons, 1883.

CHAPTER XXV.

EDUCATION AND THE SOCIAL PROBLEM—HISTORIC.

AMERICA.

An Old Civilization in a New Country.—Old Methods in a New System of Schools.—Sordid Views of Education.—The highest Aim Money-getting.—Herbert Spencer on the English Schools.—Same Defects in the American Schools.—Maxims of Selfishness.—The Cultivation of Avarice.—Political Incongruities.—Negroes escaping from Slavery called Fugitives from Justice.—The Results of Subjective Educational Processes.—Climatic Influences alone saved America from becoming a Slave Empire.—Illiteracy.—Abnormal Growth of Cities.—Failure of Justice.—Defects of Education shown in Reckless and Corrupt Legislation.—Waste of an Empire of Public Land.—Henry D. Lloyd's History of Congressional Land Grants. —The Growth and Power of Corporations.—The Origin of large Fortunes, Speculations.—Old Social Forces producing old Social Evils. — Still America is the Hope of the World. — The Right of Suffrage in the United States justifies the Sentiment of Patriotism. —Let Suffrage be made Intelligent and Virtuous, and all Social Evils will yield to it; and all the Wealth of the Country is subject to the Draft of the Ballot for Education.—The Hope of Social Reform depends upon a complete Educational Revolution.

THE discovery of America startled Europe. It was a great blow to prevailing dogmatisms. It upset many learned (?) theories. It swept away patristic geography. It completed the figure of the earth, rendering it susceptible of intelligent study. The advantages of such investigation accrued to man, to a degree, before the social and civil life of America began. In the century and a quarter which elapsed between the landing of Columbus and that of the Pilgrims, on these shores, considera-

ble social and political progress was made in Europe,
and especially in England. From the turbulent scenes of
the reigns of James I. and Charles I., which eventuated
in the Cromwellian rebellion and victory of the Com-
mons, the Pilgrims escaped. They not only bore with
them, to the new continent, the impress of the long
struggle for liberty waged by the English people, but
they were, in a certain sense, the product of the progress
of all the ages. But they constituted only a small part
of the column of immigrants. Detachments of the Cav-
aliers came also, and Germans, Frenchmen, and Irishmen
came with them.

The discovery of America was a sort of new creation,[*]
but its almost virgin soil was destined to become the
home of an old civilization. From all the nationalities of
the Old World the New World was to be peopled. The
ambitious, the restless, the adventurous, the enterprising,
and the hardy of every tongue, were gradually to assem-
ble in the new field of action. The manner in which
they treated the natives of the new country, both north
and south, showed their origin and their training. Their
determination to conquer and hold the new territory was
but thinly disguised. Their descent upon the Atlantic
coast was not the exact counterpart of that of Cæsar upon
the coast of Britain, but it was the same in spirit; and
the active trade in slaves which soon sprang up, and
which was thereafter vigorously prosecuted for two hun-
dred years, showed the taint of savagery—the impress of
Roman cruelty, rapacity, and injustice.

[*] "The discovery of America is the greatest event which has ever
taken place in this world of ours, one half of which had hitherto
been unknown to the other. All that until now appeared extraordi-
nary seems to disappear before this sort of new creation."—Voltaire.

It is evident that in its most important feature—the formation of character—education had made little if any progress at the time of the organization of civil society in America. The democratic idea was not new. It found expression in every form during the struggles of Greece and Rome, and the revival of learning had led to the discussion of governmental questions in the light of history. Besides, the reformation of Luther had opened the way to the last analysis of dissent in the person of Roger Williams, who asserted the right of absolute freedom of thought and speech. Of the religious right of private judgment the political right of an equal voice in public affairs is the corollary. Hence, that the Puritans should establish the town organizations so justly lauded by M. Tocqueville was quite logical.* Nor was the public-school system less logical; all citizens being members of the government, all children must be prepared for the duties of citizenship. But unfortunately the old system of education was put into the new schools, as the old civilizations had been transferred to the new country. The system of education under which the kings and ruling classes of England and of the continent of Europe were trained to selfishness, cruelty, and injustice, was heedlessly adopted in the schools of New England, which became the models of schools throughout the country.

* "Town meetings are to liberty what primary schools are to science; they bring it within the people's reach, they teach men how to use and how to enjoy it. . . . The township institutions of New England form a complete and regular whole; they are old; they have the support of the laws, and the still stronger support of the manners of the community, over which they exercise a prodigious influence." —"Democracy in America," Vol. I., p. 76. By Alexis De Tocqueville. Boston: John Allyn, 1876.

The popular idea in regard to the schools was (1) that they fitted their pupils for the duties of citizenship, or, more properly, for the art of governing, and (2) that they taught the art of getting on in the world; and getting on in the world was interpreted to mean getting and keeping money. That this sordid view of education was generally held in the rural districts of New England is shown by the fact that any culture beyond a limited and imperfect knowledge of reading, writing, and arithmetic was regarded as superfluous. Not even the rudiments of either the sciences or the arts were imparted, and yet it is only through a knowledge of the sciences and the arts that progress in civilization is made. The early settlers of New England devised a new system of schools, but they imported into them an old system of education, the Greco-Roman subjective system, introduced into England with the revival of learning. Of this system Mr. Herbert Spencer says, "Had there been no teaching but such as is given in our public schools, England would now be what it was in feudal times." And he adds:

"The vital knowledge, that by which we have grown as a nation to what we are, and which now underlies our whole existence, is a knowledge that has got itself taught in nooks and corners, while the ordained agencies for teaching have been mumbling little else but dead formulas."*

But these are merely negative effects of subjective methods of education. The positive evil effect of them

* "That which our school courses leave almost entirely out, we thus find to be that which most nearly concerns the business of life. All our industries would cease were it not for that information which men begin to acquire as they best may after their education is said to be finished."—"Education," p. 54. By Herbert Spencer. New York: D. Appleton & Co., 1883.

is selfishness, the sum of all villanies. Under the new system of schools—schools for all—the old philosophy of life flourished. Under the name of prudence, selfishness was deified. The maxim of Herbert—" Help thyself and God will help thee "—was reproduced by Franklin in a hundred forms. The child was taught, not that " The half is more than the whole," but that " In the race of life the devil takes the hindmost."

Thus greed and avarice were cultivated to the sacrifice of honesty. Calling selfishness prudence led to confounding right and wrong—freedom and slavery. Hence we have the Declaration of Independence containing the lofty sentiment, " All men are created equal," and the Constitution throwing the shield of its protection over human bondage. A false system of education led to political incongruities of the grossest character, as, in the preamble to the Constitution, the declaration of its high purpose—to establish justice and secure the blessings of liberty—and in the body of the instrument a guaranty of the slave-trade for twenty-five years, and a compact that it should be the duty of the national army to shoot rebellious slaves, and the duty of free citizens, of the free States, to hunt down escaping slaves and surrender them to their owners in the slave States.

The failure of the prevailing system of education to promote rectitude and right thinking was so complete that negroes escaping from slavery were called " fugitives from justice!" Its failure was so complete that the very streets of Boston in which patriots had struggled to the death in the cause of liberty now echoed the groans of the slave, and resounded with the clank of his chains. Its failure was so complete that in Faneuil Hall, the cradle of liberty, slavery was justified. Its failure was

so complete that a senator, for daring to characterize slavery as barbaric, was stricken down and beaten with a club, until he lay helpless in a pool of blood on the floor of the legislative hall of the great, free republic.

These are characteristics of the early civilizations, the civilizations of Greece and Rome. They are the product of selfishness, and they show that subjective educational processes—processes which proceed from the abstract to the concrete, thus violating the natural law of investigation—produce the same effects in the nineteenth century as they did in the first century.

Ethically, slavery was tried only by the test of self-interest. In the North, as in Europe, it was not profitable, and it faded away; in the South, in the cotton and rice fields, it was thought to be profitable, and it spread and flourished. That the opposition to slavery, at the North, did not grow out of education in the schools, is evident, because the sons of the Southern ruling class were educated in the high schools and colleges of the North; but they became, notwithstanding such training, almost to a man, slavery propagandists. The heinousness of slavery was perceptible only to those who had no personal interest in its perpetuation. It is plain that the effect of the education of the schools upon the youth of the country was to make them callous to the common impressions of right and wrong; in a word, to render them thoroughly selfish.

It is difficult to resist the conclusion that, if slavery had been as profitable at the North as it was at the South, it would have been perpetuated, and would have poisoned the infant civilization of America as that of Rome was vitiated and destroyed. Assuming the truth of this *hypothesis,* climate conditions, not education, saved this

continent from the scourge of slavery. To the fact that a large part of the territory of the United States is situated in the temperate zone we owe the elimination of slavery from the social problem.

Existing social conditions in the United States do not differ materially from those of the chief countries of Europe. We have only a small standing army; but the sole great question which divided the people during the first hundred years of our political existence — slavery—had to be settled as such questions have been settled from the beginning of history, as savages settle all questions — by violence, by an appeal to the logic of brute force.

Our government differs from the governments of Europe both in principle and form, but the governmental influence is only one of many influences which unite to mould social habits. The democratic principle, adopted as the foundation of our political institutions, has not served to counteract the tendency to the formation of social class distinctions. The people lack the wisdom, or the virtue, or both, to insist upon the first prerequisite to even an approximation to social equality, namely, universal education. Of our population of fifty millions, five millions of persons, ten years old and over, are unable to read, and six millions are unable to write. In the last census decade we made the paltry gain of three per cent. in intelligence, but in 1880 we had six hundred thousand more illiterates than in 1870. Nearly two millions of the legal voters in the United States are illiterates. Every sixth man who offers his ballot at the polls is unable to write his name. Under such circumstances class distinctions of the most pronounced type are inevitable.

The tendency to the concentration of populations in

cities in the United States is not less decided than it is in the countries of Europe. In 1820 the population of our cities constituted less than one-twentieth of the whole population of the country, but in 1880 it constituted more than one-fifth of the whole.

Cities have always been the chief source of societary disturbances. In the worst days of the Roman Empire tranquillity and prosperity reigned in many of the distant provinces. While at the city of Rome "every kind of vice paraded itself with revolting cynicism," in the provinces "there was a middle class in which good-nature, conjugal fidelity, probity, and the domestic virtues were generally practised."

Of one of the youngest large cities in the United States the late superintendent of a Training School for Waifs says, "Never in the history of this city has infant wretchedness stalked forth in such multiplied and such humiliating forms. It is hard to suppress the conviction that even Pagan Rome, in the corrupt age of Augustus, did not witness a more rapid and frightful declension in morals than that which can to-day be found in the city of Chicago."

The most graphic description ever given of a waif came from the lips of John Morrissey.* He said of himself,

"I was, at the age of seven years, thrown a waif upon the streets of Dublin. I slept in alleys and under sidewalks. I disputed with other waifs the possession of a crust. We fought like young savages for the garbage that fell from the basket of the scullion. The strongest

* A noted pugilist, proprietor of gambling-houses in New York City and at Saratoga Springs, and a politician who represented a *New York* City district in Congress.

won and satisfied the cravings of hunger; the weakest starved. I had no idea that anything was to be gained by other means than brute force. Hence my code of moral and political ethics—the strongest man is the best man. I became a pugilist."

The substantial citizen who passes the street waif with contempt should reflect that ten or a dozen years later he will meet him, a full-grown man, at the polls, still clothed in rags, perhaps, but his peer in all the rights of citizenship. It was the unfortunates of the dark alleys and noxious streets of New York—the waifs, the savages of the John Morrissey type—that made Tweedism* possible, that made robbery in the name of law possible, that made taxation the equivalent of confiscation in that city.

Mr. Charles Dickens, in "Bleak House," in the course of a pen-picture of a wretched quarter of London, under the name of "Tom-all-alones," shows how ignorance, poverty, and vice react upon society. He says, "There is not an atom of Tom's slime, not a cubic inch of any pestilential gas in which he lives, not one obscenity or degradation about him, not an ignorance, not a wickedness, not a brutality of his committing but shall work its retribution through every order of society, up to the proudest of the proud, and to the highest of the high."

The presence of the poison is already shown in the failure of justice. These waifs, grown to man's estate, but destitute of education and moral principle, wielding the power of the ballot, desecrate the jury-room with their vile presence, and tug at the skirts of sheriffs,

* For an account of the career of William Marcy Tweed, see "The American Cyclopædia," Vol. XVI., p. 85. New York: D. Appleton & Co., 1881.

prosecuting officers, and judges, and notorious criminals
escape punishment! So grievous has the abuse become
that Judge Lynch has opened his summary, awful court
in almost every State of the Union.

To say that this class menaces the government with
destruction is to state it mildly. In every case of the
failure of justice the government is in part subverted;
for when crime goes unpunished, the law, violated in
that particular instance, becomes a dead letter; and when
lynching shall have become the rule, and the execution
of the law the exception, government by law will have
ceased to exist — it will have given way to government
by force. Then the army will be invoked to shoot down
the men for whose education the law failed to provide,
in every city of the land, as it was invoked in Pittsburg
in 1877.

What are we doing to avert this danger which threat-
ens our institutions? With the exception of here and
there a weak effort on the part of a few humanitarians,
as in the training school referred to, we are leaving hun-
dreds of thousands of waifs to develop into savages, and,
what is worse, savages with the power to tax civilized
people! We have a system of public schools into which
such children as choose may enter to a certain limit, re-
main as long as they please, and depart when they please.
But there are thousands of children in every large city
who could not enter if they would, and who are not com-
pelled to receive the civilizing benefits of education, and
who hence join the army of waifs and study the art of
savagery; and, as has been remarked, they go to swell
the ranks of a populace as depraved as that which in
Rome cried for "bread and circuses!" and sacked the
city while it was in flames.

The defective, not to say vicious character of our system of education, is shown by the reckless course of our legislators on the subject of the disposition of the public domain. William the Conqueror, conceiving that any social revolution is incomplete until it disturbs the proprietorship of land, confiscated the entire landed estates of England, and conferred what remained of the proprietary, after reservations in the Crown, upon his retainers, the Normans. Eight hundred years have elapsed since the issue of William's land-tenure edict, but it still remains the controlling feature of the British Constitution. It has compelled the deportation of millions of Englishmen; it has reduced the masses of Scotland to a grinding poverty, and converted their country into hunting-grounds for the amusement of the landlord class; it has depopulated Ireland, and exasperated almost to madness the remnant of her people.

But we have failed to profit by the example of England. Our legislators have been blind to the lessons of history, or they have been corrupt. They have been ignorant of political and social laws, or they have been wanting in rectitude. In the period of thirty years, ended in 1880, Congress gave to railway corporations over 240,000 square miles, or 154,067,553 acres, of the best public lands in the States and Territories of the Union — an area double that of the whole kingdom of Great Britain and Ireland, including the adjacent isles.

On the 17th of March, 1883, the *Chicago Daily Tribune* published a history of these land grants, compiled by Mr. Henry D. Lloyd, under the following summary:

" *The story of the dissipation of our great national inheritance — thrown away by Congress, wasted by the Land Office, stolen by thieves. A land monopoly worse*

than that of England, begotten in America. English monopoly is in families; American monopoly is in corporations; and corporations are the only aristocrats that have no souls, and never die."

The following passages from the opening paragraphs of Mr. Lloyd's history are reproduced here by permission of the author:

" The public are profoundly ignorant of the facts about the public land. They know, in a dim way, that it is passing out of their hands, and that huge monopolies are being created out of the lands which they meant should be the inheritance of the settler. The land set apart for homes for families has been made into empires for corporations. In the story recited below, every element of human fault and fraud will be seen to have been at work in the spoliation of the land of the people. Congress has been extravagant and has failed to act when part of the results of its extravagance might have been saved. The Land Office has been inadequately equipped by Congress, and has on its own account been careless, dishonest, and traitorous to the interests of the people. It has been wax in the hands of the great railroad corporations, but double-edged steel in the side of the poor settler. It has overruled decisions of the Supreme Court and nullified acts of Congress to betray its trust and enrich the railroads, but has refused even to exercise its discretion when the home of a settler, held by a righteous title, was to be confiscated at the demand of corporate greed. The niggardliness of Congress makes clerks, on salaries of twelve hundred to eighteen hundred dollars a year, untrained in the law, knowing nothing of the rules of evidence, judges of the law and facts in cases involving millions of dollars *and thousands of* homes. There is no worse chapter in

the history of government than the facts we have to give
showing the deliberate and heartless evictions of the Eu-
ropean immigrant and the American settler in order to
give their farms to covetous corporations. The land-
grant roads have had millions of acres granted them by
the Land Office in excess of the grants by Congress.
The whole story is summed up in the recent remark of
one who had thoroughly investigated the subject—that
the history of the management of the land-grant roads
by the Land Office is a history of the management of the
Land Office by the railroads.

"No chapter in this story will be found of more som-
bre interest than the statements made as to the Supreme
Court by the Senate Committee on Public Lands, in a re-
port submitted by Senator Van Wyck recommending a
bill to compel the railroads to pay taxes on their lands.
Its decisions as to the titles of the railroads and the set-
tlers to the lands, like those of a weathercock, have point-
ed the way the corporation blew its breath."

The summary of Mr. Lloyd's paper by the editor of
the *Tribune*, as a preface to its publication, and the fore-
going characterization of the acts of Congress, of the
Land Office, and of the Supreme Court, by Mr. Lloyd,
are fully justified by the alleged facts marshalled in the
body of the sketch; and these allegations, after a year
and a half of public scrutiny, stand unchallenged.

It would be difficult to conceive of a more reckless
series of legislative acts than those through which the
public domain in the United States has been squandered;
and they are rendered either ignorant or vicious by the
fact that in the vast empire surrendered almost totally
without consideration, each legislator, in common with
the people by and for whom he was deputed to act

a personal interest. Through this series of acts of Congress the public domain was rudely wrested from its rightful owners, the people; the abnormal growth of corporate power unduly promoted, and a tendency to the concentration, in a few hands, of the landed estates of the country fostered.

The social and economic effects of this land legislation must be very great and far-reaching. Of the effects of the concentration of landed estates in a few hands we need not speak; they are sufficiently plain in England, Scotland, and Ireland.* But great corporations are a creation of yesterday; they are the product of steam. The railway, the factory, the mine of iron or coal, the furnace, the foundery, and the forge—these vast interests, chartered and endowed with certain muniments of sovereignty, are, as property, almost as indestructible as landed estates protected by the law of primogeniture. Men are trained from generation to generation to the care and conduct of them, and hence they are far less liable to waste and dispersion than private estates, which,

* "The more essential and important consideration is this—that whenever the few rapidly accumulate excessive wealth, the many must, necessarily, become comparatively poorer. . . . In every case in which we have traced out the efficient causes of the present depression we have found it to originate in customs, laws, or modes of action which are ethically unsound, if not positively immoral. Wars and excessive war armaments, loans to despots or for war purposes, the accumulation of vast wealth by individuals, excessive speculation, adulteration of manufactured goods, and, lastly, *our bad land system*, with its insecurity of tenure, excessive rents, confiscation of tenants' property, its common enclosures, evictions, and depopulation of the rural districts—all come under this category."—"Bad Times," pp. 65, 117. By Alfred Russel Wallace, LL.D. London: Macmillan & Co., 1885.

in transmission, may be subjected to disastrous changes of management. Being also enterprises of a semi-public character, the public is bound, as well as their owners, to see to their preservation.

It is to a small number of the greatest of these great companies that Congress has given an empire of land in the West—an area double that owned by the lords of England, Scotland, and Ireland. In the railway proprietor of the United States the two great elements of power are united—steam and land. It needs no argument to show that only the nation can control the proprietor of both the land and the railway—the sole means of reaching a market for the products of the land. The appellative—kingship—to the railway proprietor is not a misnomer. He is a real potentate, both by virtue of the multitudes of men over whom he rules autocratically, and of the magnitude of the revenue he wields. Presidents come and go, but he remains. Legislators investigate him and report upon him, but they are met by a flat denial of the authority of either State or nation to interfere with his " vested rights." He claims the right of himself and associates to control, absolutely, the internal commerce of the country ; and this claim involves the pretence that they may confiscate merchandise seeking a market by charging, for carriage, the full value of the thing transported.

The railway and the factory, the two great products of steam, are new factors in the social problem, and to properly control them will require new wisdom ; and the new wisdom is not to be drawn from old educational fountains.

State legislation has been as vicious as that of the nation. The people of nearly every State in the Union

have been made the victims of great frauds and gross ignorance at the hands of their representatives. In nearly every State syndicates have been formed with the design of securing valuable franchises without consideration; and to effectuate such designs bribery has been freely and successfully resorted to in a vast number of cases. But rarely has the guilty agent of the guilty syndicate, or the perjured, purchased legislator been brought to justice, notwithstanding the fact that exposure has often followed the iniquity.

Evidence of the essentially European character of the American civilization is afforded by the prevalence of speculation.' In Wall Street, New York, on the Board of Trade, Chicago, and on the exchanges of all large cities speculation rages. The real transactions of those business marts are very small, indeed, as compared with the transactions of a speculative character. On the New York Cotton Exchange the speculative trades in "futures" are thirty times more than the cotton sales. On the Chicago Board of Trade the speculative trades in "futures" are fifteen times more than the sales of grain and provisions, and so of the exchanges of all other large cities. To support these speculative operations fresh money is required to be constantly poured into the pool, and it is drawn from every class in the community. Very little of the "fresh money" is ever returned. Most of it remains in the hands of the pool managers, of those whose profession it is to manipulate the markets. Thus the fever of speculation extends from centre to circumference of the country, stimulating bad passions, creating distaste for labor, relieving the countryman of his surplus, and increasing the already overgrown fortune of the city *operator*. A writer on current topics, discussing this sub-

ject, says, "Put your finger on one of our great fortunes,
and nine times out of ten you will feel underneath it the
cold heart of some one who has mined on the San Fran-
cisco Stock Exchange, or packed pork on the Chicago
Board of Trade, or built railroads in Wall Street." *

A sufficient number of the salient features of Ameri-
can civilization have been brought under review to show
that the new continent has not borne new social fruits.
Under extremely favorable physical conditions—a coun-
try of vast resources, a wide range of climates, and a soil
of great fertility—we planted old social forces, and old
social evils are in process of rapid development. We are
transplanted Europeans, controlled by European mental
and moral habitudes. And the virile force, evoked by
the splendid physical opportunities of a vast new coun-
try, so intensifies the struggle for wealth and power, that
European social abuses are not only reproduced, but
sometimes exaggerated in this land of boasted equal
political rights.

But notwithstanding the fact that social tendencies in
America seem to be similar to those of Europe, it is upon
America alone that the eyes of mankind rest with an ex-
pression of ardent hopefulness. Nor is this hope desti-
tute of a basis of rationality. It is in the United States,
for the first time in all the ages, that a good reason can
be given for indulging the sentiment of patriotism. Love
of country here is a due appreciation of the value of the
right of suffrage. The private soldier who goes forth to

* "America does not now suffer from this cause [standing armies],
but nowhere in the world have colossal fortunes, rabid speculation,
and great monopolies reached so portentous a magnitude, or exerted
so pernicious an influence."—"Bad Times," p. 80. By Alfred Rus-
sel Wallace, LL.D. London: Macmillan & Co., 1885.

fight the battles of the United States is a man and citi-
zen, and upon his return from the field he may, with the
ballot, devote to the education of his children a share of
the estate of the army contractor who amassed a fortune
while he defended the country. All the property in the
United States, whether honestly or dishonestly acquired,
is subject to the order of the ballot of the citizen. It
may be taken for war purposes, and it may be taken for
educational purposes. In the universality of the right
of suffrage lies the power of correcting all social evils.
It is through the right of suffrage that the wrongs inflict-
ed upon a too patient people by corrupt and ignorant
legislation may be ultimately righted. By the suffrages
of the people the tax bill is voted; and it is through the
tax bill that the vast estates of corporations and individ-
uals, whether obtained by dishonest practices or not, may
be made to contribute to the thorough education of all
the children of the country. And it is through the
sentiment of patriotism thus inspired that the right of
universal suffrage in the United States is destined to
preservation forever.

The late proposition to limit suffrage in the city of
New York is explainable only on the theory put forth
in this chapter, that our civilization is the product of
European ideas—that we are Europeans in disguise. On
any other hypothesis it would be amazing. It is even
now sufficiently startling that the proposition to restrict
suffrage should precede the proposition to make educa-
tion universal by making it compulsory, and to purge
it of its glaring defects. Every attempt to restrict the
right of suffrage in the United States will, however, fail.
The right of self-government can be taken from the
American people only by force. The American citizen

will not vote away his right to vote, as the careless Greek sold his freedom, and as the Chinaman sells his life.

That American social abuses do not spring from free suffrage is evident, because similar abuses exist in countries where the masses have little or no share in the government. Social evils are the product of defective education. So long as European educational methods prevail·in this country, so long European social abuses will characterize our civilization. Our education is scant in quantity and poor in quality; hence the standard of the suffrage is lowered by the presence of ignorance and depravity. But when the suffrage shall be better informed, it will be more honest; and when it shall have become more honest and more intelligent, it will have gained the power to grapple with social abuses.

Such examination of history as we have been able to make fails to disclose any radical change in educational methods for three thousand years. The charge of Mr. Herbert Spencer against the schools of England, to wit, "That which our school courses leave almost entirely out we thus find to be that which most nearly concerns the business of life" — this charge applies with almost as much force to the schools of the United States as to the Greek and Roman schools of rhetoric and logic. Bacon's aphorism—"Education is the cultivation of a just and legitimate familiarity betwixt the mind and things" —is two hundred and fifty years old, but it has as yet exerted scarcely an appreciable influence upon the methods of our public schools. We still reverse the natural order of investigation proceeding from the abstract to the concrete, thus lumbering the mind of the student with trash which must be removed as a preliminary to the first step in the real work of education. We still impart

a knowledge of words instead of a knowledge of things;
we still ignore art, notwithstanding the fact that it is
through art alone that education touches human life.
We still inculcate contempt of labor, and teach the stu-
dent how to "make his way in the world" by his wits,
rather than by giving an equivalent for what he shall
receive; and, worst of all, we continue, through subjec-
tive processes of thought, to charge the mind with self-
ishness, the essence of depravity.

Meantime, social problems press for a solution, a solu-
tion here and now. Our social problems cannot be set-
tled as those of Europe have been, for two hundred
years, by emigration. We have no Columbus, and if we
had such an explorer, there is no new hemisphere for
him to discover. The lesson of all history is, that selfish
people cannot dwell together in unity. The struggle to
secure more than a fair share of the products of the labor
of all is sure to end in a quarrel; the quarrel ends in a
revolution, and the revolution, under the glare of flames,
drowns in blood the records of civilization. But in Amer-
ica the man must live with his fellows. As Mr. Henry
D. Lloyd well says, in "Lords of Industry," "Our young
men can no longer go West; they must go up or down.
Not new land, but new virtue must be the outlet for the
future. Our halt at the shores of the Pacific is a much
more serious affair than that which brought our ancestors
to a pause before the barriers of the Atlantic, and com-
pelled them to practise living together for a few hundred
years. We cannot hereafter, as in the past, recover free-
dom by going to the prairies; we must find it in the
society of the good." *

* *North American Review*, June, 1884, p. 552.

If we are to find freedom only in the society of the good, we must create such a society—a society free from selfishness; for to the stability of society public spirit is essential, and with a pure public spirit selfishness is at war. Hence, in a system of education like the prevailing one, which promotes selfishness, the germs of social disintegration are present, and, from the beginning, the end may with absolute certainty be predicted. It follows that any hope of social reform is wholly irrational that does not spring from the postulate of a complete educational revolution.

1 The speculative habit has so debauched public sentiment in England and America that distinguished authors hesitate not to give free expression to a feeling of contempt for the ancients because of their failure to engage in colossal swindling operations, as witness the following :

" The charges of fraud [in the Attic courts], which are many, are of the vulgarest and simplest kind, depending upon violence, on false swearing, and upon evading judgment by legal devices. There is not a single case of any large or complicated swindling, such as is exhib. ited by the genius of modern English and American speculators. There is not even such ingenuity as was shown by Verres in his government of Sicily to be found among the clever Athenians."— ' Social Life in Greece," p. 408. By the Rev. J. P. Mahaffy, F.T.C.D. London : Macmillan & Co., 1883.

2 " On all hands of us, there is the announcement, audible enough, that the Old Empire of Routine has ended; that to say a thing has long been, is no reason for its continuing to be. The things which have been are fallen into decay, are fallen into incompetence ; large masses of mankind, in every society of our Europe, are no longer capable of living at all by the things which have been. When millions of men can no longer by their utmost exertion gain food for themselves, and ' the third man for thirty-six weeks each year is short of third-rate potatoes,' the things which have been must decidedly prepare to alter themselves! "—" Lectures on Heroes," p. 157. By Thomas Carlyle. Chapman & Hall's People's Edition.

" Change the sources of a river, and you will change it throughout its whole course; change the education of a people, and you will alter their character and their manners:" —" Studies of Nature," Vol. II., p. 575. By Bernardin St. Pierre. London : Henry G. Bohn, 1846.

CHAPTER XXVI.

THE MANUAL ELEMENT IN EDUCATION IN 1884.

The Kindergarten and the Manual Training School one in Principle.
—Russia solved the Problem of Tool Instruction by Laboratory
Processes.—The Initiatory Step by M. Victor Della-Vos, Director
of the Imperial Technical School of Moscow in 1868.—Statement
of Director Della-Vos as to the Origin, Progress, and Results of the
New System of Training.—Its Introduction into all the Technical
Schools of Russia.—Dr. John D. Runkle, President of the Massa-
chusetts Institute of Technology, recommends the Russian System
in 1876, and it is adopted. — Statement of Dr. Runkle as to how
he was led to the adoption of the Russian System.—Dr. Woodward,
of Washington University, St. Louis, Mo., establishes the second
School in this Country.—His Historical Note in the Prospectus of
1882–83.—First Class graduated 1883.—Manual Training in the
Agricultural Colleges—In Boston, in New Haven, in Baltimore, in
San Francisco, and other places.—Manual Training at the Meeting
of the National Educational Association, 1884.—Kindergarten and
Manual Training Exhibits. — Prof. Felix Adler's School in New
York City—the most Comprehensive School in the World.—The
Chicago Manual Training School the first Independent Institution
of the Kind—its Inception; its Incorporation; its Opening. Its
Director, Dr. Belfield.—His Inaugural Address.—Manual Training
in the Public Schools of Philadelphia.—Manual Training in twen-
ty-four States.—Revolutionizing a Texas College.—Local Option
Law in Massachusetts.—Department of Domestic Economy in the
Iowa Agricultural College.—Manual Training in Tennessee, in the
University of Michigan, in the National Educational Association,
in Ohio.—The Toledo School for both Sexes.—The Importance of
the Education of Woman.—The Slöjd Schools of Europe.

THE principle of the manual training school exists in
the kindergarten, and for that principle we are indebted
directly to Froebel, and indirectly to Pestalozzi, Come-

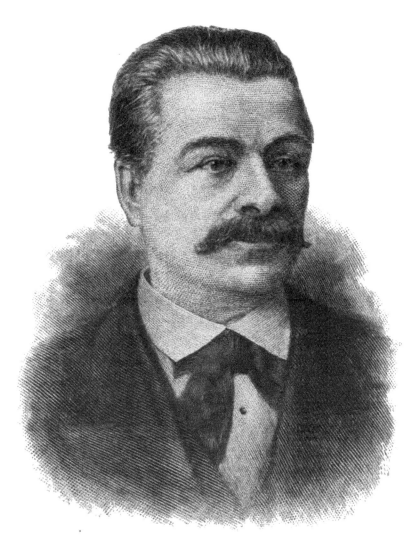

M. VICTOR DELLA-VOS, THE FOUNDER OF MANUAL TRAINING IN
RUSSIA.

nius, Rousseau, and Bacon. But it was reserved for Russia to solve the problem of tool instruction by the laboratory process, and make it the foundation of a great reform in education. The initiatory step was taken in 1868 by M. Victor Della-Vos, Director of the Imperial Technical School of Moscow. The following statement is extracted from the account given by Director Della-Vos of the exhibit of the Moscow school at Philadelphia (Centennial of 1876), and at the Paris Exposition in 1878, as best showing the inception of the new education:

"In 1868 the school council considered it indispensable, in order to secure the systematical teaching of elementary practical work, as well as for the more convenient supervision of the pupils while practically employed, to separate entirely the school workshops from the mechanical works in which the orders from private individuals are executed, admitting pupils to the latter only when they have perfectly acquired the principles of practical labor.

"By the separation alone of the school workshops from the mechanical works, the principal aim was, however, far from being attained. It was found necessary to work out such a method of teaching the elementary principles of mechanical art as, firstly, should demand the least possible length of time for their acquirement; secondly, should increase the facility of the supervision of the graded employment of the pupils; thirdly, should impart to the study of practical work the character of a sound systematical acquirement of knowledge; and fourthly and lastly, should facilitate the demonstration of the progress of every pupil at every stated time. Everybody is well aware that the successful study of any art whatsoever, free-hand or linear drawing, mu-

sic, singing, painting, etc., is only attainable when the first attempts at any of them are strictly subject to the laws of gradation and successiveness, when every student adheres to a definite method or school, surmounting little by little, and by certain degrees, the difficulties encountered.

" All those arts which we have just named possess a method of study which has been well worked out and defined, because, since they have long constituted a part of the education of the well-instructed classes of people; they could not but become subject to scientific analysis, could not but become the objects of investigation, with a view of defining those conditions which might render the study of them as easy and well regulated as possible.

" If we except the attempts made in France in the year 1867 by the celebrated and learned mechanical engineer, A. Cler, to form a collection of models for the practical study of the principal methods of forging and welding iron and steel, as well as the chief parts of joiners' work, and this with a purely demonstrative aim, no one, as far as we are aware, has hitherto been actively engaged in the working out of this question in its application to the study of hand labor in workshops. To the Imperial Technical School belongs the initiative in the introduction of a systematical method of teaching the arts of turning, carpentering, fitting, and forging.

" To the knowledge and experience in these specialties, of the gentlemen intrusted with the management of the school workshops, and to their warm sympathy in the matter of practical education, we are indebted for the drawing up of the programme of systematical instruction in the mechanical arts, its introduction in the year 1868 *into the* workshops, and also for the preparation of the

necessary auxiliaries to study. In the year 1870, at the exhibition of manufactures at St. Petersburg, the school exhibited its methods of teaching mechanical arts, and from that time they have been common to all the technical schools of Russia.

"And now (1878) we present our system of instruction, not as a project, but as an accomplished fact, confirmed by the long experience of ten years of success in its results."

For the introduction of the manual element in education to the United States we are indebted to the intellectual acumen of Dr. John D. Runkle, Ph.D., LL.D., Walker Professor of Mathematics, Institute of Technology, Boston, Mass. In 1876 Doctor Runkle was President of the Massachusetts Institute of Technology. In his official report for that year he gave an exhaustive exposition of the Russian system, in the course of which he said,

"We went to Philadelphia, therefore, earnestly seeking for light in this as well as in all other directions, and this special report is now made to ask your attention to a fundamental, and, as I think, complete solution of this most important problem of practical mechanism for engineers. The question is simply this, Can a system of shop-work instruction be devised of sufficient range and quality which will not consume more time than ought to be spared from the indispensable studies?

"This question has been answered triumphantly in the affirmative, and the answer comes from Russia. It gives me the greatest pleasure to call your attention to the exhibit made by the Imperial Technical Schools of St. Petersburg and Moscow, consisting entirely of collections of tools and samples of shop-work by students, illustrat-

ing the system which has made these magnificent results possible."

In conclusion Doctor Runkle made the following earnest recommendation:

"In the light of the experience which Russia brings us, not only in the form of a proposed system, but proved by several years of experience in more than a single school, it seems to me that the duty of the Institute is plain. We should, without delay, complete our course in Mechanical Engineering by adding a series of instruction shops, which I earnestly recommend."

In accordance with this recommendation the "new school of Mechanic Arts" was created, and made part of the Massachusetts Institute of Technology.

In his report for 1877 Doctor Runkle said,

"The plan announced in my last report, of building a series of shops [laboratories] in which to teach the students in the department of Mechanical Engineering and others the use of tools, and the fundamental steps in the art of construction, in accordance with the Russian system, as exhibited at Philadelphia in 1876, has been carried steadily forward, and I have now the pleasure of announcing its near completion."

Reference is also made in the same report to the action of the trustees of the Institute in acknowledging the reception of certain models illustrating the system of Mechanic Art education, presented by the government of Russia, as follows:

"At a meeting of the Corporation of the Massachusetts Institute of Technology, held November 20, 1877, a communication from his Excellency, Hon. George H. Boker, American Minister at St. Petersburg, was read, announcing the gift to this Institute of eight cases of

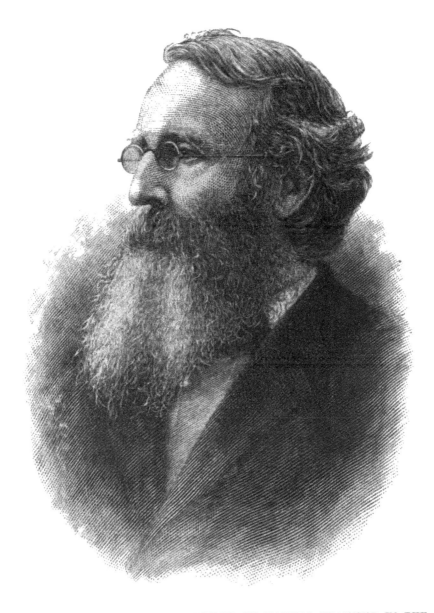

DR. JOHN D. RUNKLE, THE FOUNDER OF MANUAL TRAINING IN THE
UNITED STATES.

models, illustrating the system of Mechanic Art education, as devised and so successfully applied at the Imperial Technical School of Moscow. The undersigned have been charged with the agreeable duty of transmitting to his Imperial Highness the following resolutions:

"*Resolved*, That the Corporation of the Massachusetts Institute of Technology takes this opportunity to cordially congratulate his Imperial Highness, Prince Pierre d'Oldenbourg, that, at the Imperial Technical School of Moscow, education in the Mechanic Arts has been for the first time based upon philosophical and purely educational grounds, fully justifying for it the title of the 'Russian system.'

"*Resolved*, That this Corporation hereby tenders its grateful thanks to his Imperial Highness for his most valuable gift, with the assurance that these models will be of the greatest aid in promoting Mechanic Art education not only in the School of this Institute, but in all similar schools throughout the United States."

Appreciating the value of the services rendered to the cause of the new education by Dr. Runkle, in introducing to the schools of the United States tool practice by laboratory methods, and desiring to inform the public of the course of thought which led to results so important, the author addressed him on the subject. His reply, under date of May 22, 1884, is in substance as follows:

" From the first the course in Mechanical Engineering has been an important one in the Institute of Technology. A few students came with a knowledge of shop-work, and had a clear field open to them on graduation, but the larger number found it difficult to enter upon their professional work without first taking one or two years of apprenticeship. This always seemed to me a fault in the

education, and yet I did not see the way to remedy it without building up manufacturing works in connection with the school—a step which I knew to be an inversion of a true educational method.

"At Philadelphia, in 1876, almost the first thing I saw was a small case containing three series of models—one of chipping and filing, one of forging, and one of machine-tool work. I saw at once that they were not parts of machines, but simply graded models for teaching the manipulations in those arts. In an instant the problem I had been seeking to solve was clear to my mind; a plain distinction between a Mechanic Art and its application in some special trade became apparent.

"My first work was to build up at the Institute a series of Mechanic Art shops, or laboratories, to teach these arts, just as we teach chemistry and physics by the same means. At the same time I believed that this discipline could be made a part of general education, just as we make the sciences available for the same end through laboratory instruction.

"All teaching has in an important sense a double purpose: first, the cultivation of the powers of the individual, and second, the pursuit of similar subjects, by substantially the same means, as a professional end. Now we use our shops [laboratories] both for educational and professional ends. . . . In brief, we teach the mechanic arts by laboratory methods, and the student applies the special skill and knowledge acquired, or not, as circumstances or his inclinations dictate."

The second manual training school in this country was founded as a department of Washington University, St. Louis, Mo., by Dr. C. M. Woodward. In a paper read before the St. Louis Social Science Association, May 16,

1878, Dr. Woodward discussed the subject of education both philosophically and practically. In the course of his address he gave a full account of the Russian system of manual training as expounded by Dr. Runkle, endorsed it, and recommended it to the people of St. Louis as the true method of education in the following pregnant sentence : "The manual education which begins in the kindergarten, before the children are able to read a word, should never cease." *

In the same paper Dr. Woodward thus modestly describes the beginning of the school which is now one of the most highly-esteemed educational institutions of St. Louis :

"With the aid of our stanch friend, Mr. Gottlieb Conzelman, we fitted up during last summer a woodworking shop, with work-benches and vises for eighteen students ; a second shop for vise-work upon metals and for machine-work ; and a third with a single outfit of blacksmith's tools. During the last few months systematic instruction has been given to different classes in all these shops. Special attention has been paid to the use of wood-working hand-tools, to wood-turning, and to filing."

These tentative steps promoted a healthy public sentiment, and attracted the attention of several wealthy men, who in 1879 contributed the funds for the permanent foundation of the school. The prospectus for the year

* The pressing problem of the time in methods of practical education is to devise suitable manual exercises for the school period embraced in the interim between the end of the kindergarten series of lessons and the beginning of the series of laboratory exercises described in this work — the grammar-school period — for children of both sexes from six to fourteen years of age.

1882-83 contains the following "historical note," which shows great progress :

"The ordinance establishing the Manual Training School was adopted by the Board of Directors of the University, June 6, 1879.

"The lot was purchased and the building begun in August of the same year. In the November following a prospectus of the school was published. In June, 1880, the building being partially equipped, was opened for public inspection, and a class of boys was examined for admission. On September 6, 1880, the school began with a single class of about fifty pupils. The whole number enrolled during the year was sixty-seven. A public exhibition of drawing and shop-work was given June 16, 1881.

"The *second year* of the school opened September 12, 1881, and closed June 14, 1882. There were two classes, sixty-one pupils belonging to the first year, and forty-six to the second year, making one hundred and seven in all. Of the second-year class, forty-two had attended the school the previous year.

"The *third year* of the school will open on September 11th, when three classes will be present.

"The large addition now in progress (June, 1882) is to be completed and furnished by the day set for the examination of candidates for admission, September 8th. The number of pupils in the new first-year class is to be limited to one hundred. *Nearly one-half of that number have already been received.*"

The capacity of the school since the completion of the "addition" alluded to in the "historical note" is two hundred and forty students. The first class was graduated in June, 1883; the second class in June, 1884. The

establishment of this excellent school is due first to the energy and educational foresight of Dr. Woodward, and second, to the munificent money donations of three citizens of St. Louis—Mr. Edwin Harrison, Mr. Samuel Cupples, and Mr. Gottlieb Conzelman. Other citizens emulated their noble example, and the result was a sufficient fund for the support of the school, whose purpose is to demonstrate the practicability of uniting manual and mental instruction in the public schools of St. Louis and of the country. With a single further quotation from the prospectus of the second great manual training school in the United States, on the subject of labor, we close this too brief notice :

"One great object of the school is to foster a higher appreciation of the value and dignity of intelligent labor, and the worth and respectability of laboring men. A boy who sees nothing in manual labor but mere brute force despises both labor and the laborer. With the acquisition of skill in himself comes the ability and willingness to recognize skill in his fellows. When once he appreciates skill in handicraft, he regards the workman with sympathy and respect."

Considerable progress in manual training has been made in the State agricultural colleges of the country. In twelve of these colleges drawing and tool practice have been introduced. Generally the tool practice covers pattern-making, blacksmithing, moulding and founding, forging and bench-work, and machine-tool work in iron. The most pronounced success has been achieved at Purdue University, Lafayette, Ind., under the directorship of Prof. Wm. F. M. Goss, who graduated from the school of Mechanic Arts of the Massachusetts Institute of Technology in 1879.

Manual training in connection with the public-school system of education has been inaugurated in Boston and Milford, Mass.; New Haven, and the State Normal School, New Britain, Conn.; Omaha, Neb.; * Eau Claire, Wis.;† Moline, Peru, and the Cook County Normal School, Normal Park, Ill.; Montclair, N. J.; Cleveland and Barnesville, Ohio; San Francisco, Cal.; and Baltimore, Md.

On the occasion of the annual meeting of 1884 of the National Educational Association of the United States, at Madison, Wis., manual training received a very large share of the attention of educators. Very creditable exhibits of various manipulations in wood, iron, and steel were made by the following institutions, namely, the Massachusetts Institute of Technology, Purdue University, the St. Louis Manual Training School, the Illinois Industrial University, the University of Wisconsin, and the Spring Garden Institute of Philadelphia. There were also about thirty kindergarten exhibits, and a large number of exhibits of specimens of drawing from public schools in various parts of the country.

Prof. Felix Adler's educational enterprise in the city of New York—The Workingman's School and Free Kindergarten — is unique in this that, while it is entirely a work of charity, it is the most comprehensive educational institution in existence, as appears from the following description of its course of instruction:

"The Workingman's School and Free Kindergarten form one institution. The children are admitted at the

* In charge of Albert M. Bumann, B.S., graduate of the St. Louis Manual Training School, class of 1885.

† In charge of William F. Barnes, B.S., graduate of the St. Louis Manual Training School, class of 1885.

age of three to the kindergarten. They are graduated from it at six, and enter the workingman's school. They remain in the school till they are thirteen or fourteen years of age. Thereafter those who show decided ability receive higher technical instruction. For the others who leave the school proper and are sent to work, a series of evening classes will be opened, in which their industrial and general education will be continued in various directions. This graduate course of the workingman's school is intended to extend up to the eighteenth or twenty-first year.

"From the third year up to manhood and womanhood —such," says Prof. Adler, "is the scope embraced by the purposes of our institution!"

The following extracts from a late report of the principal of the school, Mr. G. Bamberger, on its "purposes," show that they are identical with those of the so-called manual training school, and also that its methods are similar:

"We, therefore, have undertaken to institute a reform in education in the following two ways: We begin industrial instruction at the very earliest age possible. Already in our kindergarten we lay the foundation for the system of work instruction that is to follow. In the school proper, then, we seek to bridge over the interval lying between the preparatory kindergarten training and the specialized instruction of the technical school, utilizing the school age itself for the development of industrial ability. This, however, is only one characteristic feature of our institution. The other, and the capital one, is, that we seek to combine industrial instruction organically with the ordinary branches of instruction, thus using it not only for the material purpose of creat-

ing skill, but also ideally as a factor of mind-education.
To our knowledge, such an application of work instruction has nowhere as yet been attempted, either abroad or
in this country. . . .

"In the teaching of history to these young children
we hold it essential that the teacher should be entirely
independent of any text-book, and able to freely handle
the vast material at his disposal, and to draw from it, as
from an endless storehouse, with fixed and definite purpose. We attach even greater importance to the moral
than to the intellectual significance of history. The benefits which the understanding, the memory, and the imagination derive from the study of history are not small.
But history, considered as a realm of actions, can be made
especially fruitful of sound influence upon the active,
moral side of human nature. The moral judgment is
strengthened by a knowledge of the evolution of mankind in good and evil. The moral feelings are purified
by abhorrence of the vices of the past, and by admiration of examples of greatness and virtue. Text-books
are not to be discarded, but their choice is a matter
of great difficulty. Thus, all books in which historical
instruction is given in the shape of printed questions and
answers are highly objectionable. They are convenient
bridges which lead to nothing."

The following extract from a late report of Prof. Adler shows the purpose of the establishment of what he
calls the "model school" to be identical with that of the
projectors of the St. Louis and Chicago manual training
schools, namely, the ultimate adoption by the public
schools of the country of a far more rational system of
instruction than that which at present prevails. He says,

"It seemed to us, therefore, far more necessary, far

more calculated to really advance the public good, that
one model school should be erected in which the entire
system of rational and liberal education for the children
of the poorer class might be exhibited from beginning to
end. We ventured to hope that such an example, hav-
ing once been set, would not be without effect upon the
common-school system at large, and that the extension
of our work would proceed by the natural course of the
'survival of what is fittest.' It was decided, therefore,
that the twenty - five graduates from the kindergarten
should be invited to remain with us, that a complete
school should be instituted, and that a teacher should be
at once appointed to take in hand the instruction of the
lowest class. The munificence of Mr. Joseph Seligman,
to whose name we cannot refer without gratitude and re-
spect, at this stage enabled us to go on with our under-
taking, when the dearth of funds would otherwise have
compelled us to wait, or perhaps desist altogether. His
timely gift of ten thousand dollars was the means of
starting the school, and on this as well as on other ac-
counts his memory deserves to be cherished by those
who cherish the educational interests of the people."

The Chicago Manual Training School is the only in-
dependent educational institution of the kind in the
world. All the schools of this character to which refer-
ence has been made in this chapter are departments of
colleges or institutes of technology. The Chicago school
is unique in another respect: it owes its origin entirely
to laymen. Professional educators labored long and ear-
nestly to found the schools we have described, but the
Chicago school was inspired by men unknown in the
field of educational enterprise, advocated by a secular
daily journal, and established by an association of mer-

chants, manufacturers, and bankers. For many years the
Chicago Tribune had very freely. and severely criticised
the educational methods of the public schools. Early in
the year 1881 its editorial columns were opened to the
author of this work, who began and continued, therein,
the advocacy of the establishment of a manual training
school in Chicago, as a tentative step towards the incor-
poration in the curriculum of the public schools, of more
practical methods of instruction.

The editorial advocacy of the *Tribune* was continued
for twelve months, articles appearing about once a week,
without apparent effect beyond provoking a controversy
with certain professional educators, who attacked the po-
sitions assumed by the *Tribune*. But a public sentiment
had been created on the subject, and the Commercial
Club was destined soon to embody that sentiment in ac-
tion. At its regular monthly meeting, March 25, 1882,
the subject of reform in methods of education was dis-
cussed by members of the club, and by men invited to
be present for that purpose; the establishment of a school
was resolved upon, and $100,000 pledged for its support.

The Chicago Manual Training School Association was
incorporated April 11, 1883; the corner - stone of its
building was laid September 24, 1883; and the sessions
of the school commenced on the 4th of February, 1884,
with a class of seventy-two students, "selected by exam-
ination from one hundred and thirty applicants, under
the directorship of Henry H. Belfield, A.M., Ph.D."

The Board of Trustees consists of E. W. Blatchford,
president; R. T. Crane, vice-president; Marshall Field,
treasurer; William A. Fuller, secretary; John Crerar,
John W. Doane, N. K. Fairbank, Edson Keith, and George
M. Pullman.

The object of the school is stated in the articles of incorporation as follows:

"Instruction and practice in the use of tools, with such instruction as may be deemed necessary in mathematics, drawing, and the English branches of a high-school course. The tool instruction as at present contemplated shall include carpentry, wood-turning, pattern-making, iron chipping and filing, forge-work, brazing and soldering, the use of machine-shop tools, and such other instruction of a similar character as may be deemed advisable to add to the foregoing from time to time, it being the intention to divide the working hours of the students, as nearly as possible, equally between manual and mental exercises."

· From the first annual catalogue, under the title "Building and Equipment," we extract the following:

"The school building is beautifully located on Michigan Avenue, and contains ample accommodations, in rooms for study and work, for several hundred pupils.

"The equipment in the mechanical department consists mainly, at present, of twenty-four cabinet-makers' benches; bench and lathe tools of the best quality for seventy-two boys; twenty-four speed lathes, twelve-inch swing, thirty inches between centres; a fifty-two horse-power Corliss engine, twelve-inch cylinder, thirty-six inch stroke; two tubular boilers, forty inches in diameter, fourteen feet long. The Corliss engine, boilers, and lathes were made especially for the school.

"A very valuable scientific library of nearly five hundred volumes, the property of the American Electrical Society, has been placed in the school. To this library, which is particularly rich in works pertaining to electricity and chemistry, but which contains also cyclope-

dias, dictionaries, and other works of reference, the pupils have access.

"The Blatchford Literary Society, an organization of pupils for improvement in composition, debate, etc., has lately had a handsome donation of money for the purchase of books to be placed in their alcove in the school library. Several periodicals are regularly placed on the library tables through the generosity of the publishers.

" By the kindness of Dr. Wm. F. Poole, librarian, pupils are able to obtain books from the Chicago Public Library on unusually favorable conditions."

Thus the Chicago Manual Training School, a practical school, a school of instruction in things, a school after Bacon's "own heart," sprang from the brains of a number of plain, practical business men, full-armed, as · Minerva from the brain of Jupiter.

The Trustees were fortunate in securing Dr. Belfield for the directorship of the school. Before the introduction of the new education to this country, eleven years ago, while Russia was struggling with the problem of tool practice by the laboratory method, Dr. Belfield urged the need of manual training in the public schools of Chicago, in which he was a teacher. He was met with derision; but the president of the Board of Education of Chicago and the superintendent of schools are now advocates of the new system of training.

In conclusion we present the following extracts from the inaugural address of Dr. Belfield, delivered before the Chicago Manual Training School Association, June 19, 1884, as embodying the results of his experience and observation as to the value of the new system of training :

"The distinctive feature of the manual training school

is the education of the mind, and of the hand as the agent of the mind. The time of the pupil in school is about equally divided between the study of books and the study of things; between the academic work on the one hand, and the drawing and shop-work on the other. Observe, I do not say between *school-work* and *shop-work*, for the shop is as much a school as is any other part of the establishment. Nor do I mean that the shop gives an education of the hand alone, and the class-room an education of the brain; but I mean that the shop educates *hand and brain*. That the *hand* is educated I need not stop to prove; but the shop educates the mind also.

"Had you been in the wood-working room of this school a few hours ago, what would you have seen? Twenty-four boys at work at lathes driven by a powerful engine. Are any idle? No. Are any inattentive to their work? No; you notice the closest and most earnest attention, frequently approaching abstraction. Here, then, is the cultivation of a most important faculty of the mind, attention, the power of concentration; and it is worthy of remark that this attention is not an *enforced* attention, but is cheerful, voluntary, and unremitting.

"The young workman is engaged on a problem in wood, just as, a few hours earlier, he was engaged on a problem in algebra. He has before him a drawing made to a scale. The problem is this: He must gain a clear conception of the object represented by the drawing; he must *imagine* it; he must select or cut a block of wood of the proper dimensions and **of the** right quality. **It** must not be too large, for he must guard against of material **and waste of** time. It m
for there **must** be no incomplete

product of his labor. Observe him as the work grows under his hand; observe the selecting of the proper tools for the different parts of the process; observe the careful measuring, the watchful eye upon the position of the chisel, the speed of the lathe, the gradual approach of the once rectangular block to the model which exists in his brain—and you must admit that this work demands and develops, not manual dexterity alone, but attention, observation, imagination, judgment, reasoning. . . .

"My own opinion is that an hour in the shop of a well-conducted manual training school develops as much mental strength as an hour devoted to Virgil or Legendre. . . .

"But of this I am confident, that three years of a manual training school will give at least as much purely intellectual growth as three years of the ordinary high school, because, as has been said, every school hour, whether spent in the class-room, the drawing-room, or in the shop, is an hour devoted to intellectual training. And I am also convinced that the manual training school boy's comprehension of some essential branches of knowledge will be as far superior to that of the other boy's, as the realization of the grandeur and beauty of the Alps to the man who has seen their glories is superior to the conception of him who has merely read of them. . . .

"And here is the mistake of those who would degrade a manual training school into a manufacturing establishment. The fact should never be lost sight of for an instant that the product of the school should be, not the polished article of furniture, not the perfect piece of machinery, but the polished, perfect *boy*. The acquisition of industrial skill should be the means of promoting the general education of the pupil; the education of the hand

should be the means of more completely and more effica-
ciously educating the brain. . . .

"Take two boys, one with little or no education, the
other a high-school graduate; let them enter the ma-
chine-shop of a large manufactory, beginning, as boys
ignorant of the technique of the trade must begin, at the·
lowest round of the ladder. It cannot be doubted that
in three or four years the high-school graduate, if he had
been willing to do the drudgery incident to the place,
would have reached a higher position than the other boy,
and would be in a fair way to succeed to some responsi-
ble post in the establishment. But the graduate of the
manual training school, by reason of his superior knowl-
edge of machinery and materials, his skill in.the use of
tools, added to his general mental training, would begin
at the point reached by the high-school boy after his
years of apprenticeship. From the day of his entrance
into the factory he would be conspicuous. While the
other boys would stand in the presence of the huge Titan
of the shop lost in the wonder of ignorance, the manual
training boy would gaze with delight on the marvel of
mechanism, wrapped in the admiration begotten of a
thorough understanding of its construction, and strong
in the consciousness of his mastery of it."

Manual training was introduced in the Pennsylvania
State College, experimentally, about three years ago. In
1883 the course was "greatly extended," and in Sep-
tember, 1884, it went into full operation. The course
is substantially the same as that of the Chicago school;
and that it was the outgrowth of the Russian system,
and inspired by Dr. Runkle, is shown by the following
extract from a circular lately issued by Prof. Louis E.
Reber:

"Some may think that the variety of operations in the mechanic arts is so great as to make it impossible to give the student any real knowledge in the time at his disposal. It should be borne in mind, however, that this multiplicity of processes may be reduced to a small number of manual operations, and the numerous tools employed are only modifications of, or convenient substitutes for, a few tools which are in general use."

A course in tool practice by the laboratory method has been made part of the curriculum of the College of the City of New York.* I am permitted to make an extract from a letter written in August last by Alfred G. Compton, Professor of Applied Mathematics of the College of the City of New York, to Dr. Runkle. I print this extract to show the exacting nature of the demands made upon instructors by the new education. It is as follows:

"We are anxious to find, by the opening of our term in September, a competent instructor in wood-working for our course in mechanic arts, now in its second year. He should be a good and ready draughtsman, skilful in perspective and projections, and ready in black-board sketching, besides being acquainted with the use of tools, and apt at class-teaching. He will have at first $1000 a year."

The lack of competent instructors is the most serious difficulty which the new education is destined to encounter. The desire to adopt tool practice is so widespread among the people that educators, whether willing or oth-

* "The first report of the Industrial Educational Association of New York gives a list of thirty-one schools in that city in which industrial education is furnished."—Address of Prof. S. R. Thompson, Industrial Department of the National Educational Association, Saratoga Springs, N. Y., July, 1885.

erwise, are compelled to attempt to gratify the demand. At the same time the force of competent instructors is very small, and the danger is that the new system of education will be brought into disrepute through the failure of its proper administration.

In 1882 Mr. Paul Tulane, of Princeton, N. J., made a large donation, consisting of his realty in the city of New Orleans, in aid of education in the State of Louisiana. In 1884 the University bearing its donor's name —Tulane—came into existence. In the deed of donation Mr. Tulane declared that by the term education he meant to "foster such a course of intellectual development as shall be useful and of solid worth, and not be merely ornamental or superficial." Hence manual training has been made a prominent feature of the institution.*

There is in operation at Crozet, Va., a manual training school called, after its founder, Mr. Samuel Miller, "The Miller Manual Labor School;" but of the methods of training pursued at this school the author is not accurately informed.

Girard College, dedicated nearly forty years ago, has adopted manual training. In response to a letter by the author, asking for information, Mr. W. Heyward Drayton, of Philadelphia, gives the following historical sketch of the introduction and progress of tool practice by the laboratory method in that noble institution:

* John M. Ordway, A.M., late Professor of Metallurgy and Industrial Chemistry of the Massachusetts Institute of Technology, has been called to New Orleans to organize and direct the manual training department of the institution; and he is assisted by Charles A. Heath, B.S., and Everett E. Hapgood, graduates of the School of Mechanic Arts of the Massachusetts Institute of Technology.

"From time to time some of the directors recognized
the importance of mechanical instruction, but after one
or two attempts further efforts in this direction were
abandoned, as those proved utter failures. It was not
until Dr. Runkle, of the Massachusetts Institute of Tech-
nology, at the instance of the late Mr. William Welsh,
then president of the Board of Directors of City Trusts,
delivered a short address on the subject in the lecture-
room of the Franklin Institute in this city, that any prac-
tical mode of introducing this branch of study into the
college was presented.

"... Following as nearly as possible the scheme suggest-
ed by Dr. Runkle, and aided by many suggestions from
him, in April, 1882, we began to instruct the larger boys
to use tools in several kinds of metals. We were so fort-
unate as to secure the services of a very competent and
enthusiastic instructor, who confined his instruction mere-
ly to teaching the use of tools, but without any pretence
of teaching any trade. The result of two years' experi-
ence has been so satisfactory that our boys leave the col-
lege to go to workshops, where they secure sufficient
wages to support them at once; and they have, in many
cases, been found so expert that in a few months their
wages have been increased. We have been so encour-
aged by this as a substitute for apprenticing lads, which
is fast becoming impossible, that we have just erected
commodious workshops [laboratories], in which, on the
same system, but to many more boys, we propose to teach
the use of tools in wood-work also, as we have hereto-
fore taught in metals. To this time we have been com-
pelled, from want of facilities, to confine our instruction
to about one hundred and seventy-five boys. We expect
next month (October, 1884) to increase the number to

three hundred—only being limited by the youth of the pupils, many of whom are too young to permit of their handling tools."

Manual training has been made part of the curriculum of the Agricultural and Mechanical College of Auburn, Ala., and the department is under the direction of a graduate of the Massachusetts Institute of Technology.*

Manual training has been adopted as a branch of education in the Denver (Col.) University, and the director of the department is a graduate of the manual training department of the Washington University of St. Louis, Mo.†

The present year (1885) witnesses a very important addition to the list of manual training schools—that of Philadelphia.

It is not too much to say that Mr. James MacAlister has revolutionized the public schools of Philadelphia in the short period of two years during which he has held the office of superintendent; and the last wave of the revolution reveals a fully-equipped manual training school as part of the public-school system of the conservative, grand old Quaker city. And this practical element in education is to be free to all public-school boys fourteen years of age, who can show themselves qualified to enter, as witness the following " rules " of the Philadelphia public schools :

" Promotions to the Manual Training School shall be made at the close of the June term, from the Twelfth

* George H. Bryant, B.S., graduate of the Massachusetts Institute of Technology, class of 1883.

† C. H. Wright, B.S., graduate of the St. Louis Manual Training School, class of 1885.

Grade, or any higher grade, of the Boys' Grammar, Consolidated and Combined Schools; but no boy shall. be promoted who is under fourteen years of age.

"It shall be the duty of the Principals of the several Boys' Grammar, Consolidated and Combined Schools, to certify to the superintendent of schools the names of all boys of the proper age who have finished the course of study in the Twelfth Grade, or any higher grade, and are desirous of promotion to the Manual Training School."

In calling the attention of the public to the establishment of a manual training school as part of the educational system of Philadelphia, a committee of the City Board of Education say, under date of June 10, 1885,

"The undersigned desire to call attention to the new manual training school to be opened in this city next September. It is intended for boys who have finished the Twelfth Grade, or any higher grade, of the Grammar-school course. The instruction will embrace a thorough course, so far as it goes, in English, mathematics, free-hand and mechanical drawing, and the fundamental sciences; but in addition to these branches a carefully graded course of manual training will form a leading feature of the school. This manual training is intended to give the boys such a knowledge of the tools and materials employed in the chief industrial pursuits of our time as shall place them in more direct and sympathetic relations with the great activities of the business world. The school will make our public education not only more complete and symmetrical in character than it has been heretofore, but it will be at the same time better adapted to enable the pupils to win their way in life. No matter what future a parent may have marked out for his boy— whether he be intended for an industrial, a mercantile, or

a professional occupation, it is believed that such an education will be of immense advantage to him. Upon the industries of the world, to a much larger extent than ever before in its history, depend the progress, the prosperity, the happiness of society. To prepare boys for this condition of things will be the aim of this school. The entire course of instruction and training will be *practical* in the largest and best sense of that term. The culture it gives will include the hand as well as the head, and its graduates will be trained to work as well as to think. The course will extend over a period of three years, but it is so arranged that boys whose intended pursuits in life will not warrant spending so much time may participate in its advantages for a shorter period before entering upon other studies or a permanent occupation.

"The Manual Training School has been organized in response to a growing sentiment respecting the character of public education which has been strongly manifested in Philadelphia, and the Board of Public Education believe that the movement, when fully understood, will meet with the cordial approval of our people. Your careful consideration of the nature and objects which the school seeks to accomplish is respectfully solicited."

This act of the school authorities of the city of Philadelphia is the strongest popular endorsement the theory of manual training as an element of education has received. It commits a great city to a fair trial of the new education under the most favorable auspices—under the conduct of Mr. James MacAlister, one of the most accomplished, as well as most sternly practical educators in the United States.

But this is only part of a general system of **manual training introduced throu**ghout the whole

struction given in the public schools of Philadelphia.
There are kindergartens (sub-primaries) for children
from three to six years of age, and an industrial art
department for all the students (of both sexes) of the
grammar schools. In this latter department the course
of training comprises " drawing and design," "model-
ling," " wood-carving," "carpentry and joinery," and
"metal work." These courses, including manual train-
ing proper, "at the top," form a comprehensive system
of head and hand training known as the new education.
Mr. MacAlister says, " The conviction is gradually ob-
taining among the members of the Board of Education
[of Philadelphia], and in the public mind, that every
child should receive manual training; that a complete
education implies the training of the hand in connection
with the training of the mind; and that this feature
must ultimately be incorporated into the public educa-
tion. What is this but the realization of the principles
which every great thinker and reformer in education
has insisted upon, from Comenius, Locke, and Rousseau,
to Pestalozzi, Froehel, and Spencer !" *

* In a letter to the author, Mr. MacAlister re-enforces the observa-
tions quoted in the text. He says,

" I wish you to understand that all my own convictions and action
in connection with this movement are based upon what in my judg-
ment should constitute an education fitted to prepare a human being
for the social conditions of to-day, *and not merely upon the industrial
demands of our time.* . . . I believe there is a great future for the
manual training movement in Philadelphia. I feel encouraged to go
forward with the work. The great principles which underlie the
system are with me intense convictions; *they mean nothing less than
a revolution in education.* The great ideas of the reformers of school
training must be realized in the public schools, or they will fail in
accomplishing the ends for which they were instituted and have been
maintained."

The rapid progress of the revolution in education is shown by the fact that manual training in some form has been adopted in certain of the schools of at least twenty-four of the States of the American Union.

In some of the higher educational institutions the new education is warmly welcomed, while in others public sentiment alone compels its adoption. The State Agricultural and Mechanical College of Texas has been revolutionized in this way. A member of the Faculty* writes as follows:

"This institution was opened on the 4th of October, 1876. In spite of its name, the conditions of its endowment, and its avowed object, it was founded on the plan of the old classical and mathematical college, and had no industrial features whatever till the beginning of the year 1880. At that time the public sentiment of the State had condemned so decidedly and repeatedly the misappropriation of the funds, and perversion of the energies of the college under its administration as a literary school, that the directors found it necessary to reorganize it by accepting the resignation of the members of the faculty without exception, and calling in a new corps of instructors. In 1880–81 a large dormitory building was converted into a shop [laboratory]. This was fitted with tools for elementary instruction in wood-working for the accommodation of about fifty students. A small metal-working plant was also erected, the whole being furnished with power from a twelve-horse-power engine. Since that time a brick shop [laboratory] has been provided for the accommodation of the metal-working machinery, which now includes the principal machines used

* H. H. Dinwiddie, Professor of Chemistry, Chairman of the Faculty.

in ordinary iron-working, all driven by a twenty-horse-power engine."

Massachusetts, the cradle of the American common-school system, is the first State to legalize by statute the new education, placing manual training on an equal footing with mental training, by the following act :

"Section I. of Chapter XLIV. of the Public Statutes, relating to the branches of instruction to be taught in public schools, is amended by striking out in the eighth line the words 'and hygiene,' and inserting instead the words 'hygiene and the elementary use of hand-tools;' and in any city or town where such tools shall be introduced they shall be purchased by the school committee at the expense of such city or town, and loaned to such pupils as may be allowed to use them free of charge, subject to such rules and regulations, as to care and custody, as the school committee may prescribe." *

The Legislature of Connecticut adopted a similar statute last year (1884).

The Iowa Agricultural College is the first educational institution in the country to recognize the importance of instruction in the arts of home life. In this college domestic economy has been elevated to the dignity of a department called the "School of Domestic Economy," with the following "special faculty :"

The President, Mrs. Emma P. Ewing, Dean. *Domestic Economy.*
J. L. Budd.....................*Horticulture and Gardening.*
A. A. Bennett.....................*Chemistry.*
B. D. Halsted.....................*Botany.*
D. S. Fairchild.....................*Hygiene and Physiology.*
Laura M. Saunderson.....................*Elocution.*

* "School Laws of Massachusetts. Supplement to the Edition of 1883, containing the Additional Legislation to the Close of the Legislative Session of 1885; issued by the State Board of Education."

The course of study is as follows:

FIRST YEAR.

First Term.	*Second Term.*
Domestic Economy.	Domestic Economy.
Botany.	Physiology and Hygiene.
Physical Training.	Dress-fitting and Millinery.
Household Accounts.	Essays.

SECOND YEAR.

First Term.	*Second Term.*
Domestic Economy.	Domestic Economy.
Chemistry.	Home Architecture.
Duties of the Nurse.	Home Sanitation.
Designing and Free-hand Drawing.	Home Æsthetics and Decorative Art.
Landscape and Floral Gardening.	Essays and Graduating Thesis.

Mrs. Ewing, dean of the school, thus states, clearly and powerfully, the reasons for its establishment and its purposes:

"This school is based upon the assumption that no industry is more important to human happiness than that which makes the home; and that a pleasant home is an essential element of broad culture, and one of the surest safeguards of morality and virtue. It was organized to meet the wants of pupils who desire a knowledge of the principles that underlie domestic economy, and the course of study is especially arranged to furnish women instruction in applied house-keeping and the arts and sciences relating thereto—to incite them to a faithful performance of the every-day duties of life, and to inspire them with a belief in the nobleness and dignity of a true womanhood.

"No calling requires for its perfect mastery a greater

amount of practice and theory combined than that of
domestic economy, and students, in addition to recita-
tions and lectures on the various topics of the course,
receive practical training in all branches of house-work,
in the purchase and care of family supplies, and in gen-
eral household management. They are not, however,
required to perform a greater amount of labor than is
necessary for the desired instruction.

"The course of study is for graduates of colleges and
universities. It extends through two years, and leads to
the degree of Master of Domestic Economy." *

The Le Moyne Normal Institute of Memphis, Tenn.,
is a private school, "sustained chiefly by benevolently
disposed people at the North, for colored youth." In a
letter to the author the principal of this school thus de-
scribes the manual features of its curriculum :

"Besides our Normal work proper, we give girls of
the school two years' training in needle-work of different
kinds, one year's instruction in choice and preparation of
foods, with practice in an experimental kitchen, and six
months' training in nursing or care of the sick. One
hour a day is given to each of the foregoing subjects for
the time indicated.

"I am about to erect workshops for training for our
boys in the use of wood-working tools, and in iron-work-
ing and moulding—the course to comprise two years'
time, two hours per day at the benches. We shall also
have type-setting and printing as specialties for individ-
ual students. This work will be in operation in Janu-
ary, 1886." †

* Annual Catalogue of the Iowa Agricultural College.
† A. J. Steele,

The professor in charge of the Mechanical Engineering Department of the University of Michigan writes to the author as follows :

"There can be no doubt in the mind of a sane man that this practical instruction [laboratory work] is exactly what is needed by our engineering students. We are assured of that fact by the expression of gratification on the part of our engineering *alumni* to find here the very instruction which they were obliged to spend two or three years to secure after graduating. We give our students work of an elementary character for a few weeks, or until they become accustomed to tools, when we put them to work on some part of a machine. If they spoil it, well and good—it goes into the scrap-heap; if they succeed, they have the pleasure of seeing a perfect machine grow up under their eyes and hand. Students having matured minds, as most of ours have, work better with a definite plan in view. We always require them to work from drawings. Our course in forging is very popular; and it is especially useful, as it gives our young men that knowledge of the different kinds of iron and steel which will be of the greatest benefit to them as engineers." *

The National Educational Association of the United States, at its last meeting, at Saratoga Springs, N. Y. (1885), took a great step forward in the adoption of a resolution † endorsing the kindergarten. The association was, however, singularly illogical in its subsequent ac-

* Mortimer E. Cooley, Assistant Engineer, U. S. Navy.

† "*Resolved*, That we trust the time is near at hand when the true principles of the kindergarten will guide all elementary training, and when public sentiment and legislative enactment will incorporate the kindergarten into our public-school system."

tion, in voting to lay upon the table a resolution* recommending the introduction of manual training to the public schools. The kindergarten and manual training are one in principle, and should be one in practice. All educators will soon see this, and the National Educational Association will no doubt soon place itself as heartily on record in support of manual training as it has already done in support of the kindergarten.

Ohio ranks as the third State in the Union industrially, and she is making great strides in the direction of a more practical system of education. This is shown by the prominent place given to instruction in the mechanic arts in the State University at Columbus, by the prosperity of the Case School of Applied Science, and the introduction of manual training to the public-school system at Cleveland, and by the establishment of the Scott Manual Training School at Toledo. The city of Toledo owes the inception of the movement in support of the new education to the munificence of the late Jesup W. Scott, who during his life conveyed to trustees for purposes of industrial education, in connection with the public-school system, certain valuable real estate. After the death of Mr Scott, his three sons,† still residents of Toledo, supplemented their father's donation with a sufficient sum of money to secure the erection and complete equipment of a manual training school for three hundred and fifty pupils.

The school is modelled after the schools of St. Louis and Chicago; but it gives only the manual side of the

* "*Resolved,* That we recognize the educational value of training the hand to skill in the use of tools, and recommend that provision be made, as far as practicable, for such training in public schools."

† William F., Frank J., and Maurice Scott.

curriculum, because it is conducted in connection with the public High School, receiving its pupils therefrom. It opened in the autumn of 1884 with sixty pupils, ten of whom were girls. Its register now numbers two hundred, fifty of whom are girls. Its course for boys is substantially the same as that of the Chicago school. The course for girls includes free-hand and mechanical drawing, designing, modelling, wood-carving, cutting, fitting, and making garments, and domestic science, including food preparation and household decoration. A distinguished lawyer and citizen of Toledo,* who has been prominent in the work of establishing the school, says,

"The brightest and most faithful pupils of the High School have eagerly availed themselves of the opportunity for manual instruction, and the zeal with which this new work is pursued has added a new charm to school life."

The school is in charge of Mr. Ralph Miller, B.S., who is assisted by Mr. Geo. S. Mills, B.S.† It is especially interesting, both as the newest educational enterprise and because it places the sexes on a footing of absolute equality. Reform in education must begin with woman, for it is from her that man inherits his notable traits, and from her that he receives the earliest and most enduring impressions. In the arms of the mother the infant mind rapidly unfolds. It is in the cradle, in the nursery, and at the fireside that the child becomes father of the man. The regeneration of the race through education must, then, begin with the child, and be directed by the mother ; and this being the fact, the education of woman becomes far more imperative than that of man.

* Hon. A. E. Macomber.
† Graduates of the St. Louis Manual Traini

That the ancients made so little progress in morals is due to the fact of their neglect of the education of woman. Neither in Egypt nor Persia was provision made for her mental or moral training. There were schools for boys in Greece, but none for girls; and not till late in the Empire was there any special culture for girls in Rome.

In the Middle Ages learning was confined to the religious orders. The narrow bounds of the convent contained all there was of science and art. In the castle and at the tournament woman ministered to man's pride and vanity; and in the peasant's hut, which was the abode equally of poverty and ignorance, she endured both mental and moral starvation. Sir Walter Raleigh, Lord Bacon, Swift, Addison, Lord Chesterfield, Dr. Johnson, and Southey treated woman with mingled contempt and pity, and yet they were familiar with the story of Lucretia, of Virginia, and of the Maid of Orleans! But Shakespeare, with a sublimer genius, portrayed a Cordelia, a Desdemona, an Imogen, and a Queen Catharine, and with rare prevision of a future better than the age he knew, wrote these glowing lines:

> "Falsehood and cowardice
> Are things that women highly hold in hate."

This is the rational age, though not less truly chivalrous than that of Arthur and his knights; for, as Ruskin well says, "The buckling on of the knight's armor by his lady's hand is the type of an eternal truth—that the soul's armor is never well set to the heart unless a woman's hand has braced it." *

* "Sesame and Lilies," p. 97. By John Ruskin, LL.D. New York: John Wiley & Sons, 1884.

The distinguishing features of this time are its homes and its schools, and the purity of the one and the efficiency of the other depends upon woman. It was reserved for Froebel to rescue woman from the scorn of preceding ages by declaring her superior fitness for the office of teacher—the most exalted of civil functions.

The growth of the kindergarten has not been commensurate with its importance. Indifference and prejudice have united to discourage progress. Ancient contempt of childhood — that contempt which in Persia excluded the boy from the presence of his father until the fifth year of his age * — projects its sombre shadow down the ages. But manual training, which is the kindergarten in another form, is leading captive the imagination of the American people, and where the imagination leads, woman is in the van. Woman is to man what the poet is to the scientist, what Shakespeare was to Newton, the celestial guide. She tempts to deeds of heroism and self-sacrifice. She is less selfish than man, because a more vivid imagination inspires her with a deeper feeling of compassion for the misfortunes and follies of the race. Her intuitions are truer than those of man, her ideals higher, her sense of justice finer, and of duty stronger; and she has a better appreciation of the moral value of industry, remembering the temptations of her sex to evil through habits of idleness, enforced by the decrees of custom. And she is our teacher, whether we will or no—our teacher from the cradle to the grave—and it is through her ministry that we are destined to realize our highest mental and moral ideals.'

This sketch of the history of manual training in the

* "Herodotus," Clio I., p. 136.

United States is doubtless incomplete. It is, however, sufficient to show that the subject is already one of absorbing interest in all parts of the country.

Manual training in the public schools of Europe can scarcely be called educational, since the pupils usually make articles for household use. The purpose is purely industrial, and hence the mental culture received in the course of the manual exercise is the mere incident of a mechanical pursuit. But the making of things in the schools of Europe is gradually extending.

In Denmark an annual appropriation ($2000) is made by the Legislature for the encouragement of *slöjd* (hand-cunning) in the schools. All pupils in Danish and Swedish schools make things.

In Germany, Dr. Erasmus Schwab published in Vienna, in 1873, a book, "The Work School in the Common School." Rittmeister Claussen Von .Kaas, of Denmark, travelled through Germany and delivered lectures on manual training, and now there is a considerable agitation of the subject.

In Finland all the country schools are *slöjd* schools.

In 1881 the Legislature of Norway appropriated $1250 for the support of *slöjd* in the schools.

In France a law (1882) makes manual training obligatory, and a school for training teachers has been established—"L'école Normale Superieure de travail Manuel" —in which there are about fifty students. Prof. G. Solicis was the chief supporter of manual training in France.

In Sweden, in 1876, there were eighty *slöjd* schools. In 1877 the number had increased to one hundred; in 1878, to one hundred and thirty; in 1879, to two hundred; in 1880, to three hundred; in 1881, to four hundred; and in 1882, to five hundred.

In Nääs, in Sweden, there is a seminary for the train-
ing of *slöjd* teachers.* Of this seminary Otto Salomon is
director. In the *slöjd* schools small articles are made for
use in the house, kitchen, on the farm, etc. The course
of instruction embraces one hundred models. The mate-
rials for the first series of twenty-five models cost about
40 cents; for the second series of twenty-five the cost is
75 cents; and for the third series of fifty the cost is $3.25.
The annual expense of the manual training in a Swedish
country school is about ten to eleven dollars.

The technical and mechanic art or trade schools of
Europe, generally, whether public or private, do not
come within the scope of this work, since their purpose
is industrial, not educational.

* "Four young women have graduated from the Slöjd Teacher's
Seminary at Nääs, Sweden, and two of them are now engaged in
teaching manual arts."—Letter from John M. Ordway, A.M., Chair
of Applied Chemistry and Biology, and Director of Manual Training,
Tulane University of Louisiana.

1 "In fine, I have been beloved by the four women whose love was
of the most comfort to me : My mother, my sister, my wife and my
daughter. I have had the better part, and it will not be taken from
me, for I often fancy that the judgments which will be passed upon
us in the Valley of Jehoshaphat, will be neither more nor less than
those of women, countersigned by the Almighty."—"Recollections
of My Youth," p. 306. By Ernest Renan. New York : G. P. Put-
nam's Sons, 1883.

CHAPTER XXVII.

PROGRESS OF THE NEW EDUCATION—1888-1898.

Educational Revolution in 1888-4.—Urgent Demand for Reform—
Existing Schools Denounced as Superficial, their Methods as Auto-
matic, their System as a Mixture of Cram and Smatter—The
Controversy between the School-master of the Old Régime and
the Reformer—The Leaders of the Movement, Col. Parker, Dr.
MacAlister, and Others—Followers of Rousseau, Bacon, and
Spencer—"The End of Man is an Action, not a Thought"—The
Conservative Teachers Fall into Line—The New Education Be-
comes an Aggressive Force, Pushing on to Victory—The Physical
Progress of Manual Training—Its Quality Not Equal to its Ex-
tent—The New System of Training Confided to Teachers of the
Old Régime—Ideal Teachers Hard to Find—Teachers Willing to
Learn Should Be Encouraged—The Effects of Manual Training
Long Antedate its Introduction to the Schools—Bacon's Definition
of Education—Stephenson and the Value of Hand-work—Manual
Training is the Union of Thought and Action—It is the Antithesis
of the Greek Methods, which Exalted Abstractions and Debased
Things—The Rule of Comenius and the Injunction of Rousseau
—Few Teachers Comprehend Them—The Employment of the
Hands in the Arts is More Highly Educative than the Acquisi-
tion of the Rules of Reading and Arithmetic—What the Locomo-
tive has Accomplished for Man—Education Must be Equal, and
Social and Political Equality will Follow—The Foundation of
the New Education is the Baconian Philosophy as Stated by
Macaulay—Use and Service are the Twin-ministers of Human
Progress—Definitions of Genius—Attention—Sir Henry Maine—
Manual Training Relates to all the Arts of Life—Mind and Hand
—Newton and the Apple—The Sense of Touch Resides in the
Hand—Robert Seidel on Familiarity with Objects—Material
Progress the Basis of Spiritual Growth—Plato and the Divine
Dialogues—Poverty, Society, and the Useful Arts—Selfishness

Must Give Way to Altruism—The Struggle of Life—The Progress of the Arts and the Final Regeneration of the Race—The Arts that Make Life Sweet and Beautiful—The Final Fundamental Educational Ideal is Universality—Comenius's Definition of Schools—The Workshops of Humanity—That One Man Should Die Ignorant who had Capacity for Knowledge is a Tragedy—Mental and Manual Exercises to be Rendered Homogeneous in the School of the Future—The Hero of the Ideal School.

FIFTEEN years ago a great wave of educational awakening swept over this country. It penetrated every nook and corner of the land, pervading both cities, large and small, and the rural districts. It took the shape of a demand, often almost inarticulate, for reform. The schools were denounced as superficial; their methods as automatic; their teachers as unintelligent and untrained, their system of instruction as a mixture of cram and smatter.

The school-master is a conservative, and with his champions he came promptly to the defence of the old schools and their old methods. The controversy became heated, and soon the rival forces joined battle. Col. Francis W. Parker, of the Chicago Normal School, and Dr. James MacAlister, now President of the Drexel Institute of Philadelphia, and others were prominent leaders of the new reform movement, whose banner was " Manual Training," or " The New Education."

Under this brilliant and enthusiastic leadership the movement became a crusade in the interest of the educational ideas of Montaigne, Rousseau, Bacon, Locke, Comenius, Pestalozzi, Froebel, Spencer, Mann, and their long array of sympathizers and supporters, who, with Bacon, declare that " the end of man is an action, not a thought."

But the work of the reformers was too serious to be

long controlled, either by emotion or passion. The more intelligent and better educated and trained teachers gradually came to the support of the new system and methods, and the mass of the teaching fraternity caught something of the enthusiasm by which the reformers were inspired to struggle for a great cause. Thereafter Manual Training became an aggressive force openly demanding recognition, and pushing for victory and ultimate control.

In the Appendix hereto the physical progress of Manual Training is shown in tabulated form; and the extent of such progress is all, if not more, than its most ardent friends and advocates could rationally desire. But it is not to be doubted that the quality of the progress the new education has made in the period of fifteen years under consideration is far inferior to its extent. The statistics here presented relate mainly to the village, town, and city schools of this country, and especially to its public schools, with some general observations and facts in relation to the progress of the new education in England and the chief countries in Europe. In a few instances the tabulations include institutions designed for industrial rather than strictly educational purposes. But it is deemed wise to retain them, on the ground that whether so designed or not all industrial training is educative.

It is worthy of intelligent inquiry whether as a matter of fact, not only in this country, but in all countries, the progress of Manual Training has not been very unsatisfactory in quality. In most cases the new education was necessarily confided to teachers of the old régime, who, as a preliminary, were compelled to unlearn what was false and erroneous in the old system, to overcome

the prejudices of years, sometimes of a lifetime, and to become faithful and laborious students of a new and scientific scheme of education. The main difficulty in matters educational has always been to secure ideal teachers. Education is the first of human considerations, and its professors should be the most learned of human beings. If the teachers who have been called to the Priesthood, of the New Education, have proved incompetent in many instances, instead of being hastily condemned they should be helped forward towards the goal of competency by all friends of that progress in education which is the sole hope of human perfection.

The most striking effects of Manual Training long antedate its introduction to the schools. For thousands of years, in every shop where the humble mechanic wrought; at every fireside where the domestic arts obtained a foothold; in every field where a step forward was made through the invention of some less crude implement of husbandry than the one that preceded it, the mind and the hand expressed their joint struggle towards the achievement of that skill in useful things which constitutes the very kernel of civilization. Bacon's definition of education — "the cultivation of a just and legitimate familiarity, betwixt the mind and things"—is a recognition of the philosophic fact that the hand is the source of wisdom; and the life of George Stephenson, the inventor of the locomotive, affords a most impressive illustration of the educative value of handwork. At the coal-pit's mouth Stephenson, meantime learning his "A B C's," invented the "Rocket." while the bookish engineers were declaring it to be a mechanical impossibility. Stephenson's achievement was the realization in things of Bacon's luminous precept—"The

end of man is an action, not a thought."—This is the
philosophy, the rationale, of Manual Training; it is the
union of thought and action, and it therefore demands
the elimination from educational methods of the abstract
philosophy of the Greeks. In his declaration, "All the
useful arts are degrading," Plato defined the character
of the revival of learning which was to occur hundreds
of years afterwards; it was a revival of Greek methods,
which exalted abstractions, and debased things. Mr.
Herbert Spencer refers to its baleful effects upon the
schools of England in the severest terms of condemna-
tion. That Mr. Spencer's arraignment of the schools is
just, is shown by its antithesis expressed in the dictum
of Dr. Dwight, of Yale College, who says: "Education
is for the purpose of developing and cultivating the
thinking power. It is to the end of making a knowing,
thinking mind."

Bacon discovered, and did not hesitate to declare, that
"the understanding is more prone to error than the
senses"; and this fact constitutes the basis of his phi-
losophy of "things," which is another name for the law
of induction. "For if we would look into and dissect
the nature of this real world," he says, "we must consult
only things themselves." If we would find the corner-
stone of education, we must consult labor. Nothing
great is accomplished without a due mingling of drudg-
ery and humility; for of all the virtues humility is the
most excellent. The Greeks failed to comprehend the
true educational idea because of their pride. They as-
sociated use with slavery, because in Greece all labor
was performed by slaves; and, scorning labor, they
scorned use, and, by consequence, service, the greatest
of the moralities.

Upon the foundation laid by Bacon, Rabelais, and Montaigne, Comenius, Rousseau, Pestalozzi, and Froebel raised a great superstructure of educational ideas. Words were subordinated, and things ennobled.

Comenius's rule, to " leave nothing until it has been impressed by means of the ear, the eye, the tongue, the hand," and the injunction of Rousseau that " the student will learn more by one hour of manual labor than he will retain from a whole day's verbal instructions; that the things themselves are the best explanations "—these are the maxims of the new education.

But to what extent has the old school-master adopted the new education, to what extent occupied the old school-room with new ideas? How many school-masters of even the present *régime* comprehend with John Ruskin that " the youth who has once learned to take a straight shaving off a plank, or to draw a fine curve without faltering, or to lay a brick level in its mortar, has learned a multitude of other matters which no lips of man could ever teach him?" In other words, to what extent does the conviction pervade the ranks of the fraternity of teachers, whether of public - schools, private schools, colleges, or universities, that the employment of the hands in the useful arts is more highly educative than the acquisition of the rules of reading, writing, and arithmetic? Or, considering the subject of the history and career of George Stephenson, for instance, what, in the opinion of the modern school - master, contributed most to his development as a man and citizen of the world — the mental exercise of learning to read, write, and cipher, which task he accomplished while engaged in inventing the locomotive, or the combined mental and manual exercise of taking apart, repairing, and put-

ting together the stationary engine used at the colliery where he was employed? If, in the course of our investigation, it should be found that doing things as Stephenson did is more conducive to intellectual development than memorizing words and reciting poetry, as the Greeks did, some light may be thrown on the general subject of existing educational methods. Their chief defect is their lack of moral power. Morality does not reside in the letters of the alphabet, but there is in the locomotive, for example, a great moral principle —the principle of the brotherhood of man. For, in devising the locomotive, Stephenson made man's neighborhood coterminous with earth's utmost bounds; thus, in a single act, achieving his own apotheosis, and assuring, ultimately, the moral and intellectual kinship of the race. For the hand stands for use, for service, and for unyielding integrity; and it may be confidently asserted on the conviction of observation, experience, and a studious consideration of historic facts, that its drill and discipline as enforced in the world's workshops, and in the best of existing Manual-training schools, results in a far greater degree of mind development than is produced by any exclusively academic course, and hence that Manual Training is the most important of all methods of education.

The most sacred of human rights is the right of the poor child, born in a highly civilized, wealthy community, to the same kind and degree of education as that received by the child of the most opulent citizen.

It was long ago remarked that "the inequalities of intellect, like the inequalities of the surface of our globe, bear so small a proportion to the mass that in calculating its great revolutions they may safely be neglected;"

and the late Henry George declared that the differences in men, intellectually, are no greater than their physical differences.

The perpetuity of free institutions depends upon social not less than upon political equality. But social equality is impossible without educational equality: the very thought of intimate relations with the ignorant is repulsive to the learned. Education, impartial and universal, is, therefore, the sole guarantee of an ideal civilization, and so of an imperishable state.

Old social evils constantly recur because the old crime of inequality in education is forever and ever repeated. It follows that we shall make all things equal through equal education. But what sort of education? We shall not train the child, as the ancients did, "to dispute in learned phrase as to whether we can be certain that we are certain of nothing!" Nor shall we stuff his memory with the grammar and rhetoric of an ancient tongue, in view of the profound observation of Dr. Draper, that a living thought can no more be embodied in a dead language than activity can be imparted to a corpse. But we shall rather instruct him in the principles of the Baconian philosophy, of which Macaulay so aptly says: "Its characteristic distinction, its essential spirit, is its majestic humility—the persuasion that nothing can be too insignificant for the attention of the wisest which is not too insignificant to give pleasure or pain to the meanest."

The end sought in education by the ancients was ornament, and its strict analogy is found in barbaric life. Spencer has pointed out that the savage smeared his body with yellow ochre before he covered it with clothes, and that he adorned his head with feathers be-

fore he built a hut. So, under the laws of evolution, before a Bacon could arise, whole generations of philosophers were born, lived, speculated, and died, without leaving to mankind the smallest heritage of that common sense by which we nevertheless live.

A philosophy which scorned the useful in all its aspects was essentially barbaric; for art differentiates civilized from savage life: its law was stagnation, as the law of scientific investigation is progress. Use is the greatest thing in the material world, as service is the greatest thing in the moral world; and they are united in the philosophy of Bacon, which, beginning in observation and ending in art, multiplies useful things that are beautiful, and beautiful things that are useful.

The old education was an outgrowth of the old philosophy; the new education springs as logically from the new, or Baconian, philosophy. The old education was ornamental; the new is scientific, or useful. The old education was designed to make masters; the new is designed to make men.

President Eliot, of Harvard University, admits that his method of education is to compel the student to work. On the other hand, the method of the new education is to attract him. Genius has many definitions, one of which is "a capacity for taking infinite pains." But its humblest equivalent is "attention"; and we propose to secure the student's attention through his hands: for the most significant fact in all the realm of certitude is the fact that man impresses himself upon nature through the hand alone!

Let us then, in the new school, unite mind and hand in a crusade after the truths that are hidden in things. *For* Manual Training, educationally, is the blending of

thought and action. The thought that does not lead to an act is both mentally and materially barren. For as it confers no benefit upon the human race, neither does it profit the mind that conceives it. Nay, more. An unprolific thought exhausts the mind to no purpose, as an unfruitful tree cumbers the ground. It follows that the integrity of the mind can be maintained only by the submission of its immature judgments to the verification of things. Hence the correlation of thoughts and things is as necessary to mental and moral growth as the application of the principles of abstract mechanics to the arts of peace is essential to human progress.

Sir Henry Maine supports this doctrine in a graphic paragraph: "Unchecked by external truth the mind of man has a fatal facility for ensnaring and entrapping and entangling itself. But happily, happily for the human race, some fragment of physical speculation has been built into every false system."

Things are the source of ideas. Action generates thought. He who has tools in his hand thinks best as well as acts best. The man whose finger is on Nature's pulse feels her heart-throbs, and so discovers and utilizes her secrets. The men and women who do the world's work are better educated than the schoolmen who vainly tell them how to do it; and they are better educated because they are in closer relationship with things, through the supreme sense of touch, which refines and spiritualizes the hand—that wonderful member which differentiates man from the other animals, and makes him their master.

Manual Training educationally, then, relates to all the arts whose sum is the art of living. For whether it be the chair on which we sit; or the bed on which we lie;

or the garments we wear; or the house that shelters us; or the railway train on which we cross continents; or the ship that takes us over seas; or the unspeakable marvels of the world's museums and galleries upon which we gaze with rapture; or the orchestra of an hundred instruments, whose music enchants us; or the treasures of dead cities—long buried—now unearthed; or the temples in which we worship; or the monuments which commemorate our heroes and martyrs; or the tombs in which we moulder away to dust—they are all the work of the hand!

Manual Training is the acquisition by the hand of the arts through which man expresses himself in things. It is a series of educational generalizations in things. The purpose of it is to put the mind and hand *en rapport* with each other; to make the hand acquainted with the elementary manipulations of the typical arts, by actual exercises, as the mind is familiarized with the fundamental principles of the sciences by studying their laws.

Superior observation is only another name for genius. To the dull eye the falling apple taught no lesson, but to Newton's quick apprehension it revealed the law of gravitation!

It is not alone, however, in the sense of sight that observation resides; nor is it keenest there. We have recently learned the value of object teaching; but we have yet to learn, popularly and practically, what has long been known to science—that the sense of touch is the master sense, whence all the other senses spring. It is because of this fact, and of the further fact that the sense of touch is most highly developed in the hand, that man is the wisest of animals.

It follows that more than in the sense of seeing, hear-

ing, tasting, or smelling — nay, more than in all these senses combined—the faculty of observation resides in the hand.

Dr. Wilson declares that touch "reigns throughout the body, and is the token of life in every part"; and Dr. Maudsley says: "It is the fundamental sense, the mother-tongue of language."

How apt is this definition of the sense of touch—"the token of life in every part"—and how comprehensive this—" the mother-tongue of language!" And of this master sense the hand is the chief organ and minister. How versatile it is; what adaptability it possesses; what helpfulness! In the moment of danger how reassuring its supporting grasp; how consoling its gentle touch when grief overwhelms! In defeat how it trembles with emotion, and how tense with exaltation it becomes in the hour of victory! With what infinite loathing it shrinks from a hated contact, and with what sympathetic vibrations of ardor responds to the clinging pressure of love!

If we would become familiar with objects we must subject them to the test of touch, we must handle them. As Robert Seidel, a great teacher, well says: " We must stretch them, beat them, cool them, expose them to the sun, the water, the air—we must work them."

It is through these processes of loving manipulation that the mechanic and the artisan transform things crude and ugly into forms of use and beauty. And it is in this way, and this way only, that man has trod the path of progress. It is a rugged road, whose steeps are to be climbed alone by those whose hearts are warm with holy zeal, whose souls are aglow with enthusiasm, and whose hands are endowed with the rich experiences of thought-

ful toil. And we shall fit all mankind for this noble
task by training them to usefulness—that is, by teaching
them, not merely how to think, but how to act, how to
work.

It is a broad and conclusive generalization of Herbert
Spencer that since literature and the fine arts are made
possible by the useful arts, manifestly that which is made
possible must be postponed to that which makes it possi-
ble. Nor does this rational and sober view of art detract
in the least from its dignity or sentiment. On the con-
trary, it provides a foundation for works of the imagina-
tion—a basis for that spirituality which is the fruit of the
happy conjunction of a multitude of material conditions
evolved from the humblest as well as the noblest of the
useful arts — a basis without which the beautiful arts
could never exist.

It thus becomes plain that social and economic condi-
tions are the product of education in things. Art edu-
cation differentiates the civilized from the savage man.
The pathway of progress which now blazes with the
glory of electricity stretches back to the gloom of the
caves where our early ancestors dwelt; and the steps of
this advance consist of improvements in the useful and
beautiful arts. From gesture to speech; from pictures
to types; from the canoe to the steamship, and from the
canal to the locomotive, the race has moved forward,
always and only, through art triumphs.

So all the generations of men have lived and toiled
for us. We are the heirs of the hoarded learning, of the
accumulated mental and moral fibre, and of the treasured
arts of the ages. And we are hence the elders, as Bacon
says, of the philosophers, the sages, and the inventors
and discoverers of all time. Their achievements are

heights whence we may discern and occupy new and wider fields of human endeavor.

The precise relation of the useful arts to social and economic conditions is, therefore, that of creator. As your art education is, so shall your society be. There are persons who unconsciously dissociate art and civilization—who think that things are not essential to spiritual development, who fail to realize the fact that the main reason of the barbaric character of the savage is the absence from his environment of the arts of peace and plenty. If, for example, Plato had not been provided with food and clothing and shelter, he would doubtless not have composed the divine dialogues; and if there had been neither mechanics, nor architects, nor sculptors to adorn with palaces and temples the Greek cities, his ideal republic would not have had a place in classic literature; and finally, if there had been no (slave) hand-workers in Greece (for art products are all, directly or indirectly, the work of the hand), instead of being the most venerated of philosophers, Plato might have been, perhaps, the most wretched of savages, prolonging a miserable existence by means the most inglorious. But so unconscious was he of the true relation of the useful arts to life that he denounced them all as "degrading"!

Poverty is the chief scourge of society; and it is a familiar economic fact that where the useful arts are most flourishing poverty is least pressing, so that to abolish poverty it would seem to be only necessary to multiply and extend the arts. And if poverty is to be abolished; if there is ever to be an ideal civilization, the controlling motive of humanity must be changed from selfishness to altruism; and this change can come only

through love of work. So long as work shall be regarded
as a "curse," the paramount purpose of the individual
will be to avoid it, and to compel others to submit to it.
Hence the antagonisms that arise at every point of human
contact. The sum of these antagonisms is what we call
the struggle of life, which is merely the struggle of each
to survive at the expense of his fellows, and is therefore
barbaric.

Now as we have seen that it is through the arts that
man has been civilized—that, in a word, the arts differen-
tiate the civilized from the savage man—it is evident that
the further regeneration of the race is to be wrought by
analogous means—that is to say, by a wider expansion of
the arts of peace. And the way to achieve this result is
to transform our schools, which were modelled after the
classic methods of Greece and Rome, into laboratories
for the development of useful men and women, through
the mastery of the useful arts; the arts that make life
sweet and beautiful; the arts that adorn our homes, that
render the earth fertile and make it blossom as the rose;
the arts that annihilate distance and so promote man's
brotherhood by enlarging his neighborhood—these are
the arts that inspire us with just and generous impulses,
the arts in which the noblest moral sentiments are made
manifest in things.

These, then, are the arts which ought to be made the
subject of thorough and exhaustive education—the arts
that led Comenius to define schools as the workshops of
humanity. The final essential educational condition is
universality; for it is obvious that inequality of educa-
tional opportunity is the grossest injustice of which organ-
ized society is capable. It is against this injustice that
Carlyle exclaims: "That there should one man die

ignorant, who had capacity for knowledge, this I call a tragedy, were it to happen more than twenty times in the minute."

This is indeed the tragedy of tragedies—the tragedy on the heels of which slavery stalks; in whose train caste rides in scornful state; in whose hideous shadow war waits to shed blood and spread pestilence and famine. All these are the satellites of ignorance, and hardly less of partial education than of total unenlightenment; and hence the only hope that civilization shall finally triumph over barbarism rests in universal, impartial, and scientific education.

The contrasts between the old and the new school methods pointed out in this chapter show along what lines educational progress is to be sought. The ideal school is to consist, not of one academic department, and a department of Manual Training, but of mental and manual exercises so related as to produce homogeneity.

The tabulations of facts which will be found in the Appendix show that a vast number of schools have been dedicated to the new education. If they are to be developed into ideal schools thousands of ideal teachers must devote themselves to the arduous task. Each school transformed from the dull routine of mediocrity to the vigor and elasticity which wait on development will cost the life of a hero. The school that has no hero to struggle for its salvation will surely languish and die. Every great school of the future must therefore have its hero, for it is only the hero who toils without thought of reward. As Carlyle so well says: "The wages of every noble work do yet lie in heaven or else nowhere." And he has left this message of advice and encouragement to

the hero of the school of the future which is to revolu-
tionize the world: "Thou wilt never sell thy life in a
satisfactory manner. Give it like a royal heart; let the
price be nothing: thou hast then, in a certain sense, got
all for it!"

APPENDIX

STATISTICS.—MANUAL TRAINING, 1883–1898, IN THE UNITED STATES

MANUAL TRAINING IN PUBLIC HIGH-SCHOOLS

Name of School	City or Town	State	Manual Training Established	Teachers of Manual Training	Pupils Taking Manual Training
High-school	Peru	Ill.	1883	2	41
Polytechnic High-school	Baltimore	Md.	1883	16	674
High-school	Eau Claire	Wis.	1884	1	50
Central Manual-training School	Philadelphia	Penn.	1885	13	406
Industrial Training High-school	Indianapolis	Ind.	1885	10	676
Rochester Free Academy	Rochester	N. Y.	1885	..	908
High-school	Toledo	Ohio	1885	11	394
Central Manual-training School	Cleveland	Ohio	1885	4	200
Central High-school	Washington	D. C.	1886	..	235
Manual-training High-school	New Haven	Conn.	1886	13	..
Manual-training School	Springfield	Mass.	1886	3	34
High-school	Minneapolis	Minn.	1886	4	375
Newburg Free Academy	Newburg	N. Y.	1886	2	138
Manual-training School	Galesburg	Ill.	1887	1	74
High-school	St. Paul	Minn.	1887	5	350
Manual-training High-school	Stillwater	Minn.	1887	1	12
High-school	Jamestown	N. Y.	1887	1	48
Central High-school	Easton	Del.	1888
High-school	Easton	Md.	1888
Ridge Manual-training School	Cambridge	Mass.	1888	9	178
High-school	Concord	N. H.	1888	4	52
Orange High-school	Orange	N. J.	1888	3	180
High-school	Albany	N. Y.	1888	3	750
Dist. 20 Central High-school	Pueblo	Col.	1889	1	160
Manual-training High-school	Davenport	Iowa	1889	1	82
West Des Moines High-school	Des Moines	Iowa	1889	1	50
Manual-training High-school	Fall River	Mass.	1889	1	62
High-school	Duluth	Minn.	1889	2	90
High-school	Omaha	Neb.	1889	..	100
High-school	Union	N. J.	1889	3	200
High-school	Westchester	Penn.	1889	4	240
English High and Manual-training School	Chicago	Ill.	1890	17	430
Manual-training High-school	Louisville	Ky.	1890	13	212
Approved High-school	Vineland	N. J.	1890	1	150
High-school	Passaic	N. J.	1890	2	53
High-school	South Orange	N. J.	1890	1	160
West Manual-training School	Cleveland	Ohio	1890	3	100

MANUAL TRAINING IN PUBLIC HIGH-SCHOOLS.—*Continued.*

NAME OF SCHOOL	CITY OR TOWN	STATE	Manual Training Established	Teachers of Manual Training	Pupils Taking Manual Training
East and West High-schools.............	Milwaukee	Wis.	1890	4	144
Norwich Free Academy................	Norwich	Conn.	1891	1	33
High-school......................	Waterbury	Conn.	1891	1	..
High-school......................	Springfield	Ill.	1891	1	20
Moline High-school.................	Moline	Ill.	1891	1	47
Manual-training High-school..........	Waltham	Mass.	1891	2	18
High-school......................	Bay City	Mich.	1891	*	*
Ridgewood High-school...............	Ridgewood	N. J.	1891	3	35
Manual-training High-school..........	Camden	N. J.	1891	3	150
Manual-training High-school..........	Seattle	Wash.	1891	2	70
High-school......................	Menominee	Wis.	1891	5	108
High-school......................	Bristol	Conn.	1892	1	30
Willard Hall High-school.............	Wilmington	Del.	1892	3	210
Fremont Manual-training School........	Fremont	Ohio	1892	1	60
North East Manual-training School......	Philadelphia	Penn.	1892	9	300
High-school......................	Norristown	Penn.	1892	2	200
Manual-training High-school..........	Providence	R. I.	1892	18	280
High-school......................	Spokane	Wash.	1892	3	85
Polytechnical High-school............	San Francisco	Cal.	1893	4	250
Manual-training High-school..........	Mason City	Iowa	1893	1	125
High-school......................	Manchester	N. H.	1893	1	12
High-school......................	Atlantic City	N. J.	1893	1	225
East Orange High-school.............	East Orange	N. J.	1893	3	125
Manual-training High-school..........	Denver	Col.	1894	..	400
High-school......................	Frankfort	Ky.	1894	2	100
Mechanics Arts High-school...........	Boston	Mass.	1894	11	324
Manual-training High-school..........	Brooklyn	N. Y.	1894	..	800
Washington High-school..............	Washington	Penn.	1894	..	27
Townsend Industrial School...........	Newport	R. I.	1894	2	25
Ryan High-school...................	Appleton	Wis.	1894	1	25
Manual-training School..............	Lowell	Mass.	1895	2	50
English High-school.................	Somerville	Mass.	1895	2	75
English and Classical High-school.......	Worcester	Mass.	1895	4	282
High-school......................	Medford	Mass.	1895	2	20
English High-school.................	Lynn	Mass.	1895	3	72
High-school......................	Lawrence	Mass.	1895	1	33
Rayen High-school..................	Youngstown	Ohio	1895	2	200
High-school......................	Fitchburg	Mass.	1896
High-school......................	Burlington	Wis.	1896
High-school......................	Los Angeles	Cal.	1896	6	315
High-school......................	Rockford	Ill.	1896	1	37
High-school......................	Florence	Wis.	1896	2	33
Brookline High-school...............	Brookline	Mass.	1896	1	40
High-school......................	Janesville	Wis.	1896	2	..
High-school......................	Malden	Mass.	1896	2	60
Hackley Manual-training School....'.....	Muskegon	Mich.	1896	4	850
Ishpeming Manual-training School.......	Ishpeming	Mich.	1896	1	75
Menominee Manual-training School......	Menominee	Mich.	1896	2	35
High-school......................	Summit	N. J.	1896	1	40
Barlow School of Industrial Art.........	Binghamton	N. Y.	1896	3	152
High-school......................	Syracuse	N. Y.	1896	2	300
High-school......................	Akron	Ohio	1896	2	100
Cross Creek School..................	Washington	Penn.	1896	1	24
High-school......................	Waupaca	Wis.	1897	1	40
High-school......................	Winnetka	Ill.	1897	2	5

* Abandoned temporarily for want of funds.

MANUAL TRAINING IN PUBLIC HIGH-SCHOOLS.—*Continued.*

NAME OF SCHOOL	CITY OR TOWN	STATE	Manual Training Established	Teachers of Manual Training	Pupils Taking Manual Training
High-school	Fond du Lac	Wis.	1897	1	50
Manual-training High-school	Kansas City	Mo.	1897	27	800
High-school	Oshkosh	Wis.	1897	3	250
Central and Martin Park High-schools	Buffalo	N. Y.	1897	1	50
High-school	Mayville	Wis.	1897	1	30
High-school	Red Bank	N. J.	1897	1	375
High-school	Hartford	Conn.	1898	4	140
Manual-training High school	Newark	N. J.	1898
Howard School	Wilmington	Del.	*	1	45
High-school	Iowa City	Iowa	*
High-school	Brockton	Mass.	*
High-school	South Omaha	Neb.	*
High-school	Stamford	Conn.	*
	101 Cities	23 States		320	15,942

* Date of establishment not reported.

MANUAL TRAINING IN PUBLIC SCHOOLS—GRAMMAR GRADES

CITY OR TOWN	STATE	Manual Training Established in Grammar Grades	Separate Manual-training Schools	Teachers of Manual Training	Pupils Taking Manual Training
Montclair	N. J.	1882	All	4	530
Peru	Ill.	1883	2	2	..
New Haven	Conn.	1884
Jamestown	N. Y.	1884	2	2	800
Eau Claire	Wis.	1884	1	..	100
Waltham	Mass.	1885	1	2	425
Rochester	N. Y.	1885	336
Toledo	Ohio	1885	11	11	2,257
Washington	D. C.	1896	40	43	9,452
Springfield	Mass.	1886	1	3	267
Boston	Mass.	1886	All	81	37,240
Newburg	N. Y.	1886	1	2	95
Tidioute	Penn.	1886
Beardstown	Ill.	1887	1	2	..
Easton	Del.	1888
Brookline	Mass.	1888	1	2	525
Winchester	Mass.	1888	1	2	408
Concord	N. H.	1888	2	4	492
Hoboken	N. J.	1888	6	6	1,229
Orange	N. J.	1888	5	3	842
New York	N. Y.	1888	37	32	10,187
Meadville	Penn.	1888	..	2	245
Wilmington	Del.	1889	1	..	

MANUAL TRAINING IN PUBLIC SCHOOLS.—*Continued.*

City or Town	State	Manual Training Established in Grammar Grades	Separate Manual-training Schools	Teachers of Manual Training	Pupils Taking Manual Training
Davenport	Iowa	1889	1	1	101
Vineland	N. J.	1889	All	1	500
Union	N. J.	1889	All	All	643
St. Louis	Mo.	1890	1*	5*	116*
Duluth	Minn.	1890	12	25	1,000
Passaic	N. J.	1890	..	2	152
Garfield	N J.	1890	1	2	550
Paterson	N. J.	1890	1	1	300
Ridgewood	N. J.	1890	..	4	208
Knoxville	Tenn.	1890
South Orange	N. J.	1890	1	1	500
Waterbury	Conn.	1891
Springfield	Ill.	1891	1	1	50
Moline	Ill.	1891	1	1	279
Salem	Mass.	1891	1	1	160
Northampton	Mass.	1891	1	1	909
Bay City	Mich.	1891	†	†	†
San Francisco	Cal.	1892	3	2	550
St. Paul	Minn.	1892	..	4	2,365
Camden	N J.	1892	..	4	4,000
Norristown	Penn	1892	2	3	1,439
Providence	R. I.	1892	13
Menominee	Wis.	1892	2	4	200
Bristol	Conn.	1893	2	..	276
Haverhill	Mass.	1893	1	1	290
Manistee	Mich.	1893
Minneapolis	Minn.	1893	5	5	1,214
St. Cloud	Minn.	1893	1	1	150
Manchester	N. H.	1893	All	1	196
Bayonne	N. J.	1893	All	All	All
East Orange	N. J	1893	All	2	755
Cleveland	Ohio	1893	2	1	3,500
Newport	R. I.	1893	..	4	658
Staunton	Va.	1893	..	1	200
Santa Barbara	Cal	1894	1	2	383
San Diego	Cal.	1894	5	1	370
Portland	Maine	1894	1	3	500
Medford	Mass.	1894	1	3	400
New Bedford	Mass.	1894	1	1	400
Ithaca	N. Y.	1894	2	2	420
Mason City	Iowa	1894	1	1	50
Denver	Colo.	1895	All	..	2,800
Chicago	Ill.	1895	28	39	8,300
Cape May	N J.	1895	All	3	411
Fitchburg	Mass.	1895
Buffalo	N Y.	1895	..	1	368
Pittsburg	Penn.	1895	3	2	400
Barbadoes Township	N. J.	1895	3	8	700
Woonsocket	R. I.	1895	..	1	500
Oakland	Cal.	1896	1	1	200
Carlstadt	N. J.	1896	All	5	300
Los Angeles	Cal.	1896	7	..	2,000
Summit	N. J.	1896	3	3	400
Hartford	Conn.	1896	All	3	500
Des Moines	Iowa	1896	2	2	300

* Colored School. † Abandoned temporarily for want of funds.

MANUAL TRAINING IN PUBLIC SCHOOLS.—*Continued.*

CITY OR TOWN	STATE	Manual Training Established in Grammar Grades	Separate Manual-training Schools	Teachers of Manual Training	Pupils Taking Manual Training
Florence....................	Wis.	1896	1
Menominee.................	Mich.	1896	1	1	80
Brooklyn...................	N. Y.	1896
Glens Falls................	N. Y.	1896	1	1	60
Utica......................	N. Y.	1896	..	4	2,300
Akron.....................	Ohio	1896	..	2	210
Washington................	Penn.	1896	5	3	112
Pueblo Dist. No. 1.........	Colo.	1897	..	2	180
Winnetka..................	Ill.	1897	1	1	48
Oshkosh...................	Wis.	1897	25	28	1,400
Indianapolis...............	Ind.	1897	1	2	1,000
North Adams..............	Mass.	1897	1	1	247
Lynn......................	Mass.	1897	1	1	351
Newton....................	Mass.	1897	1	1	135
Worcester.................	Mass.	1897	..	2	397
Cambridge.................	Mass.	1897	1	2	136
Muskegon.................	Mich.	1897	2	4	700
Kansas City	Mo.	1897
Newark....................	N. J.	1897	..	3	2,265
Milwaukee................	Wis.	1897	1	1	15
Pueblo Dist. No. 20	Colo.	1898	..	2	300
New Britain...............	Conn.	1898	190
Peabody...................	Mass.	1898
Moberly...................	Mo.	1898
Stockton	Cal.	*
Santa Cruz	Cal.	*
Manchester................	Conn.	*
Stamford..................	Conn.	*
Iowa City.................	Iowa	*
Augusta...................	Me.	*
Baltimore.................	Md.	*	All	..	All
Hyde Park................	Mass.	*	3	3	204
Holyoke...................	Mass.	*	1
Easton	Mass.	*
Fall River	Mass.	*
Dedham...................	Mass.	*
Malden....................	Mass.	*
Milton....................	Mass	*
Waterbury................	Mass.	*
Wellesley.................	Mass	*
Canton....................	Mass.	*
Richmond.................	Va.	*
119 Cities	24 States		287	444	118,835

* Date of establishment not reported.

MANUAL TRAINING IN PUBLIC SCHOOLS—PRIMARY GRADES

City or Town *	State	Manual Training Established in Primary Grades	Separate Manual Training Primary Grades	Teachers of Manual Training	Pupils Taking Manual Training
Montclair	N. J.	1882	All	All	1,047
Jamestown	N. Y.	1882	All	All	2,400
Baltimore	Md.	1884
Washington	D. C.	1886	55	..	12,900
Newburg	N. Y.	1886
Tidioute	Penn.	1886
Oakland	Cal.	1888	..	2	2,150
Springfield	Mass.	1888	All	..	29,256
Concord	N. H.	1888
Orange	N. J.	1888	4	3	2,122
New York	N. Y.	1888	12,600
Union	N. J.	1889	All	All	860
Vineland	N. J.	1889	All	1	709
Westchester	Penn.	1889	..	1	..
Garfield	N. J.	1890	..	1	260
South Orange	N. J.	1890	1	1	200
Waterbury	Conn.	1891	..	1	..
Moline	Ill.	1891
Northampton	Mass.	1891	..	1	900
Ridgewood	N. J.	1891	..	3	260
San Francisco	Cal.	1892	1	1	175
St. Paul	Minn.	1892	40	..	4,500
Camden	N. J.	1892	50	..	3,000
Providence	R. I.	1892	50
Bristol	Conn.	1893	2	2	144
Minneapolis	Minn.	1893	44	..	4,445
Stillwater	Minn.	1893
Cleveland	Ohio	1893	3,800
Staunton	Va.	1893	..	1	260
Menominee	Wis.	1893	..	2	290
St. Cloud	Minn.	1894	..	2	400
Phillipsburg	N. J.	1894	All	All	700
Elyria	Ohio	1894	All	All	900
Newport	R. I.	1894	..	2	104
Denver	Colo.	1895
Oshkosh	Wis.	1896	20	26	800
Waltham	Mass.	1896	200
Carlstadt	N. J.	1896	All	5	..
Utica	N. Y.	1896
Akron	Ohio	1896	All	All	1,800
San Diego	Cal.	1897	5	3	250
Newark	N. J.	1897
Indianapolis	Ind.	1897	..	2	800
Moberly	Mo.	1897
Passaic	N. J.	1897	..	1	375
Pueblo Dist. No. 1	Colo.	1896	..	1	120

* Of the 51 cities tabulated, only 9 report the number of separate primary schools in which Manual Training is taught. These 9 cities report 202 schools, or an average of 22.4 schools per city. Nine cities report all. Thirty-four cities do not report. If the average obtained from the cities reporting can be applied to all, then 1120 primary schools have Manual Training. Thirty-one cities do not report the number of teachers. Twenty cities report 34. Applying the above method shows 85 teachers of Manual Training in primary schools. It must be remembered that there are special or supervising teachers; the regular teachers doing most of this work under supervision. Thirty-two cities report 87,596 pupils taking Primary Manual Training; or 2737 on the average to each city reporting. Applying this average to the 51 cities reporting, the total is 139,587.

MANUAL TRAINING IN PUBLIC SCHOOLS—*Continued*.

CITY OR TOWN	STATE	Manual Training Established in Primary Grades	Separate Manual Training Primary Grades	Teachers of Manual Training	Pupils Taking Manual Training
Santa Cruz	Cal.
Elgin	Ill.	1	..
Augusta	Me.
Detroit	Mich.
Toledo	Ohio
Pittsburg	Penn.
Shenandoah	Penn.
La Crosse	Wis.
54 Cities	20 States		222	62	88,398

KINDERGARTENS IN PUBLIC SCHOOLS

CITY OR TOWN	STATE	Kindergarten Established	Separate Kindergartens	Kindergarten Teachers	Kindergarten Pupils
St. Louis	Mo.	1873	60	400	7,694
Milwaukee	Wis.	1880	42	83	3,816
Cedar Rapids	Iowa	1881	12	16	766
Newport	R. I.	1882	4	8	250
Lowell	Mass.	1883	12	25	400
Pawtucket	R. I.	1883	4	9	295
La Porte	Ind.	1884	3	5	163
Muskegon	Mich.	1884	8	10	581
Philadelphia	Penn.	1884	135	180	6,500
Traverse City	Mich.	1885	4	4	180
San José	Cal.	1885	7	17	337
Augusta	Ga.	1887	4	8	183
Des Moines	Iowa	1887	14	28	807
Marshalltown	Iowa	1887	7	10	260
Louisville	Ky.	1887	10	59	750
Albany	N. Y.	1887	19	30	750
Boston	Mass.	1888	67	126	3,925
Brookline	Mass.	1888	11	18	373
Rochester	N. Y.	1888	13	68	1,972
Sheboygan	Wis.	1888	9	27	980
Bristol	Conn.	1889	3	7	253
Richmond	Ind.	1889	2	2	75
Cambridge	Mass.	1889	11	22	583
Grand Rapids	Mich.	1889	8	7	352
Montclair	N. J.	1889	5	12	273
Louisburg	N. Y.	1889	5	10	165
North Tonawanda	N. Y.	1889	4	4	200
Norwich	Conn.	1890	3	7	120
Lexington	Ky.	1890	5	10	360
Grand Haven	Mich.	1890	1	3	105
Garfield	N. J.	1890	2	2	80
East Orange	N. J.	1890	6	6	180
South Orange	N. J.	1890	1	2	55
Providence	R. I.	1890	15	31	700

KINDERGARTENS IN PUBLIC SCHOOLS—*Continued.*

CITY OR TOWN	STATE	Kindergarten Established	Separate Kindergartens	Kindergarten Teachers	Kindergarten Pupils
Los Angeles	Cal.	1891	29	78	1,800
Covington	Ky.	1891	5	10	600
Frankfort	Ky.	1891	1	2	80
Somerville	Mass.	1891	5	11	200
Iron Mountain	Mich.	1891	11	11	586
Ironwood	Mich.	1891	3	9	290
Negaunee	Mich.	1891	2	2	78
Concord	N. H.	1891	5	7	286
Passaic	N. J.	1891	6	8	284
Greenwich	Conn.	1892	1	1	82
Terre Haute	Ind.	1892	16	11	425
Worcester	Mass.	1892	10	19	518
Lowell	Mass.	1892	12	26	900
Duluth	Minn.	1892	16	27	1,000
Omaha	Neb.	1892	26	40	1,600
Plainfield	N. J.	1892	5	5	230
Utica	N. Y.	1892	11	26	750
Cohoes	N. Y.	1892	2	4	127
Niagara Falls	N. Y.	1892	4	6	156
San Diego	Cal.	1893	6	6	260
Denver	Colo.	1893	25	50	2,534
Chicago	Ill.	1893	51	121	2,500
Newton	Mass.	1893	13	29	569
Lincoln	Neb.	1893	8	22	700
Menominee	Mich.	1893	5	5	380
Kansas City	Mo.	1893	5	5	200
Ridgewood	N. J.	1893	1	2	75
Union	N. J.	1893	2	3	120
Saratoga Springs	N. Y.	1893	9	24	500
Flushing	N. Y.	1893	3	4	60
New Rochelle	N. Y.	1893	5	7	475
El Paso	Tex.	1893	1	3	100
Burlington	Vt.	1893	4	8	157
Racine	Wis.	1893	6	11	573
Fond du Lac	Wis.	1894	5	11	390
Hammond	Ind.	1894	1	2	60
Oskaloosa	Iowa	1894	5	5	230
Sioux City	Iowa	1894	3	6	221
Springfield	Mass.	1894	8	17	366
Peabody	Mass.	1894	3	6	138
Medford	Mass.	1894	4	8	260
Superior	Wis.	1894	5	11	385
Lawrence	Mass.	1894	1	2	88
Escanaba	Mich.	1894	4	4	165
Winona	Minn.	1894	8	13	385
Natchez	Miss.	1894	1	1	150
Portsmouth	N. H.	1894	4	6	220
Binghamton	N. Y.	1894	13	14	660
Geneva	N. Y.	1894	4	5	200
Sing Sing	N. Y.	1894	3	3	91
Wilkesbarre	Penn.	1894	2	2	80
Marinette	Wis.	1894	5	5	200
La Crosse	Wis.	1894	3	3	200
Madison	Wis.	1894	2	2	134
Oakland	Cal.	1895	1	1	60
Jeffersonville	Ind.	1895	7	7	200
Burlington	Iowa	1895	5	5	200
North Adams	Mass.	1895	3	3	120

KINDERGARTENS IN PUBLIC SCHOOLS—*Concluded.*

City or Town	State	Kindergarten Established	Separate Kindergartens	Kindergarten Teachers	Kindergarten Pupils
Vicksburg	Miss.	1895	4	5	180
Fremont	Ohio	1895	.3	5	160
Oshkosh	Wis.	1896	9	25	800
Winnetka	Ill.	1896	1	5	57
Indianapolis	Ind.	1896	1	1	53
Dubuque	Iowa	1896	4	8	232
Malden	Mass.	1896	2	5	85
Northampton	Mass.	1896	2	4	90
Ishpeming	Mich.	1896	2	6	300
Detroit	Mich.	1896	6	12	91
Nashua	N. H.	1896	2	4	120
Syracuse	N. Y.	1896	2	4	97
Mt. Vernon	N. Y.	1896	2	2	30
Cleveland	Ohio	1896	12	24	500
Stevens Point	Wis.	1896	4	5	180
New Bedford	Mass.	1897	3	6	140
Walden	Mass.	1897	1	2	40
Newark	N. J.	1897	26	50	2,100
Hoboken	N. J.	1897	7	15	365
Bayonne	N. J.	1897	*	*	*
Brooklyn	N. Y.	1897	14	28	..
Woonsocket	R. I.	1897	1	2	30
Pueblo	Colo.	1898	1	2	65
Akron	Ohio	1898	1	3	30
Seattle	Wash.	1898	1	2	51
Appleton	Wis.	1898	4	8	200
Anniston	Ala.	..	2	..	122
Hot Springs	Ark.	..	1	1	16
Sacramento	Cal.	..	4	8	172
Santa Cruz	Cal.	..	1	2	53
Manchester	Conn.	..	1	8	210
New Britain	Conn.	..	6	13	410
New Haven	Conn.	..	8	19	676
Hartford	Conn.	..	12	138	1,326
Norwalk	Conn.	..	3	6	95
Rockville	Conn.	..	1	1	..
Willimantic	Conn.	..	2	6	229
Rome	Ga.	..	1	1	16
Evanston	Ill.	..	2	6	100
Augusta	Me.	..	1	1	..
Portland	Me.	..	6	10	125
Fall River	Mass.	..	2	4	202
Sault Ste. Marie	Mich.	..	3	5	300
St. Paul	Minn.	..	28	57	..
Trenton	N. J.	..	1	1	65
Paterson	N. J.	..	15	17	500
† Buffalo	N. Y.	..	10	15	925
Gloversville	N. Y.	..	4	4	411
New York	N. Y.	..	15	16	571
Schenectady	N. Y.	..	1	2	40
Newark	Ohio	..	2	3	33
Pittsburg	Penn.	..	16	48	800
Oil City	Penn.	..	2	2	104
Allegheny	Penn.	..	3	12	120
146 Cities	**26 States**	..	1,202	2,695	7,3,543

* All first-grade schools have kindergartens. † Kindergartens are conducted by a private association financially assisted from public-school funds.

APPENDIX

MANUAL TRAINING IN SCHOOLS FOR THE COLORED RACE

Name of Institution	Location	Grade of Academic Work	Manual Training Established	Teachers of Manual Training	Pupils Taking Manual Training
Storrs School	Atlanta, Ga.	Grammar	1865	..	120
Shaw University	Raleigh, N. C.	Collegiate	1865	6	216
Storer College	Harper's Ferry, W. V.	High	1867	9	121
Hampton Normal Institute	Hampton, Va.	Gram. and High	1868	48	668
Mt. Hermon Female Seminary	Clinton, Miss.	High	1875	3	16
Southland Col. and Normal Inst.	Southland, Ark.	Primary to Coll.	1876	..	56
Princess Anne Academy	Princess Anne, Md.	High	1878	7	101
Colored Industrial School	Huntsville, Ala.	High	1879	4	150
Knoxville College	Knoxville, Tenn.	Gram. and High	1879	4	125
Penn Normal and Ind. School	Frogmore, S. C.	High	1880	3	164
State Colored Normal School	Salisbury, N. C.	Gram. and High	1881	4	118
Allen University	Columbia, S. C.	Primary to Coll.	1881	4	333
Tuskegee Nor. and Ind. Institute	Tuskegee, Ala.	Gram. and High	1882	..	661
Tougaloo University	Tougaloo, Miss.	Primary to Coll.	1882	..	175
Albion Academy	Franklinton, N. C.	High	1882	5	100
Spelman Seminary	Atlanta, Ga.	Gram. and High	1883	16	375
Ballard Normal and Ind. School	Macon, Ga.	Gram. and High	1883	12	415
Scotia Seminary	Concord, N. C.	Gram. and High	1883	16	366
Central Tennessee College	Nashville, Tenn.	Gram. to Coll.	1884	7	108
Hartshorn Memorial College	Richmond, Va.	High	1884	8	108
Biddle University	Charlotte, N. C.	Gram. to Coll.	1885	6	136
Fisk University	Nashville, Tenn.	Gram. and High	1888	4	275
Roger Williams University	Nashville, Tenn.	High and Coll.	1885	1	68
Paul Quinn College	Waco, Tex.	High	1885	3	31
Norfolk Mission College	Norfolk, Va.	1886	2	320
Howard University	Washington, D. C.	1887	6	189
Colored Public Schools	Jacksonville, Fla.	Prim. to Gram.	1887
Straight University	New Orleans, La.	High	1887	3	50
Wilberforce University	Wilberforce, Ohio.	Gram. and High	1888	7	133
Mary Allen Seminary	Crockett, Tex.	Gram. and High	1888	..	445
Virginia Institute	Petersburg, Va.	High	1888	5	399
Scofield Industrial School	Aiken, S. C.	Grammar	1889	6	155
Institute for Colored Youth	Philadelphia, Penn.	High and Norm.	1889	9	299
Burrell Academy	Selma, Ala.	Grammar	1890	6	298
Emerson Mem. Home School	Ocala, Fla.	Gram. and High	1890	2	30
State Normal and Ind. College	Tallahassee, Fla.	High	1890	1	27
State Nor. School for Col. Persons	Frankfort, Ky.	High	1890	3	96
Southern University	New Orleans, La.	Gram. to Coll.	1890	5	107
Alcon Agr. and Mech. College	West Side, Miss.	Collegiate	1890	5	396
State Normal School	Goldsboro, N. C.	High	1890	4	163
Lincoln Academy	King's Mount'n, N. C.	Gram. and High	1890	6	186
St. Augustine School	Raleigh, N. C.	Gram. to Coll.	1890	4	96
Lincoln Academy	Jefferson City, Mo.	High	1891	8	400
Arkansas Industrial University	Pine Bluff, Ark.	High	1892	6	62
Berea College	Berea, Ky.	High and Coll.	1892	3	86
Colored Industrial School	Bordentown, N. J.	Gram. and High	1892	6	74
Bishop College	Marshall, Tex.	Gram. and High	1893	5	176
Brewer Normal School	Greenwood, S. C.	Gram. and High	1893	6	101
Hearne Academy	Hearne, Tex.	High	1893	5	95
Shorter University	Arkadelphia, Ark.	Gram. and High	1894	5	91
Knox Institute	Athens, Ga.	Gram. and High	1894	5	96
Walker Baptist Institute	Augusta, Ga.	High	1894	4	98
Chandler Normal School	Lexington, Ky.	Gram. and High	1894	4	52
Washburn Seminary	Beaufort, N. C.	Gram. and High	1894	4	62
State Col'd Nor. and Ind. School	Normal, Ala.	High	36	...
Cookman Institute	Jacksonville, Fla.	High

MANUAL TRAINING IN SCHOOLS FOR THE COLORED RACE —
Concluded.

NAME OF INSTITUTION	LOCATION	Grade of Academic Work	Manual Training Established	Teachers of Manual Training	Pupils Taking Manual Training
Beach Institute...............	Savannah, Ga.	Gram. and High	7	55
Allen Industrial School........	Thomasville, Ga.	High	3	80
Leland University.............	New Orleans, La.	High and Coll.
New Orleans University	New Orleans, La.
Mississippi State Normal School	Holly Springs, Miss.	High	1	55
State Colored Normal School...	Elizabeth City, N. C.	High
Plymouth State Normal School.	Plymouth, N. C.	High
Rankin-Richards Institute.....	Orangeburg, S. C.	Gram. and High	20	454
Slater Training School.........	Knoxville, Tenn.	Gram. and High	*	1	25
Tillotson Institute.............	Austin, Tex.	4	55
Emerson Institute......... ...	Mobile, Ala.	Gram. and High
67 Manual-training Schools ...				327	10,332

* The date given is that of establishment of school. Date of establishment of Manual Training was not ascertained in these instances.

PRIVATE MANUAL-TRAINING SCHOOLS

NAME OF INSTITUTION	LOCATION	Grade of Academic Work	Date of Establishment	Teachers of Manual Training	Pupils
Massachusetts Inst. of Technology *	Boston, Mass.	High	1876
Penn. School of Industrial Arts	Philadelphia, Penn.	High	1876
Working-men's School.............	New York, N. Y.	Grammar	1878	19	353
Miller Manual-labor School.......	Crozet, Va.	High	1878	..	198
Washington University M. T. School	St. Louis, Mo.	High	1879	14	300
Girard College	Philadelphia, Penn.	Gram. and High	1882	11	650
Chicago Manual-training School ...	Chicago, Ill.	High	1883	13	263
Hebrew Technical Institute........	New York, N. Y.	Grammar	1883	11	254
M. T. School of Tulane University..	New Orleans, La.	High	1884	6	114
H. Mann School and Teachers' Coll.	New York, N. Y.	Primary to Coll.	1884	12	257
Halsh Manual-training School	Denver, Col.	1886	2	11
Pratt Institute..................	Brooklyn, N. Y.	High	1887	..	125
H. S. Newcom Memorial College....	New Orleans, La.	High and Coll.	1887
Sloyd Manual-training School......	Boston, Mass.	Normal	1889	3	104
Tyler School....................	Providence, R. I.	Gram. and High	1890	6	330
Jewish Training School..........	Chicago, Ill	Prim. and Gram.	1890	27	700
National University..............	Chicago, Ill.	1890	5	500

* The Massachusetts Institute of Technology was established in 1865 ; but in 1876 it adopted Manual Training as a system into all its grades, and thus became the first distinctive Manual-training School without prejudice to its high standing as an Institute of Technology.

PRIVATE MANUAL-TRAINING SCHOOLS.—*Concluded*.

Name of Institution	Location	Grade of Academic Work	Date of Establishment	Teachers of Manual Training	Pupils
Miss Sayer's School	Newport, R. I.	Gram. and High	1891	2	20
Swedenborgian School	Waltham, Mass.	Grammar	1891	1	60
Thorp Polytechnic Institute	Pasadena, Cal.	Gram. to Coll.	1892	8	308
Friends' Select School	Philadelphia, Penn.	High	1892	..	122
Providence Training School for Sloyd	Providence, R. I.	Normal	1893	1	49
Plainfield Academy	Plainfield, N. J.	Prim. to High	1893	2	25
California School of Mechanical Arts	San Francisco, Cal.	High	1895	7	310
St. Andrew's	Rochester, N. Y	High	1895	1	60
Lewis Institute	Chicago, Ill.	High and Coll.	1896	10	200
Free Industrial School	San Diego, Cal.	Gram. and High	1896	2	80
Commons Manual-training School	Chicago, Ill.	Grammar	1896	1	40
Hull House Manual-training School	Chicago, Ill.	Gram. and High	1897	3	70
Elmwood School	Buffalo, N. Y.
Franklin School	Buffalo, N. Y.
Lasell Seminary	Auburndale, Mass.
Talladega College	Talladega, Ala.
Kenilworth Academy	Kenilworth, Ill.
Y. M. C. A. Manual-training Dep't.	Hartford, Conn.
Clark University	Atlanta, Ga.
Private Manual-training Class	Winnetka, Ill.

MANUAL TRAINING IN PUBLIC NORMAL SCHOOLS

Name of School	Location	Manual Training Established	Teachers of Manual Training	Pupils Taking Manual Training
Santee Normal Training School	Santee Agency, Neb.	1870	12	72
Cook County Normal School *	Chicago, Ill.	1882	..	450
State Normal School	Whitewater, Wis.	1883	2	100
State Normal Training School	New Britain, Conn.	1884	5	
Industrial Institute and College	Columbus, Miss.	1885	1	
West Chester State Normal School	West Chester, Penn.	1889	2	
State Normal School	San José, Cal.	1890	3	
Georgia Normal and Industrial College	Milledgeville, Ga.	1891	15	
State Normal and Model School	Trenton, N. J.	1891	1	
State Female Normal School	Farmville, Va.	1891	2	
Normal College of New York	New York, N. Y.	1892	13	
Normal and Industrial School	Greensboro, N. C.	1892	3	
Keystone State Normal School	Kutztown, Penn.	1893	2	
State Normal School	Framingham, Mass.	1893	1	
Westfield Normal School	Westfield, Mass.	1894	2	
State Normal School	Los Angeles, Cal.	1894	2	
Alabama Normal College for Girls	Livingston, Ala.	1	

* *The Cook County (Illinois) Normal School was originally established as a private school It is now the public training school for teachers in the public schools.*

PRIVATE TRADE SCHOOLS AND INSTITUTES OF TECHNOLOGY

NAME OF INSTITUTION	LOCATION	Date of Establishment	Teachers	Pupils
Rensselaer Polytechnic Institute	Troy, N. Y.	1824	18	...
Ohio Mechanics' Institute	Cincinnati, Ohio.	1828	..	720
Massachusetts Institute of Technology	Boston, Mass.	1865	6	222
Cornell University	Ithaca, N. Y.	1866	36	599
Worcester Polytechnic Institute	Worcester, Mass.	1868
Stevens Institute of Technology	Hoboken, N. J.	1871	22	266
Lowell School of Practical Designing	Boston, Mass.	1872	..	65
Rhode Island School of Design	Providence, R. I.	1878	..	341
Chicago College of Horology	Chicago, Ill.	1880
Case School of Applied Sciences	Cleveland, Ohio.	1881	11	...
School of Ind. Art and Tech. Design for Women	New York, N. Y.	1881
New York Trade School	New York, N. Y.	1881	26	566
Rose Polytechnic Institute	Terre Haute, Ind.	1882	6	...
*Textile Schools	Philadelphia, Penn.	1882	..	65
Milwaukee Cooking School	Milwaukee, Wis.	1884	2	...
Newark Technical School	Newark, N. J.	1885	6	260
Technical School of Cincinnati	Cincinnati, Ohio.	1886
Technical Drawing School	Providence, R. I.	1887
Cogswell Polytechnic School	San Francisco, Cal.	1888	7	150
Institute for Artisans	New York, N. Y.	1888
Watchmakers' Trade School	La Porte, Ind.	1888
Institute for Colored Youth	Philadelphia, Penn.	1889	9	259
Master-Builders' Mechanical School of Phil'a.	Philadelphia, Penn.	1890	6	87
Lawrence Scientific School of Harvard Univ'ty	Cambridge, Mass.	1891	3	64
Baron de Hirsch Trade School	New York, N. Y.	1891
†University of Cincinnati	Cincinnati, Ohio.	1891
Leland Stanford University	Palo Alto, Cal.	1891
Williamson Free School of Mechanical Trades	Williamson Schools, Pa.	1891	10	160
Springfield Industrial Institute	Springfield, Mass.	1891	5	105
Drexel Institute	Philadelphia, Penn.	1892	36	...
Armour Institute	Chicago, Ill.	1893	15	300
Mechanics' Institute	Rochester, N. Y.	1893	15	972
Private School of Carpentry	Racine, Wis.	1893	1	30
Lafayette College	Easton, Penn.
Vanderbilt University	Nashville, Tenn.
Boston Normal School of Cookery	Boston, Mass.

NOTE.—Private trade schools for teaching watch-making, some fifteen in number, are omitted, because no data was secured. Private cooking schools, dress-making schools, barber schools, etc., have within the last five years sprung up in various parts of the country. Some of these are of considerable importance, but most are small, and no effort has been made to secure reports from them.

* These schools are supported by both legislative appropriations and private endowments. They are not public schools in the usual sense of the term.

† The University of Cincinnati is supported by both public funds and private endowments. It is unique in this, that, although a university in its grade of work, it is essentially a part of the public-school system. The city collects a one-tenth mill tax annually for its benefit; and the university, including its technical and Manual-training course, is free to residents of the city. The necessary expenses, such as laboratory fees, are kept to the lowest possible limit; and every family in the municipality is entitled to educate its children in this thoroughly equipped university, practically without cost.

TECHNOLOGY IN PUBLIC EDUCATIONAL INSTITUTIONS OF COLLEGIATE GRADE—EXCLUSIVE OF PURELY AGRICULTURAL COLLEGES

Institution	Location	Technical Training Established	Teachers	Pupils
United States Naval Academy.............	Annapolis, Md.	1845
State Agricultural College.................	Agricultural College, Mich.	1857	14	332
Maine State College.....................	Orono, Me.	1864	13	191
University of Vermont....................	Burlington, Vt.	1865	11	119
Illinois University......................	Urbana, Ill.	1868
University of Minnesota..................	Minnesota, Minn.	1869	9	180
University of Tennessee..................	Knoxville, Tenn.	1869	6	180
University of Iowa.......................	Ames, Iowa.	1869	9	384
Kansas State Agricultural College.........	Manhattan, Kan.	1873	20	590
Ohio State University....................	Columbus, Ohio.	1873	9	373
University of California..................	Berkeley, Cal.	1874	3	84
*Purdue University......................	Lafayette, Ind.	1874	10	280
Agricultural and Mechanical College.......	College Station, Tex.	1876	16	313
State Agricultural College................	Fort Collins, Col.	1879	3	137
Agricultural and Mechanical College.......	Agricultural College, Miss.	1880	3	...
Agricultural and Mechanical College.......	Blacksburg, Va.	1880	13	190
Mechanical College of State University....	Baton Rouge, La.	1880	1	86
Storrs Agricultural College...............	Storrs, Conn.	1881	4	145
Agricultural and Mechanical College.......	Auburn, Ala.	1885	4	209
Arkansas Industrial University............	Fayetteville, Ark.	1885	7	160
Michigan Mining School..................	Houghton, Mich.	1886	11	62
Agricultural College of South Dakota......	Brookings, S. D.	1887	11	180
Florida Agricultural College..............	Lake City, Fla.	1888	9	62
Oregon State Agricultural College.........	Corvallis, Ore.	1888	9	257
Agricultural College of Utah.............	Logan, Utah.	1889	7	119
New Mexico College of Mechanical Arts....	Messilla Park, N. M.	1890
University of Michigan...................	Ann Arbor, Mich.	1890	6	...
Delaware College........................	Newark, Del.	1891	3	28
Agricultural and Mechanical Coll. of Kentucky	Lexington, Ky.	1891	3	81
State University........................	Columbia, Mo.	1891	2	144
College of Mining.......................	Rolla, Mo.	1891	7	228
University of Nebraska...................	Lincoln, Neb.	1891	3	210
Nevada State University..................	Reno, Nev.	1891	1	108
University of Wyoming...................	Laramie, Wy.	1891	4	60
North Dakota Agricultural College.........	Fargo, N. D.	1892	3	34
West Virginia University.................	Morgantown, W. Va.	1892	5	70
Clemson Agricultural College.............	Clemson College, S. C.	1893	9	625

* Purdue University is partially supported by endowment, but as it secures regular appropriations, it is here classified as a State University.

INDUSTRIAL TRAINING IN CHARITY SCHOOLS *

NAME OF SCHOOL	LOCATION	Industrial Training Established	Teachers of Industrial Training	Pupils Taking Industrial Training
Baltimore Manual-labor School	Arbutus, Md.	1841	2	60
Wilson Industrial School for Girls	New York, N. Y.	1853	3	100
Industrial Home School	Washington, D. C.	1867	6	60
McDonough School	McDonough, Md.	1873	5	140
South End Industrial School	Roxbury, Mass.	1884	21	313
Five Points House of Industry	New York, N. Y.	1885	9	331
Indiana Soldiers' Orphans' Home	Kingstown, Ind.	1885	7	80
Skyland Institute	Blowing Rock, N. C.	1886
Samuel Ready School for Female Orphans	Baltimore, Md.	1887	3	60
Chicago Waifs' Mission and Training School	Chicago, Ill.	1888	3	30
Industrial School Association	Brooklyn, N. Y.	1888	8	80
Kalamazoo Industrial School	Kalamazoo, Mich.	1889	18	224
Industrial School of Rochester	Rochester, N. Y.	1890	5	120
Industrial School for Boys	Glenwood, Ill.	1890	..	400
Jewish Orphan Asylum	Cleveland, Ohio.	1891	8	157
St. George's Boys' Industrial Trade School	New York, N. Y.	1892	6	259
Boys' Club in Carpentry	Lynn, Mass.	1895	1	25
Polish Orphans' Home	Chicago, Ill.
Unity Church Manual-training School	Chicago, Ill.
Iowa Orphans' Home	Davenport, Iowa.

* Industrial Training, rather than Manual Training, characterizes the Charity Schools, the central idea being to prepare the child for some occupation by which it can become self supporting. As will be seen by the table, this idea found very early expression in the Manual labor School at Arbutus, Maryland. The co-education of mind and hand, because of its equal, or greater, educational value, was not thought of in these charity institutions until recently, and cannot be said to obtain in any of them even now

26

PROGRESS OF MANUAL TRAINING BY YEARS, IN CITIES

The following table shows growth by years, as represented by cities establishing Manual Training or Kindergartens in Public Schools. The number refers to cities adopting this feature of education in the years named.

HIGH SCHOOLS		GRAMMAR GRADES		PRIMARY GRADES		KINDERGARTENS	
Year	Number of Cities	Year	Number of Cities	Year	Number of Cities	Year	Number of Cities
....	1873	1
....	1880	1
....	1881	1
....	..	1882	1	1882	2	1882	1
1883	2	1883	1	1883	0	1883	2
1884	1	1884	3	1884	1	1884	3
1885	5	1885	3	1885	0	1885	2
1886	5	1886	5	1886	3	1886	0
1887	4	1887	1	1887	0	1887	5
1888	6	1888	8	1888	5 .	1888	4
1889	8	1889	4	1889	3	1889	7
1890	7	1890	8	1890	2	1890	7
1891	10	1891	6	1891	4	1891	9
1892	7	1892	6	1892	4	1892	10
1893	5	1893	11	1893	6	1893	15
1894	7	1894	7	1894	4	1894	20
1895	8	1895	8	1895	1	1895	7
1896	15	1896	13	1896	5	1896	12
1897	8	1897	13	1897	5	1897	7
1898	2	1898	4	1898	1	1898	4
*	5	*	18	*	8	*	28

* Not reported.

NOTE ON STATE LAWS IN RELATION TO MANUAL TRAINING.

Connecticut, in 1888, authorized and empowered school boards to introduce Manual Training in public schools.

Congress appropriated $8000 to Manual Training equipment in the District of Columbia in 1896.

In 1885 the State of Georgia passed a law authorizing and recommending school boards to introduce Manual Training in the public schools of the state. The law was simply a moral indorsement, and had little practical effect.

Indiana has a law authorizing the introduction of Manual Training into the public schools of all cities of 100,000 inhabitants or over.

Massachusetts passed an authorizing act in 1884, and on April 14, 1894, a law was adopted, section one of which is as follows:

"After the first day of September in the year eighteen hundred and ninety five, every city of twenty thousand or more inhabitants shall maintain as part of its high-school system the teaching of Manual Training. The course to be pursued in said instruction shall be subject to the approval of the state board of education."

In 1887 New Jersey passed a law to encourage the introduction of Manual Training in public schools. The chief provision of the act was, that whenever any school district should raise by taxation, subscription, or both, a sum of money not less than $1000, for the establishment of Manual Training in such school district, the state should appropriate a sum equal to that raised by the district, to aid in the establishment of such school; provided that no one district should receive over $5000 in any one year from state funds. In 1888 this law was amended so as to include districts that should raise not to exceed $500, the state agreeing to duplicate the sum raised. The effect of this law was very marked in 1890, resulting in the establishment of a large number of schools.

In 1888 New York passed a law authorizing local school boards to establish Manual Training within their respective jurisdictions. The same law makes the teaching of Manual Training compulsory in normal schools, subject, however, to recommendations of the state superintendent of public instruction, which provision has practically nullified it.

Ohio has a law authorizing a tax levy of $\frac{6}{10}$ of a mill for cities of a certain size, and $\frac{1}{4}$ of a mill for certain other cities, in excess of other taxes; the sums so raised to be used for the purpose of introducing Manual Training into the public schools.

In 1895 Wyoming authorized school boards to establish Manual Training in the public schools.

In 1895 Wisconsin authorized the establishment of Manual Training in its public schools providing state aid for the same, but limiting the number to receive state aid to ten high-schools to be selected by the state superintendent of schools.

The best of existing state-aid laws is that of Maryland, enacted April 7, 1898. It is very liberal and will doubtless greatly stimulate the progress of the new education in that state. The Wisconsin law gives $250 to each of its schools per year, and the New Jersey law duplicates whatever the school board raises for that purpose. But the Maryland law gives $1500 to each school the first year, and $50 per pupil per year thereafter, up to the limit of $1500 per school per year—enough, probably, to pay the entire expense of the system. Following is the text of the statute:

"*Whereas*, The establishment of well-conducted and liberally supported schools, or departments, in one of the large graded schools or high-schools in each county of the state, for the development and training of the manual ability of pupils, must tend to supply a growing want in each county of the state; and

Whereas, It is especially the duty of the state to afford the best educational facilities to its youth in those technical studies which are directly associated with the material prosperity of its people; and

Whereas, It is for the best interests of this state that the colored population of each county shall have an opportunity for the establishment of separate industrial schools; therefore,

SEC. 1. Be it enacted by the General Assembly of Maryland, That

It shall be the duty of the board of county school commissioners, when a suitable building, or room or rooms connected with one of the large graded schools or high-schools shall be provided by the county, or money sufficient for the erection of such building, or room or rooms, to accept the same (if, in the judgment of the board, there is any necessity therefor), and thereafter to provide for the maintenance of a Manual Training school, or Manual Training department, for said county, and the salaries of teachers and Manual Training instructors, out of the general school fund and the state aid hereinafter provided.

SEC. 2. *And be it enacted,* That whenever a Manual Training school, or Manual Training department, is opened in any county, the president and secretary of the board of county school commissioners of said county shall report to the secretary of the state board of education, and the state board of education shall, without delay, proceed to appoint the principal of the state normal school, or one of the teachers in said school, well qualified for such service, to visit the school and give a certificate of approval of its condition and the plan upon which it is conducted; and thereafter the president and secretary of the board of county school commissioners shall report to the comptroller the condition of the school, the number of instructors, and the number of pupils enrolled, on or before the twentieth day of January in each year.

SEC. 3. *And be it enacted,* That the comptroller of the treasury, after receiving the certificate of approval concerning the county Manual Training school, or Manual Training department, according to the provisions of the second section of this act, is hereby authorized and directed to issue his warrant upon the treasurer of the state for the sum of fifteen hundred dollars, payable to the order of the treasurer of the board of county school commissioners of the county filing the certificate of approval aforesaid, out of any moneys in the state treasury not otherwise appropriated, on the first day of October in each year, for the support of said Manual Training school, or Manual Training department.

SEC. 4. *And be it enacted,* That the county Manual Training school, or the Manual Training department and the school to which it is attached, shall be under the management and control of the board of county school commissioners.

SEC. 5. *And be it enacted,* That it shall be the duty of the board of county school commissioners of each county in this state, whenever a suitable building, or room or rooms connected with one of the colored schools of said county, shall be provided by the county to accept the same, if in the judgment of the said board there is any necessity therefor, and thereafter to provide for the maintenance of such member [number] of separate colored industrial schools as in their judgment may be needed, and the salaries of such teachers as may be required

for that purpose shall be paid out of the general fund and the state aid hereinafter provided.

SEC. 6. *And be it enacted,* That whenever any such separate colored industrial school or schools are opened in any county, the president and secretary of the board of county school commissioners of said county shall report the fact to the secretary of the state board of education, and the state board of education shall without delay proceed to appoint a proper person well qualified for such service, to visit the said school or schools and give a certificate of approval of its condition and the plan upon which it is conducted, and thereafter the president and secretary of the said board shall report to the comptroller of this state the condition of said school or schools, the number of instructors and the number of pupils enrolled during the school year last ended, on or before the 20th day of August in each year.

SEC. 7. *And be it enacted,* That the comptroller of the treasury upon receiving the certificate of approval concerning the county colored industrial school or schools, as aforesaid, according to the provisions of the sixth section of this act, is hereby authorized and directed to issue his warrant upon the treasurer of the state for the sum of fifteen hundred dollars, payable to the order [of the] treasurer of the board of county school commissioners of the county, upon the filing of the certificates of approval aforesaid, out of any moneys in the state treasury not otherwise appropriated, on the first day of October in each year, for the support of said colored industrial school or schools, and thereafter the said industrial school or schools shall be under the management and control of the said board of county school commissioners.

SEC. 8. *And be it enacted,* That no entire appropriation for the benefit of any Manual Training school, provided for under this act, shall be paid as authorized, after the first annual appropriation, unless said school have had an average daily attendance of thirty scholars for the preceding year ; and in case said attendance shall fall short of said number, then there shall only be paid towards the maintenance of said school at the rate of fifty ($50.00) dollars for each scholar of its daily average annual attendance, to be determined by the report hereinbefore required to be made to the comptroller.

SEC. 9. *And be it enacted,* That no appropriation for the benefit of the colored industrial schools of any county, provided for under this act, shall be paid after the first annual appropriation, unless the average daily attendance at such school or schools shall have been, for the preceding year, at least thirty scholars ; and in case said attendance shall fall short of said number, then there shall be paid to the treasurer of the county school commissioners maintaining said school or schools, only at the rate of fifty ($50.00) dollars a scholar, for the daily average annual attendance at the same, to be determined by the report hereinbefore required to be made to the comptroller.

Approved April 7, 1898."

The report of the state superintendent of public instruction for Michigan, for the year 1897, shows that Kindergartens exist in the public schools of the following cities and towns: Cities of over 4000 population as shown by state census of 1894—Albion, Big Rapids, Cadillac, Calumet, Detroit, Escanaba, Grand Haven, Grand Rapids, Holland, Ionia, Ironwood, Ishpeming, Jackson, Menonimee, Mt. Clemens, Muskegon, Negamee, Niles, St. Joseph, Traverse City, West Bay City, Wyandotte—twenty-two cities of over 4000 population. The twenty-four cities and towns with less than 4000 population as shown by state census of 1894, and having Kindergartens in their public schools, are: Algonac, Alma, Au Sable, Caro, Crystal Falls, Dowagiac, Fremont, Greenville, Hartford, Houghton, Ithaca, Lake Linden, Lake View, Mancelona, Manistique, Montague, Morenci, Nashville, Pentwater, Reed City, Sand Beach, Stanton, Union City, Vassar. Such of these cities and towns as furnished reports will be found in the accompanying tables; from the others no data was received.

Two thoroughly equipped Manual Training schools are projected: one, to be in Pullman, Illinois, is to result from a bequest in the will of the late Mr. George M. Pullman, who left a large sum for its construction, and an annuity of $25,000 for its maintenance; the other school is to be built by the Calumet and Hecla Mining Company, at Calumet, Michigan. Both these schools will be free, and will probably become a part of the public-school system of their respective towns.

The legislature of Massachusetts in 1898 passed an act establishing a trade-school for weavers, to be located at Lowell, Massachusetts, provided the city would raise half the money necessary for its construction, the state to pay the other half. This is the first well-defined movement in this country to establish public trade-schools to teach the trades prevailing in the locality of the school. Europe has many such schools.

MANUAL TRAINING IN RUSSIA.

There is, as yet, no established national school system in Russia. The school systems of Finland and other Russian dependencies are provincial and local. An imperial decree of March 7, 1888, however, contained an elaborate plan for elementary national education, in which Manual Training, Technical, and Trade education were given not only prominence but precedence. The doctrine of state aid to educational institutions is, however, fully and liberally recognized. Manual Training was founded in Russia in 1868, as mentioned in the first edition of this work, by M. Victor Della Vos, and revived and extended in 1884 by the then Minister of Finance, who sent two teachers to Naäs, Sweden, to take a six weeks' course of instruction, and a workshop for boys' hand labor was the same year established in connection with the Teachers' Institute in St. Petersburg. In 1885 this was made a permanent feature of Teachers' Institute work, and an annual grant of 3000 rubles ($1659) was voted; and in 1887 a course in metal work was added to this school. In 1888 three normal courses for instructing teachers in Manual Training were instituted and subsidized by the imperial government. One of these at Novaia Ladoga trains both city and country school-teachers; at Riga, city teachers only, while at Kiev only country teachers are trained. The instruction of teachers in Manual Training was also made part of the teachers' institutes at Glookhov, Vilna, and Orenboorg in 1889. Besides these there were in 1890 eleven vacation institutes, training two hundred and fifty teachers for the work of imparting manual instruction. These teachers' institutes, vacation and permanent (or normal schools), have increased rapidly and received rich subsidies from the imperial treasury. In 1891 the Russian Minister of War introduced Manual Training into all the cadet schools. The most recent available data indicate the introduction of Manual Training into one hundred and sixteen establishments, as follows : four teachers' institutes, fourteen teach-

ers' seminaries, four intermediate schools, forty-four higher
public schools, and thirty-four elementary common schools.
A more recent report—which, however, is not at hand—is
said to show remarkable developments in Manual Training
in common and rural schools. A brief survey of technical
and trade schools in Russia follows.

The technical schools at Moscow and St. Petersburg are
imperial schools of university grade, richly endowed, and
reputed to be the best equipped schools in Europe. The
oldest and best technical school in Moscow below university
rank, and making no attempt to teach trades, is the Ko-
misarof Technical School, founded in 1865 by two railroad
contractors. It now receives government aid, and has about
four hundred pupils. The Society for the Promotion of
Technical Education in 1873 founded a school called the
"Mechanical Handicraft School of Moscow." The govern-
ment contributes $1000 per year to this school. There are
five technical schools having a grade of academic work
comparable with our high schools—the Komisarof Tech-
nical School of Moscow, mentioned above, founded in 1865;
the Lodz, in 1869; Irkootsk, 1873; Kungursk, 1877; and the
Omsk, in 1882. The five schools had 1052 students at date
of latest available report. Trade-schools of grammar grade,
twenty-three in number, had 2474 pupils. Of these schools
three were established in 1868; one in 1871; two in 1872; one
in 1873; one in 1874; one in 1875; two in 1877; one in 1878;
two in 1879; one in 1880; two in 1883; two in 1885; three
in 1886; one in 1887. Trade-schools of primary grade, sixty-
three in number, with 2562 pupils. One was established
in 1865; one in 1866; two in 1867; one in 1870; one in 1871;
three in 1872; two in 1873; five in 1874; six in 1875; one in
1876; six in 1877; four in 1878; three in 1879; two in 1880;
two in 1881; four in 1882; five in 1883; five in 1884; one in
1885; one in 1886; four in 1887; two in 1888; one in 1889.

MANUAL TRAINING IN FINLAND.

Finland was the birthplace of the man who first devised
and practised that method of education known as Sloyd—
a form of Manual Training.

Otto Cygneans, of Helsingfors Teachers' Seminary, after a thorough study of Froebel and Pestalozzi (to whom he gives ample credit), originated in 1858 a system for carrying the education of the hand beyond the kindergarten into all grades of schools. To Finland also belongs the credit of being the first country to officially recognize the value of such education. Since 1866 (sometimes stated 1868) Manual Training (Sloyd) has been compulsory in all the elemental and normal schools of Finland. In 1896 there were four normal schools with 569 students, and 75,712 pupils taking Manual Training in the elementary schools of the cities. Statistics of rural schools are not obtainable. In addition to these, there were in 1896 forty-two separate and distinctively Manual-training high-schools, with 1030 pupils, besides eight industrial schools, with 56 teachers and 380 pupils. All are public schools. There are technical and trade schools of all grades, from the Polytechnic School at Helsingfors to the elementary trade and weaving schools. There are seven schools where navigation is taught, twelve weaving, dyeing, and sewing schools, supported wholly or in part by the government, fourteen elementary technical schools, five high-grade technical schools, and ten trade-schools other than weaving and navigation. Government aid is granted to all of these schools.

MANUAL TRAINING IN ENGLAND.

The activity of Germany along the line of trade and technical schools, immediately following the Centennial Exposition at Philadelphia, alarmed the people of England, producing in 1882 what has been termed a "Technical education scare." The friends of Manual Training, acting upon this popular and commercial anxiety, secured the passage of the "Technical Instruction Act of 1889." By the terms of this act the schools organized under it were not to be trade-schools ; and the construction put upon the expression "Manual Instruction" makes the term practically synonymous with our term Manual Training. The following table shows the growth of these schools. The

growth of cooking schools is also statistically represented in the table.

Date	Manual Instruction Number of Schools		Schools of Cookery and Domestic Science		
Year	Number of Schools Existing in Year Named	Number of Schools Established During Year Named	Number of Schools Existing in Year Named	Number of Schools Established During Year	Number of Pupils
1876...................	29	29	..
1877...................	125	96	..
1878...................	178	53	..
1879...................	223	45	..
1880...................	276	53	..
1881...................	299	23	..
1882...................	347	48	..
1883...................	420	73	1,251
1884...................	541	121	7,697
1885...................	715	174	17,754
1886...................	812	97	24,826
1887...................	921	109	30,431
1888...................	1,086	165	42,180
1889...................	1,365	269	57,589
1890...................	30	30	1,554	199	66,620
1891...................	145	115	1,796	242	64,291
1892...................	285	140	2,113	317	90,794
1893...................	430	145	2,419	-306	106,192
1894...................	677	247	2,634	215	122,325
1895...................	949*	272	2,775	141	134,990

* The number of pupils taking Manual Training cannot be given; as an indication, however, it may be said that the London School Board reports that in 1895, 30,508 boys were instructed in wood-work in London schools alone.

Governmental aid to drawing and Manual Training, when incorporated in the curriculum of day grammar-grade schools, evening "continuation schools," and teachers' training colleges, is bestowed through the executive department, styled "The Science and Art Department." Special attention is paid to training teachers in the teachers' colleges, so that they will be able to give instruction in Manual Training. This is specially true to grammar-grade teachers. In 1894 56 teachers' colleges were giving Manual Training to 4,434 teacher-pupils, the government granting $13,290 in aid of such training. In 1895, the science and art department, upon examinations aided 910 elementary Manual-training schools, giving instruction to 67,470 pupils; the amount of aid granted was $81,537.

In 1890 a law was passed empowering county councils to use the surplus from duties on liquor to aid Manual-train-

ing and technical schools. Many districts use the "liquor
money" to establish purely Manual-training schools, attach-
ing them to municipal technical schools. Generally, how-
ever, the "liquor money" goes to technical and art schools.
The report for 1895 shows $5,699,046 applied by local author-
ities to technical instruction under the "liquor money" law.
Scotland secured in 1887 a law empowering local authorities
to levy a tax of a penny in the pound for the support of
technical schools. In 1889 a similar law was passed for
England. The Welsh law of 1889 organizing intermediate
schools, recognizes and defines Manual Training. These acts
led up to the "liquor money" law referred to.

The City and Guilds of London Institute, organized in
1876, is the principal private promoter of technical education
in England. This organization has founded three schools
of its own, besides aiding liberally similar schools in all
parts of the kingdom. With the exception of the well-
known South-Kensington school, the Manchester school, and
the Birmingham schools, the technical schools of England,
as well as its Manual-training schools and kindergartens, are
of recent origin. Huddersfield Technical School, founded
as a mechanics' institute in 1841, is another exceptionally
old and especially good school of its class.

MANUAL TRAINING IN SWITZERLAND.

As each canton regulates its own school system, the
federal constitution requiring only that education must be
obligatory and free, the same diversity of conditions exists
in the cantons of Switzerland that is found in the states of
our own Union :—

Thus in the canton of Geneva, kindergartens and Manual-
training schools are a part of the public-school system,
entirely supported by public funds, and Manual Training is
compulsory for all male pupils, in all grades of the public
schools. The gradual advance from kindergarten work to
primary, grammar, and high-school, makes a complete course
in Manual Training in the schools of Geneva — perhaps the
most complete to be found in any single public-school system.
In other cantons, however, kindergartens exist generally as

private institutions, aided by public funds and contributions from societies and individuals. The growth of kindergartens in Switzerland by years cannot be shown from any data at hand; the following table, however, shows the status at the date of most recent available data:

PUPILS AND TEACHERS IN KINDERGARTENS OF SWITZERLAND

CANTON	Number of Separate Kindergartens	Number of Pupils	Number of Teachers
Zurich..	61	3,552	79
Berne.............	62	2,550	63
Lucerne........	3	360	6
Uri ...	1
Schwytz ..	4	91	4
Unterwalden	2	85	2
Zug...	5	188	6
Freyburg..	10	912	10
Soleure ..	8
Basel Town.......................................	32	2,117	45
Basel Land.......................................	8	452	8
Appenzell Outer Rhodes..........................	16	843	19
Appenzell Inner Rhodes..........................	1	60	2
Grisons ..	2	80	4
Aargau...	13	..	13
Ticino..	23	1,351	43
Vaud...	160	4,000	160
Valais..	3	249	3
Neuchâtel...	36	997	36
Geneva...	65	3,872	85
Total.......................	**515**	**21,639**	**589**

Manual Training for boys was introduced into the Switzerland schools in 1884 by M. Rudin, who in that year instructed a class of forty teachers; in 1891 over one hundred teachers were taking a Manual-training course under his instruction. The following table shows the growth of Manual Training to 1889, or five years after its introduction. More recent data are unfortunately not available.

MANUAL-TRAINING CLASSES IN SWITZERLAND

CANTON	Number of Classes	Number of Pupils	Number of Teachers
Zurich ...	19	305	13
Basel ..	32	558	19
Saint Gall..	6	122	8
Schaffhausen.....................................	2	120	2
Grisons ..	2	48	2
Thurgau..	2	46	1
Soleure	40	1
Aargau...	1	..	1
Berne...	5	175	5

Classes in Manual Training are reported from the cantons of Vaud, Neuchâtel, Appenzell, Freyburg, and Glarus; but statistics are not given. Manual Training for girls has been an integral part of the public schools of Switzerland for many years, and in practically all of the cantons this instruction is obligatory. The instruction consists in knitting, sewing, mending, cutting, and fitting, with lectures on house-keeping, and was introduced into the schools rather for its industrial use than in recognition of its educational value. Switzerland early recognized the importance of technical instruction and the development of artisan skill. The Municipal School of Art at Geneva was founded in 1751, and is intended as a school for working-men. It is the oldest in Switzerland. The working-man's school at Berne was founded in 1829, and, though a private institution, it is subsidized by the federal government. The Polytechnic School at Zurich was founded by the federal government in 1854. The Industrial School in that city, founded in 1873 by a society, is subsidized by the city, canton, and federal government. "The Tecknikum" of Winterthur, probably the most complete of its class of schools, was founded as a cantonal institution in 1873. The most extensive are the technical institutions for the education of working-men. The government began the establishment of these at the beginning of this century. By 1865, ninety-one had been established ; in 1889, eleven hundred and eighty-four of these schools, having 26,716 pupils, were reported. Trade-schools have sprung up everywhere, adapting themselves to local industries and common needs. The School of Watchmaking, at Fleurier, was founded as a private institution in 1850, but has been municipal property since 1875. Municipal Schools of Watchmaking exist at Chaux-de-Fonds, 1865; St. Imier, 1866; Locle, 1868; Neuchâtel, 1871; Bienne, 1872; Porentruy, 1883, is a municipal and state school, as is also that at Soleure, 1884. The Trade School for Women is a private institution of Basel, founded in 1879; that of Berne, in 1888. These schools are founded by Societies for the Advancement

of Public Utility, and teach women the millinery and dress-making trades, and give instruction in household work, and all the means by which women can become self-supporting. The societies have also founded numerous House-keeping Schools, and Schools for Domestic Servants.

No attempt is here made to give a complete list of Switzerland's trade-schools, or the efforts being made to advance the skill of her artisans. It is but proper, however, to mention the latest efforts to overcome the difficulties growing out of the decline in apprenticeship. In 1884 the Mannheim Trade Unions asked for a committee of investigation into the condition of the small trades. The committee reported, recommending the adoption of a suggestion received from the Karlsruhe Trades Union. It was in effect, that master-workmen who are willing to train apprentices systematically, according to regulations prescribed by school authorities, shall be aided by the state treasury. In 1888 Baden appropriated 5000 marks per annum for this purpose, and in 1892 twenty-two trades, or one hundred and twenty-two workshops, having one hundred and eighty apprentices, were subsidized. In 1895 the appropriation was increased. In 1898 the federal government of Switzerland adopted the plan and purposes to greatly extend it. The result of this is, practically, that every skilled master-workman who desires may become to a certain extent a public-school teacher, and every factory or workshop is, or may become, a school-house.

MANUAL TRAINING IN GERMANY.

The officials of the regular school systems of Germany, while for some years past active in advancing trade-schools, have never recognized Manual Training as worthy a place in the public schools, except as regards female handiwork, which is everywhere a part of the course in grammar and high schools for girls. Individuals, and "societies for the promotion of practical education," must therefore take the initiative in Manual Training, and this results either in private schools, or in persuading municipal or state author-

ities to annex a Manual-training department to some public school.

Of the 328 Manual-training schools for boys existing in 1892, 126 were independent schools, and 202 were annexes attached to other educational institutions of various kinds. Special societies maintain 50 schools and 72 annexes, of the above total, while municipal authorities maintain 70 schools and state authorities 66 annexes. The growth by years since 1878 is shown in the following table:

Established	Independent Schools	Annexes to Other Schools	Established	Independent Schools	Annexes to Other Schools
Prior to 1878..	..	26	1885..........	2	11
1878..........	1	..	1886..........	1	9
1879..........	3	..	1887..........	8	11
1880..........	4	4	1888..........	13	11
1881..........	9	6	1889..........	19	23
1882..........	4	3	1890..........	21	30
1883..........	2	6	1891..........	27	36
1884..........	3	10	1892..........	9	16
			Total.......	126	202

In 1892 there were 285 teachers and 7374 pupils in the independent schools; 363 teachers and 6841 pupils in the annexes, or 648 teachers and 14,235 pupils in both. While something had been done in Germany in the way of trade-schools prior to that date, the general interest and official zeal was created by the Centennial Exhibition at Philadelphia in 1876, when Professor Reuleaux cabled to Bismarck, "Our goods are cheap but wretched." The various states began to inaugurate the educational system that had made the manufactures of France so superior to those of her competitor, and from 1879 to 1890 over 50 trade-schools were established in Prussia.

Some of the German states, notably Saxony and Würtemberg, had early established trade-schools. In 1837 three royal labor-schools were established by the state of Saxony; one in 1838, and two in 1840. Special schools for instruction in weaving, embroidery, and lace-making were established; one in 1835, one in 1857, one in 1861, one in 1366, and one in 1881. Of the 32 trade-schools in Saxony seven have been

established since 1886. In the 20 *"Kleinstaaten"* or so-called small states of Germany there were, in 1895, 218 trade-schools having 2047 pupils. Practically all of these have been established since 1879. The city of Berlin in 1895 reported 21 trade-schools with 8992 pupils, 332 teachers, and expenditures (exclusive of state aid) for these schools of $129,102; besides $80,339 spent for trade education in so-called "continuation" schools. In February, 1897, the number of students attending these schools in Berlin was 14,750, or 1 per cent. of the population.

It will be interesting, in view of the antagonistic attitude of the school authorities to the introduction of Manual-training methods in public schools from kindergartens up, to note how long Germany will follow the trade-school experiment of France, without learning, as did France, to fit her boys for the trade-schools by putting their little hands to school in the kindergarten, the primary school, and so on through grammar and high school; so that by the time the trade-school comes in to differentiate and accentuate special skill, the boy will have learned equally the use and control of muscle and of mind.

The highest results of trade-schools upon a nation's manufactures, and therefore upon its exports and its wealth, cannot be realized until the Manual-training school has furnished the educated hand as raw material for the trade-school to work upon. The nation that begins with the trade-school first will have a long and expensive lesson to learn. France learned it. Will Germany require as long and expensive a tuition? Germany has, however, the advantage, in that many of her private citizens, and "societies for practical education," are, as usual, far more intelligent than her school authorities.

Manual Training in France.

The thorough reorganization of the public schools of France by the law of June 16, 1881, renders any reference to the prior system unnecessary here.

By this law primary education was rendered absolutely

27

free; and by the law of March 28, 1882, compulsory education for all children between the ages of 6 and and 13 years was established. The law of October 30, 1886, systematized the public schools, classifying and grading them, and fixing a curriculum. Kindergartens admitting pupils from the ages of 2 to 6 years were made general by this law, and in 1886–87 there were 3597 kindergartens with 543,839 pupils. In 1895 this number had grown to 4734 kindergartens, 714,734 pupils, and 9199 teachers, all women.

The government programme contemplates that Manual Training proper shall begin where its elements in the kindergarten leave off, and be continued throughout the four grades of primary instruction. But the full purpose of the law seems slow of realization, for in 1890, four years after the passage of the law, only 400 shop-schools of primary grade had been established, 101 of these in Paris. Manual Training has been compulsory in all public high-schools of France since 1886. These may be either independent schools or classes annexed to an elementary school. In the latter case they are called *cours complémentaires.* In 1886 there were 16,217 boys and 5150 girls in public high-schools; in 1895 there were 21,996 boys and 8660 girls, a rise of 35 per cent. for boys and of 68 per cent. for girls in the ten years.

In the *cours complémentaires* there were 11,518 boys and 5223 girls in 1895, an increase of 37 per cent. for boys and 26 per cent. for girls over the figures for 1886. This result was not, however, accomplished at once. There had been the usual struggle for Manual-training schools before the law of 1886 made them universal and compulsory. The school authorities of Paris introduced sewing into the public schools in 1867, and in 1873 M. Salicis began the introduction of Manual Training into what we would term grammar-schools. Shops were annexed to the boys' school in the Rue Tournefort in 1873. From that time until the general law of 1886 the growth was gradual. There are in France a large number of Manual Apprenticeship schools. They are a kind of primary trade-school. Prior to 1880 various cities, as Paris, Havre, Rheims, etc., had founded

apprenticeship schools. Private schools of the same character had been established by individuals and industrial associations. The law of 1880 organized these efforts, assimilated all these institutions, and brought them under the control of the public. The tendency to bring all industrial institutions, whether classical, manual, trade, or technical, under control of the state has been very marked since 1880 in France, and still more so since the law of 1886. Of the six industrial and house-keeping schools for girls in Paris four were founded by the city; the others were private institutions absorbed by the city—one in 1884, the other in 1886. They are of high-school grade, and, in addition to general domestic economy, teach special trades to women, such as millinery and artificial flower work. The nation maintains high - class trade and technical schools in all industries important to her commerce. And there can be no doubt that the excellence of her manufactures has its origin in the large number, variety, and excellence of her free schools. The National School of Watch-makers was founded in 1848 by the government of Savoy, and reorganized by the French government in 1890. The National Schools of Arts and Trades, four in number, are the oldest and most important of the public institutes of technology and trades. The first of these was founded as a private institution in 1780, and became national property during the First Republic. The second of these schools was established in 1804, the third in 1843, and the fourth completed in 1892. These schools instruct fully in the mechanical arts, the purpose being to educate at public expense thoroughly equipped superintendents and masters of workshops for industrial establishments. Such, too, is the purpose of the Central School of Arts and Manufactures at Paris, which, founded as a private institution in 1829, became the property of the state in 1857.

Schools of Mining, such as the one at Houghton, Michigan, are located, one at Paris (National High-school of Mines); one at St. Étienne (School of Mines); and schools for master miners at Alais and at Douai. The National Conservatory

of Arts and Trades, founded by the National Convention in 1794, began in 1819, under special ordinance of the government, gratuitous courses of instruction upon the application of the sciences and industrial arts. It is to industrial education what the College of France is to classicism and "pure science"—whatever that may mean. No attempt is here made to give a complete list of the trade and technical schools of France, whether public or private. They are exceedingly numerous, and cover every phase of industry. The purpose here, however, is to call attention to the fact that France began with trade-schools, and, after a hundred years of experimenting with trade and technical institutions, she reached the wisdom embodied in the laws of 1886 and 1890, which provide for the training of the hand of the child in the kindergarten and continuously throughout the school age, thus furnishing aptest possible pupils for her higher trade and technical institutes, and the greatest possible development of skill for her industries. The character of her manufactures shows the importance of the scholar in industry.

Manual Training in Italy.

Discussions in 1882 and 1885 led to an official adoption of Manual Training in normal schools in 1892, when twenty selected teachers were given one month's gratuitous training. In 1893 Sloyd was made obligatory in the practice department of all normal schools. In 1893, 34 men and 34 women teachers were taking the Manual-training course at Repatrausone. The school authorities in Italy acting upon the English idea of teaching Manual Training to the teachers first, and so interest them that they will introduce Sloyd into the elementary schools of their districts.

Beyond the statement that Manual Training was experimentally taught to 400 pupils in Genoa in 1892, no data is at present obtainable as to the success of this plan. There are 194 industrial schools, seeking to teach special industries. In 1887 there were 419 technical schools, of more or less importance, and 74 institutes of secondary technology.

With the exception of the Aldini-Valeriani institute in Bologna, founded in 1834, and the *Scuola Professionale* at Foggia, established by the state in 1872, the trade and technical schools of Italy seem to be of recent origin.

Manual Training in Belgium.

The law of July 1, 1879, reorganizing the public-school system of Belgium, made kindergartens a universal and integral part of the public schools. Children are admitted at 3 years of age, remaining till seven. "At Brussels, Liege, and Verviers, experimental transition classes exist, which prolong kindergarten methods in the primary grades, the Manual-training exercises of Froebel reappearing in the primary schools, and there developing into some simple form of actual hand labor, with paper, pasteboard, or clay. The results have been very satisfactory." In 1891 the city of Liege reported 4717 children attending public kindergartens. A normal school for training kindergarten teachers is maintained at Liege. In 1890 Belgium maintained 1042 kindergartens having 104,760 pupils. The movement to generalize Manual Training in the public schools began in 1882, took definite shape three years later, and by 1887 the state made Manual Training obligatory in all state normal schools, sixteen in number. Fifty cities also reported Manual Training established in their public schools in 1888. The more recent reports, while not given much to statistics, show satisfactory growth in the system. Schools of apprenticeship and of trade have received more encouragement in Belgium than Manual Training has in the schools of grammar and high-school grades.

Apprenticeship schools to teach lace-making to the indigent peasantry were established by the state as early as 1776. With the introduction of machinery, and the expansion of industries, the character of these schools was changed. Abuses grew up. Academic tuition was abandoned for work, and the schools practically turned over to financial interests of the exploiters of the labor of children. A reoganization occurred in 1890 when the state s

some forty of these apprenticeship schools, and abolished many others.

Trade-schools of every variety, from the schools for fishermen at Ostend and Blankenberg to the famous trade-schools of Brussels, abound in Belgium. While these schools are for the most part private schools, they are usually subsidized by the city or local government. The industrial school at Ghent is a technical school of importance founded in 1828. That at Tournay was opened in 1841. These are the oldest schools of their type in Belgium. A new impetus was given to these schools in 1885, and from that date many have sprung up in all parts of the country, the local industries determining the character of the trade-schools. The trade-school at Ghent, established in 1890, is the best expression of modern methods, as distinguished from the early ideas represented by Tournay. This school was overcrowded with pupils in 1892. The state grants a subsidy of 6000 francs ($1158), and the province also aids the school. In 1889, 54 industrial schools were reported in Belgium. In 1872 a house-keeping school for girls was established by M. Smits, of Couillet, the first of its kind in Belgium. In 1890 there were 160, and in 1892, 250 such schools, and classes in house-keeping attached to other schools. Practically all of these were either public schools or free classes in private institutions.

MANUAL TRAINING IN AUSTRIA.

In Austria no attempt is made to combine in the same institutions the discipline of shop-work and the academics of the public schools. The first shop-school was established in Vienna by a private association, August 10, 1883. The second followed, February 16, 1887. In 1884 a normal school for the training of Manual-training teachers was established. At Budapest a Manual - training school was organized by private initiative in 1886.

The municipal statutes almost immediately required one such school to be maintained by each school district, and in 1889 there were in the twelve districts sixteen such schools,

One unimportant trade-school dates back to 1871; but with the exception of the work done in Vienna and Budapest, and a few so-called "continuation schools" and trade-schools, nothing of importance was done by Austria until 1896. The activity of the empire since the latter date has been directed towards the establishment of apprenticeship schools.

MANUAL TRAINING IN SWEDEN, NORWAY, AND DENMARK.

From Finland the new educational ideals developed by Otto Cygnaeus spread to Sweden, and thence to the world at large. Dr. Salomon of Naäs introduced Manual Training (Sloyd) into his school in 1872, and in 1878 there were 103 Sloyd schools in Sweden. In 1879 there were 163; in 1880, 234; in 1881, 300; in 1882, 377; in 1883, 463; in 1884, 584; in 1885, 727; in 1886, 872; in 1887, 991; in 1888, 1167; in 1890, 1278; in 1891, 1492; in 1892, 1624; in 1893, 1787; in 1894, 1887; in 1895, 2483; or an increase of 2380 in 17 years. In 1877 parliament voted $4000 per annum to advance Sloyd instruction; in 1891 this was increased to $30,000 per annum, in addition to amounts given by provincial authorities, agricultural and private societies, and parish authorities. The Naäs seminary for the instruction of teachers of Sloyd (Dr. Salomon's school) reports that 2627 teachers of Sloyd had been taught between 1875 and 1896. In the Sloyd teachers training-school at Stockholm 573 women instructors were taught in the years from 1885 to 1897, inclusive. There are 32 evening and holiday schools, which in 1895 received a subsidy of $12,060.

There is no definite data on Manual Training in Norway earlier than 1889, though Sloyd had doubtless been introduced from adjacent countries prior to that time. By law, however, Sloyd was made compulsory in all city elementary and intermediate grade schools in 1892, and optional in village schools. In 1891, $5060 was given as a subsidy for teaching Sloyd in 178 schools. The number of students in rural elementary schools in which Sloyd is optional is given at 236,161; number of students in city schools where Sloyd is compulsory, 58,871.

In 1883 the first Danish Sloyd school was established. The Copenhagen Seminary for instructing teachers of Sloyd was established in 1885. In 1888, 46 schools reported Sloyd courses with 2000 pupils under instruction; this number in 1889 had grown to 59, and in 1896 to 114. Of this latter number 30 are regular Sloyd schools; the others educational institutions having Sloyd as a part of the course. In 1890, $4368 was appropriated to further the introduction of Sloyd into the schools of Denmark. In this connection must be mentioned the "Home Industry" schools of Denmark. Not less than 500 of these schools exist, generally attached to other schools, and supported by 400 societies for promotion of home industries and by state aid. It was the powerful advocacy of these schools by their champion, Clauson-Kaas, that delayed the introduction of Sloyd into Danish schools until 1883, when the influence of Professor Mikkelsen began to gain the ascendency. Not only was Clauson-Kaas a powerful man in his advocacy of these home industry schools, but equally vociferous and partisan in his opposition to Manual Training or Sloyd as a means of education and intellectual development. In the terrific strife of partisan school-teachers as to what constituted education, the schools of Denmark not only deteriorated but were wellnigh closed. That the home industry schools had their use is witnessed by the fact that practically every Danish housewife is not only an expert needlewoman and house-keeper, but expert in all those arts that go by the name of female handicraft. Grade schools and technical education have not developed greatly in Scandinavian countries. Sweden has two important schools for weaving, the Eskilstuna school for metal-workers, and four technical schools. Norway has two schools for teaching the wood-carver's trade, two of carpentry, a school for mechanics, three technical schools, and four industrial schools for women. Apart from the numerous schools of home industries, difficult if not impossible to classify, Denmark has a trade-school for shoemakers, and one of considerable importance for watch-makers.

Manual Training in the Netherlands.

The normal course in the Netherlands includes Manual Training for boys, it being the intention to teach teachers first, and to establish Manual Training in the schools later. There are a large number of trade and apprenticeship schools, the government taking far more interest in these than in Manual Training. In 1895 there were twenty "*Ambacht-scholen*" (for training tinners, carpenters, and dyers), with 2295 students. There are forty-eight industrial schools.

Manual Training in Argentine Republic.

January 13, 1896, a commission was appointed to report a plan for the introduction of kindergartens and Manual Training into the public-school system. In 1897 the report was made, and its recommendations were enacted into a law going into effect January 1, 1898. The introduction of Manual Training is to begin with the national colleges, sixteen in number, with 2629 pupils; the normal schools, thirty-five in number, with 1770 pupils. Ultimately under the law Manual Training will be adopted in the 3749 elementary schools, having 264,294 pupils, though no statistics are at hand showing to what extent this has been already accomplished. The papers presented before the commission which sat through February, 1896, were upon the importance of kindergartens as a basis for Manual Training; Manual Training as a means of education; Manual Training from the hygienic standpoint, etc. Some speakers favored industrial rather than Manual-training schools, but the commission reported that the system of Sloyd used at Naäs, Sweden, with certain modifications to suit local conditions, was the proper one to adopt. The kindergarten system recommended is purely Froebelian. From one of the papers read before the commission it is learned that Manual Training is a recognized part of the course of instruction in the national colleges of Uruguay, and to some extent in its elementary schools. Definite data for Uruguay schools are not, however, at hand.

INDEX.

A.

Abstract ideas regarded as of more vital importance than things, 185.

Adam, legend of, and the stick, 157.

Adams, Charles Francis, Jr., arraigns the schools of Massachusetts for automatism, 201; declares that, in the public schools, children are regarded as automatons, etc., 205.

Adler, Prof. Felix, declaration of [in note], that manual training promotes rectitude, 142; unique educational enterprise of, in New York City, 342; extracts from report of, as to purposes of the "model school," 344, 345.

Age of force, the, is passing away, 303.

Age of science and art, the, has begun, 303.

Agricola, noted for the practice of the most austere virtue, 274; after great services, was retired, 274.

Agricultural colleges, manual training in twelve, of the State, 341.

Agriculture nearly perishes in the Middle Ages—prevalence of famines, 281.

Alabama, Agricultural and Mechanical College of, adopts manual training, 355.

Alcibiades kept not his patriotism when he was being wronged, 255.

Alison, his theory of the cause of the decline of Rome, 63.

Altruism, stability of government depends upon, 135.

America, discovery of, the crowning act of man's emancipation from the gloom of the Dark Ages, 286; gives wings to hope, 287; startles the people of Europe from the deep sleep of a thousand years, 287; a great blow to prevailing dogmatisms, 307; completes the figure of the earth, rendering it susceptible of intelligent study, 307.

America, early immigration to, consisted of Puritans and Cavaliers, Germans, Frenchmen, and Irishmen, 306; destined to become the home of an old civilization, 306; the manner in which the colonists of, treated the natives showed the Roman taint of savagery, 306; European social abuses exaggerated in, 323; the eyes of mankind rest upon, alone with hope, 323.

Americans, are transplanted Europeans controlled by European mental and moral habitudes, 323; will not vote away their right to vote, 324, 325,

Commercial Club, the, founds the Chicago Manual Training School, 2; guarantees $100,000 for its support, 3; meeting of, March 25, 1882, 346.

Common-school system of the United States, glaring defects of, shown by the Walton report, 197, 198, 199.

Composition, automatism in teaching, in the schools of the United States, as shown by the Walton report, 199.

Compton, Prof. Alfred G., on the exacting nature of the demands made upon instructors by the new education, 352.

Concrete, progress can find expression only in the, 151, 152; a lie always hideous in the, 224.

Connecticut, manual training in State Normal School, 342; legislature of, adopts manual training as part of the course of public instruction, 360.

Contempt, in the Middle Ages, withered hope, 284.

Convent, of the Middle Ages, the home of religion and of art, 280.

Cook County Normal School, Ill., manual training in, 342.

Cooley, Lieut. Mortimer E., letter of, to the author on effects of manual training in the University of Michigan, 363.

Cordova the abode of wealth, learning, refinement, and the arts, 282.

Corporate power unduly promoted by reckless legislation on the subject of land in the United States, 320.

Corporations, a creation of yesterday, the product of steam, 320; almost as indestructible as landed estates, 320; men trained from generation to generation to the care of, 320.

Cort, Henry, an English inventor of the eighteenth century, 84; experiments of, with a view to the improvement of English iron, 115.

Cotton-gin, the, trebled the value of the cotton-fields of the South, 160.

Cotton Exchange of New York, speculative trades in futures on, thirty times more than the actual cotton sales, 322.

Crane, R. T., Vice-President of the Chicago Manual Training School Association, 346.

Cranege, the Brothers, inventors of the reverberatory furnace, 66.

Crerar, John, Trustee of the Chicago Manual Training School Association, 346.

Crusaders, their astonishment at the splendors of Constantinople, 285; they expected to meet with treachery and cruelty—they found chivalry and high culture, 285; they returned to Europe relieved of many illusions, 285, 286.

Crusades, the, pitiful and prolific of horrors as they were, shed a great light upon Europe, 285; brought the men of the West face to face with a progressive civilization, 285.

D.

Dædalus, invention of turning ascribed to, by the Greeks, 33.

Damascus blades, the most signal triumph of the art of the smelter and the

F.

- Fairbank, N. K., Trustee of the Chicago Manual Training School Association, 346.

Faneuil Hall, slavery justified in, 311.

Feudalism emasculated human energy, 281; the ruin of, set thousands of serfs free, 290.

Field, Marshall, Treasurer of the Chicago Manual Training School Association, 346.

File, the, older than history, dating back to the Greek mythological period, 91; of the Swiss watch-makers, 91; dexterity of the hand-working cutter of, 91; invention of file-cutting machine in 1859, 91.

Finland, all the schools of, give instruction in hand-cunning, 368.

Fire, legend in regard to its discovery, 62.

Foley, Thomas, on the excellence of the laboratory methods of instruction, 217, 218.

Force, new elements of, to be discovered and applied to the needs of man, 180.

Forging, laboratory of, 58; pen-picture of a class of students in, 61; story of the origin of the Turkish Empire related by the instructor in, 61; the management of the forge fires in, 62; lessons in, on the black-board and at the forges, in detail, 66; the instructor in, at the forge, 69; questions by the students in, 69; the school-room converted into a smithy which resounds with the clang of sledges, 69, 70; healthful effects of the exercise—the anvil chorus, 70; the tests of merit in, applied, 75; the instructor in, gives a lecture on the steam-hammer, 75; extent of the course in, 77.

Founding, laboratory of, 45; history of the art of, 46; first applied to bronze, 46; lesson of the day, casting a pulley, 48; the process in detail, 51; pen-picture of the students pouring the steaming metal into moulds, 52.

- France, permanently weakened by the increase of her national debt, 296; debt, statement of—what the war with Germany cost her, 296; cannot double her debt again and make her people pay interest on it, 297; a law of, makes manual training obligatory, 368; supports a school for training teachers of manual training, 368; Prof. G. Solicis the chief supporter of manual training in, 368.

Franklin, the famous selfish maxims of, 311.

Froebel, the school he struggled in vain to establish, 2; first applies Rousseau's ideas to school life, 126; his definition of education, 126; condemns the old system of education, 126; a character of, 127; his discovery of the superior fitness of woman for the office of teacher, 127, 128; foresees the manual training school, 245; it was reserved for him to rescue woman from the scorn of the ages, 367.

J.

Lucretia, political effects of the tragic fate of, 264.
Luther, the reformation of, opened the way to the last analysis of dissent in America, 309.

M.

MacAlister, James, declaration of, that there has been but little change in the ideas that have controlled our methods of education in four hundred years, 154; his graphic description of the power and versatility of the hand [*note*], 155; observation of, that a skilled hand, to the majority of men, is quite as important as a well-filled head, 208; has revolutionized the public schools of Philadelphia in two years, 355; one of the most accomplished as well as sternly practical educators in the United States, 357; opinion of, that every child should receive manual training, 358; opinion of, that the great principles which underlie the system mean nothing less than a revolution in education [*note*], 358, 364.
Macaulay's, Lord, analysis of the Baconian philosophy, 377.
Machiavelli, philosophy formulated by, 284; political maxims of, not invented by him, 284; maxims of, atrocious character of, 284, 285; maxims of, promote barbarism, 285.
Machines, automatic, nails, screws, pins, and needles flying from the fingers of, by the thousand million, 82; more powerful to be constructed in the future, 180.
Machine-tool laboratory, the students of, enter upon a most important inquiry, 82; the study of minute and ponderous tools in, 83; delicacy of the processes of, 91; the poverty of words as compared with things asserted in, 91; silence of, how eloquent, 91, 92; a screw-engine lathe taken to pieces in, 92; improvements in the lathe explained in, 92; fundamental and auxiliary tools of, explained, 93; course of training in, orderly, 93; students work from their own drawings in, 94; why skill is required to handle steam-driven tools of the, 94; aspect of the, when in repose, 97; aspect of the, when steam is on, 98; pen-picture of students of, 99; students of, at work on graduating projects in, 100; dream of instructor in, 100–103; completing graduating projects in, 103, 104.
Machine-tool shop, the modern, an aggregation of hand-tools made automatic, and driven by steam, 8; revolution in the useful arts caused by the, 78; what this creation of modern times, a huge automaton with steam coursing through its veins, does, 78–81; its arms, its hands, its brain, its food, and its products, 81; lines of modern development converge in the, 81; human pursuits widely diversified by, 82.
Macomber, A. E., on the Toledo Manual Training School, 365.
Madrid, people of, threatened with starvation, 283; lost half its population in the seventeenth century, 283.
Maine, Sir Henry—his tribute to things, 379.

ND - #0086 - 050922 - C0 - 229/152/27 - PB - 9781330877982 - Gloss Lamination